KU-713-396

COMPARATIVE TEXTUAL MEDIA

TRANSFORMING THE HUMANITIES IN THE POSTPRINT ERA

N. KATHERINE HAYLES AND JESSICA PRESSMAN, EDITORS

Electronic Mediations, Volume 42

UNIVERSITY OF MINNESOTA PRESS
MINNEAPOLIS
LONDON

UNIVERSITY OF WINCHESTER
LIBRARY

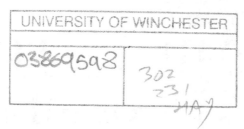

UNIVERSITY OF WINCHESTER

03869598

302
231
MAY

Portions of chapter 3 appeared in "The .txtual Condition," *Digital Humanities Quarterly* 6, no. 4 (2013), http://www.digitalhumanities.org/.

Copyright 2013 by the Regents of the University of Minnesota

All rights reserved. No part of this publication may be reproduced, stored in a retrieval system, or transmitted, in any form or by any means, electronic, mechanical, photocopying, recording, or otherwise, without the prior written permission of the publisher.

Published by the University of Minnesota Press
111 Third Avenue South, Suite 290
Minneapolis, MN 55401-2520
http://www.upress.umn.edu

Library of Congress Cataloging-in-Publication Data

Comparative textual media : transforming the humanities in the postprint era / N. Katherine Hayles and Jessica Pressman, editors. (Electronic mediations ; volume 42)
 Includes bibliographical references and index.
 ISBN 978-0-8166-8003-0 (hc : alk. paper)
 ISBN 978-0-8166-8004-7 (pb : alk. paper)
1. Electronic information resources—Social aspects. 2. Digital media—Social aspects. I. Hayles, Katherine, 1943–. II. Pressman, Jessica.
 HM851.C656 2013
 302.23'1—dc23
 2013028373

Printed in the United States of America on acid-free paper

The University of Minnesota is an equal-opportunity educator and employer.

20 19 18 17 16 15 14 13 10 9 8 7 6 5 4 3 2 1

CONTENTS

Introduction
Making, Critique: A Media Framework

N. Katherine Hayles and Jessica Pressman

AS TRADITIONAL print-based humanities move into the digital era, many strategies are emerging to support and retrofit academic departments. Some universities have established freestanding centers for digital humanities, including the University of Maryland, the University of Virginia, and the University of Nebraska. Others are hiring one or more faculty members in the area of digital humanities and incorporating them into an existing department and curriculum. Some are fiercely resisting change and remaining resolutely in the print era. Whatever the case, few have attempted to rethink categories, courses, and faculty hiring in ways that take more than a superficial account of digital technologies and their implications for disciplines that have been operating on a print-based model of scholarship. This book is intended to promote such rethinking.

The approach we advocate is comparative and media focused. It recognizes that print is itself a medium, an obvious fact that tends to be obscured by its long dominance within Western culture. As the era of print is passing, it is possible once again to see print in a comparative context with other textual media, including the scroll, the manuscript codex, the early print codex, the variations of book forms produced by changes from letterpress to offset to digital publishing machines, and born-digital forms such as electronic literature and computer games. The broad term for this approach is *comparative media studies,* which typically includes not only text but also film, installation art, and other media forms. The focus in this volume is specifically on text; by analogy, the approach modeled here can be called *comparative textual media* (CTM). Although our argument will proceed with this more specific focus, many aspects of it apply as well to humanities disciplines that analyze media forms other than text.

"Why Compare?" R. Radhakrishnan (2009) asks in his article of that title in a recent issue of *New Literary History* devoted to rethinking comparative literature in a transnational globalized era, noting at the same time that we compare endlessly. The anecdote he tells of conversations with his Indian autorickshaw driver suggests one powerful answer. His driver sings the praises of the Indian traffic system, which he sees as fostering a driver's creativity, aggressiveness, and competence, whereas Radhakrishnan prefers the rationality, order, and safety of the U.S. lane system. One can see how this small debate might open onto a landscape of sweeping differences in cultures, attitudes, and practices. The example illustrates the potential of comparative studies to break the transparency of cultural sets and denaturalize assumptions and presuppositions, bringing into view their ideological underpinnings. This will scarcely be news to comparative disciplines such as cultural anthropology, comparative literature, transatlantic studies, and postcolonial studies. These rich disciplinary traditions serve to highlight by contrast that there has been a relative paucity of work in comparative media studies in the United States, which nevertheless embodies a similar denaturalization of assumptions.

Even though, for the last few hundred years, Western cultures have relied to a greater or lesser extent on print, and notwithstanding the excellent work of scholars such as Elizabeth Eisenstein (1980), Adrian Johns (2000), Mark Rose (1995), and others to understand the complex ways in which assumptions born of print are entwined with social, cultural, economic, and (especially!) academic structures, the comparative media project remains as open ended and challenging as ever. Indeed, if anything, it has become more complex in the last couple of decades. In the new millennium, the media landscape is changing far faster than our institutions, so we now find ourselves in situations where print-born assumptions linger and intermingle with practices such as social media networking, tweeting, hacking, and so on, to create highly diverse and heterogeneous social–technical–economic–political amalgams rife with contradictions and internal inconsistencies. A case in point is Rebecca Walkowitz's (2009) category of "comparison literature," texts written with the expectation that they will immediately be translated into multiple languages, a situation

that reconceptualizes what *comparative literature* means. Contexts like this, along with the complexly heterogeneous contemporary mediascapes, enable comparative media studies to catalyze new insights, allowing us to understand more deeply the implications of the choices we (and our institutions) are in the process of making. Part of the appeal of comparative media studies is its ability to contextualize complexities in ways that do not take for granted the assumptions and presuppositions of any one media form (or media culture).

The advantages of a comparative approach, then, have never been clearer. But why focus on media, and textual media in particular? As John Cayley (2002) and Jay David Bolter (2001) remind us, writing surfaces have always been complex, reaching beyond the surface deep into the surrounding culture. Yet when writing was accomplished by a quill pen, ink pot, and paper, it was possible to fantasize that writing was simple and straightforward, a means by which the writer's thoughts could be transferred more or less directly into the reader's mind. With the proliferation of technical media in the latter half of the nineteenth century, that illusion became much more difficult to sustain, for intervening between writer and reader was a proliferating array of technical devices, including telegraphs, phonographs, typewriters, Dictaphones, Teletypes, and wire recorders, on up to digital computing devices that themselves are splitting into an astonishing array of different protocols, functionalities, interfaces, and codes. The deepening complexities of the media landscape have made mediality, in all its forms, a central concern of the twenty-first century. With that changed cultural emphasis comes a reawakening of interest in the complexities of earlier media forms as well.

Textual media constitute a crucial aspect of this media landscape. Arguably even more powerful as historical resources than visual and aural media, they provide primary access to the thoughts, beliefs, discoveries, arguments, developments, and events that have preceded us; they hold the key to understanding the past, analyzing the present, and preparing for the future. It is no accident, then, that textual media are central to many humanities disciplines, including history, philosophy, religion, languages, and literatures, among others. Yet investigations of textual media *from a media*

standpoint remain relatively small subfields within humanities disciplines, relegated to specialties such as bibliographic studies and textual studies. A media perspective would move these fields from the margins to the center of contemporary humanistic inquiry. In addition, it would recognize that recursive feedback loops between form and content are not only characteristic of special cases (which we have elsewhere called technotexts [Hayles 2002]) but are the necessary ground from which inquiry proceeds.

As the centrality of recursivity suggests, CTM pursues media as objects of study and as methods of study, focusing on the specificities of the technologies as well as the cultural ecologies they support, enable, and illuminate. A focus on media promotes awareness that national, linguistic, and genre categories (typical classifications for text-based disciplines) are always already embedded in particular material and technological practices with broad cultural and social implications. National distinctions, for example, may be linked with the invention, dissemination, and adoption of different media technologies, and genre conventions can be reconceptualized so they are approached through the ways in which they presuppose and draw on different media functionalities. Poetry is typically distinguished from prose by the introduction of line breaks, for example, but how line breaks are implemented differs significantly for handwriting, typewriting, and letterpress technologies. Thus CTM offers, we suggest, a way of accounting for existing categories by making them productive within new contexts.

In what ways does CTM alter existing paradigms in the humanities? Potential sites for change can be found in departments of religion, history, and philosophy, among others, which traditionally have focused on conceptual frameworks to delineate subfields, with little or no attention to the material infrastructures undergirding epistemic transformations. Categories such as "Enlightenment thought" or "Reformation philosophy," for example, track strains of philosophic thought through famous thinkers and writers, with only glancing treatment of medial forms. Even when media are considered—the printing press would be an obvious example—they are often treated as if they were homogeneous across time and space, with little attention to variations within a medium or

the effects of overlapping media on one another. Within literature and language departments, a comparable emphasis falls on literary form and content, but without sustained attention to the material instantiations of the words, sentences, and paragraphs. In the last decades, there has been a growing awareness of the importance of the materiality of media for authors such as William Blake, Emily Dickinson, and Walt Whitman, but such materially oriented awareness remains the exception rather than the rule. Programs that take the specificity and materiality of media as a principal focus for curricular development and field conceptualizations are still very much in the minority in the United States.

This lack of programmatic development notwithstanding, the frameworks associated with media-focused inquiry nevertheless open onto a host of issues currently at the forefront of scholarly debates in the humanities. Just as many scholars in the field of comparative literature now find it essential to interrogate the nature of the relation between Self and Other that they see as the heart of their comparative project, so comparative media studies aims to unsettle assumptions about the human and nonhuman actors involved in a medial relation to each other. What (or who) is the "Other" of comparative media studies? One kind of answer might posit "other media," in which case scholarship would turn to tracing genealogical relations between different media forms, a project already well under way by such scholars as Errki Huhtamo and Jussi Parikka (2011), and others, in the rapidly emerging field of media archeology. Another kind of answer might argue that media begat media, a thread that can be traced from Marshall McLuhan (1964) through Friedrich Kittler (1992, 1999) and Bernhard Siegert (1999). By arguing that the content of one medium is always another medium, McLuhan implies that media studies are always already comparative, an insight that Jay David Bolter and Richard Grusin (2000) further develop in *Remediation: Understanding New Media*.

Still another answer might turn to an interrogation of the role of nonhuman objects as the "Others," a move with strong connections to speculative realism and object-oriented ontology (OOO), as developed by Graham Harman (2011), Ian Bogost (2012), Quentin Meillassoux (2010), Levi Bryant (2011), and

others. This focus also opens onto the historical change that oc-
curs when objects move from allopoetic forms (i.e., forms that
take their raison d'être from outside themselves) to autopoetic
forms capable of defining their own goals, actions, and behaviors
through evolutionary algorithms. Pioneering this change in per-
spective through his actor network theory, Bruno Latour (2007)
anticipates the "flat ontology" of OOO by placing human and
nonhuman actors on the same plane of action, refusing to privi-
lege human actors a priori as the ones controlling or determining
the network's spread and dissemination. Yet another focus seeks
to understand technical and human change as coevolutionary
processes that were determinative in the physical, psychological,
and biological development of *Homo sapiens*; scholars working
in this vein include Bernard Stiegler (1998), Mark Hansen (2006),
and N. Katherine Hayles (2012). Human cognition in this view
is deeply bound up with technics on conscious, unconscious, and
nonconscious levels, with media technologies serving to support,
scaffold, and extend cognition in ways consequential for social,
economic, and political structures.

Many of these research programs are associated with the digital
humanities, which we understand inclusively as projects aiming
to digitize historical information through virtual and augmented
reality; text analytics intended to analyze corpora too vast to be
read in their entirety ("big data" projects); and theoretical inquiries
into the nature, effects, and specificities of different media. Our
purview here, however, is broader than the digital humanities be-
cause it advocates *comparative study of all text-based media,* not
only the digital. An example of how wide this spectrum can be is
Whitney Trettian's dissertation on the "Harmonies," scrapbook-
like remixed texts created by cutting and pasting passages from
the Scriptures and other religious texts, crafted by the women at
the religious community Little Gidding in the seventeenth century.
Trettian, a graduate student in the English department at Duke
University, also considers as media such handiwork texts as embroi-
dered book covers, samplers, and even pillowcases adorned with
embroidered inscriptions. Her work recovers women's expertise in
needlework and textual compilations as forms of creative textual
media in which inscriptions are enhanced by finely developed craft

skills. To indicate the diverse and rapidly changing landscape in which media-based inquiries are proceeding, we use the term *media framework*, denoting a wide spectrum of approaches and chronologies in which the specificities of media are central.

In addition to the research programs it fosters, a media framework also supports work that explores connections between different media forms, including film, installation art, electronic literature, digital art, emergent narratives, and a host of other computational and analogue media forms. In this way, it facilitates collaboration and cooperation between disciplines focusing on visual and aural forms (work often located in art and art history departments) and text-based disciplines such as literature and language departments. Such connections are especially valuable in the contemporary period when boundaries between text, visual, and aural forms (e.g., electronic literature and digital art) are difficult or impossible to draw. Many other kinds of research projects also work well with a media framework, including cultural studies projects that explore the relation between media epochs and social, cultural, and economic institutions as well as historical periodizations that take media transformations into account and national studies that link the transformation of cultural forms with the dissemination or development of media technologies.

A media framework naturally has political implications, including how academic institutions organize themselves and distribute rewards, hiring priorities, and scholarly recognition. Many humanities departments are now facing internal splits that divide along print–digital lines, with some scholars fiercely resisting the digital because of the threat they see it posing to their hard-won print-based skills and scholarly paradigms. This reaction is entirely understandable; it is also unnecessary. A CTM framework does not render print-based skills obsolete; on the contrary, they form an essential component of critical and pedagogical practices. Rather than implicitly assuming that these print-based practices are transhistorical and universal, however, the CTM approach emphasizes their historical and technological specificity. Furthermore, as some of the writers gathered in this collection show, *print* is not a monolithic or universal term but a word designating many different types of media formats and literary practices. CTM takes

as given that relationships between media forms are complex and commingled. Many bibliographic scholars have made this clear by pointing out that manuscript traditions continued long after the advent of print, influencing the development of print, while at the same time being influenced by it.

Similar complex relationships are developing now. Print is no longer the way most people in developed countries scan the news, communicate through letters, or encounter opinion pieces, but print practices remain vitally important in exerting cultural and artistic influence, including in contemporary contexts, where their vibrant and robust interplays with digital media are producing new print forms (e.g., Jonathan Safran Foer's print novel *Tree of Codes*, peppered with die-cut holes and produced by digital machines, and Mark Z. Danielewski's *Only Revolutions*, an experimental print novel that combines database and narrative forms). Hybrid and transmedia narratives, such as Steven Hall's *The Raw Shark Texts*, are also witness to the creative exuberance and innovative forms emerging from the digital–print dialectic. Indeed, so intermixed are digital and print media through modern printing and publishing machines that they must be considered comparatively to make sense of their production at all. Recognizing this situation can (and should) inform critical practices and pursuits. It also has important implications for pedagogical practices and curricular designs.

As many have noted, the culture of critique that has dominated the humanities for the last several decades seems, as Bruno Latour (2004) phrased it, to have "run out of steam." There are many reasons for this, including the culture and science wars, the economic downturn that has resulted in the disestablishment of many interdisciplinary programs, and the low esteem in which the humanities are held by the general public. Another important reason may be that critique has ceased to operate as a fruitful method for many scholars and for most beyond the academy; it often yields results that are apt to seem more formulaic than insightful, and it speaks to an isolated audience. The complexity of these factors notwithstanding, there is also a fundamental problem with the culture of critique: by its nature, it tends to be critical rather than constructive in tone. As someone once said,

only partly with tongue in cheek, it amounts to saying to others, "Give me your best ideas and I will show you what's wrong with them," a proposition that has struck many colleagues in the social and natural sciences as a bad bargain indeed. Rita Felski (2008, 5) puts it another way; she chastises literary critics for separating their object of study from the social world in which it lives by highlighting literature's uniqueness in ways that "overlook the equally salient realities of its connectedness...the specific ways in which such works infiltrate and inform our lives."

One way to analyze literature that emphasizes its connections to the real world and to other fields of intellectual inquiry is through a focus on media. We suggest that CTM promotes a paradigm shift, a move from a culture in which critique dominates to one in which it is put into productive tension and interplay with what may be called an ethic of making. Media are necessarily associated with specific technologies and material structures as well as economic, legal, and social institutions. Although these can certainly be described and analyzed discursively, conceptual understandings are deepened and enriched by practices of production, a conjunction that puts critique into dynamic interplay with productive knowledges, as Jay David Bolter (2001) has argued. This is self-evidently true of digital media, where the practices of making digital objects are deeply interwoven with theorizing about them. But it is also true of other media as well. Working with a letterpress printing machine, for example, gives one a richer and more resonant context for understanding print codices than would otherwise be the case, as Johanna Drucker has shown in her introduction of a flat-bed Vandercook printing press to her classroom at the University of California, Los Angeles. The same could be said of all media, from scrolls to manuscripts to print broadsides to digital poetry.

A major development in integrating a media framework into humanities disciplines is the advent of the Humanities Lab. Among the early pioneers was Jeffrey Schnapp. When he was at Stanford University, he envisioned the Humanities Lab as providing space for collaborative work on large projects that he calls the "Big Humanities" (by analogy with "Big Science"). As digital methodologies are adopted for humanities research, many of these projects focus

on analyzing large data sets (e.g., several thousand nineteenth-century novels) to gain insight into a wide spectrum of literary questions that hitherto could not be answered satisfactorily (or at all), including issues of production, canon and genre formation, and historical change over time. Franco Moretti and Matthew Jocker's Stanford Literary Lab illustrates the methodologies and results that analyzing "big data" can yield.

In addition to opening the field to new kinds of questions (as Franco Moretti [2007] argues in his concept of "distant reading"), Humanities Labs also lead the way in offering new models of pedagogy. The typical model of humanities scholarship is that of the single author working more or less alone to produce books and articles. Although the author connects with other scholars in myriad ways, from having colleagues read and comment on work in progress to operating within networks of researchers with similar interests, these interactions tend to be cooperative rather than truly collaborative, to use John Unsworth's (2007) distinction. Thus humanities research has been something of an anomaly in the academic production of knowledge, for virtually all of the science disciplines, and most of the social sciences, use a teamwork model in which researchers at many levels—professors, postdoctoral fellows, graduate students, and undergraduates—work together on large-scale projects that might stretch over many years (and many grant cycles). Indeed, most of the world's work gets done through teams working together. Students majoring in the humanities typically come into this world with little practice in such work environments, a less than optimum situation for their integration into it.

Humanities Labs offer an alternative model for research and pedagogy that emphasizes collaborative team projects, integration across multiple stakeholders in academic research, and individual contributions within larger frameworks of ongoing research. The kind of transformations this model encourages can be illustrated through the undergraduate course that Caroline Bruzelius, an art historian specializing in medieval architecture at Duke University, offers on Gothic cathedrals. When Duke introduced software making it easy for faculty to put their lectures online, Bruzelius took advantage of the opportunity to convert her traditional

lecture course into a studio environment in which students worked in teams of three, each team having as its project the construction of a fictional cathedral. Team members were assigned the roles of a master builder, responsible for learning the computer design program AutoCad, an iconographer, responsible for designing the decoration (stained glass and portals), and a historian, charged with creating the cathedral's narrative, beginning with the Christianization of the site. The teams had to consider carefully the cathedral's location, including the requirement that the site be close to roads, ports, rivers, and supplies of wood and stone. In addition, the teams had to construct fictional budgets (incomes and expenditures) and outline the organization of the labor force. The teams worked on their projects throughout the term. Because the lecture material giving context and background was available to them outside of class time, Bruzelius was freed to circulate among the teams as they prepared the portfolios describing their cathedrals, including architecture drawings (and, in one case, a virtual fly-through). At the end of the term, the teams made presentations before a panel of judges; the following day, the dean awarded the prizes in a final celebration. One of us (Hayles) was fortunate to attend the session in which presentations were made and came away amazed at the rich detail, imaginative stories, and architectural precision of the projects. Even the budgets, seemingly mundane components, served important pedagogical purposes in underscoring the importance of finding wealthy patrons and organizing the labor force efficiently so that the most skilled craftsmen were assigned to the most challenging and creative tasks.

The example illustrates the rich insights that our students can gain by being involved in the production processes themselves. Scholars working in the contemporary era and focusing on digital media widely accept that students should know not only how to interpret and critique but also how to make digital objects. Without theorizing, practice can be reduced to technical skills and seamless interpolation into capitalist regimes; without practice, theorizing is deprived of the hands-on experience to guide it and develop robust intuitions about the implications of digital technologies. A generation of scholar-researchers in digital media now also have credentials as programmers, hardware engineers, and software

designers, including Ian Bogost, Wendy Chun, Alexander Galloway, Lev Manovich, Jeremy Douglas, and a host of others. The phenomenon of the theorist-practitioner (or, to put it another way, practice-based research), pervasive in the contemporary period, has extended into the study of earlier periods as well. Bridges across the practice–interpretation divide have been built by scholars such as Alan Liu, Jerome McGann, and Peter Stallybrass, to name a few. Many researchers have developed seminars where students go into rare book rooms and do original research with early texts; one could imagine extending such seminars so that they include sessions with letterpress printing, woodblocks, and other technological media.

Another example of CTM at work in the classroom comes from a seminar cotaught by Jessica Pressman and Jessica Brantley at Yale University, "Medieval Manuscripts to New Media: Studies in the History of the Book." Organized around the deceptively simple question "what is a book?" the seminar explored the history of the book medium by examining the intersections of medieval manuscript culture and contemporary digital literary culture. Comparative textual media was the course's subject and method, but it was also its environment, because the course met in the Beinecke Rare Book and Manuscript Library, where, on display for comparative discussion each week, were medieval scrolls and manuscripts, printed books, Kindles, and projections of digital literature. As final projects, students produced their own comparative textual media "essays," which included elaborate digital ink mark-ups of medieval manuscripts, animated video mash-ups of diverse textual media, and a QR-barcode-based locative narrative that sent the professors scrambling around the building and its surrounding courtyard to read an essay that analyzed literary space by mapping it onto specific places in the archive.

Pedagogically, CTM encourages practice-based research as part of the context of understanding, alongside and deeply integrated with theoretical and critical methodologies. This kind of hands-on approach can reveal nuances and contexts that have the capacity to illuminate, in a flash of insight, why a cultural object is formed the way it is and what its formation has to do with its textual and historical significance. Peter Stallybrass's (2002) work

on the manuscript codex, Christopher Funkhouser's (2007) study of "archaic" digital poetry, Scott McCloud's (1994) commentary on comics, and a host of other studies testify to this power of production-informed, materially oriented approaches to yield new and powerful insights. Moreover, an ethic of making shifts the emphasis from deconstructing existing ideologies and practices to constructing new kinds of practices. Both are undoubtedly necessary, but the culture of critique by itself is only half the picture. CTM explores the possibilities for cultural, social, economic, and theoretical transformation not only by tearing down but also by building up, thereby opening new horizons of understanding and alternative practices. Hence our introduction's title, "Making, Critique": read across the comma, it can be understood as the status quo of endorsing critique, but acknowledging the disruptive punctuation introduces another element into the picture: "making." Unconstrained by subordinate clauses or other grammatical indicators, the phrase leaves the relationship between making and critique entirely open, to be configured as necessary or useful in particular contexts.

An advantage of the CTM approach is its ability to function at different scales. One problem with suggesting any kind of framework for humanities departments is their diversity. It is unlikely that a single approach will fit every need and situation, ranging from departments in small liberal arts colleges to regional universities to Research 1 institutions, not to mention disciplinary differences between text-based humanities departments. Departments at different institutions have quite different student populations, they educate their students for different kinds of roles after graduation, and they employ faculty with different research and teaching profiles. Because CTM can be deployed in a variety of ways, it is flexible enough to fit many different kinds of situations. At the more narrowly focused end, it can provide the framework for an individual class; at a wider scope, it can serve as the theoretical scaffolding for a certificate program in media studies; at the broadest scope, it can provide an approach for rethinking an entire department's mission, curricula, and focus. In addition, the different emphases and methodologies of humanities departments (e.g., philosophy compared to literature or religion compared to

history) necessitates that different fields construct different kinds of relations to textual objects. A media framework provides a way to join theory with practice in a wide variety of conceptual contexts, thus lending itself to flexible adaptations.

To see the effects of a media framework that has been fully implemented in an academic program, we can turn to the Media Faculty of the Bauhaus-University in Weimar, Germany, which recently won the highest ranking from the German government for its research activities. The Media Faculty include scholars in the humanities, economics, and technical and artistic- and design-related fields, working together as a unified group. The Media Faculty offer a wide range of degree programs, including media architecture, media art and design, integrated international media art and design studies, media culture, European media culture, media management, and computer science and media. Moreover, the Media Faculty have close associations with a research institute, the Internationales Kolleg für Kulturtechnikforschung und Medienphilosophie (IKKM), which invites for one or two semesters ten fellows working on media projects. IKKM also publishes a journal, *Zietscrift für Medien-und Kulturforschung*, edited by Lorenz Engell and Bernhard Siegert. During a site visit to Weimar, one of us (Hayles) had an opportunity to talk at length with Lorenz Engell. According to him, media studies in Germany has increased exponentially in the last two decades, for example, going from five professors in the field in 1990 to over one hundred today, with comparable growth in other measures, such as numbers of students, members of the professional Media Studies Association, and the diversity of media studies programs. This growth has not been uncontested; particularly strained have been the relations of media studies programs with communication studies, which argues that the study of (mass) media is its turf. Engell distinguishes media studies from communication studies in its emphasis on media other than mass communications and in its focus on the materiality of media. These tensions notwithstanding, faculty members in the program at Weimar are actively working to make connections with other fields that have traditionally not considered the materiality of media, such as philosophy. Christiane Voss, along with Engell, recently organized a conference, "Was Wär Der Mensch,"

specifically designed to bring together media archeologists and theorists with philosophers in serious, sustained discussions. The success of the Weimar program, and of media studies generally in Germany, indicates the potential of CTM to catalyze new kinds of research questions, attract students, reconceptualize curricula, and energize faculty.

To our knowledge, the only comparative media studies program now in existence in the United States is at MIT, chaired by William Uricchio. One of us (Hayles) made a site visit to the program in January 2012. The program has impressive physical facilities, with several lab spaces, including the HyperStudio directed by Kurt Fendt, the GAMBIT Lab, the Center for Civic Media, and the Imagination, Computation, and Expression Lab. The CMS program fully embraces the integration of theory and practice, encouraging students both to make media and to reflect on them in a variety of lab settings under the rubric of "applied humanities." Moreover, it has an expansive vision of what *comparative* means, including comparisons across media, national borders, historical periods, disciplines, and making and thinking. In this sense, it fully implements the comparative media framework advocated earlier. The CMS program follows the MIT Media Lab model in seeking partnerships with corporate sponsors. At the time of the visit, it was run largely on soft money, with contracts and grants in the three- to four-million-dollar range. As Uricchio explained, however, the CMS program was then in transition and was about to be folded into writing programs. The move was intended to solve several structural problems, including the program's previous inability to hire and have its own faculty lines.

The program illustrates both the potential and challenges of using a media framework as the basis for an academic program. Although the MIT CMS had no faculty lines of its own at that time (with the exception of Uricchio), it is able to employ a large professional and technical staff of twenty to thirty programmers, technicians, and so on, thanks to the steady supply of grants and contracts. One might wonder, however, if this structure would lead to a split between academic researchers and paid staff, a model that has proved problematic on several scores within the sciences. Moreover, there would seem to be a tension between projects

undertaken to fulfill grant "deliverables" and projects that might be less profitable but more conducive to student education. Finally, the high-end technology necessary for the work of the labs is a large continuing expense, requiring frequent cycles of upgrading and replacement. For institutions such as liberal arts colleges, where a model of corporate sponsorship may be problematic, it is not clear how such a high-tech enterprise would be affordable.

One possibility for smaller or less affluent programs is to broaden the focus beyond digital technologies to include older media that are already obsolete for commercial purposes (though still viable as teaching affordances) and so do not require "replacement" or "upgrading." The English department at the University of Connecticut, under the leadership of Wayne Franklin, for example, is acquiring a letterpress printing press precisely to implement this strategy for its students; the English department at the University of Iowa has long championed this approach in its Center for the Book. As these examples illustrate, none of these difficulties of moving to a media framework is insurmountable, but they indicate that careful thought must be given to the full implications of the shift, including economic, programmatic, and political considerations.

While any single book cannot hope to explore all the possibilities and challenges of CTM, this volume's essays stage encounters with a wide range of different media forms and manifest a similarly diverse spectrum of methodologies and approaches. Rather than aspiring toward definitive status, this book aims to showcase generative approaches that open onto new kinds of questions, pose novel problems for consideration, and demonstrate the range of insights that can come from a CTM orientation. Owing to their diverse subjects and periods, these essays could not usually share the same audience; it is by virtue of their focus on textual media that they speak to one another and, moreover, illustrate collectively the benefits of studying textual media in a comparative manner. It is, we hope, the beginning of a new era in the humanities, one that relies on the rich traditions of the print era to provide historically specific frameworks for comparative understanding of the mediascapes of the deep as well as the recent past, the future as well as the present.

The essays that follow have been grouped into three general sections. The first section emphasizes why new approaches are needed by exploring instances in which older assumptions are no longer adequate to cope with new kinds of textualities, new archives composed of digital artifacts, and new modes of representing letter forms. Lest this section leave the impression that the advantages of CTM apply only to the new, the second section illustrates how a media framework can help to discover affinities between widely separated chronological periods, for example, between the classical era of the bookroll in ancient Greece and Rome and the contemporary example of a posthuman computer game. The third section focuses on the relation of content to material form, thus illustrating how a media framework can enrich and illuminate traditional modes of close reading.

Beyond these general thematics, the individual essays open onto many fruitful avenues of exploration. Adriana de Souza e Silva's "Mobile Narratives: Reading and Writing Urban Space with Location-Based Technologies" discusses the role of location-aware technologies, such as smart phones and GPS devices, in overwriting urban landscapes, creating dynamic new meanings that people can access by moving to certain locations. Because the information is linked to a physical site, it participates in creating paths that define a user's movement through the landscape as well as imbuing the landscape with semiotic, emotional, and narrative meanings through messages left there. As de Souza e Silva points out, these technologies differ from earlier locative media art, such as audio walks, because they are not created by artists but by people in the course of their everyday lives. Previously, landscapes acquired meaning through memories, whether inside the head of a person or memorialized through a textual technology such as a plaque, a marker, or a tourist's guidebook. In the latter instances, sites were required to be vetted for significance. Because the information was funneled through a bureaucratic procedure—a town council or a publisher, for instance—it tended to employ formal rhetoric, rational criteria for recognition, and a sense of historical importance. With the new locative technologies, however, messages circulate outside the pale of sanctioned information, pertinent to the moment and available to be changed or erased when circumstances dictate.

These virtual markings, differing from texts on other more durable substrates in their audience, intent, and purpose, nevertheless have analogues and precedents in such textual practices as graffiti.

Rita Raley's essay "TXTual Practice" carries the argument further by considering mobile displays that are not only public but live and interactive, as in an LED display on the side of a building that shows text messages sent by people passing. Enacted in different installations with variations such as time delay–no delay and filtered–unfiltered, these public artworks nevertheless share certain features that challenge traditional modes of understanding in the humanities. Part of the point is to disturb the environment, creating new kinds of relationships between people moving through ambient space and the landscape through which they move. (We may recall Rita Felski's [2008] admonition for humanities scholars to connect their objects of study with the real world; here the objects of study not only connect with, but actually constitute a part of, the surrounding environment.) Another feature of these textual landscapes is the ephemeral nature of the messages, constantly changing as one audience moves on and another comes into the area. Raley contrasts this situation with durable objects that can be archived, the traditional situation with texts of interest to the humanities. She suggests that curatorial and interpretive practice would then become closer to something like performance studies, in which a record exists (artist statements, archived messages or other materials) but the crucial durational aspect of the event—its ephemerality and unrepeatability—can be evoked but not stored as such, because the event itself can be experienced fully only at the time of its unfolding.

Archiving in the digital era is precisely the topic that Matthew G. Kirschenbaum discusses in "The .txtual Condition." When the Maryland Institute for Technology in the Humanities received the Deena Larsen Collection, it was presented with a number of challenges, from the obsolete platforms on which most of the collection was stored (e.g., floppy disks) to the collection's wildly heterogeneous nature (which includes Larsen's marked-up shower curtain). Kirschenbaum discusses the ways in which digital objects challenge standard archival practices and assumptions, starting with the collapse of the distinction between the object and its

access. As he argues, digital objects are in a literal sense re-created each time they are accessed, a situation that poses unique problems for keeping detailed records of the data stream flow. He also notes programs that have chosen to archive obsolete machines as well as the objects that play on them, a strategy that places the archivist in the gritty material world of the engineer and circuit designer. The implication is that, at every stage and level, archiving must transform to meet the challenges of born-digital objects, from theory to criteria for best practices to practice itself. This situation, which Kirschenbaum calls the ".txtual condition," illustrates that the materiality of born-digital objects cannot simply be folded into older ideas of archiving that assume the world of print as the norm.

In "From A to Screen," Johanna Drucker asks questions about the migration of letters from print to screen, noting that the status of letters cannot be resolved through technology alone but necessarily involves philosophical and even perceptual questions. In this respect, her essay complements Kirschenbaum's insistence that the ".txtual condition" invites a wholesale reexamination of the assumptions underlying archival theory and practice. Any given letter, she argues, emerges from the interplay between the *concept* of the letter and what it essentially *is*. In digital media, this interplay is doubled by the dynamic between the code specifying the letter (which would seem to be clear-cut and unambiguous, with a specific location within the computer) and distributed contingencies that involve code situated in multiple locations, including in a document file, a printer, a computer operating system, the web, or a cloud computing facility. Given these contingencies, she cautions against constructing a timeline for media epochs based solely on changing technologies. Equally important, she implies, are the concepts and cultures with which the media technologies are in dynamic interplay.

This lesson resonates differently for different historical epochs, as William A. Johnson's discussion of bookrolls shows for the Greco-Roman period. Although most scholars are aware that bookrolls (a subset of scrolls with a set of specific characteristics and typically employed for literary texts) lacked punctuation, what they may not know is that the omission was not a result of ignorance or lack of imagination but a deliberate choice not

to employ reading aids. Johnson beautifully contextualizes this choice in his discussion of how bookrolls were read and what functions they served when the Romans adopted them (in the first century A.D.). The difficulty of reading the continuous script of the bookroll made it an elite practice, a cultural attainment associated with wealth, privilege, and culture; concomitantly, proficiency in deciphering and understanding it could lead to significant rewards in money, prestige, and social status. Like Drucker's essay, this chapter cautions us that technological determinism alone cannot adequately explain cultural developments. Media are always embedded in specific cultural, social, and economic practices, and the interplay between technological possibility and cultural practices is often crucial for understanding why a technology developed as it did.

A similar conclusion emerges from Stephanie Boluk and Patrick LeMieux's "Dwarven Epitaphs: Procedural Histories in *Dwarf Fortress*," an analysis of the computer game *Dwarf Fortress*. This fascinating game, which attracts dedicated players who devote untold hours to it, sacrifices the realistic visuals so dominant in most computer games in favor of computational intensity. Its procedures put into action multiple agents and agencies, whose interactions then create the environment and its inhabitants (human and nonhuman) as emergent results. Players can intervene by giving the dwarves commands and making changes in the environment, but their control is never absolute, as the nonhuman mechanics of the game create unexpected and unpredictable consequences. That such a difficult and esoteric game would have generated its own community of expert readers-writers is perhaps not surprising (providing a striking parallel with Johnson's discussion of the expert communities of readers-writers of bookrolls in the Greco-Roman period); more startling is the appearance of premodern literary forms, such as the annal and chronicle. As Boluk and LeMieux point out, the chronicle differs from a history in its lack of causal explanations. There is no connective discursive tissue between one event and another, just a succession of events. With the development of explanatory devices in the modern period, from measuring devices to statistics to scientific theories, everything is presumed to happen for a reason. In *Dwarf Fortress*, the interactions of the

procedural mechanics would constitute that explanatory frame-
work, except that they are not accessible in their totality to human
users. Although some small part of them may be explained, there
is always more going on behind the scenes than the players can
either access or weave into an explanatory account. Hence the im-
pulse to narrativize the gameplay in what Boluk and LeMieux call
"Dwarven Epitaphs," to place it within a human-understandable
and human-meaningful context. Noting that the game's creators,
Tarn and Zach Adams, begin with one of Zach's short stories and
then translate the story's dynamics into procedural algorithms
within the game, Boluk and LeMieux trace a cycle which begins in
narrative and transforms into game mechanics that proceed with
nonhuman players and nonanthropomorphic perspectives and
then are translated back into narratives by the players. Despite its
affinities with premodern literary forms, the interactions between
human and nonhuman agents within the game context mark it as
very much a postmodern, posthuman construction.

Patricia Crain's "Reading Childishly? A Codicology of the
Modern Self" moves the discussion from reading communities
to the reading individual, especially the child reader. As books
produced specifically for children began to emerge as the dis-
tinct genre of children's literature around 1800, the possession
of a book became increasingly identified with the formation and
possession of a self. A book, Crain observes, was frequently the
first commodity object that a child would own. Regardless of its
content, a book was thus a training ground for commodity cul-
ture and for the formation of a subject defined by consumption.
On occasion, the contents of the books reflected this recursive
cycle. Narratives about the production, assemblage, storage, and
distribution of books positioned children both as part of the labor
force producing them and (on the privileged side) as consumers of
books that, in these instances, described how books were made.
In addition to this recursive dynamic, books also served as con-
tainers for handwritten inscriptions, notations, poems, and other
sentiments as well as for physical objects such as amorous notes
or pressed flowers. The inclusion of these within the covers of a
book indicated their special relation to the book's owner. If the
book was identified with the self, especially with the heart, then

including objects within the book was tantamount to indicating that those objects were incorporated within the heart as well. Here, as in other instances discussed earlier, the book's materiality—the properties of the paper, the presence (or lack) of covers, the signs of use, the personal inscriptions—marked it as an individual object (notwithstanding that it had been mass-produced), owned by a specific individual (or individuals) and differentiated by the personal marks with which the owner had invested it.

Whereas the examples discussed previously focus on communities and kinds of readers, Lisa Gitelman's "Print Culture (Other Than Codex): Job Printing and Its Importance" narrows the inquiry to the kinds of practices associated with job printing. Arguing that the multiply ambiguous and ill-defined phrase *print culture* may productively be understood to mean the culture of printers, she shows that job printing—printing of bookkeeping forms, tickets, stock certificates, and the like—was a major economic driver in print shop economies over several centuries. She points out that such products as letterhead were not meant to be read in the usual sense—certainly not subjected to "close reading"—but rather functioned to inscribe a corporate voice into communications between firms and individuals. These forms, she argues, did not have *readers* but rather *users*. Moreover, business forms, although printed, did not go through the normal channels associated with publication, nor were they deemed worthy of copyright protection. This implies that job printing fulfilled very different social and communicative purposes than literary forms such as the novel, intimately associated with the expression and creation of subjectivities. Noting that job printing has received little or no notice in discussions of media history, Gitelman suggests that it may be more useful to focus on specific practices and structures at precisely defined sites rather than on more general histories focusing on media forms. Expanding on this idea, we note that practices and structures are always entangled with the material objects and media technologies necessary to implement them. Drawing on Andrew Pickering's (1995) idea of the "mangle of practice," we can say that concept, object, and practice coevolve and codetermine one another (as Drucker's discussion of the nature of letters suggests).

Jessica Brantley's "Medieval Remediations" emphatically reminds us that media did not begin with the printing press (a point that William Johnson also makes clear). Moreover, she argues for the particular insights that medieval media can bring to media archeology and media theory. Rather than present us with epochal shifts, she argues, medieval media enable us to see gradations of change in which innovation and tradition interact in ongoing negotiations over meaning. In particular, she highlights three distinct kinds of tension: between oral and aural; between literate and visual; and between Latin and vernacular languages. In a stunning close reading of the Paternoster diagram in the Vernon manuscript (provenance fourteenth-century England), she demonstrates that the form of the diagram both conveys and reflects its meaning. The diagram teaches users how to read it by opening multiple reading paths across and between languages and by creating oscillations between letters as semiotic signifiers and visual forms. As she shows, the word and the word-image go hand in hand and mutually reinforce one another. The richness of her reading and the beautiful complexity of the object itself strongly witness to the importance of medieval media in developing fully adequate media theories and practices.

Thomas Fulton's "Gilded Monuments: Shakespeare's Sonnets, Donne's Letters, and the Mediated Text" not only reminds us that the "print revolution" stretched over centuries but also that print coexisted with other media practices well into the seventeenth century, including manuscript letters. Indeed, print continued to carry somewhat of a stigma for such authors as Shakespeare and Donne; when their works were printed, they were often pirated editions from which the author made no money and over which he had no control (the famous example being the "bad quarto" of *Hamlet*). When manuscript poems survive (the latest being a verse letter by Donne written on gilt-edged paper, astonishingly found in 1970), they often indicate an expressive range of punctuation, visual emphasis, and markings lost when they were transferred to print. More surprisingly, the Donne poem also shows a complex play between the verbal content and the paper's material qualities, especially the gilt edge. Fulton speculates on the possibility that Shakespeare's sonnets that mention "gilded tombs" (Sonnet 101)

and "gilded monuments" (Sonnet 55) may similarly have been written on gilt paper, setting up complex recursions between the content and its material substrate. His argument shows the importance of a medium's materiality as well as the heterogeneous nature of mediascapes in the Renaissance.

John David Zuern's "Reading Screens: Comparative Perspectives on Computational Poetics" picks up on the theme of recursivity in his discussion of Brecht's radio play *Lindbergh's Flight* compared with the digital Flash work by Judd Morrissey and Lori Talley, *My Name Is Captain, Captain.* He argues for the advantages of a comparative approach, especially for digital literature in comparison to print works and to works in other media, such as Brecht's play. In his reading, the comparison with Brecht serves to highlight the moral and ethical dimensions of the digital work. Just as Brecht removed Lindbergh's name from his work after Lindbergh's Nazi sympathies became apparent (calling it *The Flight over the Ocean*), so in *My Name Is Captain, Captain.*, Lindbergh is not only the parent who suffered because Bruno Richard Hauptmann kidnapped and inadvertently killed his child but also the hero-pilot who failed to use his notoriety to move his culture toward a better world. *My Name Is Captain, Captain.* is not an easy work to understand (one of us [Hayles] has spent several hours with it without arriving at any clear grasp of its meaning), and Zuern uses an abductive method, drawing on his own experience with the work, to explore its complex interweaving of textual surfaces, animated effects, and multiple signifying codes (including letters, words, sentences, graphical images, animations, and Morse code). He suggests that the work teaches the user to understand it through wrestling with its complexities, an intent made explicit in the section called the "Link Trainer" (a metaphor for the flight simulator developed to train pilots in World War II). His superb reading illustrates the rich rewards that a comparative approach can yield, especially for a field, like digital literature, still struggling for widespread acceptance and understanding.

Mark C. Marino's "Reading *exquisite_code*: Critical Code Studies of Literature" illustrates what it would mean to read a digital literary text not primarily for its content but rather for traces of its underlying generative code. Taking as his tutor text

a collaborative writing project that seven writer-programmers produced "live" for five days in a London gallery, Marino explains the elaborate mix of algorithmic procedures, random functions, and Markov chain generators that subjected what the writers wrote to interventions that both transformed and mixed with their content to become the output text for the project. Each writer submitted a prompt, and the program chose one at random to begin the process. As the writers watched their content (produced in intense six-minute writing intervals) disappear or get "munged" into a mishmash, they became cannier about producing text that was more likely to make it into the output text, in particular by gaming the procedures that the Markov chain generator used to assemble chunks of text. The writers also began producing text that commented recursively on the nonhuman agents acting on it, for example, introducing a character named Markov. As Marino notes, the project self-consciously sought to undermine the idea of a writerly subjectivity expressing itself in crafted prose; instead, it staged encounters between the presumed interiority of the human writers and the nonhuman processes that, like it or not, became their collaborators in producing the "novel" (more accurately, the output text). Marino admits that the "novel," read in the usual way as the expression of a self, does not make much sense, but he argues that the pleasures of this text lie in reverse engineering the processes and understanding the interplays with code and writerly inputs that together created the final text. Processes rather than product, code rather than surface text: with this shift in emphasis, Marino's essay circles back to the first essays, discussed earlier, by Raley and de Souza e Silva, including their emphasis on ephemerality, participatory authorship, and a decentering of the liberal humanist subject.

We note in concluding that, although all the essays argue in one way or another for the advantages of a comparative media framework, they do so for different reasons, they embody different methodologies for its enactment, and they anticipate different kinds of readings, practices, and conclusions as its result. We see this diversity in approach and perspective as a strength of the volume and as evidence of the capacity of CTM to catalyze a wide spectrum of research questions and procedures. The paradigm shift

we are advocating here, if adopted on a large scale, is likely to generate myriad controversies about what it means for scholarship, pedagogy, and the relation of the humanities to other disciplines and to the general public. Indeed, it is precisely the potential of a media framework to energize old questions and raise new ones that is the surest sign of its vitality as an academic paradigm. The precise kinds of questions raised by juxtaposing these chapters is more fully explored in the forewords for each of the three sections on "Theories," "Practices," and "Recursions." In delineating the issues, our goal is not to settle questions but rather to indicate the productive new directions toward which they point.

REFERENCES

Bogost, Ian. 2012. *Alien Phenomenology, or What It's Like to Be a Thing.* Minneapolis: University of Minnesota Press.

Bolter, Jay David. 2001. *Writing Space: Computers, Hypertext, and the Remediation of Print.* 2nd ed. New York: Routledge.

Bolter, Jay David, and Richard Grusin. 2000. *Remediation: Understanding New Media.* Cambridge, Mass.: MIT Press.

Bryant, Levi. 2011. *The Democracy of Objects.* Ann Arbor, Mich.: MPublishing.

Cayley, John. 2002. "The Code Is Not the Text (Unless It Is the Text)." *Electronic Book Review.* http://www.electronicbookreview.com/thread/electropoetics/literal.

Eisenstein, Elizabeth L. 1980. *The Printing Press as an Agent of Change.* Cambridge: Cambridge University Press.

Felski, Rita. 2008. *Uses of Literature.* London: Blackwell.

Funkhouser, Christopher. 2007. *Prehistoric Digital Poetry: An Archeology of Forms, 1959–1995.* Tuscaloosa: University of Alabama Press.

Hansen, Mark. 2006. *Bodies in Code: Interfaces with Digital Media.* New York: Routledge.

Harman, Graham. 2011. *The Quadruple Object.* Abington, U.K.: John Hunt.

Hayles, N. Katherine. 2002. *Writing Machines.* Cambridge, Mass.: MIT Press.

———. 2012. *How We Think: Digital Media and Contemporary Technogenesis.* Chicago: University of Chicago Press.

Huhtamo, Erkki, and Jussi Parikka. 2011. *Media Archaeology: Approaches, Applications, and Implications.* Berkeley: University of California Press.

Johns, Adrian. 2000. *The Nature of the Book: Print and Knowledge in the Making.* Chicago: University of Chicago Press.

Kittler, Friedrich A. 1992. *Discourse Networks, 1800/1900.* Translated by Michael Metteer. Stanford, Calif.: Stanford University Press.

———. 1999. *Gramophone, Film, Typewriter.* Translated by Geoffrey Winthrop-Young. Stanford, Calif.: Stanford University Press.

Latour, Bruno. 2004. "Why Has Critique Run Out of Steam? From Matters of Fact to Matters of Concern." *Critical Inquiry* 30 (Winter): 225–48.

———. 2007. *Reassembling the Social: An Introduction to Actor–Network Theory.* Oxford: Oxford University Press.

McCloud, Scott. 1994. *Understanding Comics: The Invisible Art.* New York: William Morrow Paperbacks.

McLuhan, Marshall. 1964. *Understanding Media: Extensions of Man.* New York: Mentor.

Meillassoux, Quentin. 2010. *After Finitude: An Essay on the Necessity of Contingency.* London: Continuum.

Moretti, Franco. 2007. *Graphs, Maps, Trees: Abstract Models for Literary History.* London: Verso.

Pickering, Andrew. 1995. *The Mangle of Practice: Time, Agency, and Science.* Chicago: University of Chicago Press.

Radhakrishnan, R. 2009. "Why Compare?" *New Literary History* 40, no. 3: 453–71.

Rose, Mark. 1995. *Authors and Owners: The Invention of Copyright.* Cambridge, Mass.: Harvard University Press.

Siegert, Bernhard. 1999. *Relays: Literature as an Epock of the Postal System.* Stanford, Calif.: Stanford University Press.

Stallybrass, Peter. 2002. "Books and Scrolls: Navigating the Bible." In *Books and Readers in Early Modern English: Material Studies*, edited by Jennifer Andersen and Elizabeth Sauer, 42–80. Philadelphia: University of Pennsylvania Press.

Stiegler, Bernard. 1998. *Technics and Time, 1: The Fault of Epimetheus.* Stanford, Calif.: Stanford University Press.

Unsworth, John. 2007. "Creating Digital Resources: The Work of Many Hands." http://people.lis.illinois.edu/~unsworth/drh07.html.

Walkowitz, Rebecca. 2009. "Comparison Literature." *New Literary History* 40, no. 3: 567–82.

Part I
THEORIES

NEW MEDIA is an unfortunate term for at least three reasons: it is a temporal rather than a technical designation, and what is new now will soon become old (and do we then say "old new media"?); it is very imprecise as to what constitutes "new media"; and most troublesome, it implies through back-formation that there exist "old media," evoking cultural prejudices that equate "old" with "uninteresting," "obsolete," "already known and therefore incapable of innovation," and so on. Carolyn Marvin (1990), Lisa Gitelman (2008), and others have fought against this tendency, reminding us that all media were once new. What we now consider new media may already be headed for obsolescence, as Kathleen Fitzpatrick (2011) notes.

With the development of cloud computing, a fundamental shift is taking place in computational media, away from desktops and laptops to smaller, more portable devices that do not need a lot of memory or processing speed because they function primarily as portals to the web, where applications reside and processing is done. In a sense, we can regard the laptop as the dying instantiation of an idea prominent in artificial intelligence in the 1960s to 1980s, namely, that the goal is to create an artificial intelligence capable of mimicking human cognition. According to prevailing notions of the time, human cognition occurred in the brain (a model to which Andy Clark [2010] refers as "BRAINBOUND"); therefore the desktop–laptop has a "brain" that must contain more and more memory and faster and faster processing speeds. Just as models in cognitive science have moved away from thinking of the brain as the exclusive site of cognition and toward a broader view of cognition as a whole-and-extra-body faculty, so hardware development is moving toward a distributed model of computation with the advantages of flexibility, redundancy, and efficiency. Those who resist this tendency may do so in part because of the

very American idea of self-sufficiency: one *owns* one's desktop–laptop and so is in control of how it operates. This is an illusion, because the communicative function of networked computers depends not just on the device sitting on one's desktop but on an entire infrastructure of fiber optic cables, transfer protocols, a topography of nodes and lines, and other network architectures. The illusion is comparable to the idea of national self-sufficiency in a transnational world, which, like our computer networks, has economic, social, financial, and cultural connections so deeply entangled that events in any one sphere quickly travel through the entire network, leaving nothing unaffected. So despite the resistance, the movement to the cloud continues, and our devices become smaller and more portable. Intimately connected with our embodied movements, they serve as portals through which data stream and from which data issue, perhaps to be displayed on a large ambient screen, such as Rita Raley (chapter 1) discusses.

What does this imply for the possibility of a theory of "new media," which we can broadly define as digital devices with screen interfaces, especially networked and programmable machines? As long as screens could be conceptualized as book-sized objects placed at a book distance for reading, the analogy of screen to page was compelling, and each served as the other for its contrary. For scholars interested in creating theories of new media, the analogy was endlessly recycled as the starting point for thinking about the implications of new media (Birkerts 2006; Davidson 2010), either to bemoan the death of the book or to celebrate the rise of the screen. The analogy becomes less compelling when screens shrink to matchbook size or expand to the size of building walls. The theoretical "othering" dyad of books and computer screens is about to be displaced (or perhaps supplemented) by other theoretical binaries that have different issues at stake and yield different results.

This movement is apparent in the four essays in this section. While Matthew G. Kirschenbaum (chapter 3) and Johanna Drucker (chapter 4) assume that the relevant theoretical other to digital media is the page or the book and discuss the challenges that digitization poses for archival practice and letters, respectively, Adriana de Souza e Silva (chapter 2) takes the other to be the artistic use of cell screens versus the everyday usage she discusses. Rita Raley

falls somewhere in between these poles, taking as her other both the ambient, nondigitized environment and the archivable durable object associated with print culture. As digital objects move away from the desk and into the environment, a wealth of new interactions open up, including the movement of human cognizers through intelligent environments and the dynamics that digital affordances enact in mapping or creating new paths through urban spaces.

As a result, new theoretical entities and disciplinary alliances then enter the picture. Consider, for example, the "technological unconscious" posited by Nigel Thrift, a cultural geographer whose work is increasingly cited by literary and cultural critics. With digital objects in motion and embodied human cognition supported and extended by environmental scaffolding (the model Andy Clark calls "EXTENDED"), new kinds of assemblages come into play that would be difficult to imagine if one were to take as the relevant entity interacting with human intelligence the stationary desktop computer (or even the laptop). As always, theory is on the move, and the essays in this section explore the emergent territory.

REFERENCES

Birkerts, Sven. 2006. *The Gutenberg Elegies: The Fate of Reading in an Electronic Age*. New York: Faber and Faber.

Clark, Andy. 2010. *Supersizing the Mind: Embodiment, Action, and Cognitive Extension*. New York: Oxford University Press.

Davidson, Cathy. 2010. *Now You See It: How Technology and Brain Science Will Transform School and Business for the 21st Century*. New York: Penguin.

Fitzpatrick, Kathleen. 2011. *Planned Obsolescence: Publishing, Technology, and the Future of the Academy*. New York: New York University Press.

Gitelman, Lisa. 2008. *Always Already New: Media, History, and the Data of Culture*. Cambridge, Mass.: MIT Press.

Marvin, Carolyn. 1990. *When Old Technologies Were New: Thinking about Electronic Communication in the Late Nineteenth Century*. New York: Oxford University Press.

1

TXTual Practice

Rita Raley

We demand that art turns into a life-changing force. We seek to
abolish the separation between poetry and mass communication,
to reclaim the power of media from the merchants and
return it to the poets and the sages.... We will sing to the
infinity of the present and abandon the illusion of a future.
—Franco Berardi, *The Post-futurist Manifesto*

Does art have a point? Is this art? Does it have a point?
—anonymous contribution to *Urban_diary*

ARE TEXT MESSAGES displayed on large video screens or mobile
variable message signs, or projected on building facades or on
open ground in public squares, meaningful or not meaningful? And
what is the structural form or logic of these scenes of reading and
writing that would command critical attention? Would a lauda-
tory or skeptical tone predominate in an analysis of interactive
text installations, the expressive heights of which at times run the
gamut from "u r gorgeous" to "This wall is way more popular than
me"? Were one to approach these works by focusing on linguistic
content alone, regarding, or attempting to regard, each line or set
of lines as literary utterance with the interpretative method that
implies, most likely it should be the skeptical, but to consider only
the substance of any particular text message would be to occlude all
of the moving parts of each installation: hardware, software, screen
or projection surface, audience, physical environment, telecom-
munications infrastructure, and all of the social and technological
protocols that govern the production and reception of the projected
messages. The urge to read, to do more than acknowledge or see
the words, is not so easily disregarded, but the transitory aspect
of the messages means that the subjectivity constituted in relation

to the text cannot be understood to be literary as it has histori-
cally been understood. The exact temporal structure of each art
project, each installation, differs, but what they necessarily share
is the evental form. Unlike billboards, posters, signs, and even
video art installations, they are live, continually refreshed; they
are said to "run" for a set number of days or hours per day, and
the messages on display are thus impermanent.[1] What one reads
with a momentary peripheral glance is likely not to return and,
though the moment of textual consumption might be captured and
replayed through recorded documentation, that moment cannot
be restaged or reenacted. Any installation might, of course, suf-
fer all manner of glitches and errors that would cause the text to
freeze, but in their fully operational state, the displays are dynamic,
the trajectory is forward, and the already mined phrases are not
available for further mining.

The public art installations I address in this chapter are *interac-
tive* (remote and on-site participants are invited to contribute an
SMS message of their own to the data feed); *sited* (they cannot but
engage the specificities of each place and, by extension, prompt a
consideration of what is "public" and what is "private"); and *social*
(participants are continually negotiating their relationship to the
audience, crowd, and readerly communities that are themselves
continually mutating). For example, in Matt Locke and Jaap de
Jonge's *Speakers' Corner* (2001–), participants contributed text to
the live feed on a fifteen-meter LED display wrapped around the
corner of the Media Centre building in Huddersfield, shouting by
SMS, through a web interface, or by voice message from a phone
booth. Its title invoking the ritual performance of public speech
as civic participation, the eventual fate of *Speakers' Corner* was
entirely fitting: the screen was hacked, the external booth was
vandalized, and a library of expletives accrued after the contribu-
tions were filtered in response to municipal complaints.[2] What was
at stake was less the physical parts of the work than a negotia-
tion of control over property, technological systems, and public
speech. A similar experiment with civic dialogue was performed
by Johannes Gees with *Hello Mr. President,* a laser projection on
a mountainside of text messages sent to its ostensibly singular ad-
dressee, then-president Bush, during the World Economic Forum

in Davos in 2001 (the signature message from this event: "I feel poor"). About the sociocultural function of this installation, along with that of his Hello World series, which was installed in four locations around the world during the United Nations summit in 2003, Gees notes, "We speak about public space and that it belongs to everybody, but the use of public space is actually set into regimentation.... You can buy the space for advertising, but that takes money. Or you can do graffiti, but that's illegal" (quoted in Bounegru 2009, 208–9). The extant discourse on text messaging for open display is remarkably thorough in its concern with urban environments, interventions in public space, and audience participation.[3] But the installations or events in question have not yet been considered, as I think they ought to be, as scenes of reading and writing that are particular to the moment of ubiquitous mobile media and that make visible certain transformations that are occurring in our relationship to text in the ordinary sense of linguistic signs. The premise of my analysis is that understanding what is happening in these new scenes of reading and writing, that is to say, the rhetoric of interactive text events, can help us more fully to understand the dynamics of ephemerality and vernacularity that are at the heart of the way we read and write now.

In a taxonomic account of what I am calling TXTual practice that takes as its core examples some of the more widely known and installed SMS installations—those that have both a critical and a geographic reach—I mean then to contribute to the conversation about comparative textual media by taking account of communicative technologies in use.[4] A concrete example related to my analysis of TXTual practice will illustrate this point. Erkki Huhtamo (2004) has for some time made a persuasive case for the development of what he calls "screenology," a historicized phenomenology of the screen that focuses not only on "screens as designed artifacts, but also on their uses, their intermedial relations with other cultural forms and on the discourses that have enveloped them in different times and places" (see Huhtamo 2004, 31–82).[5] The artifactual and genealogical work he does toward this end is richly narrated, extending well beyond what we might call a mechanistic or positivist formulation of the screen to account not only for shadow theater and modes of visual storytelling that

lack a traditional technological apparatus but also for the social rituals, discursive conventions, and bodily habits that they have engendered. The media archaeological approach to screens that he performs and for which he calls is neither narrowly technological nor strictly aesthetic; the "screen" as an object of inquiry is identifiable as such only in relation to other medial forms, and the task of the critic is to understand its social uses and its embeddedness in a particular historical moment and technological–geographic milieu.

Comparable work needs to be done for writing within digital environments. There is by now well-known and definitive scholarship on the formal features of digital writing and the embodied apprehension, especially sense perception, that is at the heart of the reading experience. Many critics have carefully delineated the signifying components—for example, structures of interaction, sound, kineticism, and temporal processes—that are particular to writing with networked and programmable media.[6] Compositional uses of locative and mobile media, writing "beyond the screen," are receiving more critical attention, but here, too, the emphasis tends to fall on the phenomenological, on affect and sensation (see Schäfer and Gendolla 2010).[7] This is all important work, but it relies on an articulation of born-digital works as works (e.g., a Flash poem) that have a dependable and documentable structure that produces an accountable experience, as opposed to born-digital textual practices, an important analytical distinction given that we now clearly confront a variety of expressive activities that are neither formalizable as "electronic literature" nor reducible to a singular medium. We confront, in other words, expanded textual practices that are not–electronic literature, not-print, not-codex, not–mobile messaging, not-game, not-conversation, not–algorithmic instructions, not–data mining, not–collaborative content creation, but that which is situated in the interstitial field.[8] This rhetorical abstraction of writing from material substrate (to which it, of course, remains concretely tethered) is productive because it allows us to think across media, platforms, and genres and to articulate a discourse on textual practices that are sited, social, and live.

I read texting for public display as a practice, following Nigel Thrift (2007, 8), for whom "practices [are to be] understood as

material bodies of work or styles that have gained enough stability over time, through, for example, the establishment of corporeal routines and specialized devices, to reproduce themselves." Practices unfold within a structure of bodily habit, a set of physical activities that, while modular, nonetheless cohere when ordered by a procedural script. This script is necessarily repeatable, and it is the repetition that allows a practice to emerge as a practice. *Practice*—from the French *practiser*, "to strive," the Portuguese *pratiquei*, "fit for action," and the Greek *praktikos*, from *prassein*, "to experience, negotiate, perform"—is that which is experiential and enacted in the moment, but it follows in the wake of what has been, retracing routinized activities that have been performed in the past and necessarily directed toward the reenactment of these routinized activities in the future. The actors within these procedural scripts are not only humans but encompass the whole of the object world and specifically the material presence of "specialized devices" that are neither inert nor simply used. As Bruno Latour and others have made clear, the world is a complex mixture of discrete actors, human and nonhuman, with each actor mediating and thereby transforming the other. Devices then play a necessary role in the digital textual practices I am outlining, but the installation–event–performance spaces as a whole are concrete assemblages of bodies, mobile devices, screens, wires, signs, architectural structures, and barricades in the form of walls and fences governing the movement of traffic. In other words, these practices are not reducible to artifacts and technological apparatuses, nor are they explicable as aftereffect or consequence, as in the notion that the activities that unfold are simply the result of a script that has been programmed and put into play. Rather practices are themselves generative; again, they "reproduce themselves." They are not products but processes, always embedded within human and nonhuman networks of relation that are themselves constituted through performative acts.

For scholarly investigations within the framework of comparative textual media, TXTual practice can present certain challenges precisely because there is no durable object to recover and preserve for future study. Certainly the individual events can be documented with photography, video, and narrative description; the hardware and software preserved and/or emulated; and the

eyewitness accounts and explanatory statements by artists criti-
cally explored. Site analyses might be performed to record the
dimensions and placement of screens or projection surfaces, lines
of sight, and variables in the viewing conditions, particularly those
concerning the quality of light and sound. (Indeed, my analysis is
entirely dependent on all these archival techniques. It would not
be possible for it to be otherwise.) The displayed messages are
also incidentally archived, though archiving is a technological
by-product rather than part of the structural logic of the work.
But these practices are importantly live, enacted and decoded in
the moment, and participants aspire to be part of that moment,
to contribute to events as they unfold, rather than to be part of
the permanent record. In this regard, these practices might in part
be situated under the rubric of performance studies, much like
the Electronic Disturbance Theater, which is known for its inter-
ventionist distributed denial-of-service attacks and announces its
affiliation with performance in its very name. But arts practices
that are participative and discursive, multimodal, multiplatform,
and multisited, exceed even the performative, so a better analog
might be Natalie Jeremijenko's (2004) OneTrees project, which
delineates cloning procedures, gallery exhibition, site-specific plant-
ing and physical tours of the same, A-Life trees, virtual landscapes,
and public response as component parts of what she terms both
"information environment" and "bioinformatic instrument" but
is really only intuitively legible under the rubric of "project" itself.
A project, however, is singular, whereas a practice is reiterative.
It functions within a certain material structure that is shareable
and translatable to different contexts, and it is that structure that
is available to critical scrutiny.

THERE ARE MULTIPLE GENEALOGIES for SMS artworks for public
space, almost all of which discuss Chaos Computer Club's *Blink-
enlights* (2001–2), an interactive work that invited participants to
engage with and contribute content to a pixelated display screen
formed out of a lighting system installed in the windows of the top
eight floors of a building in Berlin's Alexanderplatz (see, e.g., Strup-
pek 2006; Bounegru 2009).[9] Less discussed as precursors are two
works that primarily used web interfaces for remote participation

but are nonetheless part of the history of the reconfiguration of relations between production and reception that are at the core of the broadcast and print model, an ontological and practical distinction fundamentally complicated by mobile and digital technologies and replaced by a model of participation. The first is *Clickscape* (1998), a work of "clickable public space" with projections on two buildings on either side of the Danube in Linz; in this instance, remote participants were invited to transmit messages for display, and on-site visitors were made aware of their (tele)presence.[10] Around the same time, Hans Muller, in collaboration with Zwarts/Jansma Architecten, installed *Internettunnel* in the Leidschenveen Tunnel, an electronic display to which people were invited to contribute messages via a web interface.[11] But the projects out of which my thinking on TXTual practice fully emerged involve participation on a much larger scale, either in terms of sheer numbers of messages, duration, or geographic reach: rude_architecture's *Urban_diary* (November 2001 to February 2002),[12] a screen-based installation on the platform of the Alexanderplatz underground station in Berlin that garnered approximately ten thousand entries throughout the course of its three-month exhibit; Paul Notzold's *TXTual Healing* (2006–10), a series of performances produced with a laptop and mobile projector in Brooklyn, Baltimore, San Francisco, Munich, Hamburg, Bucharest, Rotterdam, Beijing, and other cities; and *Cityspeak*, a project from Obx Labs at Concordia University that uses large LED screens and has been installed nearly twenty times in cities throughout North America since it was first used as a proto–chat wall during a mobile digital commons workshop at Upgrade! Montreal in May 2005 (Figure 1.1).[13]

A truly comprehensive catalog of real-time interactive text projection is well beyond the scope of this chapter, but an overview of these three projects will allow me to outline the distinctive aspects or rhetoric of TXTual practice, which encompasses a range of handhelds (phones and PDAs), along with web-to-SMS, and is not limited to a particular hardware architecture. Input devices and projection technologies may vary, and certainly, for many of these projects, multiple platforms are enabled to allow for audience contributions (e.g., kiosks or voice messaging systems).[14] While I recognize the importance of the recent proliferation of

FIGURE 1.1. *Cityspeak*, illustration. Courtesy of Jason Lewis, Obx Labs.

scholarship on the material specificities of hardware and soft-
ware, an expansive and transmedial concept of public messaging
allows me to articulate TXTual practice as such and identify the
aspects that are relatively stable across a diverse range of events
and installations. Such a critical move need not be subject to
the charge of "screen essentialism" as Matthew Kirschenbaum
outlines it in his refutation of a "medial ideology," which is our
seduction by flickering signifiers and blindness to inscriptive acts
(see Kirschenbaum 2008, esp. 31–45).[15] That one type of proj-
ect should require only a portable projector and mobile phone,
another should be programmed for a virtual environment from
which it cannot be exported, and another should involve exten-
sive preliminary work on site, along with the negotiation of civic
and commercial strictures, does matter, but matter—the material,
whether framed in terms of inscription, apparatus, platform, or
technological object—cannot alone account for their significance.
To think exclusively in terms of material specificities is to lose sight
of the intermedial and social systems in which the object or thing

is embedded, the myriad ways in which they are used and experienced, and the micro-communities they engender. The emphasis Lisa Gitelman (2006, 7) places on the "vernacular experience" of what is now termed forensic materiality is to the point, as is her definition of media as "socially realized structures of communication, where structures include both technological forms and their associated [social, economic, material] protocols." The argument is not particular to comparative textual media; Charles Acland (2012, 168), for example, makes a similar case in his prescriptive sketch of the discipline of screen studies:

> Technical specifications—screen size, aspect ratio, resolution, frame and refresh rate, brightness, color scale—might help us define what we are talking about in a specific instance, or better yet complicate what we presume we know about media. But the mechanical level only gets us so far in our job of actually understanding the related senses, sensibilities, and practices that form as a consequence of media use. All those unruly features of human existence simply can't be neatly confined and appended to medium specificity.

Accounting for the absolute physical singularity of a medial object affords a certain readerly satisfaction—as with Homeric narration, there are no descriptive gaps, no questions left unanswered—but it is equally important to integrate that object into a discursive field, to situate it in relation, or nonrelation, to other medial objects, so as to pose questions about social habits and experiences held in common. Here, too, one might consider Adriana de Souza e Silva's suggestion in chapter 2 of this volume that net locality is best understood in terms of social practices rather than specific technologies.

To become mired in the assessment of comparable specifications for each particular SMS artwork in public space would be to fix each as a static, single-state entity, with the dynamic and temporal properties stripped away and no conceptual means by which to account for qualitative and evolutionary changes as the minutes, hours, and days unfold. A notion of TXTual practice—based on public contribution of 140- to 160-character messages and visible

display—instead makes it possible to recognize structural logics that are both shared and repeatable in different social and technological contexts. Though my analysis of TXTual practice does not directly engage Charles Musser's (1994) pivotal work on the history of "screen practice," there is a crucial point of intersection in the notion that practices emerge as such through the stability of styles and presentational schema. At the core of Musser's account of the "emergence of cinema," which not incidentally informs Huhtamo's (2004) work on screenology, is the notion that cinema itself is one of many screen practices based on projected images and accompanying sound. Framing the discipline in this manner circumvents the inevitable determinist account of what is and is not properly cinema. So, too, TXTual practice circumvents the inevitable ontological distinctions between the algorithmic and nonalgorithmic, which would have the effect of retroactively ascribing technological foundations, converting means into ends, and establishing parameters for a set of projects based on criteria secondary to the artists' and designers' investments. The purpose is not to articulate a definitive category that would serve as a critical heuristic; many such descriptors—for example, SMS artworks, interactive text events—suffice for the practical purpose of indicating the objects at hand. The purpose rather is to sketch the field of inquiry in such a way as to account for reading and writing practices that are sited yet virtual, computational and live, distributed and social, and a challenge to the human capacity to synthesize discrete data flows that need not be recognized or responded to as such.

For the *Urban_diary* installation, the rude_architecture group (Gesa Glück, Tobias Neumann, and Friedrich von Borries) invited passersby to submit 160-character diary entries that were then anonymously projected onto three advertising billboards on the Alexanderplatz station walls after a twenty-four-hour interval, the temporal lag between reception and projection allowing the contributor to become part of the audience and preventing direct physical address in the form of hailing, yet still allowing participants to seek ordinary responses or self-affirming feedback, or even simply to make some noise.[16] The only explanatory information in the station during the one hundred days it was installed was a

web address and telephone number on the fade-out of individual messages; the effect of this withholding (in that there were no wall labels or flyers in circulation) was to create a sense of secrecy, the knowledge of the project transmitted through the same popular word-of-mouth channels that circulate rumors and gossip. The practical intervention was to "design and install interfaces between streams of technical information, on the one hand, and perceptible urban spaces on the other," that is, to construct a new public space, one that would be situated in between the actual and physical, on one hand, and the virtual, on the other. This newly imagined public space functions as a sandbox, a tool kit with which to think, experiment, and play, and as such constitutes a sharp refusal of the impoverished technocratic imaginations of the so-termed creative industries. The overarching purpose of the installation, however, was even more provocative: it was, as the architecture team explains, "to give place to—to re-place or re-locate—existing communicative potentialities within urban space." Instead of a melancholic lament for a public space overwritten by neoliberal economic interests, then, it was an affirmative gesture, an invitation to its audience to exploit the latent potentiality within the communicative field, in other words, to produce something new. What matters is not the substance of any one message, powerful as it may be to provide the infrastructure for the expression of political and economic frustration. (Anonymous contributor: "I just wanted to say that ever since the Euro, I am paying more for practically everything, but I'm not earning any more!") What matters rather is in fact that infrastructure, which extends well beyond hardware and software to include the conditions of possibility for the actualization of those potentialities. *Urban_diary* is in this sense, as the architects assert, "a reclamation, a winning back of life itself."

More modest, in terms of both technology and philosophical commitments, was Paul Notzold's staging of his *TXTual Healing* events in cities throughout North America and Europe.[17] Using a building facade as a projection screen and writing spaces demarcated with speech bubbles or geometric shapes, Notzold essentially set up temporary shop on street corners and distributed his mobile number to passersby, soliciting messages that were displayed

automatically, anonymously, and in real time. Unlike the *Urban_ diary* installation, for which the messages were scanned and those that violated extant privacy laws, along with others having to do with data transmission, were intercepted, the messages sent during the *TXTual Healing* events were not filtered. What results is a mishmash of babble, general commentary, interpersonal dialogue, and anonymous self-articulation—utterances in the form of "I am, I like, I love" that allow a participant to establish a certain relationship to herself and to risk self-exposure in exchange for affirmation from others. The fleeting affective component of the various utterances is reminiscent of Mark Hansen and Ben Rubin's *Listening Post* or the sentiment analysis visualizations such as "We Feel Fine" and "Twistori" in that the projected text messages capture a mood by presenting the murmurs of the crowd. The projected messages also seem to represent the "idle mutterings of ourselves to ourselves," as was noted about another visualization, *London Wall,* which culled publicly available status updates from social networking sites over a ten-day period in 2010, the data from which have been preserved as "instantaneous social history."[18] However, *TXTual Healing,* along with other interactive installations of the sort that I am describing here, are crucially different in that they are instances of distributed writing and synchronous communication rather than data collection. Moreover, the modality of TXTual practice is not collective in aggregate but rather disparate individuals acting and speaking in common, a mass of subjective articulations that masquerade as collective consciousness. (Not "we feel fine" but "my loneliness is killin me."[19])

Texting for public display reroutes the circuit between input and output, making the writing space visible and allowing participants to ping a channel, any channel, seeking ordinary response or self-affirming feedback, or sometimes simply to make some noise. ("Hello world.") The virtuosity, then, is that of the common speaker rather than the technically proficient or conceptually sophisticated performance artist, for, as Paolo Virno (2004, 55) reminds us, "the fundamental mode of virtuosity, the experience which is the base of the concept, is *the activity of the speaker.* This is not the activity of a knowledgeable and erudite locutor, but of *any* locutor." For Virno, it is precisely the vacancy and transitory nature of what

he terms "idle talk" that makes it generative; because it is not anchored in philosophical, historical, or emotional substance, it can function as a free-floating site of discursive invention. As he notes, "idle talk resembles *background noise*: insignificant in and of itself...yet it offers a sketch from which significant variances, unusual modulations, sudden articulations can be derived" (90). "Background noise" is in this analysis a zone of potentiality, a site that may give rise to creativity and inventiveness. Put another way, it provides the structural conditions of possibility for improvisation, unpredictable opportunities, and aleatory performances. Accordingly, communicative activities do not reflect but rather produce the state of things. The utter ordinariness of most of the messages on display—"I would like a hot chocolate"—is therefore entirely the point.[20] Expertise is shifted from the professional and granted to the ordinary speaker, whose "idle talk" might be insignificant but for this very reason can remain open to swerves, divergences, and unforeseen interactions.

Cityspeak, from Jason Lewis and Obx Labs at Concordia University, is an exemplary instance of background noise, a field of communicative activity that has the potential to generate something new (Figure 1.2). Whether in a city square or the more contained space of an art gallery, *Cityspeak* invites passersby to read and contribute what the project designers term "ephemeral graffiti," with text messages taking the form of multiple layered data streams displayed on large LED screens.[21] With this project, Obx Labs has been able to realize its investment in "massively multi-contributor texts," where "massive" refers both to the display screens and, in certain settings, to the size of the audience. (In the weeklong Victory Park installation in Dallas in June 2007, for example, they were able to work with the largest outdoor LED screen system in North America.) A custom Java library manipulates the visual appearance of the text: the contributions of individual senders are color-coded; new messages appear in larger font in the foreground; and previous texts scroll right-to-left and upward in the background. The transition between the two states is visually accomplished by a "pixel eater" in the lower right corner; new messages are pulled into it, pixelated, and then reformulated letter by letter for the conversational history in the background. As befits a project that

encourages "ephemeral graffiti," the significance and meaning of the *Cityspeak* installations derive in part from their interventions in public space and their effects on their immediate environment. In practical terms, this might take the form of repurposing spaces given over to advertising, appropriating spaces of composition that are traditionally given over to consumption. In this respect, they transform both the form and function of the large-screen video displays, from commercial broadcasting to participatory circuits that include the public. Monologic advertisements instead become bulletin boards and chat spaces. Scott McQuire (2006) suggests more generally that tactical interventions into commercial spaces "provide a striking comparison to manufactured 'media events,' where the media simultaneously desires spontaneity as a way of attracting an audience, but generally occludes the spontaneous by imposing standardized frames in order to minimize the risk that 'nothing happens.'" What is important about *Cityspeak* as a site for the generation of "idle talk" is that something might indeed happen at any moment. But so, too, something might not, and in this context, it is worth noting that the external forces work-ing against the emergence of "unusual modulations" include not only social and linguistic protocols but also the law. (*Cityspeak* is presented as an artwork but regulated as a public broadcast, so contributions are filtered and offending texts are anagramatically reformulated in such a way that a participant can recognize her input and recognize as well that it has been scrambled.)

Even with content filters in place, however, interactive text pro-jection is necessarily spontaneous rather than rehearsed because one cannot predict what information will be input. Multicontributor SMS events are not in themselves new, but something emerges in the process of "city speak" that is performatively and operatively different from texts with single input channels. The streaming of multiple messages makes stabilizing a singular voice impossible, the collective quality announced in the visual and verbal density of palimpsestic displays of text. And the signature of the indi-vidual author or artist then becomes displaced onto the design of the installation itself, particularly the construction of the site, the algorithms that manage text display, and the structures of participation. Michael Giesecke (2002) delineates the historical

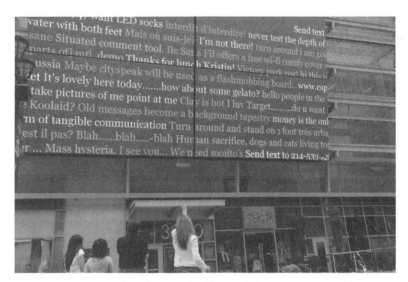

FIGURE 1.2. *Cityspeak,* Victory Park Plaza, Dallas, Texas, June 2007. Courtesy of Jason Lewis, Obx Labs.

context for the prioritizing of multiple communication channels operating in real time. In his account, as mass communication—with its minimizing of participation—gives way to a culture of interactivity, feedback, and recursivity, we see a deep sociocultural, literary, and aesthetic investment in "face-to-face communication as the situation of maximal interactivity and multimediality" (13). Once media breaks from the print market model and develops to the point of synchronic feedback between production and reception, the issue of "synchronization between communicators" (or interactive channels) necessarily emerges at the fore. If one follows the logic here, text-based interactive installations would be the paradigmatic instance of media communication in our present moment. They are a rich investigative site both for me and for the artists involved from and through which to explore the fundamental experiential transformations that have occurred in our reading and writing practices.

What, then, are the implications for comparative textual media—or for literary studies or the humanities—of a textual practice that is manifestly about transient display and process rather than the artifact? How do we approach a "literary document," such as

Urban_diary, that is "constantly transformed during the interval of its installation," or an installation with a textual display that moves at such a rapid rate that the words cannot be parsed by a human reader? How can we understand the significance of events that are pure process, pure performance, pure participation: objects of analysis that, on the face of it, seem to disappear rather than endure? In what sense, if at all, does the *experience* of ephemerality push the parameters of a discourse on comparative textual media to a kind of limit? These textual practices are antihermeneutic to an extent perhaps not even imagined by those who advocate for "surface reading" as a turning away from interpretation and symptomatic reading, from a "hermeneutics of suspicion" that seeks out the hidden meanings of a text, that which is masked or buried deep within its linguistic folds, that which is not said but needs to be brought to light. Surface, in the words of Stephen Best and Sharon Marcus (2009, 9), who introduce this approach, is "what is evident, perceptible, apprehensible in texts; what is neither hidden nor hiding; what, in the geometrical sense, has length and breadth but no thickness, and therefore covers no depth. A surface is what insists on being looked *at* rather than what we must train ourselves to see *through.*" But the screenic surfaces I am describing here as representative of the move away from a hermeneutic are such because there is no stable text that one can look *at* for a meaningful period of time. They are not texts but text effects. The sociotechnological context for such a practice is the shift from static pages to real-time streaming data. And the philosophical context is work that draws our attention to techniques and practices of mediation, as with Alex Galloway's (2012) recent argument that we need to think in terms of the "interface effect" rather than in terms of objects and things.

IN THE CASE of an interactive media arts installation to which the audience might contribute bodily activity but not actual content—as, for example, Camille Utterback's *Text Rain*—the participatory script will differ from encounter to encounter, but the piece can still be regarded as an artifact that has a distinct form and structure that can be mapped both at the level of code and at the level of interface, with fairly precise verbico-visual constructions of what

we read and see. So, though we may recognize the fluidity and mutability of the projected text in Text Rain, we can also think in practical terms of a stable and fixed entity because of a legible connection between cause and effect (if I move my arm a certain way, the movement of the words will correspond). In the case of an interactive installation driven entirely by crowd-generated content, conversely, there is the problem of articulating underlying form as it has been understood in humanistic inquiry. Participatory SMS-based installations are not scripted, unlike many mobile media projects, the structured forms of which (e.g., guided walks) hark back to Myron Krueger's (1977) notion that interactive environments work best when they compose the user's experience. A participant may be given a phone number but no instructions directing textual content or mode of contribution. Participation is spontaneous, improvisational, and nonchoreographed rather than programmed.[22] "Text," then, is the whole of the event, its physical, logical, and conceptual architecture; the enactment and experience; its temporal structures; and associated social and juridical protocols. Text events are communication circuits: feedback as opposed to the data separation inherent in the archive. The display surface may be a writing surface, but it is not a scene of inscription or a graphic technē but rather chance juxtapositions, the play of dialogue, conversation. Compare an instance of TXTual practice with a work by Jenny Holzer: with the latter, a singular input for a speech act manifesting as linguistic spectacle, and with the former, multiple inputs that produce a dynamic interactive conversation that is experienced as momentary.[23] The basic units of analysis, then, are durational: how long does the text hover in the foreground; how long does the audience remain in place; how long is the work installed?

The projected messages are *experienced* as ephemeral and eruptive, part of the still-pertinent history of "flickering signifiers" that one can trace at least in part to Eduardo Kac's (1996a, 247) work to develop a poetic language that was "malleable, fluid, and elastic" and not tethered to the page. The result of Kac's experimentation with the display of linguistic forms in different media was the "new syntax" of holopoetry, the defining quality of which "is not the fact that a given text is recorded on holographic

film"—not, in other words, the forensic materiality (Kac 1996b, 186). Rather, "what matters is the creation of a new syntax, exploring mobility, non-linearity, interactivity, fluidity, discontinuity and dynamic behavior" (186). The ever-increasing prominence of text analysis—as methodology, practice, and core project of the digital humanities—has arguably had the effect of enforcing an institutional imaginary of text as a static entity that awaits the search query. While techniques or practices of "deformance" might suggest a certain dynamic quality, in other words, text as such lies inert until it is reformed in accordance with algorithmic procedures. Text analysis performs a certain epistemological translation of text into data that is manipulable and mutable, but the notion of that very mutability relies on the practical fact of text as a thing that can be altered and made to change states. The tension here might seem to be that of the poetic versus the empirical, but the empirical has become hegemonic, a disciplinary truth of text in relation to which "flickering" language is putatively frivolous, merely and inconsequentially poetic.

TXTual practice has the potential to generate immediacy, a sense of being-in-the-moment, a real time that is an enactment rather than a destruction of the present. Contra Paul Virilio (1994, 4)—for whom the technologies of real time "kill 'present' time by isolating it from its presence *here and now* for the sake of another commutative space that is no longer composed of our 'concrete presence' in the world, but of a 'discrete telepresence' whose enigma remains forever intact"—an interactive text event does not displace present time from itself. Rather, the event itself is composed in the moment of performance; it is not in this respect a replay. To pursue this line of thinking further, contrast the potential to generate immediacy, a sense of being-in-the-moment, with our cultural obsession with storage and archiving, perfectly illustrated by Chris Mendoza's *Every Word I Saved*: an alphabetized list of all the words the artist saved to his hard drives from 2000 to 2006. Even a poetics of "radical mimesis," such as Kenneth Goldsmith's "uncreative" retyping of the September 1, 2000, edition of the *New York Times* word for word in *Day*, does archival work, all claims to function as a "monument to the ephemeral" notwithstanding. And consider, again, the London Wall installation, the data from

which have been preserved as a "museum of ordinary London" in the form of A3 posters.[24]

Although texting for public display may be framed in terms of "ephemeral graffiti," graffiti is a highly skilled practice that at once articulates and consolidates identificatory group formations. The bar for participating in text events, conversely, is quite low. No particularly specialized literacy or skill is required; everyone has an invitation to participate; and no communicative device is more widely available.[25] Indeed, at this point, there are many text-to-screen systems available for commercial use, and it is colloquially said that every first-year media student worth his salt makes a project in this vein, interactive and social works that make prominent use of messaging. As with Flash mobs, too, the cultural consciousness of text events far exceeds the actual participants, so it is possible to claim that they are commonly accessible even if they are not commonly (actually) experienced. Along the same lines, TXTual practice might seem specialized in terms of generation (Generation M, the texting generation), habit, or media environment, and a first-time reader-viewer might initially be noncomprehending, overwhelmed, bemused in her search for meaningful signifiers, or at least uncertain about how to construct a meaningful lexical structure around the display. Fragments, words, and lines are discontinuous, voices and genres are mixed, scenes are jumped. Sequentiality exists only insofar as there is an actual spatiotemporal connection between fragments or messages, and there is no governing discursive frame that would bring them into order either retrospectively or in real time. Here it is helpful to refer to Roger Chartier's (2004, 151) commentary on the connections between form and the mode and experience of reading, as in the case of encyclopedias, the reading of which is "segmented, fragmented, discontinuous," because the structure and design of the text is such. Much the same could be said about reading projected text messages, but absent the firsthand knowledge of sender and receiver, they also crucially lack a discursive context, indexicality, and the kind of navigational menus that cross-referencing can provide.

The use of a single screen might seem to function as a focal point for the audience's attention, but as Erica Robles, Clifford

Nass, and Adam Kahn (2009, 73) have persuasively argued, a shared screen does not necessarily correlate with shared information, and "co-orientation toward a central source" is dependent on the alignment of context (the single screen) and mode of address (the articulation of a common audience). Co-orientation toward a central source would also necessitate the management of ordinary environmental factors, such as noise and obstructed views, and even if a programmable text were to fulfill all of the internal and external conditions necessary to function as a single focal point, it would do so only momentarily. All the different text displays are intended to be to some degree legible, but semiotic certainty can only ever be partial, and sustained attentive reading is improbable. Were one to approach these works and focus on linguistic content alone, regarding, or attempting to regard, each line or set of lines as literary utterance with the interpretative method that implies, one would quickly come up against the practical—and familiar—problem of the limits of cognitive apprehension when there are multiple data streams. But this scene of apprehension cannot be understood as it once was as a problem of sensorial overload. That is, we could be, or we are even now, being inaugurated into different practices of reading and viewing such that complex screen environments are becoming ever more quotidian. Our so-called distracted reading is thus only such in relation to the conventional symbolic structures beyond which we are conditioning ourselves to move, and it is entirely possible to imagine that the socially mediated displays are able to hold the sustained attention of at least some of the participants.

In a recent media archaeological investigation of public media interfaces, Huhtamo (2011, 38) concludes with a brief account of the structural transformations in the screenic landscape of Los Angeles in 2009, identifying the LED billboards as a "new medium" that at the time of writing had not been fully integrated into the urban environment. So rapid has the pace of technological change been, however, that now these brightly glowing billboards can only be considered "new" in relation to prior screen technologies; they are no longer new in the sense of newly encountered. They are objects more likely of habituated perception, so ordinary as not to provoke the need to orient, even so ordinary as perhaps

to escape notice. In other words, large-scale displays, while on one hand directing attention, are also ambient, foregrounds that function as a kind of background, ambient but not necessarily in the sense of managing behavior and perception. Responses by the audience—acknowledgments of the receipt of messages, recognition of repeated or threaded messages, even the communication of boredom—suggest a certain conditioning to want more stimulus. The varied responses remind us that individual lines or phrases can be processed—that is, received, recognized, contextualized. It follows, then, that modes of engagement are both conscious and aperceptive: semiotic structures that are so manifest as to be interpreted without the reader-viewer ever becoming self-conscious about that interpretation. Here we might recall Johanna Drucker's (1998, 99) observation that "as we observe words in the landscape, they charge and activate the environment, sometimes undermining, sometimes reinforcing our perceptions."

Interactive text events invite collective attention, not in a pernicious fashion, but rather in the sense of propagandistic manipulation. The group or collective (audience) is held together by the transmission of affect; the unity is thus to be understood as functional, operational. As Nicolas Bourriaud (2002, 61) says of relational aesthetics, that which substitutes intersubjectivity, the experience of being together, for the private symbolic space of art, "the audience concept must not be mythicized—the idea of a unified 'mass' has more to do with a Fascist aesthetic than with these momentary experiences, where everyone has to hang on to his/her identity. It is a matter of predefined coding and restricted to a contract, and not a matter of a social binding hardening around totems of identity." The contract specifies a momentary experience, an immediacy that has both a temporal and spatial dimension: it is about what happens in a particular place at a particular moment. Individual subject and collective are linked by processes of exchange: an inner life might be projected to an indeterminate audience, thus making it collective. And another's affect, the affect of the crowd or gathering, might become one's own. (Anonymous contribution to *Urban_diary*: "It's going to get worse.") The coalescence of a crowd and the mobilization of affects are temporary, though nonetheless inextricably linked, as Teresa

Brennan (2004, 51) explains in her account of "how a gathering is constituted, in part, through the transmission of energetic affects (which may add up to something more than the individual affects of the group's members)."[26] Relationality, then, is enacted rather than harnessed or captured, which is all the more meaningful in a sociotechnological milieu that is in no small measure dependent on the manufacturing and regulation of mutuality. (Anonymous contribution to *TXTual Healing*: "I'm so over audience participation. No. Let's talk it out face 2 face it's complex.")

Interactive text events that have been installed or performed in different times and places might share the same structure, but they would not have the same content in the sense that external forces would shape each event differently; thus individual motivations (teleology) and characteristics (volatility, unpredictability) result in different manifestations of a reiterable practice. The micro-communities that emerge from the anonymized mass or crowd are contingent, the occupation of physical space temporary, the negotiation of relations to that space and to others fluid, dynamic, emergent. They are then counterpublics, which, for Michael Warner (2002, 88), are "spaces of circulation in which it is hoped that the poeisis of scene making will be transformative, not replicative merely." Counterpublics, idle talk, background noise: these are fields of energy the transformative potential of which remains to be exploited. To hope that they will be exploited is to speculate; to communicate, to enact rather than transmit, is to open up a space for creativity, experimentation, and invention. The significance of TXTual practice is precisely this: to provide the ground for ephemeral "idle talk," the communicative flotsam and jetsam out of which something new might emerge.

What is the relation, then, between a cultural imaginary of the humanities as pragmatically and theoretically structured by an archival impulse, on one hand, and TXTual practice as an instance of the subjective experience of ephemerality on the other (Figure 1.3)? Perhaps we might consider the extent to which the humanities could stake its public claim not only on the basis of the historicist work of accumulation, classification, and narration but also on the basis of its capacity to reflect on the contemporary, not simply the everyday but the momentary as well. In other words,

documentation/Art

2001-12-03 00:36:33

Access to the archive is impossible. The diary's expansion into a
larger discourse appears either impossible
or undesirable. ART gets you nowHERE

start

introduction concept documenta

FIGURE 1.3. Anonymous contribution to *Urban_diary*. Courtesy of rude_
architecture.

a nontrivial project of the humanities ought to be to consider the
production of meaning that may not necessarily be preserved, to
understand the significance of medial objects and cultural processes
that seem to go away. We have a clear vested interest in forms
of monumentality (archives, canons, durable inscriptions), but
we have a less-recognized interest in maintaining a continuous
connection to ephemeral production—in recognizing that which
would otherwise disappear. TXTual practice has a certain place
in the conversation about comparative textual media precisely
because it reminds us of this interest in taking account of things
as they happen in real time—a present time that is not isolated
from its presence here and now but one that nonetheless allows
for critical reflection.

NOTES

I have greatly benefited from discussions of different permutations of this chapter with audiences at USC, NYU, the University of Bergen, the HUMlab at the University of Umeå, Concordia University, and the University of California, Riverside. Particular thanks are due to Holly Willis, Virginia Kuhn, Lisa Gitelman, Tom Augst, Scott Rettberg, Patricia Tomaszek, Patrik Svensson, Charles Acland, Haidee Wasson, Jessica Pressman, and N. Katherine Hayles for their generosity and probing questions.

1 Henkin's (1998) wonderfully narrated account of "city reading" in antebellum New York offers a historical counterpoint that highlights quantitative and qualitative differences between the commercial advertisements, broadsides, and political broadsides of a modern capitalist era and the guerrilla laser projections and institutionally sponsored art installations of a postindustrial sociotechnological milieu. The two forms of spectatorship Henkin identifies—browsing and quoting—would in the present moment need to be expanded to include annotation and collaborative creation. So, too, the material differences in production (paper vs. computational media) necessarily entail differences in reception (sense perception).

2 Conversation with Jaap de Jonge, Dutch Foundation for Literature, December 14, 2011.

3 The discourse on the urban screen phenomenon itself predominantly concerns questions of publics, spectacle, and socialization: of particular note are the series of conferences held in Amsterdam (2005), Manchester (2007), and Melbourne (2008) and related publications, among them Scott McQuire, Meredith Martin, and Sabine Niederer (2009) and a special issue of *First Monday*, "Urban Screens: Discovering the Potential of Outdoor Screens for Urban Society" (2006), http://firstmonday.org/ojs/index.php/fm/issue/view/217. Also see Mirjam Struppek's Urban Screens Initiative at http://urbanscreens.org/.

4 My syntactical formulation is borrowed from Paul Notzold's *TXTual Healing* performances (2006), which I discuss later in this chapter.

5 Also see "Screen Tests" (Huhtamo 2012), in which he argues that screenology is necessary so as to "break the illusion of timelessness, of media without history" (145).

6 John Zuern's essay in this volume (chapter 11) is one representative example, along with extensive work by N. Katherine Hayles, Espen Aarseth, John Cayley, Roberto Simanowski, Serge Bouchardon, Jan

Baetens, Maria Engberg, and others too numerous to name here.

7 In *Digital Art and Meaning,* Simanowski (2011) suggests that the emphasis on sensation, affect, and experience has come at the expense of reflective semiotic analysis.

8 Here I appropriate Rosalind Krauss's (1979) definitive statement on "Sculpture in the Expanded Field."

9 For a project description, see http://www.blinkenlights.de. A second iteration, "Arcade," was installed on the Bibliothèque nationale (September–October 2002).

10 Visual and textual documentation is available from http://www. servus.at/clickscape98.

11 Documentation is available from http://www.zwarts.jansma.nl/page/ 560/nl.

12 Documentation is available from web archive http://web.archive. org/web/20070218152223/http:/www.urban-diary.de.

13 See http://cspeak.net.

14 It is important for my analysis of TXTual practice that the events be enacted in real time. This will exclude a number of SMS projects with fixed output, e.g., Ananny, Biddick, and Strohecker's (2003) *TexTales,* which invited participants to text captions for community photos that were then installed in an apartment complex in Dublin on the verge of being demolished and rebuilt. An encyclopedic catalog of interactive text events would necessarily need to take account of the different experiments with outputs, whether text, sound, image, or directed action. Indeed, experimentation with output is usually one of the central objectives of such projects.

15 Kirschenbaum appropriates the phrase "screen essentialism" from Nick Montfort; for each, the field of new media studies has been misguided in its privileging of the graphical user interface, which, for Kirschenbaum, is "often uncritically accepted as the ground zero of the user's experience" (34). His intervention—to redirect critical attention to inscriptive acts—has unquestionably changed the paradigm of the field of electronic textuality, but it risks a certain overcorrection if investigations of phenomenological experience, interface design, and semiosis are foreclosed.

16 *Urban_diary* was part of "Berlin Alexanderplatz U," organized by Neuen Gesellschaft für Bildende Kunst (NGBK). All of the visual and textual documentation cited here is available from the archived versions of http://urban-diary.de. The site contains representative messages from the installation, documentation from which was also shown in the exhibit "Reality Bites: Making Avant-Garde Art

in Post-Wall Germany," at the Mildred Lane Kemper Art Museum (Washington University, St. Louis, 2007).

17 Notzold's (2006) most recent SMS event appears to have been October 2010. Notzold has also collaborated with Graffiti Research Lab to compile do-it-yourself instructions for public projecting.

18 All quotations from the BBC London radio interview (2010). The London Wall project culled data from local and publicly available social media accounts in the interests of creating an ordinary museum of London, but participants could also contribute to the database by text message. See http://www.thomson-craighead.net/docs/londonwall.html.

19 Anonymous contributor to Stefhan Caddick's *Storyboard*, commissioned for "May You Live In Interesting Times," Cardiff's Festival of Creative Technology (2005). The public was invited to text messages for mobile variable message signs, the usual purpose of which is to display traffic and weather information. Documentation is available from http://www.axisweb.org/ofSARF.aspx?SELECTIONID=112.

20 Anonymous contribution to *TXTual Healing*.

21 All of the visual and textual documentation cited here is available from http://cspeak.net. *Cityspeak* continues to have an average of two showings a year, the most recent as of this writing in Quebec City in fall 2011.

22 One could choreograph participation to a certain extent by asking a set of participants to execute the same set of actions every day of an installation, but it would be a performance of repetition rather than an actual repetition.

23 Here the irony of articulating a rhetoric of a practice that is inherently antiarchival must be noted. Capturing a snapshot, a synchronic slice of a dynamic work, turns it into a Jenny Holzer–like object. A synchronic slice, whether a screen capture or wall label, fixes a particular work as a work in space and time, thus reducing process to object.

24 Robert Elms, BBC London radio interview with Jon Thomson and Alison Craighead, 2010, http://www.thomson-craighead.net/minimovies/londonwall.mp3.

25 London-based Troika's *SMS Guerrilla Projector* (2003/2007), essentially a do-it-yourself portable projector with a mobile phone, is a representative example of the growing openness of text projection technologies. Documentation is available from http://troika.uk.com/node/44.

26 Commentary along the lines of Brennan on the biochemical basis of entrainment—the linking of human affective responses—is beyond

the scope of my analysis, but her work does address salient questions about collective understandings and collective drive, as opposed to thinking in terms of an assemblage of self-contained rational, individual actors.

REFERENCES

Acland, Charles. 2012. "The Crack in the Electric Window." *Cinema Journal* 51, no. 2: 167–71.

Ananny, Mike, Kathleen Biddick, and Carol Strohecker. 2003. "Constructing Public Discourse with Ethnographic/SMS 'Texts.'" *Human–Computer Interaction with Mobile Devices and Services* 2795:368–73.

Best, Stephen, and Sharon Marcus. 2009. "Surface Reading: An Introduction." *Representations* 108, no. 1: 1–21.

Bounegru, Liliana. 2009. "Interactive Media Artworks for Public Space." In *Urban Screens Reader,* edited by Scott McQuire, Meredith Martin, and Sabine Niederer, 199–213. Amsterdam: Institute of Network Cultures.

Bourriaud, Nicolas. 2002. *Relational Aesthetics.* Translated by Simon Pleasance and Fronza Woods. Paris: Les presses du réel.

Brennan, Teresa. 2004. *The Transmission of Affect.* Ithaca, N.Y.: Cornell University Press.

Chartier, Roger. 2004. "Languages, Books, and Reading from the Printed Word to the Digital Text." Translated by T. L. Fagan. *Critical Inquiry* 31, no. 1: 133–52.

Drucker, Johanna. 1998. *Figuring the Word: Essays on Books, Writing, and Visual Poetics.* New York: Granary Books.

Galloway, Alexander R. 2012. *The Interface Effect.* London: Polity.

Giesecke, Michael. 2002. "Literature as Product and Medium of Ecological Communication." *Configurations* 10, no. 1: 11–35.

Gitelman, Lisa. 2006. *Always Already New: Media, History, and the Data of Culture.* Cambridge, Mass.: MIT Press.

Henkin, David M. 1998. *City Reading: Written Words and Public Spaces in Antebellum New York.* New York: Columbia University Press.

Huhtamo, Erkki. 2004. "Elements of Screenology: Toward an Archaeology of the Screen." *ICONICS: International Studies of the Modern Image* 7:31–82.

———. 2011. "Monumental Attractions: Toward an Archaeology of Public Media Interfaces." In *Interface Criticism: Aesthetics beyond the Buttons,* edited by Christian Ulrik Andersen and Søren Bro Pold, 21–42. Copenhagen: Aarhus University Press.

———. 2012. "Screen Tests: Why Do We Need an Archaeology of the Screen?" *Cinema Journal* 51, no. 2: 144–48.

Jeremijenko, Natalie. 2004. "OneTrees." http://www.nyu.edu/projects/ xdesign/onetrees/.
Kac, Eduardo. 1996a. "Key Concepts of Holopoetry." In *Experimental—Visual—Concrete: Avant-Garde Poetry since the 1960s,* edited by K. David Jackson, Eric Vos, and Johanna Drucker, 247–57. Amsterdam: Rodopi.
———. 1996b. "Holopoetry." *Visible Language* 30, no. 2: 184–212.
Kirschenbaum, Matthew G. 2008. *Mechanisms: New Media and the Forensic Imagination.* Cambridge, Mass.: MIT Press.
Krauss, Rosalind. 1979. "Sculpture in the Expanded Field." *October* 8:30–44.
Krueger, Myron. 1977. In *AFIPS 46 National Computer Conference Proceedings,* 423–33. Montvale, N.J.: AFIPS Press.
McQuire, Scott. 2006. "The Politics of Public Space in the Media City." *First Monday,* special issue no. 4. http://firstmonday.org/ojs/index.php/ fm/article/view/1544.
McQuire, Scott, Meredith Martin, and Sabine Niederer, eds. 2009. *Urban Screens Reader.* Amsterdam: Institute of Network Cultures.
Musser, Charles. 1994. *The Emergence of Cinema: The American Screen to 1907.* Berkeley: University of California Press.
Notzold, Paul. 2006. "TXTual Healing." http://www.txtualhealing.com/.
Robles, Erica, Clifford Nass, and Adam Kahn. 2009. "The Social Life of Information Displays: How Screens Shape Psychological Responses in Social Contexts." *Human–Computer Interaction* 24:48–78.
Schäfer, Jörgen, and Peter Gendolla, eds. 2010. *Beyond the Screen: Transformations of Literary Structures, Interfaces, and Genres.* Bielefeld, Germany: Transcript/Transaction.
Simanowski, Roberto. 2011. *Digital Art and Meaning.* Minneapolis: University of Minnesota Press.
Struppek, Mirjam. 2006. "The Social Potential of Urban Screens." *Visual Communication* 5, no. 2: 173–88.
Thrift, Nigel. 2007. *Non-representational Theory: Space, Politics, Affect.* New York: Routledge.
Virilio, Paul. 1994. "The Third Interval." In *Rethinking Technologies,* edited by Verena Conley, 3–12. Minneapolis: University of Minnesota Press.
Virno, Paolo. 2004. *The Grammar of the Multitude.* Translated by Isabella Bertoletti, James Cascaito, and Andrea Casson. New York: Semiotext(e).
Warner, Michael. 2002. *Publics and Counterpublics.* New York: Zone Books.

2

Mobile Narratives: Reading and Writing Urban Space with Location-Based Technologies

Adriana de Souza e Silva

IN HIS BOOK *Consumers and Citizens,* Néstor García Canclini (2001) points to the fragmentation of the contemporary urban landscape, arguing that it refuses narrative form. The eclectic architecture of megacities, their multiple outdoor advertisements and their diversity of sounds and stimuli, contributes to the perception of a fragmented and deconstructed urban space, one composed of disconnected places. Increasingly, however, formerly dissociated places are linked to each other through the use of location-aware mobile technologies, such as smart phones[1] and GPS devices. These technologies enable users to inscribe locations with digital information, such as texts, images, and videos, and find other people in their vicinity. As a consequence, they play an important role in helping people imbue locations with new dynamic meanings and construct new types of urban mobilities and narratives. To experience these new urban narratives and interact with location-based information, people are required to move physically. As such, they "read" and "write" city spaces with the aid of mobile technologies.

This chapter explores the role of location-aware technologies in enabling users to read and write space, either by accessing location-based information left by others or by attaching information to them. Because people can only access certain types of information when they are standing at the location where the information belongs, these technologies encourage specific spatial trajectories (Benford et al. 2009). These spatial trajectories are, however, different from early locative media art audio walks and location-based art performances: they are created by common users rather than

by artists. Therefore, an increasing amount of location-based information is constantly being created, erased, moved, and accessed and becomes an intrinsic part of a new dynamic urban landscape.

This chapter explores this shift in the way we interact with texts and narratives, which now become embedded in urban spaces via location-aware technologies. By drawing on examples of mobile annotation applications and projects, I analyze how these new forms of location-based texts transform contemporary cities into a sort of palimpsest, containing several layers of text on the same (urban) surface and generating many layers of meaning. An important shift to be observed is that, with the popularization of smart phones and location-based authoring tools, the ability of reading and writing space moves from the historical domain of art and research to the general public. Though artistic experiences were important to explore these new ways of reading and writing space, today the impact of location-based texts on urban spaces, mobility, and location can be perceived at a greater scale. This shift is part of what we call net locality (Gordon and de Souza e Silva 2011), a new logic of digital networks in which physical location defines how we interact with people and information around us. With net locality, the Internet is brought into public spaces, thereby creating a type of hybrid space (de Souza e Silva 2006) in which physical space and digital texts are layered onto each other. One of the major implications of net locality for comparative textual media is the realization that locations now acquire dynamic meanings owing to the constantly changing digital information that is attached to them. When digital texts become location aware and therefore an intrinsic part of locations, people are able to read and write urban spaces in new and unprecedented ways. For example, they can read spaces by following location-based stories created by others, or they can write spaces by leaving tips and comments at specific locations. This new ability to inscribe and read locations leads to new forms of sociability and mobility in urban spaces.

To analyze this new character of location embedded with digital texts, I start by defining the context of net locality as a theoretical framework to help us understand how the increasing amount of location-based information that is attached to locations changes the very meaning of public spaces. Then, I contextualize

the development of location-based narratives from a historical perspective to demonstrate that layering information on physical spaces is not a new phenomenon. I split this analysis into four main sections. I start with audio walks, an early type of artistic experimentation in which participants listened to a narrative presented by an artist to follow specific routes in space. Then, I show how these early audio walks differ from early mobile annotation projects, such as *Murmur* (Shawn Micallef, James Roussel, and Gabe Sawhney 2003)[2] and *Yellow Arrow* (Christopher Allen, Michael Counts, Brian House, and Jesse Shapins 2011).[3] In these projects, participants used their own cell phones not only to follow narratives created by artists but also to construct their own spatial narratives that could be followed by others. Other types of projects, however, such as *Urban Tapestries* (Proboscis, 2002)[4] and *Rider Spoke* (Blast Theory + The Mixed Reality Lab, 2007),[5] make use of location-based technology. Location-aware technology allows people to attach information to specific latitude–longitude coordinates, making the act of reading and writing space intrinsically connected to location. Finally, I focus on the shift that the popularization of location-aware technologies and applications brings to the way people interact with location-based texts and, consequently, locations. Applications such as SCVGR (2010) and 7Scenes (Waag-Society 2007) are location-based authoring tools, available to anyone who owns a smart phone and has access to the Internet—not only to participants of artistic experiences. Ultimately, I propose that the shift from the sphere of art and research to the commercial and public domain evidences the main characteristic of net locality, which is that our public spaces are now intrinsically embedded with location-based texts. As a consequence, we need to reconsider the character of location because physical location becomes paramount to the way we read and write urban spaces and interact with location-based texts.

THE CONTEXT OF NET LOCALITY

Net locality denotes a shift in the way we navigate (read and write) the web, highlighting the fact that digital networks are increasingly composed of local information and that the organizational

logic of networked interactions depends also on what is nearby, and not only on what is far away (Gordon and de Souza e Silva 2011). In the model of net locality, location becomes paramount to how we read and write the web and, as a consequence, to the way we read and write public spaces. Today, increasingly, the types of information (people's locations, audio, images, and texts) we access online depend on our physical location. Our position, defined by latitude–longitude coordinates, becomes our entrance to the Internet. For example, if somebody opens Google Maps on her mobile device, the map will center around the user and will display search results (e.g., restaurants, hotels) depending on relative distance to the user's location. According to this logic, location works as a filter that determines the types of information we access and the way we interact with the spaces around us.

Location-aware applications allow users to attach information to places as well as to access place-specific information, as is the case with WikiMe, by which users can access Wikipedia articles depending on their location. For example, if somebody who is in Los Angeles nearby the Getty Center opens WikiMe on his cell phone, the first article he will see displayed on the screen is the one about the Getty Center. After the article's title, he will see the approximate distance from that landmark, such as 4.6 miles. Subsequent articles will be listed depending on the relative distance to the user. This is a fundamental shift in how information had been normally found on the web. Prior to net locality, the organizing logic of the web was based on search engines. Typing a keyword into a search engine displayed results relevant to the incidence of that keyword and to the number of links to websites that contained that keyword, among other things. Today, however, even a simple search on Google takes into consideration the computer's location via its IP address. Keywords typed in different locations will yield different search results. Similarly, pictures taken with smart phones are increasingly tagged with latitude–longitude coordinates and organized on maps according to their location in applications like Flickr or PicasaWeb.

Location-based applications do not only allow people to find texts and images according to their location. They also allow people to find other people. These apps, such as Foursquare[6] and

Loopt, named *location-based social networks,* allow users to see the locations of other people on a map on their cell phone screens. In addition, location-based social networks allow users to leave tips and notes on specific locations. These tips are generally reviews— "This is the best restaurant in town. I would highly recommend the lobster"—or personal stories that took place at those locations. Location-based applications also include augmented reality apps, such as Layar and TwittAround, by which users can see images and texts overlaid on physical space through the mobile screen.

Net locality, however, is not just a set of technologies but a set of social practices associated with the use of location-aware technologies in public spaces (Gordon and de Souza e Silva 2011). It is the awareness that location matters and that our public spaces are becoming increasingly intertwined with digital texts. Being able to consistently and persistently locate ourselves through location-aware technologies fundamentally changes how we understand both the Internet and the physical space around us. Location, then, becomes the new organizing logic behind the Internet and determines the types of texts, people, and information we find in public spaces. In a way, our physical location determines how we read and write both the Internet and physical spaces and, consequently, how we navigate the Internet and physical spaces. But it has not always been that way.

During the 1990s, with the emergence of the World Wide Web, the navigational logic of the web was based on hypertexts. By clicking on links, users associated chunks of information and navigated digital space, going from website to website. As N. Katherine Hayles (2002, 26) defined, hypertexts have at least three characteristics: "multiple reading paths, chunked text, and some kind of linking mechanism to connect the chunks." The hypertextual mode of reading is not exclusive to the web, though. We can find multilinear reading in printed volumes like encyclopedias, which are clearly not meant to be read from the first to the last page. Similarly, children's books like those in the Choose Your Own Adventure series allow readers to choose multiple paths through the text and experience multiple endings to the stories. However, these stories are limited by the interface of the book, which has a limited storage capacity, restricted between the first and the last

page. The storage capacity of the Internet, however, is exponentially higher when compared to a book. A single server no larger than a regular paperback book might contain thousands of volumes, and digital information can be increasingly compressed into smaller and smaller devices. Furthermore, the act of clicking on a link is much more effortless than turning pages. Today, we mostly take the hypertextual logic of the web for granted: from searching for Wikipedia articles to clicking on links on social networking sites like Facebook, this is just part of how we move through the vast amount of digital information available to us.

However, if hypertexts are the navigational logic of the web, what happens when the web starts to be embedded into public spaces? How does the way we navigate public space change when digital information is attached to locations? How do we interact with texts differently when they become location aware? What new ways of reading and writing urban spaces emerge when they are embedded with digital information?

LOCATION-BASED EXPERIENCES: HISTORICAL ANTECEDENTS OF MOBILE ANNOTATION

Location-based experiences are not new. The desire to create a layer of (audio, visual, or textual) information on top of physical space, which influences the way we move through space, precedes even the ability to attach information to locations via GPS technology. The most popular examples are outdoor audio walks. Since the 1990s, audio walks, such as the ones created by artists Janet Cardiff and George Bures Miller, were developed as ways to offer participants a guided audible experience through specific spaces (Butler 2007).[7] For example, in *Forest Walk* (1991),[8] an audio walk developed at the Banff Centre for the Arts in Canada, Cardiff and Miller gave participants a cassette deck containing instructions on how to navigate the woods around the center. Participants listened to audio, such as "Go towards the brownish green garbage can. Then there's a trail off to your right. Take the trail, it's overgrown a bit. There's an eaten-out dead tree. Looks like ants." By following Cardiff and Miller's instructions recorded on a tape, participants followed trajectories through outdoor spaces.

Steve Benford and Gabriella Giannachi (2011) define a tra-

jectory as an individual journey through mixed reality spaces. According to them,

> an important characteristic of trajectories is that they establish a sense of continuity. From a participant's point of view, trajectories may often appear to be continuous, extending backward in time to reveal a coherent history of experience, and forward in time to suggest anticipated routes and possible future actions. (230)

As such, trajectories are spatial and temporal ways by which participants of an artistic experience or performance link the chunks of texts and information provided by the artist. In experiences like audio walks, or—as analyzed by Benford and Giannachi—mixed-reality performances, artists are responsible for providing a context for the participant experience, and participants are then supposed to follow a path (literally moving through space) to interact with the piece. Artists, in this case, strive to elicit ways of moving through space that are new and unknown to participants. Even if participants are already familiar with, in this case, the Banff Centre for the Arts, participating in an audio walk like *Forest Walk* is supposed to add new layers of meaning and information (literally) to the physical space of the center.

Audio walks like *Forest Walk* are mostly a linear experience, that is, there is one narrative that participants must follow to experience the piece. Other GPS-based audio walks, however, such as *Itinerant* (Teri Rueb, 2005)[9] and *34 North 118 West* (Jeff Knowlton, Naomi Spellman, and Jeremy Hight, 2002), follow a navigational logic very similar to the hypertextual logic of the web. The artists (or authors) create a context, chunks of texts and information, and participants (or readers) must make sense of that context by linking the information in a meaningful way. Information is then linked according to their movement through hot spots that contain location-based texts left by the artists. Interestingly, Benford and Giannachi (2011, 231) state,

> this approach of thinking of experiences in terms of continuous trajectories is in direct contrast to ... the World Wide Web, which adopts the paradigm of hypermedia, in which discrete

elements are interconnected into complex structures using hyperlinks.

They suggest that whereas navigating hyperlinks is almost instantaneous, trajectories are marked by a temporality based on the distances in physical spaces users must traverse. They oppose the "discrete and connected" to the "continuous and interwoven." Nevertheless, in all audio walks, there is still navigational logic by which authors create a context of possibility, and participants connect parts of this context to navigate the piece.

Benford and Giannachi (2011) differentiate between canonical trajectories and participant trajectories. The first ones are "pre-scripted and embedded into the original structure of the piece," whereas the latter are "defined by participants and are emergent and unpredictable" (54). According to them, there is always a tension between the artists' and the participants' envisioned trajectories. This distinction also highlights another aspect of what they call mixed-reality performance: these experiences generally require some kind of orchestration from the artists' part, that is, the anticipated creation of texts, possible routes through space, and foreseeable ways by which participants will interact with the piece. Like the early audio walks, mixed-reality performances, such as *Uncle Roy All Around You* (Blast Theory + The Mixed Reality Lab, 2003)[10] and *Can You See Me Now?* (Blast Theory + The Mixed Reality Lab, 2003), as well as GPS-based audio walks, such as *34 North 118 West* and *Itinerant,* require artists' orchestration and the creation of content so that participants follow their individual trajectories through space. These types of projects fall into the domain of canonical trajectories.

MOBILE ANNOTATION AND USER-GENERATED CONTENT

Other types of location-based experiences, however, rely less on content creation by the artists and more on the participants' ability and creativity in uploading texts, audio, and images to locations. By annotating space, participants not only follow trajectories envisioned by the artists but also create their own trajectories. Raley (chapter 1 in this volume) also points out the distinction between structured audio walks and SMS installations,

like Jaap de Jonge's *Speakers' Corner* (2000–1)[11] and Johannes Gees's *Helloworld Project* (2003),[12] which are based on user-generated content. She points out that in these pieces, "participation is spontaneous, improvisational, and nonchoreographed rather than programmed." Because this act of inscribing physical space with digital information is mostly done via mobile and location-aware devices, Gordon and de Souza e Silva (2011) classified these experiences as mobile annotation. Mobile annotation projects not only allow participants to read urban spaces—as it happens when they access stories left by others—but also enable people to write space, by uploading texts and digital information to specific locations. Raley also highlights that SMS installations use urban spaces as screens, creating an emergent mode of reading and writing particular to mobile media. The difference between these urban screens, however, and mobile annotation pieces is that whereas SMS installations are visualized on screens in public spaces (such as TVs and LCD displays), or use public spaces (facades, mountains) as screens, mobile annotation happens anywhere. Any place with fixed geographic coordinates can be transformed into a location containing location-based texts, which are then visualized on the screens of mobile devices.

Like the early audio walks, the first mobile annotation projects were also created by artists. They did not employ any type of GPS technology to precisely locate users in space. However, unlike audio walks and mixed-reality performances, they were based on the possibility of emergent narratives in public spaces. As such, they focused on participants' trajectories and on their ability to write space by creating content that would be linked to specific places.

For example, *Murmur*, a mobile storytelling project, collected stories about specific places that could be heard through one's cell phone. The project started in Toronto, Canada,[13] and expanded to many cities in the world, including São Paulo, Brazil; Dublin, Ireland; and Geelong, Australia. In each of these cities, a green ear-shaped sign marked the availability of a story. Each sign contained a phone number and a code. When a person stood near the sign, she could call the number, enter the code, and hear a thirty-second to two-minute audio recording telling a story about that place that was left by somebody else.

In a way, *Murmur* stories are like the audio walks discussed

previously. According to the project's website, "some stories suggest that the listener walks around, following a certain path through a place, while others allow a person to wander with both their feet and their gaze." *Murmur* stories motivated people to walk around neighborhoods and pay distinct attention to specific places. As a consequence, the piece changed the way participants moved through the city and influenced how they read city space in particular ways. However, they are different from traditional audio walks in that the stories are not created solely by the artists but also by participants, common city dwellers who happen to know interesting things about particular places. For instance, one of the stories in Toronto began like this:

> It was towards the end of May 1994 and I was walking home towards College Avenue, and it was around three or four in the morning. I think it was a weekday like a Tuesday night. I was just a little bit passed a Laundromat on my right, looking down towards College, and across the street I see a deer run by. I've never actually in my life seen a deer in the wild before.

Through stories like this one, participants annotated space, changing the meaning of places. By listening to these stories, other participants learned about narratives that belonged to those places and could see those places through other people's eyes.

Another similar project was *Yellow Arrow*. Developed by Counts Media, a New York–based gaming company, *Yellow Arrow* was also constructed on the premise of embedding personal stories in places, but this time with text messages. Participants would find a singular place about which they would like to tell a story. They then ordered yellow arrow stickers from the project website, each of which was marked with a single code. Once they placed the sticker somewhere, they could send an SMS to the *Yellow Arrow* number beginning with the arrow's unique code. After that, they could text their messages, which would be connected to that specific code. According to the project's website, "messages range from short poetic fragments to personal stories to game-like prompts to action." When another person encountered the yellow arrow sticker, he could send its code to the *Yellow Arrow* number

and immediately receive the story on his cell phone. An advantage of the coding system was that, once a message was attached to a code, it could be changed as often as the user wished.

ADDING LOCATION AWARENESS TO MOBILE ANNOTATION

Both *Yellow Arrow* and *Murmur* were mobile annotation projects implemented without GPS technology. Therefore, participants could overlay stories onto physical spaces, but to attach information to places, they had to physically stick an arrow to a wall or place an ear-shaped sign on a post. Likewise, to interact with the stories, users needed to make the point to call or text a number. In addition, although the stories were based on specific places, they were not location based per se; that is, if a user would write down the code of a specific place and take it home, she would be able to listen to the story about that place even if she were remote. GPS technology not only automates the way people interact with information in locations but also creates a different spatial relationship to locations. Participants must be in the same location of the information to interact with it. If two users annotate two different locations ten meters apart from each other, a mobile annotation app based on GPS will be able to detect that distance and display different information to each participant, depending on where each stands.

On one hand, interaction with information becomes more passive—users no longer need to actively dial a number or a code but simply need to open the app on their mobile phones or GPS devices—but on the other hand, information and location become intrinsically connected. This connection is also much more dynamic and, paradoxically, ephemeral. It is easier to annotate locations, as it is easier to change and update the information that is connected to that location. Digital information, then, becomes a dynamic element that belongs to locations.

As with the former examples, artists were the first to start experimenting with this intrinsic connection between location and information. And just like the former two examples, they created a context in which participants could create their own stories and overlay them onto physical spaces. The difference with GPS-based projects, however, is that stories are uploaded and retrieved based

on specific latitude–longitude coordinates. Already in 2002, the group Proboscis developed a project called *Urban Tapestries,* which allowed participants to author the environment around them. Proboscis developed a mobile prototype that ran on PDAs and Sony Ericksson cell phones and allowed people to attach images, text, sound, and videos to specific locations.

What's more interesting, the *Urban Tapestries* system was designed to enable participants to create relationships between locations. According to the project's website, "The Urban Tapestries software platform enabled people to build relationships between places and to associate stories, information, pictures, sounds and videos with them." In *Yellow Arrow* and *Murmur,* participants could incite others to move between locations by telling a story that included many different places, associating them with each other. But each story was self-contained because it had a beginning and an end and was not formally linked to any other story. With *Urban Tapestries,* however, the system allowed people to create pockets and threads. Pockets were like self-contained stories but defined by their explicit connection to location. Participants could attach text, sounds, video, and images to specific locations within a granularity of one square meter. Threads were created by the thematic relationship between pockets and locations. The interesting thing about the threads is that they created connections *between* locations. As a consequence, *Urban Tapestries* promoted the development of emergent trajectories through urban spaces.

Blast Theory and The Mixed Reality Lab's *Rider Spoke* works similarly. To experience *Rider Spoke,* participants must cycle through the streets of the city. The bike is equipped with a Nokia N800 tablet, which displays a map of the city and the locations where participants can access and upload information. Participants can either look for stories left by others or can tell their own stories and attach them to specific locations. While they ride, a narrator talks to them through the headphones that come from the mobile device, asking them questions and encouraging them to seek out locations that might have personal meaning. The narrator's voice also prompts riders to reflect on personal issues. An example is the following:

While you think about this I want you to find a place in the city
that your father would like. Once you've found it stop there
and record your message about your father at that moment
in time. (Rowland et al. 2009, 5)

Unlike some of the early audio walks, *Rider Spoke* "does not in-
volve a predefined route. Rather, riders are encouraged to explore
the city freely, choosing locations at which to record and 'hide'
their stories for others to find later on" (Rowland et al. 2009, 5).
Therefore, instead of following a predefined trajectory chosen by
the author of the piece, *Rider Spoke*'s informational landscape is
built by its participants. Each rider contributes to the patchwork
of stories and personal narratives that become intertwined with
the physical landscape of the city. This is important not only for
the construction of a new meaning of locations, now embedded
with location-based information, but also for generating new ways
of writing and reading urban spaces. When looking for stories left
by others in particular locations, participants develop new pat-
terns of mobility through the city. For example, someone might
visit unfamiliar locations in the city because she is looking for
a particular story. Alternatively, a participant might start seeing
familiar locations with unfamiliar eyes because reading a story left
by somebody else will trigger new memories and associations. As a
result, mobility, location, and urban spaces shift with the presence
of location-based texts visualized by location-aware technologies.

Another interesting fact about *Rider Spoke* is that each story
always needs to be attached to a different location, as one single
location cannot contain more than one story. As a consequence,
Rider Spoke contributes to the definition of location, as specific
(and dynamic) information becomes intrinsically attached to one
single combination of latitude and longitude coordinates. It also
contributes to redefining what it means to read urban spaces based
on location-specific information.

Rider Spoke and *Urban Tapestries* highlight another character-
istic of spatial trajectories: the juxtaposition of digital and physical
environments. Both call participants' attention to how physical
space intertwined with location-based information promotes new
ways of moving through the city. Each location, inscribed with

digital information, contributes to the information ecology of urban spaces, and new connections among these locations are forged by the narratives and personal stories users attach to locations.

WHEN LOCATION-BASED NARRATIVES GO INTO THE MAINSTREAM

So far I have been describing location-based experiences that allow people to read and write spaces by either accessing or uploading digital information to locations. All these experiences have one thing in common: they are artistic experiences, developed by a select group of artists experimenting with the relationship between digital information and physical spaces. Although they have a critical role in the history of location-based narratives, in defining how we read and write city spaces today, they were restricted to a small number of participants. Mostly, these experiences were well known among a small group of experts, but the general public was oblivious to their existence. Additionally, even if one was indeed aware of these experiments, actively participating in them required one to be in the right city, at the right time, when one of these perfomances or prototypes was being tested.

This scenario began to change around 2008, with the popularization of smart phones such as the Apple iPhone and the Verizon Droid. Although cell phones have always been location aware (because their location could be retrieved by triangulation of waves), up to that point, GPS-enabled cell phones constituted a very small portion of the market. Four main factors contributed to the increased public access of mobile annotation applications. First, the preciseness of GPS technology. Contrary to GPS, triangulation of waves is very imprecise for locating people and things in space. Second, today's smart phones are more than talking and texting devices. They are able to run applications that take advantage of GPS technology, interfacing user and location. Third, these applications can be developed by anyone with programming skills, not only cell phone providers or a specialized group of artists and computer scientists. Finally, mobile applications are available to the general public, downloadable by anyone who owns a smart phone.

Among the myriad new applications now available for smart

phones, some are a direct legacy from early mobile annotation projects. Normally, location-based social networking applications, such as Foursquare and Yelp, let users annotate space, leaving tips and comments about locations. For example, a cupcake store in Raleigh has the following tip attached to it: "Just stopped by there for the 1st time today. .got the cookie monster, chocolate truffle and the mocha. .can't wait to try them!" Other Foursquare users are able to read this tip via their cell phones when they go to the cupcake store. Although these tips clearly inscribe public spaces with digital information and allow people to read and write locations in particular ways, they do not necessarily promote the development of narratives about the city, nor do they forcefully connect locations.

However, other apps have been primarily created as storytelling authoring systems. Now, artists are no longer solely responsible for creating the context for an experience, nor are users restricted to merely uploading stories. Users are able to develop a framework that can be used to inscribe a diversity of stories and narratives on urban spaces. An example is 7Scenes. Developed by the Waag-Society in the Netherlands, 7Scenes's slogan is "connect your story to the city!" (Waag-Society 2007). The authoring system provides a platform that allows developers to create scenes; that is, they can easily drag and drop information (text, video, audio) onto a location on a map. This location can be connected to other locations. Quizzes and questions can be part of a scene, as they allow participants to interact with the information inscribed in that location. Once participants load the 7Scenes app on their cell phones and get physically close to a scene, their positions trigger whatever information is attached to those locations. A difference from former mobile annotation projects is that apps like 7Scenes allow people to interact with locations by solving puzzles, playing games, and answering riddles rather than just listening to stories. The 7Scenes app can also be used to create audio walks, multiplayer location-based games, guided tours, and educational games.

An app like 7Scenes challenges García Canclini's (2001) assumption presented at the beginning of this chapter that cities refuse narrative form. It is true that the fragmentation of

contemporary metropolises is visible in the mixture of architectural styles from different time periods, the multiculturalism of various neighborhoods, and diverse socioeconomic areas growing side by side. However, mobility through urban spaces acquires a different kind of structure and coherence when people are able to create their own location-based narratives and embed them in multiple locations. For example, 7Scenes's website suggests that common users can use the app to share with friends stories of their lives and memories associated with specific places in a city. Friends would then read space by following a narrative created by somebody else. The narrative forcefully connects locations that could have been previously disconnected from the friends' perspective. Apps like 7Scenes have implications not only for mobility in the city but also for education and entertainment. Games Atelier, for instance, is a learning tool built on the 7Scenes platform that allows high school students to create their own location-based games. The underlying assumption is that students learn better when the learning experience is contextual and when it ties narratives to locations (de Souza e Silva and Delacruz 2006).

Another example of a location-based storytelling authoring tool is SCVNGR (2011). SCVNGR presents itself as a location-based game authoring tool that allows users to complete challenges in particular locations. It is similar to a location-based social network, such as Foursquare, in that users can check in to different locations, gather points, receive badges, see where friends are, and share the adventures of playing the game with friends through Facebook and Twitter. However, SCVNGR can also be used creatively to build location-based narratives because it has some additional features, such as challenges, treks, and rewards. A challenge includes any kind of activity performed in a specific location, such as taking pictures, uploading text, answering a multiple-choice question, or scanning a QR code. Challenges resemble *Urban Tapestries* pockets in that they connect digital information to a specific location. The difference is that in SCVNGR, the information is generally interactive; that is, users are prompted to do something at each location. SCVNGR's treks are similar to *Urban Tapestries*'s threads: they connect several challenges and prompt participants to go from location to location, moving through urban spaces in particular

ways. Finally, rewards, such as free items and discounts in stores, are received after users complete challenges and earn points.

A very innovative use of SCVNGR was developed by two master students at the IT University of Copenhagen, Louise McHenry and Marlene Ahrens. In conjunction with the National Museum in Copenhagen, Denmark, they used the platform to create a location-based narrative in which participants played the role of a detective investigating the theft of the golden horns, a relic in Danish history. The golden horns were two Viking artifacts from the fifth century. They were found by chance in the seventeenth and eighteenth century, respectively, and were later on displayed in the National Museum. However, in 1802, a goldsmith stole the horns and melted them into coins, jewelry, and gold pieces. The narrative created by McHenry and Ahrens transformed participants into the main character of a story whose objective was to find the location of the gold horns' thief. While trying to complete the main challenge, the fictitious narrative took participants through several different historical locations in downtown Copenhagen, following a trek. At each location, participants had to listen to an audio file with information about the development of the story. They could also access a bonus audio file containing historical information about that period in the history of the city. After learning about the whereabouts of the thief, participants had to complete challenges, such as "look for the eldest door in this street and take a picture of the door number." Correctly completing the challenge gave participants further information about the theft and the thief's interactions with other characters in the story. By experiencing the narrative, participants not only learned about a very important (and often unknown) fact about Danish history but also learned about the history of the city of Copenhagen, visiting the actual locations where the story unfolded in the past.

LOCATION-BASED NARRATIVES AND THE MEANING OF LOCATION

Applications such as SCVNGR and 7Scenes not only allow users to read and write urban spaces but also to connect locations by following narratives that are overlaid onto public spaces. When information is attached to locations, urban spaces become a sort

of palimpsest, containing many layers of texts and different layers of meanings. As we have seen with the examples of 7Scenes and SCVNGR, Foursquare and Yelp, an increasing number of applications allow users to read and write space, attaching their own narratives and personal stories to locations. Depending on the application used, people are able to access different types of information attached to the same location. According to de Souza e Silva and Frith (2012, 181), "each location-based text does not erase the previous one, but contributes to generate new textualities and interaction in public spaces." For example, somebody looking for a restaurant in the vicinity who opens Yelp will see nearby restaurants plotted on a map and will be able to access customer reviews about these restaurants. If the same user opens the "Explore" function in Foursquare, and clicks on "food," he will see a different set of restaurants, containing a different set of tips and reviews, because Foursquare and Yelp draw from different databases. Different people will write reviews for Foursquare and Yelp, and different people will read them. A restaurant with an excellent review in Yelp will attract Yelp users, whereas the same restaurant with a bad review in Foursquare will likely have no Foursquare users. As a result, location-based texts not only add to the meaning of locations but also influence how people move in city spaces and the places they visit.

The awareness that now locations are increasingly composed of digital information is an intrinsic component of net locality (Gordon and de Souza e Silva 2011). This shift has implications not only for how we experience city spaces but also for how we will experience narratives in the future—as texts that have latitude and longitude coordinates and that help us navigate urban spaces and learn new things about the hybrid spaces we inhabit. A necessary implication of the increasing availability of location-based narratives, and the ability to inscribe urban spaces with location-based information, is a change in the meaning of location. Location has often been subordinated to place: it has been conceptualized as an aspect of a place, deprived of meaning (Agnew 1987; Cresswell 2004; Harvey 1996; Tuan 1977). However, locations now acquire dynamic meanings as a consequence of the constantly changing location-based information that is attached to them (de Souza e

Silva and Frith 2012). As a result, finding a location no longer means only finding geographic coordinates but also accessing an abundance of digital information that belongs to that location. It means engaging with digital information and experiencing new forms of mobilities and textualities.

NOTES

1 I consider a smart phone any mobile phone with an operational system capable of running applications, able to connect to the Internet, and with location awareness owing to the use of GPS, Wi-Fi, and triangulation of waves.
2 http://murmurvancouver.ca/about.php.
3 http://yellowarrow.net/v3/.
4 http://urbantapestries.net/.
5 http://www.blasttheory.co.uk/bt/work_rider_spoke.html.
6 http://www.foursquare.com/.
7 There have been prior experiences of guided tours in public spaces, with the aim of drawing participants' attention to the sounds of the urban landscape. Max Neuhaus's series of walks between 1966 and 1976 took participants around the city so that they could listen to live urban sounds (Butler 2007). Cardiff's work, however, overlays a prerecorded sound onto physical space.
8 http://www.cardiffmiller.com/artworks/walks/forest.html.
9 http://www.turbulence.org/Works/itinerant/index.htm.
10 http://www.blasttheory.co.uk/bt/work_uncleroy.html.
11 http://www.jaapdejonge.nl/portfolio/opdrachten/speak.html.
12 http://johannesgees.com/?p=142.
13 http://murmurtoronto.ca/place.php?232626.

REFERENCES

Agnew, John A. 1987. *Place and Politics: The Geographical Mediation of State and Society.* Boston: Allen and Unwin.
Benford, Steve, and Gabriella Giannachi. 2011. *Performing Mixed Reality.* Cambridge, Mass.: MIT Press.
Benford, Steve, Gabriella Giannachi, Boriana Koleva, and Tom Rodden. 2009. "From Interaction to Trajectories: Designing Coherent Journeys

through User Experiences." In *Proceedings of the 27th International Conference on Human Factors in Computing Systems*, 709–18. Boston: ACM.

Butler, Toby. 2007. "Memoryscape: How Audio Walks Can Deepen Our Sense of Place by Integrating Art, Oral History, and Cultural Geography." *Geography Compass* 1, no. 3: 360–72. doi:10.1111/j.1749-8198.2007.00017.x.

Cresswell, Tim. 2004. *Place: A Short Introduction*. Malden, Mass.: Blackwell.

de Souza e Silva, Adriana. 2006. "From Cyber to Hybrid: Mobile Technologies as Interfaces of Hybrid Spaces." *Space and Culture 9*, no. 3: 261–78.

de Souza e Silva, Adriana, and Girlie Delacruz. 2006. "Hybrid Reality Games Reframed: Potential Uses in Educational Contexts." *Games and Culture 1*, no. 3: 231–51.

de Souza e Silva, Adriana, and Jordan Frith. 2012. *Mobile Interfaces in Public Spaces: Locational Privacy, Control, and Urban Sociability*. New York: Routledge.

García Canclini, Néstor. 2001. *Consumers and Citizens: Globalization and Multicultural Conflicts*. Minneapolis: University of Minnesota Press.

Gordon, Eric, and Adriana de Souza e Silva. 2011. *Net Locality: Why Location Matters in a Networked World*. Boston: Blackwell.

Harvey, D. 1996. *Justice, Nature, and the Geography of Difference*. Cambridge, Mass.: Blackwell.

Hayles, N. Katherine. 2002. *Writing Machines*. Cambridge, Mass.: MIT Press.

Rowland, Duncan, Martin Flintham, Leif Oppermann, Joe Marshall, Alan Chamberlain, Boriana Koleva, Steve Benford, and Citlali Perez. 2009. "Ubikequitous Computing: Designing Interactive Experiences for Cyclists." Paper presented at MobileHCI'09: The 11th International Conference on Human–Computer Interaction with Mobile Devices and Services, New York.

SCVNGR. 2011. SCVNGR [software]. http://www.scvngr.com/.

Tuan, Yi-fu. 1977. *Space and Place: The Perspective of Experience*. Minneapolis: University of Minnesota Press.

Waag-Society. 2007. 7Scenes [software]. http://7scenes.com/.

3

The .txtual Condition

Matthew G. Kirschenbaum

IN APRIL 2011, scholars were buzzing with the news of Ken Price's discovery of thousands of new papers written in Walt Whitman's own hand at the National Archives of the United States. Price, a distinguished University of Nebraska literature professor and founding coeditor of the digital Walt Whitman Archive, had followed a hunch and gone to the Archives II campus in College Park looking for federal government documents—red tape, essentially—that might have been produced by the Good Gray Poet during Whitman's tenure in Washington, D.C., as one of those much-maligned federal bureaucrats during the tumultuous years 1863–73. Price's instincts were correct: he has to date located and identified some three thousand official documents penned by Whitman and believes there are still more to come. One point to make in passing is that the boundaries between digital and analog scholarship have already been warped beyond recognition, with the texts destined to be digitized and added to the online collections at the Whitman site—is this a harbinger of comparative textual media, then, or is it merely what good scholarship looks like in the twenty-first century? Yet the documents have value not just or perhaps not even primarily prima facie. Rather, collectively, they constitute what Friedrich Kittler once called a discourse network, a way of aligning or rectifying (think maps) Whitman's activities in other domains through correlation with the carefully dated entries in the official records. "We can now pinpoint to the exact day when he was thinking about certain issues," Price is quoted as saying in the *Chronicle of Higher Education* (Howard 2011a).

Put another way, the official government documents written in Whitman's hand are important to us not just as data but as metadata. They are a reminder that the human lifeworld all around us

bears the ineluctable marks and traces of our passing, mundane more often than not, and that these marks and tracings often take the form of written and inscribed documents, some of which survive, some of which do not, some of which are displayed through glass in helium- and water vapor–filled cases, and some of which lie forgotten in archives, or under our beds, or beneath the end papers of other books. Today such documents are as likely to be digital, or more precisely *born-digital*, as they are physical artifacts.

The category of the born-digital, I will argue, is an essential one for comparative textual media. In 1995, in the midst of the first widespread wave of digitization, the Modern Language Association saw fit to issue a "Statement on the Significance of Primary Records" to assert the importance of retaining physical artifacts for evidentiary purposes even after they have been microfilmed or scanned for general access. "A primary record," the MLA told us, "can appropriately be defined as a physical object produced or used at the particular past time that one is concerned with in a given instance" (27). The situation in which we find ourselves today is one, simply put, where the conceit of a "primary record" can no longer be assumed to be coterminous with that of a "physical object." Electronic texts, files, feeds, and transmissions of all sorts are also now, indisputably, primary records (for proof, one need look no further than recent Twitter hashtags such as #Egypt or #Japan). In the arena of literature and literary studies, a writer working today will not and cannot be studied in the future in the same way as writers of the past because the basic material evidence of their authorial activity—manuscripts and drafts, working notes, correspondence, journals—is, like all textual production, increasingly migrating to the electronic realm. Indeed, as I was finishing revisions to this essay, the British Library opened its J. G. Ballard papers for public access; it is, as one commentator opines, likely to be "the last solely non-digital literary archive of this stature," since Ballard never owned a computer (Hall 2011). Consider by contrast Oprah enfant terrible Jonathan Franzen, who, according to *Time* magazine, writes with a "heavy, obsolete Dell laptop from which he has scoured any trace of hearts and solitaire, down to the level of the operating system" (Grossman 2010). Someday an archivist may have to contend with this rough beast, along with

Franzen's other computers and hard drives and USB sticks and floppy diskettes in shoeboxes.

In fact, a number of significant writers already have material in major archives in born-digital form. The list of notables includes Norman Mailer, John Updike, Alice Walker, Jonathan Larson (composer of *RENT*), and others. The most compelling example to date is the groundbreaking work that's been done at Emory University Library, which has four of Salman Rushdie's personal computers in its collection, among the rest of his papers. One of these, his first, a Macintosh Performa, is currently available as a complete virtual emulation on a dedicated workstation in the reading room. Patrons can browse Rushdie's desktop file system, seeing, for example, which documents he stored together in the same folder; they can examine born-digital manuscripts for *Midnight's Children* and other works; they can even take a look at the games on the machine (yes, Rushdie is a gamer—as his most recent work in *Luka and the Fire of Life* confirms). Other writers, however, have been more hesitant. Science fiction pioneer Bruce Sterling, not exactly a luddite, recently turned over fifteen boxes of personal papers and cyberpunk memorabilia to the Harry Ransom Center at the University of Texas at Austin but flatly refused requests to consider giving over any of his electronic records, despite the fact that the Ransom Center is among the places leading the way in curating digital collections. "I've never believed in the stability of electronic archives, so I really haven't committed to that stuff," he's quoted as saying (Howard 2011b).

We don't really know, then, to what extent discoveries on the order of Ken Price's will remain possible with the large-scale migration to electronic documents and records. The obstacles are not only technical but also legalistic and societal. The desktop Windows environment, our universal platform for all manner of media production, makes it increasingly difficult to distinguish between such sacrosanct categories as literature and other forms of multimodal composition and expression, sometimes now as concentrated and contained as thumbing the "Like" button on a social networking site. For its part, Sterling's brand of technofatalism is widespread, and it is not difficult to find jeremiads warning of the coming of the digital dark ages, with vast swaths of the

human record obliterated by obsolescent media. And physical media like hard drives and floppy disks are actually easy in the sense that at least an archivist has hands-on access to the original source. The accelerating shift to Web 2.0–based services and so-called cloud computing means that much of our data now reside in undisclosed locations inside the enclaves of corporate server farms. Typical users today have multiple network identities, some mutually associating and some not, some anonymous and some not, some secret and some not, all collectively distributed across dozens of different sites and services, each with its own sometimes mutually exclusive and competing end user license agreements and terms of service, each with its own set of provisions for rights ownership and transfer of assets to next of kin, each with its own separate dependencies on corporate stability and commitments to maintaining a given service or site. Indeed, for many now, this born-digital footprint begins literally in utero, with an ultrasound JPEG passed from Facebook or Flickr to soon be augmented by vastly more voluminous digital representations as online identity grows, matures, proliferates, and becomes a lifelong asset, not unlike financial credit or Social Security, and perhaps one day destined for Legacy Locker or similar digital afterlife data curation services now becoming popular.

For several years, I've argued this context has become equally essential for thinking about textual scholarship and literary studies, especially if it is to engage the objects and artifacts of its own contemporary moment—the .txtual condition of my title. In this essay, I will use the example of the Maryland Institute for Technology in the Humanities (MITH) at the University of Maryland as a means of illustrating the kinds of resources and expertise a working digital humanities center can bring to the table when confronted head-on with the challenges of receiving the kind of hybrid textual media collection that is representative of what scholars will be reading and traditional manuscript repositories will be receiving. Comparative textual media demand not only new theoretical articulations but also new institutional configurations and allocations of praxis. MITH's engagement with the born-digital literary archives of several early experimental authors is instructive in this regard.

DERRIDA (1995, 90) DIAGNOSED the contemporary fixation on the archive as a malady, an "archive fever": "Nothing is less reliable, nothing is less clear today than the word 'archive,'" he tells us. In one sense, this is indisputable: recent archival thinkers and practitioners, such as Terry Cook, Heather MacNeil, Brien Brothman, and Carolyn Heald, have all (as John Ridener [2009] has shown) laid stress on core archival concepts, including appraisal, original order, and the authority of the record. At the same time, however, the definition of archives has been codified to an unprecedented degree as a formal model or ontology, expressed and embodied in the Open Archival Information System, a product of the Consultative Committee for Space Data Systems adopted as ISO Standard 14721 in the year 2002. The OAIS is the canonical authority for modeling workflows around ingestion, processing, and provision of access in an archive; it establishes, at the level of both people and systems, what any archive must do to act as a guarantor of authenticity (Consultative Committee for Space Data Systems 2002):

> The reference model addresses a full range of archival information preservation functions including ingest, archival storage, data management, access, and dissemination. It also addresses the migration of digital information to new media and forms, the data models used to represent the information, the role of software in information preservation, and the exchange of digital information among archives. It identifies both internal and external interfaces to the archive functions, and it identifies a number of high-level services at these interfaces. It provides various illustrative examples and some "best practice" recommendations. It defines a minimal set of responsibilities for an archive to be called an OAIS, and it also defines a maximal archive to provide a broad set of useful terms and concepts.

The contrast between the fixity of the concept of archives captured in the OAIS reference model and the fluid nature of its popular usage is likewise manifest in the migration of *archive* from noun to verb. The verb form of *archive* is largely a twentieth-century construction, due in no small measure to the influence of computers

and information technology. To archive in the realm of computation originally meant to take something offline, to relegate it to media that are not accessible or indexical via random access storage. It has come to do double duty with the act of *copying*, so archiving is coterminous with duplication and redundancy. In the arena of digital networking, an archive came to connote a mirror or reflector site, emulating content at remote hosts to reduce the physical distance information packets had to travel. To function as a reliable element of network architecture, however, the content at each archive site must be guaranteed as identical. This notion of the archive as mirror finds its most fully developed expression in the initiative now known as LOCKSS, or Lots of Copies Keeps Stuff Safe.

The idea of archiving something digitally is thus an ambiguous proposition, not only or primarily because of the putative instability of the medium but also because of fundamentally different understandings of what archiving actually entails. Digital memory is, as the German media theorist Wolfgang Ernst (2002) has it in his brilliant reading of archives as "agencies of cultural feedback," a simulation and "semantic archaism." "What we call memory," he continues, "is nothing but information scattered on hard or floppy disks, waiting to be activated and recollected into the system of data processing" (109). In the digital realm, then, there is a real sense, a *material* sense, in which archive can only ever *be* a verb, marking the latent potential for reconstitution.

This palpable sense of difference with regard to the digital has given rise to a series of discourses that struggle to articulate its paradoxical distance and disconnect with the ultimately unavoidable truth that nothing in this world is ever truly immaterial. Collectively, they offer a kind of program for what this volume explicitly names comparative textual media. Nick Montfort and Ian Bogost have promoted "platform studies" as a rubric for attention to the physical constraints embodied in the hardware technologies that support computation; in Europe and the United Kingdom, media archaeology (of which Ernst is one kind of exemplar) has emerged as the heir to the first-wave German media theory pioneered by Friedrich Kittler; Bill Brown, meanwhile, has given us thing theory; N. Katherine Hayles has given us media-specific analysis; Wendy Chun favors the conceit of the "enduring ephemeral"; I myself

have suggested the dualism of forensic and formal materiality; and I have seen references in the critical literature to continuous materiality, vital materiality, and liminal materiality as well. All these notions find particular resonance in the realm of archives, because an archive acts as a focalizer for, as Bill Brown might put it, the thingness of things, that is, the artifactual aura that attends even the most commonplace objects (the radical reorientation of subjectivity and objectivity implicit in this worldview is the ground taken up by the rapidly rising conversation in object-oriented philosophy, from the new materialism of political science thinkers like Diana Coole and Samantha Frost to Ian Bogost's call for an alien phenomenology).

Clearly, then, questions about materiality are once again at the center of a vibrant interdisciplinary conversation, driven in no small measure by the obvious sense in which digital objects can, indeed, function as a "primary record" (in the MLA's parlance), forcing a confrontation between our established notions of authority and authenticity and the unique ontologies of data, networks, and computation. Abby Smith (1998) puts it this way:

> When all data are recorded as 0's and 1's, there is, essentially, no object that exists outside of the act of retrieval. The demand for access creates the "object," that is, the act of retrieval precipitates the temporary reassembling of 0's and 1's into a meaningful sequence that can be decoded by software and hardware. A digital art-exhibition catalog, digital comic books, or digital pornography all present themselves as the same, all are literally indistinguishable one from another during the storage, unlike, say, a book on a shelf.

The OAIS reference model handles this Borgesian logic paradox through a concept known as *representation information,* which means that it is incumbent on the archivist to document all of the systems and software required to re-create or reconstitute a digital object at some future point in time. "In order to preserve a digital object," writes Kenneth Thibodeau (2002), director of electronic records programs at the National Archives and Records Administration, "we must be able to identify and retrieve all its digital

components." Here I want to go a step further and suggest that the preservation of digital objects is *logically inseparable* from the act of their creation—the cycle between creation and preservation effectively collapses because a digital object may only ever be said to be preserved *if* it is accessible, and each individual access creates the object anew. Media, as so many before me have said, matter. Just as a critic such as Jerome McGann (2006) argues that no two texts are ever inherently self-identical—even should their linguistic content happen to match—computational paradigms literalize the performative dramas of access and opening that constitute our entry points into the discourse network. Though the bitstream may indeed be identical—indeed, mathematically verifying it as such is trivial—a file stored on a USB stick and opened via an emulator on my contemporary laptop desktop is not the same as the bits reconstituted by a magnetic read-head from a spinning disk.

One can, in a very literal sense, *never* access the "same" electronic file twice, because each and every access constitutes a distinct instance of the file that will be addressed and stored in a unique location in computer memory. In the terms I put forth in *Mechanisms,* each access engenders a new logical entity that is forensically individuated at the level of its physical representation. Access is thus duplication, duplication is preservation, and preservation is creation and re-creation. This is the catechism of the .txtual condition.

If only it were that simple.

IN MAY 2007, MITH acquired a substantial collection of computer hardware, storage media, manuscripts, and memorabilia from the author, editor, and educator Deena Larsen. MITH is not an archive in any proper sense: it is a working digital humanities center, with a focus on research, technical innovation, and supporting new modes of scholarship. While this poses certain challenges in terms of our responsibilities to the Larsen Collection, there are also some unique opportunities. Without suggesting that digital humanities centers summarily assume the functions of archives, I want to describe some of the ways in which MITH was positioned to embrace the challenges of receiving a large, complex assemblage of born-digital materials; how the availability of these materials

has served a digital humanities research agenda; and how that research agenda in turn is creating new models for the steward-ship of such a collection.

Deena Larsen (b. 1964) has been an active member of the creative electronic writing community since the mid-1980s. She has published two pieces of highly regarded hypertext fiction with Eastgate Systems, *Marble Springs* (1993) and *Samplers* (1997), as well as additional pieces on the web. A federal employee, she lives in Denver and is a frequent attendee at the annual Association for Computing Machinery (ACM) Hypertext conference, the meetings of the Electronic Literature Organization (where she has served on the board of directors), and kindred venues. Crucially, Larsen is also what we might think of nowadays as a "community orga-nizer"; that is, she has an extensive network of correspondents, regularly reads drafts and work in progress for other writers, and is the architect of some landmark events, chief among them the CyberMountain workshop held outside Denver in 1999. As she herself writes (Larsen 2009),

> These gatherings were more to acknowledge each other's work and to encourage writers to soldier on, to continue explorations and intrigue than to create an orderly community. I conducted writers workshops at these conferences and even online. We worked together to develop critiques—but more importantly methods of critiques—of hypertext, as well as collections of schools of epoetry, lists and groups. And thus I have been lucky enough to receive and view texts in their infancy—during the days when we thought floppy disks would live forever. And thus I amassed this chaotic, and perhaps misinformed treasure trove that I could bequeath to those interested in finding the Old West goldmines of the early internet days.

What this means for the collection at MITH is that, in addition to her own writing and creative output, Larsen also possessed a broad array of material by other electronic literature authors, some of it unpublished, unavailable, or believed otherwise lost, effectively making her collection a cross section of the electronic writing com-munity during its key formative years (roughly 1985–2000). The

files contain multiple versions of nationally recognized poet William Dickey's electronic works, Dickey's student work, nationally recognized poet Stephanie Strickland's works, M. D. Coverley's works, Kathryn Cramer's works, *If Monks Had Macs*, the *Black Mark* (a hypercard stack developed at the 1993 ACM Hypertext conference), *Izme Pass*, Chris Willerton's works, Mikael And's works (the author himself no longer has copies), Jim Rosenburg's works, Michael Joyce and Carolyn Guyer's works that were in progress, Stuart Moulthrop's works, George Landow's works and working notes, textual games from Nick Monfort, *Coloring the Sky* (a collaborative work from Brown in 1992–94), and Tom Trelogan's logic game. Most of these are on three-and-a-half-inch diskettes (over eight hundred of them) or CD-ROMS. The collection also includes a small number of Zip disks and even some audiovisual media such as VHS tapes and dictation cassettes. The hardware at present consists of about a dozen Macintosh Classics, an SE, and a Mac Plus (these were all machines that Deena used to install instances of her *Marble Springs*) as well as a Powerbook laptop. All of this is augmented by a nontrivial amount of more traditional archival materials, including manuscripts, newspaper clippings, books, comics, manuals, notebooks, syllabi, catalogs, brochures, posters, conference proceedings, ephemera, and yes, even a shower curtain (Figure 3.1).

Some readers may wonder what led Larsen to MITH, as opposed to a more conventional archival repository. The circumstances are particularized and not necessarily easily duplicated, even if that were desirable. First, Deena Larsen and I had a working relationship; we had met some years ago on the conference circuit, and I had corresponded with her about her work (still unfinished) editing William Dickey's HyperCard poetry. MITH was also, at the time, the institutional home of the Electronic Literature Organization (ELO), and our support for ELO signaled our interest in engaging contemporary creative forms of digital production as well as the more traditional cultural heritage that is the mainstay of digital humanities activities. The ELO, for its part, had also raised questions about the long-term preservation and accessibility of the work of its membership. At a University of California, Los Angeles conference in 2001, N. Katherine Hayles had challenged writers,

FIGURE 3.1. The Marble Springs shower curtain from the Deena Larsen Collection at MITH, University of Maryland. Image by Amanda Visconti.

scholars, and technologists to acknowledge the contradictions of canon formation and curriculum development, to say nothing of more casual readership, in a body of literature that is obsolescing with each new operating system and software release. The ELO responded with an initiative known as PAD, which produced two key public deliverables: a widely disseminated pamphlet titled *Acid-Free Bits,* which furnished writers with practical steps to begin ensuring the longevity of their work, and a longer, more technical and ambitious white paper, "Born Again Bits," which outlined a theoretical and methodological paradigm based on XML schema and a "variable media" approach to the representation and reimplementation of electronic literary works. Given ELO's residency at MITH, and MITH's own emerging research agenda in these areas (in addition to the ELO work, the Preserving Virtual Worlds project had just begun), Larsen concluded that MITH was well positioned to assume custody of her collection.

From MITH's perspective, the Deena Larsen Collection was an excellent fit with our mission and sense of purpose as a digital

humanities center. As noted earlier, MITH is actively interested in contemporary cultural production, what is sometimes referred to as new media, in addition to the digital humanities. Likewise, our emerging research agendas in digital preservation mitigated in favor of taking possession of a collection in-house, one that could function as a test bed and teaching resource. Our relationship with the University of Maryland's Information School, which includes an archives program, further encouraged us in this regard. Finally, and most frankly, MITH was also positioned to operate free of some of the limitations and constraints that a library special collections would face if it were to acquire the same material. There are no deadlines with regard to processing the collection, nor is it competing with other processing tasks. We were free to create our own workflows and milestones. While we took possession of the collection with every good intention, we were careful to make no guarantees as far as recovering data from obsolescent media goes or with regard to the provision of researcher access to that data.

Once a deed of gift had been secured, our initial efforts with the collection consisted of what an archivist would term arrangement and description, eventually resulting in a pair of Excel spreadsheets that function as finding aids. No effort was made to respect the original order of the materials, an archival donnée that makes sense for the records of a large organization but seemed of little relevance for an idiosyncratic body of materials we knew to have been assembled and packed in haste. Several things about the collection immediately became apparent. First and most obviously, it was a hybrid entity: both digital and analog materials coexisted, the digital files themselves were stored on different kinds of media and exhibited a multiplicity of different formats, and most important of all, the digital and analog materials manifested a complex skein of relationships and dependencies. Second, as noted earlier, the collection was not solely the *fonds* of Deena Larsen herself; it includes numerous works by other individuals as well as third-party products, such as software, some of it licensed, some of it not, some of it freeware, abandonware, and grayware. (This alone would likely have proved prohibitive had special collections here on campus sought to acquire this material. While the deed of gift makes no warrant as to copyright, the provisions of the Digital

Millennium Copyright Act raise questions about the legality of transferring software without appropriate licensing, a contradiction that becomes a paralyzing constraint when dealing with a large, largely obsolesced collection such as this.) The Larsen Collection is thus a *social* collection, not a single author's papers. Finally, of course, the nature of the material is itself highly ambitious, experimental, and avant-garde. Larsen and the other writers in her circle used software that was outside of the mainstream, and indeed, sometimes they invented their own software and tools; their works often acknowledge and include the interface and hardware as integral elements, thus making it difficult to conceive of a satisfactory preservation program based on migration alone, and much of what they did sought to push the boundaries of the medium and raise questions about memory, representation, and archiving in overtly self-reflexive ways.

None of this, I hasten to add, is new or unique to the Deena Larsen Collection in and of itself. All archival collections are "hybrid" and "social" to greater or lesser degrees, and all of them present challenges with regard to their materiality and their own status as records. But the Larsen Collection dramatizes and foregrounds these considerations in ways that other collections perhaps do not and thus provides a vehicle for their hands-on exploration in a setting (MITH) that is sequestered from many of the constraints of an established archives. Collectively, we believe these activities are helping to limn the contemporary material foundations of the literary. Bill Bly, a colleague of Deena's who was visiting MITH earlier this year, in conversation with me, spoke unabashedly about the joy he felt firing up his old hardware for the first time in many years, the dimensions and scale of his real-world surroundings instantly realigning themselves to the nine-inch monochrome display of his Mac Classic screen, their once familiar focalizer. The .txtual condition: not merely lip service to the materiality of the digital but a way of capturing full-bodied haptic, even proprioceptive relations to our newest textual media. The disorientation, the *impression,* of the archive.

WOLFGANG ERNST, quoted earlier, has emerged as one of the more provocative figures in the loose affiliation of thinkers self-

identifying with media archaeology. As Jussi Parikka (2011) has documented, for Ernst, media archaeology is not merely the excavation of neglected or obscure bits of the technological past; it is a methodology that assumes the primacy of machine actors as autonomous agents of representation. Or in Ernst's own words, rather more lyrically, "media archaeology is both a *method and aesthetics* of practicing media criticism . . . an awareness of moments when media themselves, not exclusively human any more, become active 'archaeologists' of knowledge" (239; emphasis added). What Ernst is getting at is a semiotic broadening beyond writing in the literary symbolic sense to something more like inscription and what Parikka characterizes as "a materialism of processes, flows, and signals" and the flattening of all data as traces inscribed on a recording medium, which Ernst dubs "archaeography," the archive writing itself. What separates digital media and practices of digital archiving radically from the spatial organization of the conventional archive (embodied as physical repository) is the so-called time criticality of digital media, the inescapable temporality that accounts for observations, such as Duranti's (2010), about the errant ontology of digital documents. Indeed, though the chronological scope of the Larsen Collection is easily circumscribed, it resists our instinct toward a linear temporal trajectory. On one hand, the avant-garde nature of the material is such that traditional procedures of appraisal, arrangement and description, and access must be challenged and sometimes even overruled. On the other hand, however, the media and data objects that constitute the born-digital elements of the collection are themselves obsolescing at a rapid rate. This ongoing oscillation between obsolescence and novelty, which manifests itself constantly in the workflows and routines we are evolving, is characteristic of the .txtual condition as I have come to understand it; as Wolfgang Ernst (2011, 241) puts it, "'historic' media objects are radically present when they still function, even if their outside world has vanished."

Although the OAIS never specifically stipulates it, the assumption is that Representation Information must ultimately take the form of human-readable text. The Reference Model does incorporate the idea of a "Knowledge Base" and offers the example that "a person who has a Knowledge Base that includes an

THE .TXTUAL CONDITION 67

understanding of English will be able to read, and understand, an English text" (Consultative Committee for Space Data Systems 2002, 2–3). Lacking such a Knowledge Base, the model goes on to suggest, Representation Information would also have to include an English dictionary and grammar. What we have here is what I would describe as a modularized epistemological positivism, one that assumes that a given chain of symbolic signification will ultimately (and consistently) resolve to a stable referent. Thus one might appropriately document a simple text file by including a pointer to a reference copy of the complete ASCII standard, the supposition being that a future member of the designated user community will then be able to identify the bitstream as a representation of ASCII character data and apply an appropriate software decoder. Yet Ernst's archaeography is about precisely displacing human-legible inscriptions as the ultimate arbiters of signification. The examples he gives, which are clearly reminiscent of Friedrich Kittler's writings on the technologies of modernity, include ambient noise in wax cylinder recordings and random details on the photographic negative, for instance (and this is my example, not Ernst's), in the 1966 film *Blow-Up*, where an image is placed under extreme magnification to reveal a detail that divulges the identity of a murderer. Nonetheless, the implications for "literature" and "the literary" amid a landscape of comparative textual media are obvious. For Ernst, all of these semiotic events are flattened by their ontological status as data or a signal to be processed by digital decoding technologies that makes no distinction between, say, a human voice and a background noise. In this way, "history" becomes a form of media, and the writing of the literary—its alphabetic semantics—is replaced by signal flows capturing the full spectrum of sensory input.

What becomes dubious from the standpoint of archival practice—affixing the OAIS concept of Representation Information to actual hardware and devices—thus becomes a legitimate mode of media archaeology after Ernst, and indeed, Ernst has enacted his approach in the archaeological media lab at the Institute of Media Studies in Berlin, where "old machines are received, repaired, and made operational" (Parikka 2011, 64). As Parikka puts it, "the difference from museum-displayed technologies becomes evident

with the task of the media archeologist becoming less a textual interpreter and a historian, and more an engineer and specialist in wiring and diagrammatics of circuits" (64). A similar approach has been adopted by Lori Emerson at the University of Colorado at Boulder: "The Archeological Media Lab... is propelled equally by the need to maintain access to early works of electronic literature... and by the need to archive and maintain the computers these works were created on." Thus the Deena Larsen Collection, housed within a digital humanities center, begins to take its place in a constellation of media archaeological practices that take their cues from both the professionalized vocation of archival practice and the theoretical precepts of media archaeology.

Media archaeology, which is by no means co-identical with the writings and positions of Ernst, offers one set of critical tools for coming to terms with the .txtual condition as well as articulating a program of comparative textual media. Another, of course, is to be found in the methods and theoretical explorations of textual scholarship, the discipline from which McGann launched his ongoing program to revitalize literary studies by restoring to it a sense of its roots in philological and archival forms of inquiry. As I've argued at length elsewhere, the field that offers the most immediate analog to bibliography and textual criticism in the electronic sphere is computer forensics, which deals in authenticating, stabilizing, and recovering digital data. One early commentator is prescient in this regard: "much will be lost, but even when disks become unreadable, they may well contain information which is ultimately recoverable. Within the next ten years, a small and elite band of e-paleographers will emerge who will recover data signal by signal" (Morris 1998, 33).

For those of us who take seriously the notion that the borndigital materials of today *are* the literary of tomorrow, what's at stake is nothing less than what Jerome McGann (2006) has pointedly termed the "scholar's art." This is the same impulse that sent Ken Price to the National Archives in search of scraps and jottings from Whitman, the bureaucratic detritus of the poet's day job. "Scholarship," McGann reminds us, "is a service vocation. Not only are Sappho and Shakespeare primary, irreducible concerns for the scholar, so is any least part of our cultural inheritance that

might call for attention. And to the scholarly mind, every small-est datum of that inheritance has a right to make its call. When the call is heard, the scholar is obliged to answer it accurately, meticulously, candidly, thoroughly" (ix). There's still work to be done, don't you think?

NOTE

A longer version of this essay appears online in *Digital Humanities Quarterly* 7.1 (2013). I am grateful to the editor of *DHQ* for permission to reprint it in an abbreviated and somewhat modified form here.

REFERENCES

Consultative Committee for Space Data Systems. 2002. *Reference Model for an Open Archival Information System (OAIS)*. Washington, D.C.: CCSDS Secretariat. http://ddp.nist.gov/refs/oais.pdf.

Derrida, Jacques. 1995. *Archive Fever: A Freudian Impression.* Translated by Eric Prenowitz. Chicago: University of Chicago Press.

Duranti, Luciana. 2010. "A Framework for Digital Heritage Forensics." In *Computer Forensics and Born-Digital Content.* College Park: University of Maryland. http://ebookbrowse.com/4n6umd-duranti-pdf-d173267046.

Ernst, Wolfgang. 2002. "Agencies of Cultural Feedback: The Infrastructure of Memory." In *Waste-Site Stories: The Recycling of Memory,* edited by Brian Neville and Johanne Villeneuve, 107–20. Albany: State University of New York Press.

———. 2011. "Media Archaeography: Method and Machine versus History and Narrative of Media." In *Media Archeology: Approaches, Applications, Implications,* edited by Erkki Huhtamo and Jussi Parikka, 239–55. Berkeley: University of California Press.

Grossman, Lev. 2010. "Jonathan Franzen: Great American Novelist." *Time,* August 12. http://www.time.com/time/magazine/article/0,9171, 2010185,00.html.

Hall, Chris. 2011. "JG Ballard: Relics of a Red-Hot Mind." *The Guardian,* August 3. http://www.guardian.co.uk/books/2011/aug/04/j-g-ballard-relics-red-hot-mind.

Howard, Jennifer. 2011a. "In Electric Discovery, Scholar Finds Treasure

Trove of Walt Whitman Documents in National Archives." *Chronicle of Higher Education* 12. http://chronicle.com/article/In-Electric-Discovery-Scholar/127096/.

———. 2011b. "U. of Texas Snags Archive of 'Cyberpunk' Literary Pioneer Bruce Sterling." *Chronicle of Higher Education* 8. http://chronicle.com/article/U-of-Texas-Snags-Archive-of/126654/.

Larsen, Deena. 2009. "Artist's Statement." The Deena Larsen Collection. http://mith-dev.umd.edu/larsen/items/show/165.

McGann, Jerome. 2006. *The Scholar's Art: Literary Studies in a Managed World*. Chicago: University of Chicago Press.

Modern Language Association. 1995. "Statement on the Significance of Primary Records." http://www.mla.org/resources/documents/rep_primaryrecords/repview_records/primary_records1.

Morris, R. J. 1998. "Electronic Documents and the History of the Late Twentieth Century: Black Holes or Warehouses?" In *History and Electronic Artefacts,* edited by Edward Higgs, 31–48. Oxford: Oxford University Press.

Parikka, Jussi. 2011. "Operative Media Archeology: Wolfgang Ernst's Materialist Media Diagrammatics." *Theory, Culture, and Society* 28, no. 5: 52–74. http://tcs.sagepub.com/content/28/5/52.abstract.

Ridener, John. 2009. *From Polders to Postmodernism: A Concise History of Archival Theory.* Duluth, Minn.: Litwin.

Smith, Abby. 1998. "Preservation in the Future Tense." *CLIR Issues* 3. http://www.clir.org/pubs/issues/issues03.html.

Thibodeau, Kenneth T. 2002. "Overview of Technological Approaches to Digital Preservation and Challenges in Coming Years." In *The State of Digital Preservation: An International Perspective.* Washington, D.C.: Council on Library and Information Resources.

4

From A to Screen

Johanna Drucker

HOW DO LETTERS appear on our screens, these exquisite expressions of design, our Baskerville so clearly differentiated from the Caslon and Comic Sans that we recognize instantly what font families we are inviting into view? Do they come, like pasta letters in a can of alphabet soup, intact and already formed, down the pipeline of network connections, so many obedient foot soldiers in the ranks of our textual forces? Are they conjured to their tasks through the sorcery of application apprentices calling the infinite stream of glyphic figures into service for maneuvers as written rows and ranks? Arguably among the most nuanced and thus demanding figures in our graphical universe, letters and fonts rely on an infrastructure that largely disappears in its daily operation, even as their existence guarantees the performance of the alphanumeric codes that underpin our encoded communications. We take the virtual letters as things, mistaking their appearance for substance, and we also overlook the agency of alphanumeric code, taking it for granted. In each case, and across an array of other activities sustained by writing in our analogue and digital worlds, letters function as much on account of how we *conceive* of them as on the basis of any autonomous existence based in what they *are*. Indeed, our concepts of what the letters are, as well as their literal forms, have migrated from scratched stone and inked surface to screen, and in their current iteration, they reveal much about assumptions on which other functional illusions are based.

For a profound paradox governs the conception of alphabetic letters and their functional identity in the digital environment: they are at once understood as atomistic elements, discretely defined and operationally distinct, and they are also understood as expressions of complex, distributed contingencies whose identities are

produced across an array of ephemerally connected conditions. Code, that is, functional discrete-ness, should not be confused with appearance, the graphical particulars of individual forms. They are different orders of things in different conceptual systems. After all, the signs in alphanumeric code *could* be replaced. Another set of symbols, equally arbitrary and distinguishable one from another, *could* be substituted. The circumstances that have led us to use these familiar entities from historical reasons, our *a*'s, *b*'s, and o's to 9's, are now less important than the dependence built into and around their use in many multiple trillions of lines of code. Few elements of our digitally literate lives are more integral to its operations. Alphanumeric notation underpins the processing of code, it *is* code, as well as the stuff of higher-order expressions in languages of all kinds.

But the code–contingency paradox has implications for the ways we use letters, taking them for granted as a stable system in the first instance and recognizing their complex contingency in networks linking design, storage, delivery, display, and output in the second. The roots of the distinction are deep, linked to philosophical debates about stability and change that apply to particles and waves at a higher level of physics and to discussions of autonomy and codependence in systems theories and ecologies. The way we "think" the letters—how we conceive of them—shapes their design and our understanding as much as the technologies through which we make them.

Conceptions of letters function as expressions of beliefs about form and identity, providing the basis on which functional activity of alphabetic code operates. If I could activate the *a* on my keyboard only through a process of distinguishing it from every other letter in the system of all letters in all fonts and styles, my typing speed would slow to geologic (or philosophical) time rates. But the fact that I can single out a letter of the alphabet is built on an assumption that it is an unambiguous, discrete entity. However, the unique reaction triggered when a keystroke communicates with an application in my system tells me nothing about the identity of letters in an ontological sense. Atomistic theories of letters have led to medieval theories of the kabbalah, the manipulation of the many names of god, the attributes and elements of the cosmos, Lullian

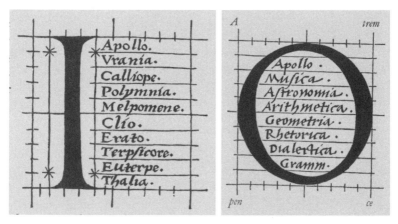

FIGURE 4.1. Geoffroy Tory, *Champfleury.* 1529.

methods of *ars sciendi,* and cosmological interpretations of male
and female properties in procreative metaphors projected onto their
forms (Drucker 1994). But this combinatoric mojo has no relation
to the digital processes and platforms that are too often and so
easily considered the extension of a world of spinning volvelles and
diagrammatic charts (Gardner 1982). The technological distance
between merkebah meditations and Turing machines cannot be
measured on a single scale any more than the fact that the GATC
sequences used to represent four nucleic proteins that make up
genetic code can be read as if they were actually alphabetic. Such
approaches mistake accident for substance, incidental informa-
tion for essential properties. Probing the relation of atomistic
concepts of alphabetic letters quickly ensnares the technological
and intellectual discussions with mystical resonances. That said,
the graphical primitives that make up letterforms lend themselves
to atomistic analysis. I/O elements, straight–curve oppositions,
quickly get absorbed into mystical analysis of digital notation for
its own sake, just as they have served occultists of various kinds
over the centuries (a good example is Tory 1529) (see Figure 4.1).

The graphical appearance of letters, their style and shape, which
seems self-evident for other reasons, also has a history of productive
tensions in relation to techniques and materials (Kinross 1992).
The production of a "letter" in a digital environment is an effect
of multiple, distributed processes, each of which participates in its

production as surely as constraints of varied material substrates have in other circumstances. Thus the second part of the dualism in our paradox: that specific forms (be they letters, human shapes, or natural phenomena) assume their identity only as momentary configurations of energy in flux. This has connections to a systems-based ecology of signs, a view in which human apperception of the fleeting phenomena is always partial, situated, ephemeral. For letters to be grasped fully, in all their philo-semio-sophical actuality, a Peircian tripartite description of signs would need to be pressed into service (Colapietro and Olshewsky 1996). In such a description, the very formation process of signs is considered in three parts, beginning with the undifferentiated world, through resistance to difference, and into a system of relations. Such a view encompasses all signs, human and natural, in which configured meaning is understood as an effect of a larger semiotic ecology (Taborsky 1998; Frost and Coole 2010).[1] Though essential to a theory of meta-informatics and signs, such frameworks are not explicitly related to an analysis of the migration of alphabetic letters across technological platforms—except insofar as the very notion of "letter" in that discussion depends on these philosophical debates and explanations. I don't aspire to such grand ambitions, except by implication. The level of abstraction to which such arguments rise, though intoxicating, won't explain the shape of the letters on the screen or their connection to their rich history of prior conceptions. So let's return to the letters, the inventory of their conception, and ways such notions shift in the transubstantiation the alphabet undergoes in the course of historical change and technological variation.

What are the letters? Did our ancestors ask this, forming their proto-Canaanite glyphs in the early part of the second millennium B.C., as the alphabet emerged in a cultural exchange between cuneiform scripts and hieroglyphic signs (Driver 1976; Diringer 1943; Albright 1966)?[2] If they did, they left no trace of these ruminations. The earliest recorded reflections on the letters, their origins and their identity, come from the Greeks almost a thousand years later. Their adaptation of the alphabet was, these Hellenes knew full well, a borrowing from the peoples to the East. Cadmus, the Phoenician, was identified by Herodotus as the bearer of the

letters, those signs that had come into Greece from Asia Minor by a route in the north and also by sea along the Mediterranean trade routes in various waves of diffusion and exchange some time in the ninth or eighth century B.C. (Bernal 1990).

But in addition to mythic (albeit accurate) histories of writing, the Greeks were aware of the differences among sign types and systems. Plato had been to Egypt, and his investigation of self-evident signs and the myth of mimesis, *The Cratylus,* bears within it a mistaken conviction that the hieroglyphics he had seen on monuments abroad had a capacity to communicate directly to the eye. The contrast between his own abstract script and the pictorial signs of the Egyptians gave him ground on which to consider the effects and implications of this difference. But the "Greek" alphabet, like many of the variant scripts that spring into being on the Eastern edge of the Mediterranean, is in fact a host of different strains, spores of experiment that take hold and mutate, adopt and adapt to new soil and new tasks (Naveh 1982; also Petrie, 1912; Cottrell, 1971; Albright, 1966).

Wait, you say, suddenly pausing for a moment in confusion. Who invented the alphabet? Which alphabet? The Greek alphabet? Each of these three questions leads to an abundance of wrong answers. The *idea* that the Greeks invented *the* alphabet is based on a particular conception—that the alphabet is a specific kind of transcription of a particular spoken language (Havelock 1976). But this is only one among several concepts of the alphabet, and the Greeks, in fact, were late in the game, receiving their packet of potential notation as a hand-me-down transmission after the initial formation of an alphabetic script on which the sequence, names, and "powers" of their letters are based (Logan 1986). The Semitic language speakers forged an alphabet to serve a tongue whose consonantal morphemes communicated adequately without vowels, and the technical specifications for their writing were different than for the Greeks, who later modified the writing for their own use. It was the Semites who fixed the sequence of signs (so securely that the assembling of architectural elements followed its order, a code of instructions for putting pieces of built form together in the right order in the turquoise-mining region of the Sinai). They gave the letters their names—aleph, beth, gimel, and

so on—and their original graphic identities more than a millennium before the Greeks took them up like dragon's teeth to sow their own ground and bring forth generations of poetic texts and language.

The alphabet was not invented but emerged, and all known alphabets spring from the same common root, which tracks to the lands of Canaan, Accad, Moab, Byblos, Sinai, and other realms whose names haunt the biblical history of a region of the Middle East that stretched as a fertile crescent from Mesopotamia to northern Africa (Sanders 2009). Its origins are intertwined with the histories of nations and peoples whose inscriptions provide a piecemeal record of the first appearances of a system of signs that was neither cuneiform, nor hieroglyphic, nor syllabic, logographic, or ideographic, but *alphabetic* (letters used to represent phonemes) in the centuries beginning around 1700 B.C. at the earliest. That original alphabet has been seen through many interpretative lenses, as archaeological evidence expanded and its techniques of analysis replaced biblical histories and origin myths linked to Adam, Abraham, and the angels. But the archaeologists' conception is also just that, one of many, rooted in empirical study of objects and evidence correlated with information about ancient languages and narratives of history retrospectively projected onto shards and fragments of remains. Even among these scholars of antiquity, passionate debates rooted in differences of opinion about the symbolic role of the alphabet within the formation of national identity versus its mere advantages of functionality continue to appear (Sanders 2009). Empirical evidence, in this case, builds on the assumptions to which it is put rather than serving to dispel the foundations of belief. Tracking the connections between fragments of ancient inscriptions and the morphing of forms into all the many variants of Arabic, Ethiopic, South Indian, Indonesian, Glagolitic, Slavonic, Germanic, Runic, and Roman forms creates a genealogical model of cultural diffusion (Senner 1989). This can in turn be countered by a more diffuse approach to the early emergence of this, the most persistent and long-lived writing system.

But the question that guides our investigation into the paradox of letters on the screen, the tension between the atomistic and systemic identities of these forms, remains much as it has been

for centuries—not simply "What is the alphabet?" but "How does the alphabet function according to the ways we may conceive it?" Just as our ancestors made use of the fixed sequence of letters, a model of order and ordering, so we take advantage of a concept of atomistic discreteness. Thus the answers have implications for our current condition, for the unacknowledged hegemonic hold of the Western alphabet on computational processing, on its infiltration into the very structure of the networked world in which its ASCII, Unicode, and Bin-Hex systems operate. As stated before, letterforms (graphical expressions) and alphanumeric code (discrete elements of a system) should not be confused. But the two use a common set of alphabetic signs that have been in continuous use from the sands of the ancient Middle East to the digital present, over a span of almost four thousand years. And problems of technology, concealed in the apparently mechanistic issue of design, turn out to be a Trojan horse in which the problems of philosophy make their stealth entry into our guarded precincts. The migration of the letters is not a history of things across spaces, time, and material substrates but of models and concepts reformulated. One strain of this reimagination springs from the encounter with materials.

The development of contemporary modes of production, that is, the design problems of technological migration, could be studied by looking at the career of an individual designer. One example is justly renowned Matthew Carter, who began with lessons in stone carving from his father, accompanied by exercises in calligraphy, before becoming involved in each successive wave of design production, from hot type (lead) to cold (photographic), and digital, from earliest pixel wrangling to programmable fonts whose variants are produced through an algorithm generating random variations (Re 2003). When he worked on designs of phototype, his training stood him in good stead, his eye attuned to the difficulties of scale and the need to compensate for the ways in which light spreads as it goes through a negative and onto a photosensitive surface, clotting the finer elements of letters at the points where strokes connected or where serifs met strokes. To correct these visual awkwardnesses, for the fattening of the ankles or swelling of the bellies or filled-in counters, the designer has to chisel away bits of the letter at a microscale so that the projected

light coming through the film strip negative onto the photosensitive paper would not result in clumsy forms. Retrospectively, phototype seems physical, direct, only moderately mediated by contrast to digital fonts, whose identity as elements is stored, kept latent, waiting for a call by the machine to the file that then appears on screen or passes into a processing unit on a device. Carter's early work in digital type was equally nuanced, and as memory and processing capacities escalated exponentially, so did the ability to refine digital typography.

But what to draw? Consider the complexity of the problem. Carving curved letters in stone is difficult, but inscription is direct. Description—the indication of a set of instructions for drawing produced by a design—remediates the direct process. Bitmapped fonts could be hand-tuned so that pixel locations could be defined for every point size. The image of a needlework grid at finer and finer scales makes a vivid analogy. Outline fonts had to be stored as a set of instructions for rendering the outline of the glyph, with the instructions for filling in provided by the printer. The decision to create a number of system fonts that shipped with desktop computers meant that Apple, at least, put its energy into making particular letterforms work throughout its file storage, screen, and output units (Ploudre 2011). A distinction between screen fonts and printer fonts enabled printer-specific files to communicate ways of drawing and making letters. As laser printers came into use, graphical expressions became more refined, and the demands on systems of processing and memory increased. The distributed aspects of a font's existence had to be considered across an array of operations. Challenges of graphic design led to encounters with questions of ontology and identity.

From the outset, digital fonts had to be created across a life cycle of design, storage, processing, display, and output in environments that each had different requirements and protocols. The earliest output devices were plotter pens and dot matrix printers, primitive graphical means at best. They created crude versions of letters whose patterns of dark spots in a grid bore little resemblance to font designs. The pixilated letters on early blinking amber and green screens had the grace of punch card patterns, as refined as cross-stitch and only as resolved as the scale of the grid. But what

produced these letters? What was being stored where, and how? Digital fonts explode any illusion on which stable, fixed, atomistic autonomy could be based. Even at the level of their graphic identity, letters have only to be able to be distinguished from each other, not hold their own as pictorial shapes.

Designs for typography on desktop computers began to take shape in the mid-1980s, before fonts had any connection to networking activities. The basic problem of how to create the illusion of curves in a world of pixels forced designers into a choice between vector graphics and the tapestry world of pixels. Scalable vector graphics, designed with Bezier spline curves spaced at close enough intervals to create nuanced transitions from thin to thick, swelling shapes, and neatly nipped points of connection between strokes, required a great deal of memory. Displaying them on the screen, except while they were being designed, was probably not worth the processing and storage overhead. But each rendering of a letter required that the file be stored and processed to be seen. Even on a single machine, the existence of a letter had stretched along a line of contingent connections.

The choice of what to store—a glyph outline, curves and points, or a pixel pattern—had consequences at every step of the font's life cycle. The creation of TrueType,[3] Apple's way to store outline fonts, was meant as competition for Adobe's Type 1 fonts used in Postscript.[4] The great advantage of TrueType and Adobe's Type 1 fonts was scalability—the same design could be redrawn at any size, or so it seemed (Phinney 2011). Experiments with multiple-master fonts, such as Minion, played (briefly) with the computer's capacity for morphing letterforms across a set of variables. But each size of a font requires rework, and in the digital design world, this is referred to as *hinting*. Questions of where and how a printing language lived—whether it was part of an operating system or part of applications or the software associated with particular printers—had market implications because every device had to be equipped with the ability to recognize a font file format if it were to render the letters accurately. Agreeing on a single standard for type formats, Microsoft and Apple collaborated on TrueType in the early 1990s.

Fonts were sold as files, their screen, printer, and display ele-

UNIVERSITY OF WINCHESTER LIBRARY

ments packaged on disks and shipped. The size of font files was large; they took up lots of space in the hard drive. And changing fonts too many times in a single document could clog the output pipeline as a poor printer chugged away like a dancer required to change from tango to waltz and square dance moves at every step. On-screen display posed its own challenges. Counterintuitive though it may seem, in grayscale displays, blurring the font's appearance through a process called *anti-aliasing* took advantage of the eye's ability to create a sharper appearance.[5] Up close, anti-aliasing looks fuzzy, out of focus, and ill defined, but from a reading distance, the letters look finer than in the high-contrast resolution of most screens. Likewise, the RGB lines of the monitor tended to be brutal to the nuances of typefaces. Subpixel rendering, another technique for improving the way screens display fonts, takes advantage of the ways the red, green, and blue lines of RGB displays can create their own refracted image so that it recombines into a sharp illusion, using the physical properties of the display to best advantage. These are technical problems, however, challenges for engineers and designers, not philosophers.

Or are they? Font designers speak of "character drift" when they talk about hinting, noting that the specific features that give a particular letterform its identity are at risk, losing their defining boundaries in the process. How long before the well-defined lowercase *r* looks like an *i* whose point has slipped? What is a letter in these conditions? Where is its identity held? And how is that identity specified? A basic font contains multiple tables that include both structured and unstructured data, the specific forms and shapes of icons, and instructions on how to talk to and work with a word processor or an application. The data about a font are merely stored until needed, held in the virtual memory awaiting a command.

Web-safe fonts are linked to the capacities of browsers to access font information stored in the operating system. Font files had to be loaded, rasterized, autohinted, and configured by the browser, translating a web page's information using locally stored fonts and display capacity. If an unfamiliar font was referenced in an HTML file, a browser would use a default font in the desktop operating system. At first, HTML had no capacity to embed fonts. Fonts were controlled by the browser. Each browser had its own limitations

and specifications. Designers were appalled. HTML, designed for "display," had stripped out one of the fundamental elements of all graphic design—font design. The crudeness of HTML's <H1>, <H2> system—simply regulating relative sizes of the handful of fonts available for web pages—was extremely reductive but very powerful. By ignoring the information required for font description, HTML could concentrate on other aspects of display in the early days of low bandwidth and still primitive browser capability. For designers, this was the equivalent of forcing a world-class concert pianist to perform Rachmaninoff on a child's toy piano of a dozen dull keys. By 1995, Netscape introduced a tag that allowed a designer to specify that a particular font was to be used in a web display, but this required that the viewer have that exact font installed. Again, a series of default decisions could revert to the system fonts if that font were not present.

Early cascading style sheets provided the means of specifying qualities or characteristics of fonts to be displayed. They allowed for five parameters to be indicated: family (sans serif, serif, monospace, cursive, fantasy), style, variant, weight, and size. Again, an analogy is in order. Every vanilla ice cream is not the same as any other. The nuances of design were rendered moot through the need to invoke generic, rather than specific, fonts. The distinctions among different renderings of various fonts, crucial to their history and development, could not register in such a crude system of classification or description. Designers, already annoyed at the nonspecific crudeness of HTML code, had more to complain about as they watched their Gill Sans turn into Arial and Hoefler Text or Mrs. Eaves rendered as Times New Roman.

The most recent attempt to resolve these issues, Web Open File Format (WOFF), shifts font storage responsibility to a server from which the information can be called, like an actor on permanent alert for casting and appearances onstage. The notion of WOFF depends on a continuous connection to the web so that any instance of that font will be rendered from files provided on a call. The complexity of the files—suited to a variety of browsers, screens, displays, and output devices, including printers—comes from the need to coordinate the consistent identity of the font across each stage of its design, storage, transfer, processing, restorage in

memory, display, output, and so forth. The notion of distributed materiality, developed by Jean-François Blanchette (2011), provides a useful description of these interdependent relations of memory, processing, storage, networks, and other features of the computational apparatus brought into play when a letter's existence is distributed and contingent.

A letter? Imagine the lines of code, contingencies, forks, and options built into each glyph's back story and front end. The skill of the punch-cutter, so inspiring for its manual precision and optically exquisite execution, is now matched by an equally remarkable but almost invisible (code *can* read, after all, but is rarely displayed in public view) set of instructions that also encodes ownership, proprietary information, the track and trace of foundry source, and, ultimately, perhaps, a set of signals to trigger micropayments for use.[6] The model of the letter is now an economic and distribution model as well as a graphical form with identifying characteristics. The letter performs across its roles and activities, with responsibility at every stage to conform to standards and protocols it encounters in every area of the web, to live on a server without becoming corrupted or decayed, to enact its formal execution on command no matter who or what has called it into play. These are megafiles with meta-elements, wrapped with instructions for behaviors as well as form. For the font storage in our times reinforces the performative dimensions of identity, of a file that is a host of latencies awaiting instantiation (Drucker 2009). The condition exposes the relation between modes and their embodiment, even as it belies the possibility of a disembodied letter.

If a letter is an entity that can be specified to a high degree and yet remain implementation independent, what does that mean (Glaves 2006)? The term *implementation independent* recalls another moment, some years ago, when a young scholar of modern poetry interested in typographic specificity in editions of various works asked me, "Does a letter have a body? Need a body?" I had never pondered the question in quite that way. Where to look for an answer to this metaphysics of form? In the essay where he speculated on the origins of geometry, Edmund Husserl provided a highly nuanced discussion of the relation between the

"first geometer" and the ideal triangles and other geometric forms whose existence he brings us to consider as independent of human apperception and yet fundamentally created within the constitutive systems of representational thought (Husserl 1989). But letters are not like triangles. Their proportions and harmonies are neither transcendent nor perfect in a way that can be expressed in abstract formulae. Between the opening gambit of the question of embodiment and the recognition of the fundamental distinction between mathematically prescribable forms that conform to universal equations that hold true in all instances lies the path from A to screen. For if all circles may be created through the same rules with respect to center point, radius, and circumference, letters cannot be so prescribed. In fact, the very notion of pre-scription, of a writing in advance, has philosophical resonance.

Approaching this as a practical problem brought metaphysics into play through the work of Donald Knuth in the late 1970s (Knuth 1986). The mathematician and computer-programming pioneer had sought the algorithmic identity of letters. And in the course of failing to find them, he provided revealing insight into the complexity of their graphical forms. Frustrated by the publication costs involved in production of his books, Knuth wanted to use computer-generated type to set his mathematical texts. By 1982, he had come up with the idea of a meta-font to take advantage of the capabilities of digital media to generate visual letterforms and equations. At the core of the typesetting and layout programs he designed, TeX and METAFONT, was a proposition that a single set of algorithms could describe basic alphabetic letters. As Douglas Hofstadter (1985, 266) later commented, Knuth held out a "tantalizing prospect . . . : that with the arrival of computers, we can now approach the vision of a unification of all typefaces" (see Figure 4.2).

In essence, the "meta" aspect of these fonts was contained in a vision of a flexible design capable of creating "a 6 1/7-point font that is one fourth of the way between Baskerville and Helvetica" (Hofstadter 1985, 266). Knuth's assumption was that all alphabetic letters—regardless of their font—could be described as a fixed, delimited, finite set of essential forms. For an *a* to be described according to its features such that the "Helvetica-ness" of one

FIGURE 4.2. Donald Knuth, *The METAFONTbook*. 1986.

version could be mixed with "Baskerville-ness" in another would require that these stylistic characteristics be specifiable (distinct and discrete) and modifiable (available to an algorithmic specification and alteration). Hofstadter argued that letters belong to what are called *productive sets,* sets that cannot ever be complete because they are by definition composed of each and every instantiation (chairs are another example of a productive set). Not only do an infinite number of *a*'s exist, but determining precisely what their common features are—or the properties of consistency, in mathematical terms—turned out to be more complicated than Knuth had imagined.

Knuth was having these realizations in 1982, as desktop publishing and design were just coming into view over the horizon. The idea of generating fonts from a set of simple instructions, parameters describing each letter, seemed just the right fantasy to entertain because it aligned with the optimism about the capacities of computational and digital media. Conceiving the essence of a letter as an algorithm and proposing a meta-font are ideas with a direct connection to digital media's perceived capabilities. As it turned out, no single essential *a* exists. A swash letter majuscule *A* in a wildly excessive script face will have elements that could never be predicted from an algorithm responsible for the minimal stroke forms of a three-stroke sans serif *A*.

Knuth's concept of letters had everything to do with the technology in which he was imaging their production. The idea of treating letters as pure mathematical information had suggested that they were reducible to algorithmic conditions outside of instantiation. He had believed that the letters did not need a body. Clearly the technology of production and the frameworks of conception both contribute to our sense of what a letter is. The technology of digital media couldn't produce a genuine meta-font, but in the context of computational typesetting and design, such an idea seemed feasible.

This example undercuts any technodeterminist view of letter design or conception. The limit of what a letter can be is always a product of the exchange between material and ideational possibilities. Sometimes technology leads, sometimes not. If we consider the history of letterforms, we can see many moments when one (technological development or conceptual leap) gets out of synch

with the other. The serifs of Giambattista Bodoni's eighteenth-century rational modern designs, meant to embody mathematical proportion, reason, and stability in metal type, were prone to break (Updike [1922] 1962; Drucker and McVarish 2009). These forms were better suited to production through photocomposition or digital modes in which their visual fragility could be countered by a technological robustness, but like the sparkling types of Baskerville, they suited an era in which refinement of taste was linked to virtuosic skills that flaunted the ability of punch-cutters to compete with the flourishes of master penmen. Style concepts were supported by technological innovation, not the reverse, so the printer from Birmingham had his paper "calendared" to make its surfaces smooth from the pressure of heated plates so it would support the finest possible print impressions.

Business models play their own part in the creation of concepts on which letters were and are imagined, and the most recently invented standard for letterforms, to support the storage of fonts on the cloud, is as much an opportunistic effect of markets as it is an effect of design drives or desires, because liberating fonts from their licensing agreements and foundries could be one of the unintended (or perhaps deliberate) consequences. Neoliberal notions of property, the effacement of labor and authorship and redistribution of economic benefit, are bound up in the new concept of Web Open Font Format (WOFF).

Hyperrationalization of letterforms is not exclusive to the realm of digital technology. Approaches to the drawing of letters in elaborate systems has several notable precedents. Renaissance designers Giambattista Palatino, Giovanni Tagliente, and Fra Luca de Pacioli, imagining a debt to the classical forms of Roman majuscules, strove not merely to imitate the perfection of shape and proportion they could see in the giant inscriptions of the Forum but to conjure a system that could embody principles for their design (Rogers 1979; Morison 1933) (see Figure 4.3). The letters on Trajan's column, erected in A.D. 113, provided (and provide, for these aspirations continue well into the twenty-first century) the stand-out example of Roman type design. The letterforms in the inscription seemed to express order and beauty in balance, a kind of majesty that was at once imperial in its strength and

FIGURE 4.3. Fra Luca Pacioli, *De Divina Proportione.* 1509.

classical in its humanity. The myth of compass and straight-edge as the tools for their production persisted until the twentieth century, when Father Edward Catich's close observation showed that the quirks of form are too subtle to be traced to mechanistic instruments (Clough 2011).[7] The Romans drew their letters onto stone and then included the subtle alterations of shape that were the result of gestures in their carving. According to the Encyclopaedia Romana, Catich

> hypothesized that the forms first were sketched using a flat square-tipped brush, using only three or four quick strokes to form each letter, the characteristic variations in line thickness formed by the changing cant of the brush. The letters then were cut in the stone by the same person (and not, Catich contended, separately by scribe and stone mason), the illusion of form being created by shadow.[8]

Concepts of the alphabet do not walk lockstep with the history of technological change. Early carvers, scraping the letters as best they could into the surface of rock, made shapes based

on models they knew—how? Was seeing enough to imprint that memory on the Neolithic imagination? Or did these scribes carry a cheat sheet of some kind, a rock or bit of clay or papyrus with the signs carved in them? Who taught these scribes? We know of the schools at Nineveh and throughout the ancient Near East (Robson 2009); of the training of Egyptian scribes and Babylonian ones; of the measured lines of Hammurabi's stele from about 1780 B.C., its regular and elegant cuneiform speaking volumes about the habits of writing and the expertise of its inscriber and anticipated readers. But literate culture was fully developed, part of administrative systems of power and purpose in those regions. The Sinai inscriptions are in a remote region. Who *knew* the alphabet—this new set of glyphs—well enough to hold it in mind and pass it on as a fixed sequence of letters with stable names and graphic identities? The models of letter making that appear on Greek vases—the Dipylon vase is a celebrated example—would have been painted from familiar models, as a set of strokes that comprised fixed patterns. The increasingly abstract forms that became Greek writing have no easy mnemonic to guide their creation, as the aleph-oxhead resemblance did for earlier scrapers in stone. Atomists are convinced of the power of letters whether in a mystical or instrumental sense. Empirical archaeologists are equally determined to piece together a single binding narrative from physical remains, the genealogical seekers after the origins and mutations as if in a single organic tree of influence spreading like some alluvial fan across the world from a single source. Mystics believe symbolic tales adhere to the signs (or inhere in them) that are a mystery to unravel or contemplate. In the technological inventory of conceptions, another set of frameworks prevails.

But when Renaissance artists looked to their antique past, they made every effort to create perfect forms. Their worldview, figured in ideal shapes as much an expression of cosmological belief in the perfection of divine proportions and design, depended on regular circles and squares. The aforementioned Pacioli's *De Divina Proportione* (1509) bears some of the same conspicuous graphic features as the diagrams of Tycho Brahe in his explanations of the apparent motion of the planets. As an expression of a divine design, these must comprise perfect forms, and the circles

within circles elaborately constructed by Tycho to describe elliptical motions are as mistaken in their mathematical principles as are Pacioli's attempts to redraw Roman letters by the same means (Koestler 1959). Other extreme approaches to rationalized design include the elaborate calculations produced at the very end of the seventeenth century on the order of the French King Louis XIV. The resulting *Roman du Roi,* on its grid of perfect squares sanctioned by a large committee of experts, proved equally sterile, static to the eye. Modified by the punch-cutter Phillippe Granjean, the designs of the monarch's font, held by exclusive license for his use, were modified to subtle effect in the production process. Matter triumphed over idea, and the hand and body over intellection, as the experienced type designer recast the ideal forms into realized designs that passed as perfect.

Just as reason and proportion could be pressed into design service by the rationalizers of form, other approaches to production had their own systematic foundation. The discipline of the hand, conformance to a stroke pattern, ability to execute a series of marks in fixed, controlled sequence that become letters on a page—these were the skills of the writing master. Ink from a pen, paint from a brush, graphite from a pencil are all technologies that require training to be perfected. The virtuoso capacities of the writing masters of the seventeenth and eighteenth centuries will rarely be equaled or surpassed in our lifetime (Bickham [1743] 1941; Hoefnagel 2010). Those well-orchestrated moves, and the training necessary to achieve them, are part of a cultural pattern long past. But in the process of creating their own materials for training, the teachers of handwriting conceived simple charts of the basic strokes from which any and all letters might be derived. A curious combination of atomistic elements and somatic gestures, this approach is *ductal,* or gestural, in its foundation. The letters are more like traces of dance steps than ideal forms, their beauty achieved by schooling the fingers, wrist, and arm to act together in a well-regulated performance (see Figure 4.4).

In fact, every technology suggests possibilities for letterform designs: clay and stylus, brush and ink, drawing pens and vellum, metal type, steel engravings, paper and pencil, ballpoint, photography and photomechanical devices, digital type. But letter

FIGURE 4.4. George Bickham, *The Drawing and Writing Tutor. Or an alluring introduction to the study of those sister arts.* 1740.

design isn't simply determined by technology. Gutenberg's metal characters took their design from preexisting handwritten models just as surely as photocomposition copied the design of hot metal fonts—despite the unsuitability of these models to the new media. Finding a vocabulary for a new technology takes time. The aesthetics of a medium aren't in any way self-evident—or immediately apparent. How was the metal-ness of metal to be made use of with respect to the design of letterforms (Updike [1922] 1962)? The inherent aesthetics of phototype and its ability to carry decorative and pictorial images, drawn and fanciful forms; to be set so close the letters overlap; or to be produced with a bent and curved film strip through which light shining made an anamorphic or distorted form—all this had to be discovered. Similarly, in the simulacral technologies of digital media, where shape-shifting and morphing are the common currency of image exchange, what defines the technological basis of an aesthetic—the capacity for endless invention and mimicry or the ability to create a randomization in the processing that always produces a new alteration in each instantiation?

But conceptual shifts across historical moments and geographies arise from other impulses than technological change, and this is crucial. The conception of forms can be realigned radically when explanatory narratives change. The eighteenth-century scholars L. D. Nelme and Roland Jones, for instance, struggling with Irish national identity and its roots in the prehistory of the Celts, took apart the alphabet and demonstrated its foundations in myths of origin that supported their claims to cultural autonomy. The letters were a code on which policies and politics might be played out in a contemporary arena. Published in London in 1772, Nelme's *An Essay towards an Investigation of the Origin and Elements of Language and Letters* employed an old theory, that of two essential forms of the *I* and *O* as the radicals from which the ten signs of the ante-diluvian language used by the Japhetans could be derived. The original Europeans, according to Nelme, their language, were not confused at Babel. His reading of the *O* and *L* as *O-L,* the *ALL,* was put to the purpose of showing that the Celts were the chosen people. Nelme was repeating the theme of Jones's 1764 *Origin of Language,* which traced the alphabet to the ancient tongue of the Cumbri-Gallic Celts, a point of view taken up again by Charles Vallencey in 1802 in his publication *Prospectus of a Dictionary of the Language of Aire Coti, or, Ancient Irish, compared with the Language of the Cuti, or Ancient Persians, Hindoostanee, the Arabic, and Chaldean Languages.* The point is simply that what drove the analysis of the forms of letters was a powerful belief system rooted in exigencies that were sufficiently compelling in their moment that they explained the alphabet as a vivid demonstration of principles. They cannot be characterized as wrong any more than Knuth's quest for a meta-font. Each is an accurate expression of belief. No era has an exclusive claim on blindness to its assumptions.

A letter, like any other cultural artifact, is designed according to the parameters on which it can be conceived. If we imagine, for instance, that a letterform may be shaped to contain an image with a moral tale, or that the letters of the alphabet comprise cosmological elements, or national histories, then designs that realize these principles may be forthcoming no matter what the material. Similarly, a twentieth-century modern sensibility inclined

to seek forms within the aesthetic potential of materials of production was satisfied by designs that brought forth the qualities of smoothly machined curves such as those typical of Deco forms. Obviously, in any historical moment, competing sensibilities and conceptualizations exist simultaneously. The modernity of Paul Rand exists side by side with the pop sensibility of Milton Glaser and the 1960s psychedelic baroque style of poster designer Victor Moscoso (Heller and Chwast 2000). Can anything be said to unify their sensibilities? At the conceptual level, yes—a conviction that custom design and innovation are affordances permitted, even encouraged, in an era of explosive consumer culture. Thus, for our moment, the need to use the discrete properties of the alphanumeric code allows us to press its arbitrary signs into the service of a World Wide Web whose Western roots thus connect it to antiquity.

The design of optical character recognition (OCR) systems divides along conceptually familiar lines. Print materials are analyzed by imagining their characters are pictures, distinguished one from another by graphical features. By contrast, handwriting samples are studied by capturing the sequence of events in their production. OCR was already dreamed of by the visionary entrepreneurial inventors of the mid- to late nineteenth century, who hoped they might create a machine capable of reading to the blind. Not until the mid-twentieth century was the first actual "reading machine" produced. The technological capacity for reliable machine reading progressed according to various constraints. Initially fonts were designed to suit the capacities of machine reading, with a feature set that occupied distinct areas of a grid. This allowed a unique, unambiguous identity to be ascribed to each letter through a scanning process, without the need for sophisticated feature extraction or analysis (the font was essentially a code, though it could be read by humans as well as machines). Technological capacities have become more sophisticated and no longer require use of a specially designed font, but some of the processes of pattern recognition in these earliest systems are still present. These basic techniques rely on thresholding (sorting characters from background), segmentation (into discrete symbols), zoning (dividing an imaginary rectangle enclosing the letter so that points, crossings, line segments, intersections, and other elements can be analyzed optically), and

feature extraction and matching (against templates or feature sets). Problems occur when letters are fragmented, much visual noise is present, or letters overlap or touch other elements in the text or image. The feature extraction can be complemented with natural language processing, gauging the probability of the presence of a word according to statistical norms of use, frequency, or rules of syntax. In handwritten specimens, the basic act of segmentation poses a daunting challenge, and therefore the automated reading of handwriting is most effective when working with samples that store the production history of strokes or the act of a letter's coming into being. Thus the two approaches to OCR align with earlier conceptions of the letter—as either an image with distinctive features or as the result of a series of motions resulting in strokes.

The same two variables are at play, then, no matter what the individual style or cultural trend: the materials of production *and* the conception of a letter. Even at the level of production, where identity seems self-evident, a host of different concepts about what a letter *is* can be identified. In overview, we can say that a letterform may be understood graphically as a preexisting shape or model, a ductal form created by a sequence of strokes with varying pressures, an arbitrary sign, an image fraught and resonant with history and reference, an arrangement of vectors or pixels on a screen, or a digital file capable of being manipulated as an image or algorithm. Conversely, in conceptual terms, we understand a letter as a function of its origins (born in flames, traced on wet sand, marked by the hand of God on tablets of stone, reduced from images, invented out of air, scratched in rocks), its value (numerical, graphical, pictorial), its form (style, history, design), its functionality (phonetic accuracy, legibility), its authenticity (accuracy), or its behaviors (how it works). Other conceptualizations might be added to this list.

Therefore asking "what is a letter?" is not the same as asking "how is it made?" The answers are never in synch—the questions don't arise from a common ground—but they push against each other in a dynamic dualism. The road from invention to the present existence of letters is a dialogical road, not a material one. The milestones are not a set of dates with tags: creation of the quill pen, invention of printing, or production of the punch-cutting machine. Important as these technological developments are to

the transformation of designs in physical, material form, they are modified in relation to the conceptual schema by which the letters may be conjured as forms. The letters did not migrate from A to screen. Atomistic in their operation, contingently distributed in their constitution, and embodied in their appearance, they have had to be reconstituted, remade in their new environment, still mutable after four thousand years of wandering.

NOTES

1 I am indebted to Jason Taksony Hewitt for conversations that have informed my understanding of these issues.
2 Basic books on the alphabet from an archaeological point of view include Sampson (1985), Driver (1976), Healy (1990), McCarter (1975), Gardiner and Peet (1952–55), and Diringer (1943).
3 For an explanation, see http://computer.howstuffworks.com/question460.htm. See also http://www.truetype-typography.com/articles/ttvst1.htm.
4 http://en.wikipedia.org/wiki/Typography_of_Apple_Inc.
5 http://en.wikipedia.org/wiki/Font_rasterization
6 http://www.fastcodesign.com/1671073/algorithmic-typography-crafted-entirely-with-computer-code#1.
7 See also http://penelope.uchicago.edu/~grout/encyclopaedia_romana/imperialfora/trajan/column.html.
8 http://penelope.uchicago.edu/~grout/encyclopaedia_romana/imperialfora/trajan/column.html.

REFERENCES

Albright, William Foxwell. 1966. *The Proto-Sinaitic Inscriptions and Their Decipherment*. Cambridge, Mass.: Harvard University Press.

Bernal, Martin. 1990. *The Cadmean Letters*. Winona Lake, Ind.: Eisenbrauns.

Bickham, George. (1743) 1941. *The Universal Penman*. New York: Dover Reprint.

Blanchette, Jean-François. 2011. "A Material History of Bits." *Journal of the American Association for Information Science and Technology* 62, no. 6: 1042–57.

Catich, Edward M. 1968. *The Origin of the Serif: Brush Writing and Roman Letters*. Davenport, Iowa: Catfish Press.

Clough, James. 2011. "James Clough's Roman Letter." http://soulellis. tumblr.com/post/683637102/james-cloughs-roman-letter.

Colapietro, Vincent Michael, and Thomas M. Olshewsky. 1996. *Peirce's Doctrine of Signs*. New York: Mouton de Gruyter.

Cottrell, Leonard. 1971. *Reading the Past*. New York: Crowell Collier Press.

Diringer, David. 1943. "The Palestinian Inscriptions and the Origin of the Alphabet." *Journal of the American Oriental Society* 63, no. 1: 24–30. http://www.jstor.org/pss/594149.

Driver, Godfrey. 1976. *Semitic Writing from Pictograph to Alphabet*. London: Oxford University Press.

Drucker, Johanna. 1994. *The Alphabetic Labyrinth: The Letters in History and Imagination*. New York: Thames and Hudson.

———. 2009. "From Entity to Event: From Literal Mechanistic Materiality to Probabilistic Materiality." *Parallax*. http://indexofpotential.net/uploads/1123/drucker.pdf.

Drucker, Johanna, and Emily McVarish. 2009. *Graphic Design History: A Critical Guide*. Upper Saddle River, N.J.: Pearson Prentice-Hall.

Frost, Samantha, and Diana Coole. 2010. *New Materialisms*. Durham, N.C.: Duke University Press.

Gardiner, Alan, and T. Eric Peet. 1952–55. *Inscriptions of Sinai*. London: Egyptian Exploration Society.

Gardner, Martin. 1982. *Logic Machines and Diagrams*. Chicago: University of Chicago Press.

Glaves, Mason. 2006. "The Impending 'Implementation Independent' Interface." http://weblogs.java.net/blog/mason/archive/2006/06/the_implending.html.

Havelock, Eric. 1976. *Origins of Western Literacy*. Toronto: Ontario Institute for Studies in Education.

Healy, John. 1990. *The Early Alphabet*. Berkeley: University of California Press.

Heller, Stephen, and Seymour Chwast. 2000. *Graphic Style*. New York: Harry N. Abrams.

Hoefnagel, Joris. 2010. *The Art of the Pen*. Los Angeles, Calif.: Getty.

Hofstadter, Douglas. 1985. "Metafont, Meta-mathematics, and Metaphysics." In *Metamagical Themas*, 266. New York: Viking.

Husserl, Edmund. 1989. *The Origin of Geometry*. Lincoln: University of Nebraska Press.

Kinross, Robin. 1992. *Modern Typography*. London: Hyphen Press.

Knuth, Donald. 1986. *METAFONT: The Program.* Reading, Mass: Addison-Wesley.

Koestler, Arthur. 1959. *The Sleepwalkers.* New York: Grosset and Dunlap.

Logan, Robert. 1986. *The Alphabet Effect.* New York: William Morrow.

McCarter, P. Kyle, Jr. 1975. *The Antiquity of the Greek Alphabet and the Early Phoenician Script.* Cambridge, Mass.: Scholars Press for Harvard Semitic Museum.

Morison, Stanley. 1933. *Fra Luca de Pacioli.* New York: Grolier Club.

Naveh, Joseph. 1982. *Early History of the Alphabet.* Jerusalem: Magnes Press.

Petrie, W. M. Flinders. 1912. *The Formation of the Alphabet.* London: Macmillan.

Phinney, Thomas. 2011. "True Type and Post ScriptType 1: What's the Difference?" http://www.truetype-typography.com/articles/ttvst1.htm.

Ploudre, Jonathan. 2011. "Macintosh System Fonts." http://lowendmac.com/backnforth/2k0601.html.

Re, Margaret. 2003. *Typographically Speaking: The Art of Matthew Carter.* New York: Princeton Architectural Press.

Robson, Eleanor. 2009. "The Clay Table Book in Sumer, Assyria, and Babylonia." In *A Companion to the History of the Book,* edited by Simon Eliot and Jonathan Rose, 67–94. Malden, Mass.: Wiley-Blackwell.

Rogers, Bruce. 1979. *Paragraphs on Printing.* New York: Dover Reprint.

Sampson, Geoffrey. 1985. *Writing Systems.* Stanford, Calif.: Stanford University Press.

Sanders, Seth. 2009. *The Invention of Hebrew.* Urbana: University of Illinois Press.

Senner, Wayne M. 1989. *The Origins of Writing.* Lincoln: University of Nebraska Press.

Taborsky, Edwina. 1998. *Architectonics of Semiosis.* New York: Palgrave Macmillan.

Tory, Geoffroy. 1529. *Champfleury.* Paris.

Updike, Daniel Berkely. (1922) 1962. *Printing Types: Their History and Use.* Reprint, Cambridge, Mass.: Belknap Press.

Vallencey, Charles. 1802. *Prospectus of a Dictionary of the Language of Aire Coti, or, Ancient Irish, compared with the Language of the Cuti, or Ancient Persians, Hindoostanee, the Arabic, and Chaldean Languages.* Dublin: Printed by Graisberry and Campbell.

Part II
PRACTICES

FOCUSING ON PRACTICE tends to cut through ideological baggage by encouraging close observation of what is actually happening on the ground. A case in point is science studies, which went through what might be called the "practice revolution" starting with Latour and Woolgar's (1986) seminal *Laboratory Life*. Burdened with decades of pontifications about the "scientific method," science studies took on new life with Latour and Woolgar's seemingly simple agenda: they would go into the laboratory and observe everything that went on, keeping at bay as best they could their preconceptions, as if they were anthropologists dropped from Mars. What they found, of course, is that the supposed sacrosanct methodology that scientists followed (hypothesis formation, testing through carefully controlled experiments, etc.) was simply not accurate. Following their lead, many scholars (e.g., Law and Moi 2002) began talking about a diversity of practices that vary not only between sciences but within the same scientific discipline for different kinds of contexts.

This development also revealed the limitations of focusing on practice, which are of a piece with its advantages. If every situation invites its own kind of practice, then what generalizations can be drawn? Where and how does theorizing enter in? One way to stabilize the apparent anarchy of methods (cf. Feyerabend 2010) is to introduce the idea of tacit knowledge (Polanyi 1974). Practice in this view leads to embodied knowledge that operates below consciousness but nevertheless enables a technician, for example, to separate noise from signal in a laboratory instrument, even though he cannot articulate explicitly how he knows this (Collins 1992). A more nuanced and complete explanation was offered by Andrew Pickering (1995) in his idea of the "mangle of practice." According to Pickering, practice is in a continual feedback loop with theory and concept. Practice shows where the theory may need revision,

and theory reveals new directions that practice may take. With that formulation, we are now close to the situation that most programmers experience when they write code, test it, find where it doesn't work, revise it, and so on, sometimes modifying their original plans as a result of what they learn from this feedback process.

What can we say, then, about Lisa Gitelman's (chapter 8) argument that media scholars should focus on practice? Given her topic of job printing, her argument is compelling, for an orientation toward practice is apt to reveal aspects of a situation that may have been overlooked or ignored (in this case, the prevalence and importance of job printing). Patricia Crain's (chapter 7) analysis of the inscriptions, insertions, and emendations found in children's books is another example; they would be easy to overlook as extratextual elements, except for her focus on practice, which works together with an emphasis on how they were used and what social and psychological purposes they served. William A. Johnson's (chapter 5) explanation of the contexts surrounding the bookroll reveals another advantage of a practice approach: aspects of media instantiations that seem inexplicable become fully understandable when the practices that created them are contextualized within their social, economic, and political histories.

Valuable as a focus on practice can be, it can also be limiting if it is cut off too firmly from the generalizations of theory. Perhaps the best illustration of how practice and theory can work together occurs in Boluk and LeMieux's (chapter 6) essay on *Dwarf Fortress*. Without doubt, there is a strong emphasis in their discussion on the practices surrounding this game, on the part of both the Adams brothers and the players who struggle with its complexities. But in the cross-comparisons with other media forms, such as the chronicle and the annal, there is a drive toward generalization that seeks a common explanation for historically diverse phenomena. For the "mangle of practice" to be fully enacted, Boluk and LeMieux would need to create a feedback loop between their practice-based observations and their theoretically informed discussion of formal characteristics, a complication that lies beyond the scope of their essay. Nevertheless, we can see here how practice can be combined with a theoretical impulse to give a richer account than either alone could.

This is not to say that all media scholars should follow the "mangle of practice" model, nor is it to disparage those scholars who make valuable discoveries through a focus on practice. If the "mangle of practice" can be thought of as a spiral twisting upward, one can enter it at many points, develop useful insights, and exit before going through multiple cycles or even entirely through one cycle. The point we want to make here is simple: although orientations toward theory or practice may be fruitful for a time, they work best when they are seen as complements in which each implicitly invokes the other and requires it for its completion. Recalling the comparative impulse of the Massachusetts Institute of Technology Comparative Media Studies program between "making" and "thinking," we can say that the comparative impulse in CTM is both expressed by and implemented through the practice–theory dialectic.

REFERENCES

Collins, Harry. 1992. *Changing Order: Replication and Induction in Scientific Practice*. Chicago: University of Chicago Press.
Feyerabend, Paul. 2010. *Against Method*. 4th ed. New York: Verso.
Latour, Bruno, and Steve Woolgar. 1986. *Laboratory Life: The Construction of Scientific Facts*. Princeton, N.J.: Princeton University Press.
Law, John, and Annemarie Moi. 2002. *Complexities: Social Studies of Knowledge Practices*. Durham, N.C.: Duke University Press.
Pickering, Andrew. 1995. *The Mangle of Practice: Time, Agency, and Science*. Chicago: University of Chicago Press.
Polanyi, Michael. 1974. *Personal Knowledge: Towards a Post-critical Philosophy*. Chicago: University of Chicago Press.

5

Bookrolls as Media

William A. Johnson

THE BOOKROLL

When the Greeks adapted the "Phoenician letters"[1] to create their alphabet in the early first millennium, they no doubt used whatever materials were at hand to write their alphas and betas and gammas. They would have used charcoal on pottery shards or stone, sharp metal on stone or wax, and paint on bark or leather. From an early point, however, the Greeks adapted the papyrus roll from Egyptian contexts, with a concomitant concentration on papyrus as the medium of support and carbon black ink as the vehicle for the writing. With adaptation came innovation. The Greeks rarely made use of the red ink common in Egyptian texts and chose to write with a hard reed rather than the Egyptian soft brush—two tiny details that show from the start the Greek interest in papyrus as a medium for conveying *written text alone* rather than text and image. Importantly, and perhaps surprisingly, the Greeks early on developed a well-defined idea and iconography for the literary papyrus roll that included specific dimensions and a firm sense of the *mise-en-page*. We see such rolls depicted on vases from the early fifth century B.C., and our earliest surviving specimens, from the fourth century B.C., already exhibit the look and feel of a *bookroll*, with a set of formal characteristics that will dominate the Western tradition for the next seven hundred years.

What, then, do we mean exactly by a papyrus bookroll?[2] Papyrus itself was a sort of tough, flexible paper made from the plant *Cyperus papyrus* and sold in rolls roughly fifteen feet in length and eight to twelve inches tall, not unlike shelf paper today. Anything could be written on papyrus: common are personal and legal documents of all sorts, including letters, lists, receipts, deeds,

and wills. Such documents would typically be written on sheets cut from a blank roll to the needed width. The *bookroll,* however, was a long expanse cut from one roll or glued together from two or more rolls, several or even tens of feet long, and was almost always written on a refined grade of papyrus, smooth and white on the surface. The roll was held horizontally, and the writing ran left to right in columns, like a newspaper. The material was, as mentioned, tough and somewhat springy—it tended to want to roll back up—and thus reading with a bookroll involved either using two hands (Figure 5.1) or letting one end be loose, where it would naturally spill down to the floor (Figure 5.2).

Already we begin to sense a reading experience that was substantially different from our own. Far from the image conjured by the too-facile analogy to the "scrolling" computer screen, the bookroll was anything but a support that involved the passive viewing of a narrow frame of presented text. Rather, the reader—unless a listener—was either actively engaged with rolling and unrolling to make the text manifest (and in any case was often viewing several columns at once) or was gazing on a lengthy expanse of text that flowed from lap to floor, or even across the room. Moreover, the medium itself interfered with aspects of work flow that we might think fundamental. Given that the Greeks and Romans did not use desks, how did one go about common tasks like taking notes or comparing multiple texts? And there are the more familiar complaints about the bookroll, such as the difficulty of locating references in it or the unfixed points for citation. How did one manage?

But we are starting to get ahead of ourselves. We need first to conjure a clear image of the written text. In principle, writing out the literary text was a straightforward matter. One needed only the papyrus roll, pen, ink, sponge, glue. We do have a handful of surviving examples evidently made by a person or group of people who were not trained to the task (for examples and further discussion, see Johnson 2004, 157–60). Even there, the result looks more or less like a bookroll, at least in the sense that a ten-year-old's hand-produced "book" recognizably seeks to imitate something from Penguin or the Clarendon Press. But the huge bulk of fragments of bookrolls that survive from antiquity

FIGURE 5.1. Muse reading a bookroll. Klugmann Painter (fifth century B.C.). Red figure lekythos, h. 22.5 cm. Photograph by Hervé Lewandowski. Louvre, Paris. Réunion des Musées Nationaux/Art Resource, New York.

FIGURE 5.2. Laurence Alma-Tadema, *A Reading from Homer* (1885). Oil on canvas, 36 1/8 × 72 1/4 inches (91.8 × 183.5 centimeters). The George W. Elkins Collection, 1924. Philadelphia Museum of Art/Art Resource, New York.

have a very particular set of characteristics, ones that suggest that bookrolls in aggregate were the product of professionals trained from a young age to perform this artisanal task. The writing, for example, ranges from simple to calligraphic, but the letters are formed uniformly and legibly and, because scribes were paid by the line, are written with a careful, clever speed, as much as the look of the script could take without losing its clarity and character. The script styles themselves fall within a small number of traditional types.[3] The lines are even. These uniformities go on for column after column without noticeable deterioration and, in our best-surviving witnesses, for dozens of columns in a row. The columns themselves are spaced regularly, such that the measurement from column edge to column edge typically varies no more than ±1.5 *millimeters*—about the width of a pen's nib. In the Roman era, there arose a dominant style by which the columns lean forward as they march along the expanse of the roll (see Figure 5.3), and this forward lean is likewise engineered as a uniform feature over dozens of columns.

As for the text itself, there is an almost obsessive preservation of the uninterrupted flow of the letters. Famously, there were no spaces between words. It is sometimes said that ancient book-rolls had no punctuation. That is not true, but the punctuation is minimal and handled such that the flow of letters is not visually

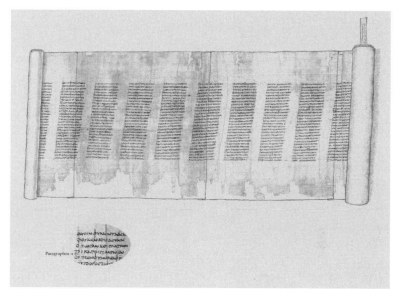

FIGURE 5.3. Anatomy of the bookroll.

interrupted. There were mostly no headings or subheadings; paragraphs are a much later invention; pauses at the level of a comma or semicolon are generally ignored in the copying of a text; and there is no differentiation of upper and lower case—again, a much later invention. Greeks and Romans shared the idea of a *period,* a notional dividing point where a thought was rounded off (something between our sentence and paragraph), and the end of each period is generally marked with a raised dot or slight space, with a short horizontal marker—the *paragraphus*—at the edge of the left column. The *paragraphus* did, then, serve as a sort of skeletal punctuation, and probably also helped the reader relocate his place in this otherwise undifferentiated text. These few marks of punctuation were, however, unobtrusive, as you can see in Figure 5.3. That this "clean" look is a deliberate as well as striking feature of the text is suggested by a couple of telling examples. In texts of tragedy or comedy, or in dialogues such as Plato's, the changes of speaker are signaled only by a horizontal mark to the left of the line of text (again the *paragraphus*). That habit maintained the look and feel of the bookroll, with its ranks of uninterrupted letters, but at a considerable price—scholars today still work to resolve

whose lines belong to whom in the plays of Aeschylus, Sophocles, Euripides. Similarly, it is a fact that individual bookrolls over time accumulate quite a few lectional marks; that is, punctuation is sometimes added by successive readers to clarify the division of the clauses and other aspects of phrasing. Yet, strikingly, when it comes time to make the next copy, the scribe will ignore these marks and produce a fresh copy reproducing only the bare run of letters with *paragraphus*. The aids to reading simply are not part of the notional bookroll-as-object (Johnson 2004, 2009).

As we hold this image of the bookroll in our minds and reflect on it, we begin to marvel at the almost aggressive impracticality of such a medium. We need to ask, pressingly, whether what we see here could be, simply, the by-product of its ancientness, the curious means by which words were captured in an early, more primitive time. Facts suggest otherwise. In our earliest form of written Greek, Linear B (late second millennium B.C.), word breaks are marked; Greek inscriptions on stone often had marks for word breaks; school exercises on papyrus rolls show routine practice with marking syllable breaks, word breaks, and elaborate punctuation; documents written on papyrus have frequent headings, indentation, punctuation, and various other lectional aids. It is not that the Greeks were ignorant of aids to reading, such as separation between words, punctuation, or the exposure of textual structure through headings and the like; rather, it was that *they chose not to use them in their literary texts.* Indeed, a fascinating episode in the history of the book is the transfer of the Greek bookroll into Rome. Our early evidence for literary texts at Rome suggests that the first Latin literary books routinely marked word separation (as did their inscriptions at all periods). After the Romans conquered the Greeks (146 B.C.), and as Greek intellectuals flooded into Rome and philhellenism took root, Rome looked to Greece not only as its model for philosophy, poetry, medicine, and literate culture in general but also for the look and feel of the bookroll. In an extraordinary move, the Romans, in roughly the first century A.D., chose to get rid of the separation between words and adopted that uninterrupted flow of letters known as *scriptio continua* for their own literary productions. This fact should give us pause. It is hard to conceive of a cultural pressure that would lead us to

FIGURE 5.4. A calligraphic bookroll. Homer, *Iliad* (*P.Hawara* 24–28, MS. Gr. class. a.1 [P], second century A.D.). The Bodleian Libraries, University of Oxford.

choose to drop word separation and most punctuation from our texts. And yet that is exactly what the Romans did.

We begin to sense that the bookroll, far from being a neutral support, simply a literary text written on a papyrus roll, was, rather, a signal feature in the cultural landscape. The (to us) odd, impractical features just reviewed—lack of word separation, minimal punctuation, lack of structural indicators—formed a central part of a reading system that showed no apparent strain from these impracticalities. The look and feel of the bookroll—stable for over seven hundred years—signifies culture in a number of different ways. As a represented object, it appears routinely on grave monuments and similar contexts as a signifier of literateness, a claim to education and inclusion in the circles of the educated. The bookroll itself, as we have seen, betrays an interest in aesthetic that in some respects verges toward that of an art object (rather than a tool), and it is no coincidence that the bookroll is also a costly item. Whatever the cost of imported papyrus (debated), the main expense in the production of a bookroll—the copying—was two to two and a half times the cost of copying out a legal contract, precisely because of the careful script and layout required to get that look and feel of a bookroll.[4] The papyrus itself is (again, unlike most documents) used in a liberal fashion, with margins generous enough that the writing covers only 40 to 70 percent of the front surface; and the back is, of course, left blank. For bookrolls

written in calligraphic or pretentious scripts (about a third of what survives), the phrase "conspicuous consumption" springs to mind (Figure 5.4); but less refined bookroll productions also suggest an elite cultural register.

Were there any doubt, one need look only at the contents. There is precious little that survives on bookrolls that is in any sense popular reading—very few fragments of the ancient novels, for example. Instead, among the many hundreds of fragments that survive, the dominant texts beyond Homer and Hesiod are those of interest to the rhetorical and philosophical schools (what constituted higher education in ancient Greece and Rome) and extremely difficult texts, such as tragedy and lyric poetry (more detail can be found in Johnson 2009, 268–69). These texts would have been challenging even to educated people in the Hellenistic and Roman eras and would have been inaccessible to *hoi polloi,* the many who were less educated or uneducated. The bookroll was, in short, an egregiously elite product, designed to signal a high-status, educated, *cultured* register.

THE READING SYSTEM

How did the reading system as a whole work? Were there different habits and perceptions among ancient readers that contribute to the radical difference between the ancient and modern conceptions of "book"? A detailed answer is well beyond the scope of this discussion. In speaking of Greco-Roman antiquity, we refer to roughly a thousand years and to two principal cultures with considerable diffusion, many subcultures, and much local variation among dozens of peoples in Europe, the Near East, and North Africa. My own work has shown that even within a relatively constrained time and place, there could exist significant, fascinating variations among reading communities with differing objectives in view (Johnson 2010). And of course, the evidence from antiquity is always uneven and often obscure. We will limit ourselves, therefore, to a few essential and tolerably generalizable ways in which bookrolls and readers interacted that distinguish them from the interactions of contemporary books and readers.

In stark contrast to the bookroll, our modern literary texts

contain an elaborated set of hints to the reader designed to convey by convention certain paralinguistic features of the text: large-scale conceptual boundaries (chapter, subchapter, paragraphs, bullets); detailed delineation of verbal phrasing (period, semicolon, colon, comma, dash, parenthesis); points of conceptual or tonal stress (italics, boldface).[5] The reader thus gains a conventionalized view of the text's "structure" as well as a conventionalized account of authorial tone and emphasis. By no means is all paralinguistic information conveyed—irony, for example—but modern typography is deployed to reduce certain types of differences in reader interpretation. Competent readers encountering italics in the sentence "There's always *something* not right" will come away with an impression of authorial intention for stress that is fairly uniform and in any case quite distinct from other possibilities ("There's *always* something not right"; "There's always something not *right*"). As we have seen, the bookroll could not be more different. You will recall that within the ancient period, sometimes a reader may have added a mark to indicate the phrasing (our comma, colon, semicolon), but only sometimes and sketchily, and that information is tossed aside when a scribe sits down to write out a fresh copy. The phrasing of a sentence—even something as basic as whether a sentence was a question—was left to the reader's interpretation. Or rather, to be more precise, the proper phrasing of a sentence emerges from the combination of the *literary style* of the author and the *reader's trained rendering* of that style. We see, then, that there is a tight symbiosis among the unencumbered letters of the text, the author's conventionalized style of writing, and the reader's training in shaping these elements into a meaningful discourse.

An anecdote from Aulus Gellius[6] may help make the ancient situation more concrete. The scene opens on a group of the educated in a bookshop in Rome, in the second century A.D. A grammarian boasts that he is the only true interpreter of an obscure text from two hundred years earlier, Varro's *Menippean Satires*. Gellius, who happens to have a bookroll of Varro on his person, walks up to him and says, "I ask you to read [pointing, apparently] these few verses and tell me the meaning of the proverb contained in them." The grammarian replies, "No, *you* read to me the words you don't understand, so that I can explain them to you." Gellius's reply is

unexpected and fascinating: "How in the world can I read words that I don't follow? Surely what I read will be badly phrased and confused, and will even get in the way of your ability to concentrate." The group around the two agree heartily with Gellius's point. Gellius now hands over the bookroll, remarking that it is an old volume, yet clearly written, but the grammarian then has grave troubles reading it: "Untaught boys picking up a book in school could not have been more laughable in their reading: so did he mangle the meaning [by breaking up the phrases incorrectly] and mispronounce the words." We see here what "to read" means for the educated reader. It is not enough to be able to sound out the words. When Gellius says he can't "read" what he doesn't follow, he points out what seems obvious to him and his audience: that the reading would be *indistincta et confusa*, "badly phrased and confused." The Latin *indistincta* is the technical term for "badly punctuated" in the sense of the reader not taking a breath pause at the proper place. Similarly, when the grammarian "mangles the meaning," the Latin *sententias intercidebat* refers to the reader's "cutting short" the clauses of the sentence, that is, mistaking the phrasing and thus confounding the meaning. Note how high the hurdle is: to be a proper reader, one must not simply divide the words correctly and get the right pronunciation but one must, on the fly, be able to convey the full meaning through proper phrasing and modulation. Importantly, to do so requires (in the ancient view) detailed understanding of the text, which in turn *means that one has already read the text*. Reading is often not so much about using a bookroll to find new texts as it is about getting together with literary friends for a visit with texts already well considered.[7]

Quintilian, writing in the first century A.D. about the proper training for young readers, makes clear how the technical requirements of reading always engage closely with understanding the literary content:[8]

> Reading is our final topic. As regards reading, it is only possible to show in actual practice such things as knowing when to take a breath, where to place a pause in a line, where a new sentence ends and begins, when the voice ought to be raised or lowered, what inflection should be used for each phrase,

and what should be spoken more quickly or more slowly, more excitedly or more gently. On this, so that he can do all these things, I offer therefore only this one precept: he must understand [what he reads].

Learning to read in the early years involves, at first, reading the text aloud to the teacher and having the teacher model the interpretation of the text. Later, the student reads aloud, and the master inquires to confirm that the student has adequately understood. Finally, the students will be free to read on their own (sometimes alone, sometimes in groups) and will inquire of the master when their understanding fails. Reading aloud for the young gentleman is always closely bound up with the goal to have "a clear understanding of what is to be read."[9] In the final stage of education, the student (like the master) excerpts exemplary passages from the text for sharing and memorization. Repetitive and shared reading of texts of recommended value is, in short, a central activity. We see, then, that reading of literary texts is deeply embedded within a closed community, one trained to certain types of appreciation for certain types of texts. This *exclusiveness* of the reading community is, from our viewpoint, a marked feature of the ancient reader's interaction with a text.

How, then, did reading events play out within such communities? Implicit in the scene from Gellius just considered is a characteristic normative behavior in antiquity, one in which the educated interact over a bookroll. This typically involves a group of the interested, a text at the center, a reading aloud, and a give-and-take that centers on the meaning of the text as a point of intellectual, social, and even political rivalry. The old chestnut that ancient Greeks and Romans could only read aloud has now been thoroughly debunked (see Gavrilov 1997; Burnyeat 1997; Johnson 2000).[10] Reading aloud to a group with a view to discussion is, however, run-of-the-mill in antiquity, whether the reader is a *lector* (a slave or freedman trained from boyhood to the task) or a gentleman amateur. Consider two illustrative examples. Plutarch describes the reading of a volume by the Epicurean philosopher Colotes *(On the Point That Conformity to the Doctrines of Other Philosophers Actually Makes It Impossible to Live)*: "While the

book was being read not long ago, one of our company, Aris-
todemus of Aegium (you know the man: no mere thyrsus-bearer
of Academic doctrine, but a most fervent devotee of Plato), with
unusual patience, somehow managed to hold his peace and listen
properly to the end. When the reading was over, he said: 'Very
well; whom do we appoint our champion to defend the philoso-
phers against this man?'"[11] Along similar lines is another scene
from Gellius.[12] In that passage, a leading intellectual, Favorinus,
is walking about the public baths with a group of friends and fol-
lowers. He notices a bookroll in the hands of a friend, and when
it turns out to be a work of Sallust, he asks the friend to read it.
The group walks and listens until an interesting passage on avarice
is reached, at which point Favorinus interrupts and asks Gellius a
pointed question on the content ("How exactly does *avarice* make
a man's body *effeminate?*"). Gellius hesitates, and immediately one
of the followers butts in, but Favorinus dismisses his remark and
turns his questioning to "a certain man of considerable learning."
After that man opines, Favorinus orders the passage on avarice to
be reread before going on to finish his argument with the learned
gentleman. Just as in Plutarch, the text is used as the springboard
to community interaction, and the community must first negoti-
ate who will act as advocates for and against the text; the ease
of movement from reading the bookroll to discussion and back
again is striking. The purpose for which the text is used is also
worth remark. The text is interrogated to see what it will yield
on a difficult philosophical point, yet the text is not presumed to
hold the truth. The reader's engagement is simultaneously with
"Sallust" and with one's contemporaries. It is the combination of
urgent, directed inquiry into the text and more open-ended discus-
sion that makes this classic text enduringly vital to the community.

Reading events were, then, elemental to *community* behavior, a
shared activity that gave structure to intellectual competition, while
affirming common values. The group character of many reading
events positioned the bookroll as a central cultural object, a thing
with considerable richness of social life (as Crain, in chapter 7 of
this volume, styles it). Again, a few examples will illustrate some
cultural specifics. The famous medical man Galen[13] comes to visit
at day's end a friend who, after a long day of business affairs at

the forum, sits with lots of bookrolls alongside, reading "with particular pleasure" a technical medical treatise on antidotes. The friend greets him and then returns to the bookroll, but now reads aloud to his friend, who comments that the treatise "is not badly put together." Of a piece is the scene sketched several hundred years earlier in Plato's *Theaetetus*,[14] in which Terpsion, after a long walk to the city, encounters his friend Euclides, who has just finished recording his recollection of a complex philosophical discussion involving Socrates. Terpsion says, "What hinders us from going through it now? Certainly I need to take a rest, since I've just come in from the country." Euclides then takes him home, picks up the bookroll, and hands it to a servant, saying, "Well, boy, take the book and read." Or consider the story Pliny the Younger tells of his uncle Pliny,[15] who was famous for the number of works he read and digested (the product of which was an encyclopedic treatise on natural history). To increase the amount he can read every day, the Elder Pliny listens routinely to a lector over dinner (of, presumably, technical materials). Once, one of his dinner companions interrupts the reader to correct a mispronounced word. Pliny asks his friend, "Couldn't you understand him?" and when his friend says yes, Pliny scolds him: "Then why make him repeat? Your interruption has lost us at least ten lines."[16] In all these stories, it is taken for granted that reading is, or can be, a shared activity, one that can move easily from reading to discussion and back. Moreover, these shared texts are treated as entertainment, but by no means as mere amusement: the reading of difficult, even technical texts is constructed as a diverting, relaxing, refreshing way to pass leisure time. Literary texts, in short, embody a sort of pleasure that *only* the educated can share.

Yet reading was also, to be sure, a personal, individual matter. Mastery of the requisite skills meant a lot of time working with the gray matter between one's ears. Reading was not the same as listening, as Quintilian makes clear in a passage of unusual clarity on the subject:[17]

> But the advantages conferred by reading and listening are not identical. The speaker stimulates us by the animation of his delivery (etc.).... Reading, however, is free, and does not hurry

past us with the speed of oral delivery; *we can reread a passage again and again* if we are in doubt about it or wish to fix it in the memory. We must return to what we have read and reconsider it with care, while, just as we do not swallow our food till we have chewed it and reduced it almost to a state of liquefaction to assist the process of digestion, *so what we read must not be committed to the memory for subsequent imitation while it is still in a crude state, but must be softened and, if I may use the phrase, reduced to a pulp by frequent re-perusal.* For a long time also we should read *none save the best authors* and such as are least likely to betray our trust in them, while *our reading must be almost as thorough as if we were participating in the writing.* Nor must we study it merely in parts, but *must read through the whole work from cover to cover and then read it afresh,* a precept which applies more especially to speeches, whose merits are often deliberately disguised.

This outstanding passage lays out several typical ways in which ancient Greeks and Romans constructed reading, features that we encounter again and again in our sources: the emphasis on thorough reading, rereading, and memorization; the reliance on the "best authors" as models; and the need to understand the whole in detail before internalizing the texts. Given such reading behaviors and targeted outcomes, one can understand readily enough that what seems to us the impracticality and inefficiency of the bookroll as a support for reading is entirely beside the point. The reading community has, rather, a stake in having the text be difficult to access, something that one trained for years to be able to manage, and even then only painstakingly mastered. The sense of exclusivity, not some sort of functional literacy, was central to this *literary* side of the reading system. How did one take notes? By dictating to a slave, of course, or by having the slave read aloud while one scribbled on a wax tablet. How did one compare multiple texts? By having different members of a group read the shared texts aloud. How did one locate references within a lengthy bookroll? By knowing the contents backward and forward. The system qua system functions well within its own terms, even if those terms are wholly unfamiliar to us.

SOCIAL AND IDEOLOGICAL CONSTRUCTIONS OF READING

Our goal has been to elucidate generalizable elements in Greek and Roman reading cultures. That has necessitated an under-nuanced approach, in which literary passages are stripped from their context and pieces of evidence spanning generations or even hundreds of years are set beside one another as like to like. As with any attempt at writing broad-stroke "social history," this method is flawed, but nonetheless can serve as a starting point, because it highlights features that are stable over time and place, and—though at the risk of an overemphasis on exoticism—it helps us focus on behaviors interestingly distinct from contemporary norms. We have come to appreciate, in gross terms, the look and feel of a bookroll; we have come to see that ease of use and efficiency are alien to ancient attitudes toward the bookroll; we have come to understand some fundamentals about ancient reading behaviors, such as the heavy use of lectors, the habits of group reading and interrogation of a text, and the ideal of a reader who reads and rereads and thoroughly absorbs a text as a normative reading practice. We should now be able to see at least some ways in which the design of the bookroll, the style and types of writing, and ancient reading behaviors work together in a system that is symbiotic and consistent in its own terms, however odd that system may seem to us.

The final task at hand is to consider how that reading system, grossly construed, worked within the society. This can be little more than suggestive and exemplary. It is simply not defensible theoretically to situate the question too broadly—there must be some particular society in view. We will choose as our focus the Roman high empire (roughly, the second century A.D.).

In that era, educated society in Rome was structured in over-lapping social networks, each centering on a "great man" (the *vir magnus*) and his circle of friends and family. The elite communities thus formed had various shared interests, such as politics and kin-ship connections, business interests, chariot racing and gambling, or hunting and the outdoors. Often enough, though, these circles self-identified as communities with common intellectual interests, and there could be a focus to these: philosophy, for example, or

poetry, or oratory, or more technical areas like medicine. Those circles interested in promoting themselves through writing are, of course, the ones best known to us (because of the dominance of literary sources). An interesting, important feature of these reading communities is how their literary activities dovetail with the broader rhythms of elite life. In a well-known letter, Pliny the Younger depicts the daily regimen of a model elder, Vestricius Spurinna.[18] Spurinna, wealthy and thrice consul, adopts in his retirement in the countryside habits that are fascinating for their balanced rotation of physical, intellectual, and social activities. For physical activity, he begins the day with a long walk; takes "passive exercise,"[19] such as a carriage ride, at midday; and, just before the mid-afternoon bath, exercises more vigorously by tossing a ball. Alternating with the physical exercise are activities to stimulate the mind: after the walk, serious, intellectual conversations or engagement with his friends over the bookroll of a challenging text; after the carriage ride, seclusion to compose Greek and Latin lyric poetry; and after the bath, readings of something "more re-laxed and pleasurable," sometimes with and sometimes without his friends. Along the way, he interleaves a variety of social arts: in the morning, the conversation with friends already mentioned; conversation tête-à-tête with a companion as he rides in the car-riage; perhaps discussion with friends over the relaxed afternoon text. The day is capped by a dinner, which itself includes literary entertainment (such as the recitation of a comedy) "so that the pleasures of dining may be spiced by enthusiasm for letters." The contrived, artful elegance of all this tells us a lot about the ideal of how the elite integrate education and letters into the leisured life.[20]

Spurinna, like any Roman aristocrat, has a villa that is as-sumed to be populated with *amici,* "friends" in the broad sense of those who constitute the circle around him, who look to him for support, including legal and political support, and whose loyalty and attendance he can assume. As we try to understand better the position of things literary in Roman society, an important angle is the material consequence that can flow from literary mastery. Fronto, a North African who came to Rome but quickly rose to be the leading light in oratory in his day, became attached to the imperial circle and was made the intellectual companion of the

future emperor Marcus Aurelius. Fronto became extraordinarily wealthy. He had at least three major estates, including a huge villa that occupied several hundred yards of coastline at a spectacular cliff overlooking the Bay of Naples (a large slice of modern Sorrento), and also one of the finest houses in Rome, sporting a pedigree from its first owner, Maecenas—the wealthiest man of his day—through to Augustus and Nero (for more detail, see Johnson 2010, 139–41). Fronto's is an extreme case, but we see repeatedly in our sources that to be well versed in literary matters can have enormous life consequence. Direct patronage was common in Roman society, as also indirect help, such as (for example) guidance with lucrative investment opportunities. Less familiar to us, perhaps, is the custom of willing shares of one's estate to friends, and even to friends of friends, which was widely practiced. The concatenation of inheritance and other material rewards can mean that belonging to a close literary network mattered, a lot. Routine, moreover, are letters that recommend a protégé on the basis of his command of letters. That same Fronto, writing to the proconsul of Africa, recommends his friend Iulius Aquilinus, who is especially well versed in philosophy and oratory, as a "most erudite and eloquent man," and goes on to say, "A man so learned and so cultured should naturally find from a man of your serious character and wisdom not only protection but advancement and honor. Aquilinus is also, believe me, a man of such a character that he deserves to be accounted an ornament to yourself no less than to me."[21] Aquilinus will become a judge and military officer yet is recommended not for his talents in those realms but because he will fit well into the cultured circle the proconsul likes to keep. He is both an "ornament" and one of "us"—of middling background (his father was a procurator) but, *because of his literary skills,* worthy of belonging to the ruling class.

Also elemental to the position of literary affairs in Roman society is the moralism in which it is often framed. The Roman alone with his books featured from early on in the *topos* of "lucubration," a sort of vigil by lamplight in which the serious, dutiful man removes himself to an inner room for solitary study (Ker 2004). A curious cultural schematic clicks into place, by which this activity is opposed to other, less virtuous possibilities common

to leisure time after nightfall. The elite anxiety over use of leisure time is profound and characteristically Roman. Not only must the dutiful aristocrat pass his daytime hours in fulfilling obligations to clients and to the state, but by an odd twist, literary enterprises like studying medicine or philosophy—and also poetry—are seen to be opposed to binge drinking, whoring, gambling, and other depraved activities. The man who knows his Cicero and Varro and Ennius must, in this scheme, be virtuous, not only because of the inherent benefit the texts of these authors bring to his mind and soul but also because literary mastery itself guarantees his serious, purposeful use of leisure hours.[22]

The ideological view that appropriates to the literarily cultured the ideal of respectable, virtuous behavior folds in with a final critical consideration, the role of literary matters in the appointment of cultural gatekeepers. A typical way in which elite in literate societies distinguish themselves from the masses is by asserting control over literature and language (Elwert 2001), and the Roman elite had been doing this for some time. Julius Caesar, for example, had definite ideas about what constituted "proper" Latin, and his nephew Augustus famously helped to inculcate a high style in Roman poetry even as he consolidated political and military control over society. The central role of oratory at Rome led the elite to readily accept mastery of language as an essential goal of education. Quintilian warns that defining correct usage as "merely the practice of the majority" would be "a very dangerous rule affecting not just literary style but life as well"; usage must be defined as "the agreed practice of the educated."[23] The way one spoke was important to elite behavior, as was what one chose to read. Appreciation of literature, as we have seen, required years of education and mental refinement to allow for proper internalization, and the very image of the bookroll—that unencumbered, unapproachable flow of letters that was our starting point—seems almost by design to instantiate the orderly exclusion of the less educated. Literary matters, like bookrolls, were decidedly for the few. Reading communities thus functioned not simply as exclusive clubs for approved entertainment and social networking but also as the place where tastes were made: in a world without publishers, it was exactly these elite reading communities that negotiated

whose literary output was to be rejected, whose validated and praised, and whose was to be truly admired and *copied,* with the chance, then, for an enduring readership—for that immortality that uniquely belongs to authorship. Along the way, these same groups continually renegotiate matters such as correct diction, appropriate style, and fashionable content. The more dominant coteries become the tastemakers in the society. This role—one already of considerable satisfaction and power—links, as we have seen, directly to real-world matters. What one read, how one understood what was read, and how one deployed one's mastery of language and literature could have immense consequence. At stake were personal relationships, political ties, status within the community, and even concrete gains such as income and wealth. Not all elite Roman communities focused on intellectual and artistic matters in this way, but it is evident that elite self-fashioning often depended on networks of reading communities in a way dramatically different from the modes by which the nexus of power is fashioned today.

Far from the medium being the message,[24] the textual medium is, as I have argued, one component in a complex *system* of reading and writing behaviors that itself is deeply embedded in social as well as cultural concerns and activities. My aim here has been to sketch—however lightly and provisionally—some ways in which the image and object of the bookroll participated in broader sociocultural systems in Greece and Rome.[25] In more general terms, however, I implicitly urge a comprehensive approach toward understanding reading cultures,[26] one that insists on the symbiotics of medium, literary text, writer, and reader as something deeply embedded within society, culture, politics, ideology. Not only the logistical formulation but the very significance of reading events—including the negotiated construction of meaning for the text—is, by implication, not only rooted in but shaped by sociocultural circumstances. I therefore also urge a particularized approach, one that attempts to understand reading events within the terms of specific societies and cultures. What I find so remarkable—and fascinating—about the evidence from the high empire is the *tightness* of interactions, not only between writer and reader, or text and reader, but between less obvious pairs, such as literariness and economic benefit or textual acuity and

social hierarchy. Thus I have chosen to speak in terms of *reading communities*: this helps to foreground one central mechanism by which the bookroll, in itself a simple object, can link so closely to matters like politics, ideology, status, and power.

This set of data and reflections can be instructive for the larger project of this volume. When we consider what a difference in media might effect, we need in the first instance to be clear that the medium per se is only one element—a contingent element—in a complex system. We know, for instance, that the bookroll gave way to the codex in the early Christian era, and the (supposedly) better "technology" of the codex is often cited as causative. But contemporary scholarship has come to understand that there were broader cultural dynamics in play than those of convenience, probably involving specific, influential reading communities; the supposed technological superiority of the codex is now seen as a modern assumption remote from ancient attitudes or practice.[27] Along somewhat different lines, we also need to be clear that "reading a text" is a highly unstable concept, unless it is contextually specific (a "reading event"). Reading a poem and a tax document are not very similar experiences, even for the same reader in the same place. Reading Yeats to a lover over wine and reading Yeats in a class are not at all the same experience. Reading Nietzsche "here" (in North Carolina) and Nietzsche "there" (while visiting his alpine summer residence in Sils Maria) are not the same. Reading Homer now and reading Homer then (whatever past you will imagine) are not the same—at all. Reading events are, in short, by nature strictly contextual and deeply embedded in sociocultural circumstances. For these reasons, too, then, I privilege the reading community in my analysis, because that, however crudely, directs focus to the social and valuative aspects latent in the idea of reading or, more generally, in the use of textual media.

Finally, by way of remark on the meta-quest of this volume (to reexamine traditional disciplinary paradigms), I quote from some earlier work:

> Why is it that students so commonly find difficult texts like Homer's *Iliad* or Plato's *Republic* (or Dante or Baudelaire or Goethe) deeply exciting *within the context of a class*? If they

do not read these texts in college, most of these same people, after all, as 40-something stockbrokers or business executives, are not likely to find these texts very engaging. Why do young men and women who find Greek or Sanskrit or Swahili captivating as students rarely read these languages much or at all once they graduate? What specifically is the nature of the magical web that a good teacher is able to spin? A great deal, I think, depends on the *socio-cultural construction of the reading group,* and much of what we do in higher education, both institutionally and individually, is to work towards the construction of particular types of reading groups. In a successful humanities class, we are not so much teaching texts as creating a reading society, which finds self-validation in the negotiated construction of meaning from these texts. That is, institutionally we work, for instance, towards creating the disposition that knowledge of, and directed engagement with, particular humanities texts is socio-culturally important: it is part of what you *need* to know to be "educated," part that is of what you need in order to become part of the cultured elite of society. Individually, we as teachers work towards creating the disposition that a particular text (the one we are studying in the class) is meaningful and relevant: it is part of what you need to apprehend the knowledge and to experience that sense of meaningfulness that bonds the group together as a productive, self-validating unit. These group dynamics—the construction of the attitude in the reader that Plato is *important,* that Plato *should be interesting*—are fundamental to education, and fundamental to the high intellectual experience. (Johnson 2002, 20)

The same logic applies, a fortiori, to one's sense of engagement as a professional within an academic discipline. If we want to change the disciplinary paradigms, then we need to start with the *questions* that interest us—that fascinate us; we need to fashion a group of the similarly interested; and there needs to be a core group of those who *profess,* who have the talent and energy to create that magical sense of common inquiry and self-validation among the constituted community.

NOTES

1 Herodotus, *Histories* 5.58, *ta grammata Phoinikêia*. The consensus view is that the Phoenician proto-alphabet was the immediate inspiration for the Greek alphabet.

2 The description that follows of the particulars of the bookroll presents in summary form the fuller discussion in Johnson (2009). For details on ancient writing materials and on the manufacture and properties of papyrus, see Bülow-Jacobsen (2009).

3 Turner (1987) surveys and offers a typology for the so-called book hands in antiquity.

4 This statement depends on *Edictum Diocletiani de pretiis rerum venalium* col. 7.41–43. See, further, Turner (1987, 1–4) and Johnson (2010, 21).

5 See, further, the foundational discussion in Olson (1994, 91–114).

6 *Attic Nights* 13.31.

7 Repeated rereading of texts may also be important in our interior life with books—the emotional attachment to books and their meaningfulness for self-identity is explored by Crain in chapter 7 of this volume.

8 *On the Education of an Orator (Institutio Oratoria)* 1.8.1–2.

9 *Inst. Orat.* 2.5.6, and more generally 1.2.12, 1.8.13–17, 2.5.5–17, 9.4 passim.

10 There is a distressing tendency for disciplines outside of classics to retain this as a fact about antiquity.

11 Plutarch, *Against Colotes* 2, *Moralia* 1107F. Second century A.D.

12 *Attic Nights* 3.1. Second century A.D.

13 Galen, *De theriaca ad Pisonem* 14.211K. Second century A.D.

14 Plato, *Theaetetus* 142A–143C. Fourth century B.C. (dramatic scene set in the late fifth century).

15 Pliny, *Letters* 3.5. Second century A.D.

16 Ibid., 3.5.

17 *Inst. Or.* 10.1.16, 19–20, trans. after Butler, italics added. Late first century A.D.

18 Pliny, *Letters* 3.1. Second century A.D.

19 On the range of ancient notions of exercise, see Gleason (1995, 87ff.).

20 For similar behaviors among the medieval aristocracy in Italy, see Petrucci (1995, 141–43).

21 Fronto, *Ad amic.* 1.4. Second century A.D. See further in Johnson (2010, 146–47).

22 We may recall here the image of a virtuous Abraham Lincoln studying law by lamplight, a probable survival of this schematic.

23 *Inst. Orat.* 1.6.44–45.
24 Marshall McLuhan's famous phrase (McLuhan 1964).
25 For a detailed analysis of elite reading cultures in antiquity (with a focus on certain communities in the high empire), see Johnson (2010).
26 For an analytical summary of the history and coherence of the term *print culture,* see Gitelman, chapter 8 in this volume; her spot-on critique of ideas like "the shared meanings of printedness" does not, in my view, pertain to the use of the term *reading culture.*
27 The decisive intervention, with a summary of earlier scholarship, is Bagnall (2009). On the question of the supposed technological superiority, see Johnson (2009).

REFERENCES

Bagnall, Roger. 2009. *Early Christian Books in Egypt.* Princeton, N.J.: Princeton University Press.
Bülow-Jacobsen, Adam. 2009. "Writing Materials in the Ancient World." In *The Oxford Handbook of Papyrology,* edited by Roger Bagnall, 3–29. Oxford: Oxford University Press.
Burnyeat, M. F. 1997. "Postscript on Silent Reading." *Classical Quarterly* 47:74–76.
Elwert, Georg. 2001. "Societal Literacy: Writing Culture and Development." In *The Making of Literate Societies,* edited by David R. Olson and Nancy Torrance, 54–67. Malden, Mass.: Blackwell.
Gavrilov, A. K. 1997. "Techniques of Reading in Classical Antiquity." *Classical Quarterly* 47:56–73.
Gleason, Maud W. 1995. *Making Men: Sophists and Self-Presentation in Ancient Rome.* Princeton, N.J.: Princeton University Press.
Johnson, William A. 2000. "Towards a Sociology of Reading in Classical Antiquity." *American Journal of Philology* 121:593–627.
———. 2002. "Reading Cultures and Education." In *Reading between the Lines: Perspectives on Foreign Language Literacy,* edited by Peter C. Patrikis, 9–23. New Haven, Conn.: Yale University Press.
———. 2004. *Bookrolls and Scribes in Oxyrhynchus.* Toronto, Ont.: University of Toronto Press.
———. 2009. "The Ancient Book." In *The Oxford Handbook of Papyrology,* edited by Roger Bagnall, 256–81. Oxford: Oxford University Press.
———. 2010. *Readers and Reading Culture in the High Roman Empire: A Study of Elite Reading Communities.* Oxford: Oxford University Press.
Ker, James. 2004. "Nocturnal Writers in Imperial Rome: The Culture of *Lucubratio.*" *Classical Philology* 99:209–42.

McLuhan, Marshall. 1964. *Understanding Media: The Extensions of Man*. New York: New American Library.

Olson, David R. 1994. *The World on Paper: The Conceptual and Cognitive Implications of Reading and Writing*. Cambridge: Cambridge University Press.

Petrucci, Armando. 1995. *Writers and Readers in Medieval Italy: Studies in the History of Written Culture*. Translated and edited by Charles M. Radding. New Haven, Conn.: Yale University Press.

Turner, Eric G. 1987. *Greek Manuscripts of the Ancient World*. 2nd ed. Revised and enlarged by P. J. Parsons. London: University of London.

6

Dwarven Epitaphs: Procedural Histories in *Dwarf Fortress*

Stephanie Boluk and Patrick LeMieux

WITH THE RISE of digital inscription technologies, the history of the twenty-first century will not be written by human hands alone. From surveillance systems to medical databases to networked computers, automated processes of information and exchange are already encoding an alternative history of humanity and coauthoring the stories of the next century. Smart phones log global position, online advertisements count clicks per capita, search engines index content (and "personalize" results) in real time, and automatic backup applications record the state of your hard drive so you can "revisit your [computer] as it appeared in the past" (Apple 2012). Nowhere are these invisible informatics more deeply felt than through the algorithmic operations driving contemporary financial markets. At 2:45 P.M. on May 6, 2010, subsecond stock exchanges between networked trading systems on Wall Street produced an unprecedented, system-wide "flash crash," which caused the Dow Jones to plummet a thousand points, only to recover just moments later. Now known as the "Crash of 2:45," this microcrisis inspired a group of physicists at the University of Miami to recover and analyze 18,520 ultrafast black swan events to study the long-term economic impact of algorithmic trading on global financial systems post-2006 (Johnson et al. 2012). Considering the massive amounts of data being produced at speeds and scales that exceed the limits of human phenomenology, future historians will find themselves in a similar situation, studying the history of the twenty-first century not in terms of human-legible days, weeks, months, and years but in machine-scale microseconds.

Like researchers applying physics to flash crashes, communities

have formed to study the complex dynamics governing play within contemporary videogames. Of the games that foreground their operational qualities and create play from the engagement with complex systems, one stands out: a text-based computer game by Tarn and Zach Adams called *Dwarf Fortress* (2002–). The game begins by generating an expansive, highly detailed world in which up to one thousand years of natural and social history are dynamically produced. Despite its minimal textual interface, the process of generating this history weighs heavily on the central processing units of most computers. The millions of events logged during world generation are granular enough not only to correspond to the history of the gamespace represented on-screen but also to ultimately historicize the processor cycles of the computer itself. In rejecting the conventions of standard game design and traditional narrative storytelling, *Dwarf Fortress* produces textual inscriptions that not only mark one horizon of human experience but recall forms of historical writing that depart from human-centered and teleological models of history, such as the annal, chronicle, and calendar. In response to (and despite) the difficulty of actually engaging with the game's deanthropomorphized, speculative terrain, a community has formed over the past decade dedicated to exploring, documenting, and translating the results of *Dwarf Fortress* into texts we call *Dwarven Epitaphs*. Dwarven Epitaphs are monuments of human play and a powerful form of comparative textual media produced amid a computational wilderness. These postmortem accounts of play navigate the interstices of fan fiction, fan translation, and fan archiving not only to expand the field of play beyond the boundaries of software but also to explore the intersection of making and critique. Whereas *Dwarf Fortress* embraces the granularity of computation over the specularity of graphical realism, delighting in the strange, formal logics of the computer, Dwarven Epitaphs convert world generator to story generator and mark the dissonant registers produced between human operators and nonhuman operations.

STRIKE THE EARTH!

Before playing *Dwarf Fortress,* one must first write the history of the world. There are no preset level designs or narrative scenarios

authored in advance. Instead, *Dwarf Fortress* offers players dozens of menus filled with detailed parameters for generating over one thousand years of natural and social history. Basic options include the size and age of the world, the composition of the soil, the character of the wildlife, the number of civilizations expected to develop, and even the probability of "forgotten beasts" roaming the underworld. Once these parameters are set, the application's smallish, 640 × 300 pixel window begins to whir with activity as everything from badger boars to bauxite boulders emerge from combinations of simple mechanics (see Figure 6.1).

World generation begins with a single seed: a pseudo-random number that acts as a kernel initiating *Dwarf Fortress*'s dynamic systems. What starts as straightforward elevation variants and temperature settings births atmospheric pressure systems that condense to form rivers, lakes, mineral formations, and, finally, vegetation. From there, ecosystems develop supporting different types of forests, foliage, fruits, and flowers. Various species of insects, rodents, predators, and prey settle each virtual environment alongside dwarves, elves, and humans. Mountains move and seasons change as civilizations spread and roads stretch across the 40 × 40 character grid of twinkling tokens. The typographic characters seen here are mimetic: a dark green "♠" could represent a particularly dense forest, whereas a teal "⊥" might denote a tributary flowing into a larger river. Zooming in for a closer look, these characters change their meaning. As Jonah Weiner (2011) writes in an article for the *New York Times*: "a normal person looks at ♠§dg and sees gibberish, but the *Dwarf Fortress* initiate sees a tense tableau: a dog leashed to a tree, about to be mauled by a goblin." Despite its constrained poetics and modest visual scale, *Dwarf Fortress*'s complex physics simulations manage to stress the processing capacity of most computers, slowing other activity to a crawl while an otherwise unassuming pocket planet slowly develops.

After world generation is complete, the player is given the option between three distinct play styles: "Legends," "Adventure," and "Fortress." By far the most popular way to play and the game's namesake, Fortress mode begins by randomly assembling a company of seven dwarves, who embark to a site of the player's choosing in the hope of founding a new dwarven outpost. During

FIGURE 6.1. World generation (above) can produce over one thousand years of nonlinear history based on dynamics such as rainfall, drainage, savagery, and volcanism (below).

the painstaking preparation process, each of the seven dwarves is outfitted with tools and trained in specific professions. These jobs range from the staples of agrarian fantasy, like mining, woodcutting, fighting, fishing, and brewing, to the arcane and often absurd beekeeping, lye making, siege engineering, glass blowing, record keeping, pump operating, and even small animal dissection. After choosing an assortment of household supplies, domesticated animals, and alcoholic beverages (which the dwarves require "to get through the working day"), the player's new party of ☺'s are plunked into the middle of an entropic environment. Their first task? To construct an architecture resistant to both the forces of nature and the volatile nature of the dwarves themselves.

At this point, the game becomes a mixture of city building, military strategy, and physics simulation. In *Dwarf Fortress,* the player can mark mountains to be mined, trees to be chopped, plants to be gathered, and architecture to be built via the designations menu (see Figure 6.2). After constructing workshops, further designations allow players to direct dwarves to build furniture, plant seeds, switch levers, and, of course, brew beer. Unlike most simulation, city-building, and strategy games, however, there is no guarantee that any one dwarf will respond exactly to the player's demands.[1] If the carpenter has not built enough barrels to store the beer being brewed, the brewer will simply quit his job and find something

else to do. Dwarves form elaborate chains of interdependence that are always at risk of being interrupted by bad weather, bad attitudes, or even a stray badger boar or bauxite boulder. As the game grows in complexity, the truly autonomous nature of the dwarves intensifies, as what could be called a "dwarven culture" begins to spontaneously emerge. While a couple holes in the ground are adequate to suit the needs of seven dwarves, seventy dwarves will not peacefully coexist without organized labor, social hierarchy, clean living conditions, and a constant flow of alcohol. Even with barracks, kitchens, workshops, and stockpiles in constant upkeep, there is always the possibility of a single disgruntled dwarf setting off a chain reaction of violence or "tantrum spiral"—their fragile psyches only rivaled by the fragility of their civilization.

The relationship between player and dwarf is only strained further by the game's minimal visual design and frustratingly counterintuitive graphic user interface (GUI). Despite the availability of both two- and three-dimensional GUIs, many of *Dwarf Fortress*'s players continue to interface with encoded representations in the form of simple matrices of multicolor type. More specifically, *Dwarf Fortress* uses a set of slightly modified code page 437 (CP437) characters in sixteen different colors to represent its world, a throwback to the textual interface of MS-DOS on the original IBM PC. Though not strictly text based (the individual glyphs are actually bitmap textures rendered in OpenGL and can be exchanged for alternative tile sets [see Figure 6.3]), *Dwarf Fortress* is clearly programmed in the idiom of text-based gaming, adding techniques like artificial intelligence (AI) and physics simulation to the lineage of games such as *Colossal Cave Adventure* (1975–6) and especially *Rogue* (1980).[2] More visually complex rendering techniques, such as overlapping, transparency, and three-dimensional positioning, are eschewed in favor of simpler effects.[3] Though many contemporary games are built on the mechanic and thematic innovations of these textual predecessors, *Dwarf Fortress* employs the enhanced processing power of contemporary home computers to push not pixels but processes.

With the constant uncertainty of both the dwarven AI and the stone age GUI, building a dwarf fortress often seems like an exercise in futility. Just learning the game's controls and interface—a

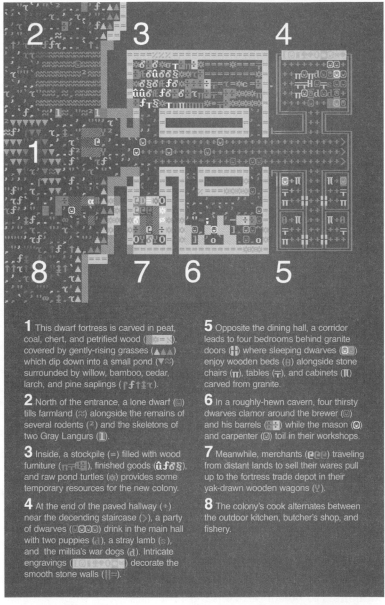

1 This dwarf fortress is carved in peat, coal, chert, and petrified wood (▓▒≡▒), covered by gently-rising grasses (▲▲▲) which dip down into a small pond (▼≈) surrounded by willow, bamboo, cedar, larch, and pine saplings (♠♣↑♣τ).

2 North of the entrance, a lone dwarf (☺) tills farmland (≈) alongside the remains of several rodents (²) and the skeletons of two Gray Langurs (Ï).

3 Inside, a stockpile (=) filled with wood furniture (π╥╢▤), finished goods (û♪♂§), and raw pond turtles (▨) provides some temporary resources for the new colony.

4 At the end of the paved hallway (+) near the decending staircase (>), a party of dwarves (☺☺☺☺) drink in the main hall with two puppies (d), a stray lamb (s), and the militia's war dogs (d). Intricate engravings (▓☺▒♦▒○▒▬▓) decorate the smooth stone walls (║═).

5 Opposite the dining hall, a corridor leads to four bedrooms behind granite doors (╫) where sleeping dwarves (☻☻) enjoy wooden beds (θ) alongside stone chairs (π), tables (╤), and cabinets (Π) carved from granite.

6 In a roughly-hewn cavern, four thirsty dwarves clamor around the brewer (☺) and his barrels (▆▟) while the mason (☺) and carpenter (☺) toil in their workshops.

7 Meanwhile, merchants (☺☺☺) traveling from distant lands to sell their wares pull up to the fortress trade depot in their yak-drawn wooden wagons (Ÿ).

8 The colony's cook alternates between the outdoor kitchen, butcher's shop, and fishery.

FIGURE 6.2. A cross-section of a growing dwarf fortress reveals about thirty dwarves living with their pets and livestock among bustling workshops and brimming stockpiles.

FIGURE 6.3. *Dwarf Fortress*'s standard tile set (left) compared with "Gold Plated" by Russian community member DrD_AVEL (right).

labyrinth of nested, text-based menus—is a serious undertaking that has inspired hundreds of hours of fan-made video tutorials, thousands of articles on the community-run "Magmawiki," and even publications like Peter Tyson's (2012) *Getting Started with Dwarf Fortress: Learn to Play the Most Complex Video Game Ever Made.* Alongside these substantial usability issues, it is in no way clear *how* to build a dwarf fortress or even *what* a dwarf fortress is. Though a player may use the game's menus to designate a given space as "bedroom" or "dining room," there are no strict requirements regarding their architecture outside of constructing a bed or table. With no clear-cut goals, only self-motivated players continue to tinker with the system after their first exposure, and this general lack of direction opens the question of whether *Dwarf Fortress* is a game at all. In the end, players decide for themselves whether it is toy or tool, sandbox or simulation.

Uncertainty in terms of how to play is at least partly due to the particularities of the Adamses' production process. For the past ten years, *Dwarf Fortress* has existed as a constant work in progress, an alpha build (currently 0.34.11) promising future versions beyond the horizon of 1.0, a release that the Adamses joke could take decades. Before proper beta testing begins, an "alpha" designation implies the phase of development in which a videogame is first playable but by no means complete. Although, in the case of *Dwarf Fortress,* alpha status allows the Adamses to continue developing new dynamics for their simulation, the indefinitely incomplete project results in frequent updates, instability, and a general lack of refinement typically resolved by in-house playtesting. Owing to the combination of this seemingly infinite alpha status with the game's capricious mechanics, bare-bones interface, and sheer

difficulty, Greg Costikyan (2011) concludes that "Dwarf Fortress is a game from an alternate universe." He imagines a history of videogames in which "there never was a revolution in computer graphics," although "Moore's Law...progressed just as it has in our own [timeline]." For Costikyan, *Dwarf Fortress* conjures a parallel reality in which "[Chris] Crawford's 1980s claim that 'process intensity' rather than 'data intensity' was the future of games" turned out to be true. *Dwarf Fortress* challenges the past three decades of game design so completely that Costikyan feels compelled to situate it within another world entirely because "no one in his right mind would have created it in our own."

In celebration of the game's unique, almost utopian problematics, the community ethos has become "failing is fun," and players have made it a practice to narrate their experiences, translating the inscrutable actions that take place in *Dwarf Fortress* into more legible accounts of play. Players exhume the remains of ancient civilizations and build Dwarven Epitaphs commemorating past plays and future failures. In *Archaeologies of the Future*, Fredric Jameson (2005, xiii) writes that "at best Utopia can serve the negative purpose of making us more aware of our mental and ideological imprisonment...and that therefore the best Utopias are those that fail most comprehensively." The ludic and narrative failures of this "game from another world" disrupt the logic of capital and produce an alternative history of videogames dictated not to production schedules, release dates, intellectual property rights, and executable code but to play.

NARRATIVE BOOKENDS

Dwarf Fortress begins and ends with stories. Narratives serve as both the inspiration for Adamses' software as well as a frequent result of playing with their system. The game's design can be traced to a series of short stories written by Zach Adams, a student of ancient history and an amateur writer with a penchant for bite- (or byte-) sized genre fiction. To devise new game mechanics for *Dwarf Fortress*, the brothers carefully analyze Zach's short stories in an attempt to uncover the underlying dynamics driving the logic of the fantasy genre, or at least its most recurring settings and plotlines (Adams and Adams 2006–11). After their collaborative

analysis, Tarn sorts each idea into card catalogs, which rank *Dwarf Fortress*'s design goals according to their plausibility and urgency. Working from mid-afternoon into the early morning on a daily basis, Tarn integrates these rules into the larger system of algorithmic processes running *Dwarf Fortress*. Needless to say, the resulting simulation never unfolds completely as expected. The experience of playing *Dwarf Fortress* can swing wildly between frustration and delight as the emergent mechanics and occult interface obfuscate any immediate understanding of the simulation. Because of its arduous gameplay and outright difficulty, the inevitable fall of each dwarven fortress is often followed by an afterword. In a rare case in which history is written by the losers, players return *Dwarf Fortress* to the textual format from which the Adams brothers began by narrativizing their experience on blogs and forums. They exchange short stories, illustrations, comics, schematics, analysis, and even modifications of Tarn and Zach's system. New ways to play are constantly being invented as these player-produced narratives complete the long circuit of translation and codevelopment between human and computer to become Dwarven Epitaphs.

Before building fortresses and erecting epitaphs, the Adams brothers mined Zach's short stories to unearth the game's mechanics. In one of his entries titled "Battlefield Lunch," Zach details a range of activities surrounding the carrion left in the wake of a large battle. The main figure of the tale is a mysterious, "barely humanoid" monster that shares a gore-ridden field with the "widows of fallen soldiers searching for enemies that were still alive so they could torture them with their long knives" (Adams and Adams 2006). Based on this short episode, in which a lone hero is tripped by a dying foe, only to become the beast's "freshest meal ... in weeks," the Adams brothers discover several behaviors not yet simulated in *Dwarf Fortress*. Among their notes are the following:

- large scavengers eating the dead
- entity hatred can manifest through acts of torture on those that can't defend themselves
- wrestling: tripping people, becoming impaled on ground objects (Adams and Adams 2006)

By analyzing the narrative to extract its implicit tropes and conventions, the Adamses attempt to translate the rules of the storyworld into the algorithmic processes running *Dwarf Fortress*. The hope is that, by identifying and encoding patterns such as revenge, scavenging, and grappling, narrative events akin to those described in "Battlefield Lunch" will propagate widely across the simulation. Thus *Dwarf Fortress* is not so much a digital-born artifact as it is "born translated." In his essay in this volume (chapter 11), John Zuern appropriates Rebecca Walkowitz's concept of "born translated" to argue for the "affinity between comparative literature and digital literary studies," and *Dwarf Fortress* stands as an excellent example of an object that cannot be regarded as a stable piece of software but rather as a process of intertwined production and play that is constantly engaged in a series of textual translations and remediations.

This translation process, however, is deepened when each of Zach's original stories is encoded into a computational environment operating under an entirely alternative set of temporal, spatial, and causal logics. The result of distilling and translating genre fiction into game mechanics does not produce infinite, ready-made fantasy stories that mirror Zach's writing. Instead, *Dwarf Fortress* generates an even more interesting, destabilized spool of diachronic ticker tape documenting a thousand years in the span of a few seconds. The computer produces the stories of processor cycles as much as cyclopses and refresh rates as much as ratmen. In one game set across a thousand-year time scale, *Dwarf Fortress*'s world generation will typically produce about fifty thousand noteworthy characters participating in over half a million events in thousands of locations. When confronted with these sprawling catalogs, stylistically reminiscent of only the barest of narrative forms—the calendar, the chronology, and the chronicle—the player is left to wonder how, for example, does a gathering cold front in the early autumn of the year 128 impact her activities over a thousand years later? Why document the construction of the market Kux Ungod, "The Cup of Gallows," in the first year of the world? What was so important about the incident of the stolen rutile ring, spirited from Elevated Dungeon in Blizzardwitch by the kobold Lrakildus? Considering these are just three of the

millions of randomly generated plot points produced during one instance of *Dwarf Fortress*'s world generation (and the average player will typically generate multiple worlds before deciding to settle on one scenario), a comprehensive survey of this material is impossible. Given an entire lifetime, no human could ever exhaust the content of this book of sand.

After *Dwarf Fortress* simulates its stream of serial events, players interact with these macro- and microhistories to translate the processes of a computer back into legible, narrative forms. Tim Denee's quirky and beautifully rendered comics *Oilfurnace* and *Bronzemurder* depict the bizarre domino effects leading up to the destruction of more than one dwarven civilization (see Figure 6.4). Inspired by the events of specific play sessions, these blocky, paper cutout–style renderings perfectly capture both the human error and dwarven eccentricities that make "losing fun" in *Dwarf Fortress*. Another example of translation can be seen in the painstaking research and attempts to narrativize the remarkable history of the dwarf Tholtig Cryptbrain, a statistical anomaly discovered in *Dwarf Fortress*'s Legends mode and the sole survivor of a century-and-a-half-long war in which she claimed 2,341 unique kills. Tholtig's story is a death-defying feat not of skill but of chance and probability. Finally, and even more puzzling, "The Design for a Dwarven Computer" is a computer engineering project that attempts to render the computational processes of *Dwarf Fortress* in terms of the dwarves themselves and has been dubbed the game's first "megastructure." The schematics for this mechanical computer depict expansive fields of pumps, levers, and switches that blanket most of *Dwarf Fortress*'s in-game environment and, given the speed of water and willfulness of the dwarves, exhaust the labor and life cycle of an entire civilization to process a few clock cycles of this prehistoric computer. These players examine the unexpected and often inscrutable operations of *Dwarf Fortress* by relocating millions of in-game deaths from the register of computational statistics back into human-legible accounts of play. Instead of forfeiting at the first sign of adversity (or anomaly), the Dwarven Epitaphs of *Oilfurnace,* Tholtig Cryptbrain, and the Dwarven Computer transform the end of the game into an endgame in itself—moving beyond the software

to engage in a form of comparative textual media by translating the actions of the game into walkthroughs, schematics, and novelizations.

The most popular player-created history of *Dwarf Fortress* is the collaboratively authored tale of "Boatmurdered" (2006–7). Originally penned on *The Something Awful Forums,* "Boatmurdered" documents a "succession game" in which different players took turns overseeing and recording the growth (and inevitable decay) of a single fortress (aptly named Boatmurdered) over the course of several in-game years. The player–authors produced a narrative framework from the game's procedural paradoxes. For example, in this particular playthrough, herds of hostile elephants wandered the jungles near Boatmurdered and became surprisingly disruptive to the development of dwarven civilization. The elephants, like many of the other creatures in this ecosystem, exhibit behaviors noted in Zach's short stories. For example, take the idea listed earlier that "entity hatred can manifest through acts of torture on those that can't defend themselves." One could speculate that these behaviors emerge in the elephants outside Boatmurdered as the players witnessed them "slowly torturing a war dog stuck outside" the walls of the mountain fortress (Various 2006–7). Here the ♠§dg from Weiner's earlier example transforms into an even stranger (and perhaps more unsettling) ♠§dE.

While this example demonstrates the relationship between Zach's narratives and Tarn's programming, the combination and layering of *Dwarf Fortress*'s complex dynamics take on a life of their own and produce unpredictable effects that do not always align with traditional forms of narrative and psychological causality. In another entry from the Boatmurdered saga, the bellicose elephants slay a dwarf who has wandered too far from the protection of the fortress. To one player's horror, an unfortunate loop propagates as, one by one, individual dwarves scurry from the safety of their mountain home onto the bloody field to loot and recover the corpses of their fallen countrymen. By exhibiting this form of scavenging behavior, one of the character traits explicitly identified in "Battlefield Lunch," almost twenty dwarves fall victim to this computational trap before the player intervened, writing (Various 2006–7),

FIGURE 6.4. Excerpts from the webcomic *Oilfurnace,* by Tim Denee, remind players that "losing is fun."

> Harsher fucking measures are necessary. I install two front doors and lock them. No one gets in or out. Boatmurdered is closed until further notice. . . . This basically stops the elephant problem for now as a temporary measure. . . . We lost about 20 dwarves to this debacle.

This unexpected effect is the aggregate of multiple game mechanics. By encoding Zach's stories into *Dwarf Fortress,* Tarn must have placed a higher priority on the routines driving each dwarf to acquire misplaced goods or stockpile corpses in designated zones over the functions accounting for the presence of danger. As they scamper across the battlefield, the artificial intelligence of each dwarf ignores the fact that the trampled bodies he intends to pick-pocket are the product of those elephants still in close proximity.

In writing their collaborative history of Boatmurdered, the succession of players inevitably anthropomorphize computational processes by assigning psychological behavior to the dwarves, describing them as irrationally "bound and determined to march to their deaths" (Various 2006–7). The legends created in and around

138 STEPHANIE BOLUK AND PATRICK LEMIEUX

Dwarf Fortress embrace the peculiar narrative effects emerging from the extended feedback loop between authorial intent and the experience of play. But exactly what happens between these two narrative bookends? Given the scale of the simulation and the number of rules interacting with each other, there is no way for the player to fully anticipate the emergent effects of dwarf and environment alike. Rather than lament this feature (which might even be construed as bugs or glitches in any other game), the possibility of inexplicable events is one of *Dwarf Fortress*'s most celebrated qualities. The pleasure in being unable to entirely foresee how the system will overwhelm the player is one of the reasons why, as Tim Denee quips, "losing is fun." The ephemeral and distinctive character of each gameplay session is what inspires players to mark particularly dramatic losses through the production of Dwarven Epitaphs like *Oilfurnace* and "Boatmurdered." These postmortem accounts of *Dwarf Fortress* narrativize the human experience of computational processes by appropriating the language of death to express not only the unexpected expiration of their dwarves but also the end of a traditional notion of play. Dwarven Epitaphs do not commemorate the fantasy of mastery in which one "beats" the game but instead appropriate death as a means to celebrate ephemeral moments of play in a system where "winning" is no longer a measurement of value.

THE EMERGENCE OF A DWARVEN COMPUTER

Videogames, unlike games of dice, cards, chess, or physical sports, conflate the rules of a game with the mechanics governing the environment in which the game is played. For example, nowhere in the rules of baseball is gravity defined, whereas in procedural games like *Dwarf Fortress,* the explicit authoring of forces such as gravity, weather systems, fluid simulation, and geophysics takes the place of traditional rule sets. Rules are social configurations, pacts between players not to peek or move outside invisible boundaries. As Bernard Suits ([1978] 2005, 10) argues in his philosophical treatise on games titled *The Grasshopper: Games, Life, and Utopia,* "rules prohibit more efficient in favor of less efficient means, and . . . playing a game is the voluntary attempt to overcome

unnecessary obstacles." Mechanics, conversely, are involuntary and necessary; there is no choice but to work within the constraints of these systems. Whereas rules can be broken, mechanics cannot be turned off. In this sense, there is no cheating in *Dwarf Fortress*. Exploits that rely on glitches or unplanned programming infelicities are still working within the logic of the software. From this perspective, direct modifications of the game's source code and each software update result in the production of a new and ontologically distinct game. Once *Dwarf Fortress* is operational, anything goes—from completely passive pause states to micromanaging the movements of a dwarven militia, there is no wrong way to play. This game does not have rules, only mechanics. Thus it could be argued that *Dwarf Fortress* is not a game at all but rather an ontological experiment.

Instead of suggesting guidelines from which to play, like "three strikes and you're out," *Dwarf Fortress* offers the ball and bat. For the community, the game functions as a tool set or platform from which to playfully experiment, author narratives, and invent new games. So though it can be called a physics simulation, a city-building game, and a story generator, the Adamses' software might feel more at home in the popular sandbox genre of computer software. Sandbox games are designed to allow players to experiment with a robust set of game mechanics without predicating play on any one scripted sequence of actions, events, and goals. Ranging from physics toys featuring particle and fluid dynamics to open-world, digital playgrounds where players can roam free, the most successful sandbox games model simple mechanics that combine to yield dynamic operations. The unexpected ludic consequences and extemporaneous narratives produced by these mechanics enable and encourage players to invent their own games within games—to build metagames like the Dwarven Epitaphs previously discussed. It is no surprise, then, that Tarn and Zach Adams invest in the concept of emergence as a core design philosophy within *Dwarf Fortress*. Emergent events seem nondeterministic but are caused by a small set of simple mechanics. When set in relation to one another, these mechanics become greater than the sum of their parts. In this sense, the Adamses are building Dwarf Physics more than *Dwarf Fortress*.

By simulating a physical world via emergent mechanics, *Dwarf Fortress* establishes an isomorphic relationship between geological processes and computation in a way that recalls Manuel De Landa's (1997) work on Gilles Deleuze and Félix Guattari's philosophy of emergence in *A Thousand Years of Nonlinear History*. In this "neomaterialist" reading of Deleuze and Guattari's "10,000 B.C.: The Geology of Morals (Who Does the Earth Think It Is?)," De Landa claims that "sedimentary rocks, species and social classes (and other institutionalized hierarchies) are all historical constructions, the product of definite structure-generating processes" (62). This kind of history, however, is not arbitrarily constrained to man-made writing but considers the movements of geological strata (alongside those of genes, memes, norms, and money) as forms of inscription in and of themselves. Recalling *Dwarf Fortress*'s computational landscapes, De Landa describes the accumulation of sedimentary rocks like sandstone or limestone as an emergent process in which "rivers [act] as veritable hydraulic computers (or at least, sorting machines) . . . [and sedimentation] is carried out by certain substances dissolved in water (such as silica or hematite in the case of sandstones) which penetrate the sediment through the pores between pebbles" (60). De Landa (1995) extends this homology between computation and sedimentation not only to pebbles drifting along the bottom of a river but also to the genetic drift of biomass across the surface of the planet. Despite this capacious account of organic matter in *A Thousand Years of Nonlinear History*, De Landa returns to what he calls a "basic geological spirit, a philosophical stance which rejects ideas of progress not only in human history but in all natural history as well." "Living creatures," he writes, "are in no way 'better' than rocks. . . . Indeed, in a nonlinear world in which the same basic processes of self-organization take place in the mineral, organic and cultural spheres, perhaps rocks hold some of the keys to understand sedimentary humanity, igneous humanity and all their mixtures." And what better than a dwarf to represent sedimentary and igneous humanity?

The flattened moral landscape of *Dwarf Fortress* dramatizes De Landa's nonhuman geological philosophy. If historical inscriptions underwrite the processes of nature, then there is a kind of code in

FIGURE 6.5. Jonathan Ng's "Design for a Dwarven Computer" envelops the landscape within *Dwarf Fortress*.

the soil. *Dwarf Fortress* expresses this logic by explicitly tying the activity of mining to computing. To dig is to code, and each dwarf is a data miner, a cog within a larger allegory of computational processes. "Computation, as defined in computer science, is a description of a regularly patterned machine operation," writes Terrance Deacon (2012, 95), and "in this respect, the workings of [a] desktop computer, or any other computing machine, are just the electronic equivalents of levers, pendulums, springs, and gears, interacting to enable changes in one part of the mechanism to produce changes in another part." This entwining of *Dwarf Fortress*'s geological processes with the mechanical and computational is best expressed through one of the most virtuosic "mega constructions" ever undertaken in *Dwarf Fortress*: the Design for the Dwarven Computer (see Figure 6.5).

Using *Dwarf Fortress*'s robust mechanics to produce circuitry, power sensors, registers, memory units, machine instructions, and arithmetic logic unit (ALU) architecture, Jonathan Ng has designed a fully functioning, universal computer within the game itself (Ganapati 2010). At first only appearing as a perverse inversion of scale, the full absurdity of the project is made clear once the digital logics of a computer are mechanized by canals, pumps,

and locks, moving water through mountains and maintained by dwarven militias for months as they slowly churn through the logical processes and computational tasks of a mainframe computer. Echoing De Landa, the rivers of *Dwarf Fortress* quite literally act as "veritable hydraulic computers," as the rise and fall of simulated water levels become storage devices for bit-wise operations.

In his essay "Reading *exquisite_code*: Critical Code Studies of Literature" (chapter 12 in this volume), Mark Marino writes that critical code studies "takes the analytic approaches of software studies and applies them to the source code." In 2012, Marino convened a working group in which *Dwarf Fortress* was discussed as an unconventional platform or "strange IDE" (integrated development environment) for designing projects like the Dwarven Computer, Dwarven Calculators, and even a Dwarven Game of Life based on John Horton Conway's classic example of emergence (Boluk and LeMieux 2012). Though building a fully functional ALU within the game itself cannot be considered "source code," the tools available to the player are flexible enough to implement many of the fundamental operations that make coding possible: Boolean variables, conditional statements, and even rudimentary operations like addition, subtraction, multiplication, and division. As Nick Montfort (2010) pointed out in a brief blog post, the Design for the Dwarven Computer is adapted from *The Elements of Computing Systems* (2005), a popular textbook that computer engineering students use to practice building CPUs.[4]

Although functional, the Dwarven Computer operates within the geological time scale of the game. A single calculation could take years of in-game time and require a multitude of mechanisms spanning acres of in-game geography. Moreover, the Dwarven Computer is in constant threat of being corrupted by the unpredictable and often slovenly behavior of the dwarves who maintain its mechanism (not to mention goblin infestations and even environmental processes like evaporation and leaking in the slowly pumping logic gates). By transposing the typical speed of computer processing into a geological register, these in-game computers juxtapose sub-human microtemporalities with superhuman macrotemporalities to conflate two limit cases of human experience. *Dwarf Fortress* enables a computer to not only remake the world but also remake

itself within that world. A potentially endless loop of creation and emergence oscillates between these geological and computational registers, while the human player is reduced to the position of helpless bystander, the flickering symbols of a dwarven wilderness spinning on and off at a subsecond or century-long time scale.

A HISTORY OF THE WORLD

"As history has infiltrated physics," De Landa (1997, 15) writes, "we must now allow physics to infiltrate human history." This is the position from which *Dwarf Fortress* commences: by inscribing a speculative history that begins, almost biblically, with the birth of the world and the creation of a thousand years of nonlinear history. Within this time span, civilizations form and legends are written featuring only a fraction of the events created during world generation (some hundred thousand entries). In *Dwarf Fortress*'s Legends mode, the player has access to text logs detailing the procedural history of every geographical formation, architectural construction, civilization, and historical figure. It is possible, for example, to pull up the historical records of a dwarf who lived and died in the subsecond cycle of a computer processor. The microtemporality of this emergent environment signals the horizon of human phenomenology. When framed against the scale of Earth's geological time, human lives flicker on and off as quickly as the billions of binary operations that drive each dwarf.

Thousands upon thousands of seemingly insignificant details are indexed from a much larger set of processes. Each of these tiny transactions is then parsed into queryable databases and assigned textual signifiers. Cobbled together from the Adamses own fictional etymologies and organized in the form of a chronology, computer processes are given names. The result is a textual archive that reads more like *The Silmarillion* than *Lord of the Rings*.[5] The irony of *Dwarf Fortress*'s microtemporal history is the way its procedural capaciousness is thrown into relief by its minimal textual output and interface. Taking a random sample:

- In the early spring of 1036 Fiviirafe, "The Furious Assault" occurred.

- In the early spring of 1037, The Pelts of Stabbing defeated The Complex Councils of The Snarling Empires and pillaged Touchbottle.
- In the early spring of 1037, The Oracular Realms accepted an offer of peace from The Static Lyrics.
- In 1042, the human Nani Hopplait became the master of The Nations of Gravel.
- In the early spring of 1043, The Rampage of the wolf Perad Crewedtrifle in Beachstop occurred.

The historical texts of *Dwarf Fortress* seem to exemplify what Noah Wardrip-Fruin (2009, 16) calls the *"Tale-Spin* effect."[6] *Tale-Spin* is an early story-generation system invented in the mid-1970s by James Meehan while he was studying at Yale. Wardrip-Fruin argues that the simplicity of *Tale-Spin*'s textual output obscures the complex processes required to simulate a navigable space, to set interactive objects within the space, and model the psychological processes of its inhabitants. The *Tale-Spin* effect can be seen in the stilted, curt language and sometimes unintentionally surreal events produced by *Dwarf Fortress*'s complex dynamics. Despite the attempt to describe the movements of several artificially intelligent agents in the preceding example, the historical sequence appears strange and arbitrary, with no transitional expressions or conjunctive adverbs to tie together the sentences. There is a hidden complexity that operates according to the formal consequences of computation rather than the narrative logic of an author or reader.

If the *Tale-Spin* effect is produced when a deceptively straightforward interface obfuscates some underlying, operational complexity, then the *"Dwarf Fortress* effect" may describe the deliberate implementation of the *Tale-Spin* effect to produce ludic, cognitive, or phenomenological defamiliarization. Usability, in this case, is contingent on inscrutability. The Adamses deploy an anachronistic textual interface that draws on earlier modes of historical writing to extend the homology between the geological and computational processes of *Dwarf Fortress* to the concept of history itself. *Dwarf Fortress*'s linguistic forms of historical inscription in Legends mode bear a striking formal and thematic resemblance to early forms of writing, such as the medieval annal and chronicle. In *The Content*

of the Form, Hayden White (1987) defines the annal as a collection of historical events listed year by year. The annal is distinguished from the chronicle, which also takes on the form of a list but is organized around a strong central subject (e.g., a church's history). Both forms lack the narrative causality that White attributes to contemporary historical writing, and for this reason, both have been regarded as somehow incomplete or underdeveloped modes of historical representation. By contrast, White argues that the annal and the chronicle are not ideologically primitive forms of inscription but instead embody a fully developed but radically different philosophical worldview. He proposes that these forms of medieval writing have been misrecognized in much the same way that it is easy to misinterpret the output of *Dwarf Fortress.* Like *Dwarf Fortress,* the annal deprivileges the place of the human within a larger cosmological landscape.

Compare the previous excerpt from *Dwarf Fortress* to the *Annal of Saint Gall,* which serves as White's principal case study (as quoted in White 1987, 6–7):

709. Hard winter. Duke Gottfried died.
710. Hard year and deficient in crops.
711. Hard year and deficient in crops.
712. Flood everywhere.
713.
714. Pippin, mayor of the palace, died.
715. 716. 717.
718. Charles devastated the Saxon with great destruction.
719.
720. Charles fought against the Saxons.
721. Theudo drove the Saracens out of Aquitame.
722. Great crops.
723.
724.
725. Saracens came for the first time.
726.
727.
728.
729.

730.
731. Blessed Bede, the presbyter, died.
732. Charles fought against the Saracens at Poitiers on Saturday.
733.
734.

One could describe these narrative forms as having suffered from a kind of literary *Tale-Spin* effect, having been denigrated as incomplete historical productions compared with more familiar and narratively rich modes of contemporary historical writing. While the paralinguistic features of modern typography have homogenized the way in which writing is interpreted, in chapter 5 of this volume, William A. Johnson notes that the legibility of historical forms of writing often depended not on information contained within the text itself but on the particularities of historical reading practices. Where to pause, breathe, separate words, toggle between various columns, raise or lower one's voice, or speed up or slow down were conventions passed on from teacher to student and not encoded within the bookroll itself. Reading was a social practice embedded within a much larger cultural and medial context. And while reading texts from *any* era always entails an act of interpretation, this fact is compounded when learning to read historical documents with alternative paralinguistic features. The same situation applies to learning the rules and linguistic codes of *Dwarf Fortress*'s eccentric textual interface. The Adamses' choice to depict the in-game historical events as overwhelming in terms of scale yet narratively sparse is not simply a product of the immense technical constraints and challenges that govern the development of a complex procedural storytelling system. By simulating a mode of historical inscription from which modern readers are estranged, *Dwarf Fortress* produces an allegory for the relationship between human and nonhuman. Both the microtemporality of computer process and the macrotemporality of geological phenomena trace their own kinds of nonlinear, nonhuman histories within different scales of silica. These times and scales, both big and small, macroscopic and microscopic, operate outside the phenomenal capacity of any human reader to produce a history without subjects.

Both Johnson and White take contrasting approaches toward

the absence of information in early writing. Whereas Johnson attributes a rich and lively sociotechnical context through which bookrolls circulated and on which their meaning was dependent, White understands the gaps and narrative disjunctures as symbolic of an alternative philosophy of history. White attempts to recuperate the annal and chronicle forms by arguing that they are not "imperfect histories" but rather "possible conceptions of historical reality, conceptions that are alternatives to, rather than failed anticipations of, the fully realized historical discourse that the modern historical form is supposed to embody" (White 1987, 6).

For White, the form of the annal rejects Hegelian grand narratives of historical progress and presents a world indifferent to human struggle. Both the medieval annal and the chronologies of *Dwarf Fortress*'s Legends mode follow a narrative model that is nonteleological and that deprivileges the place of the human within historical time. White not only reads specific genres of writing as nonteleological, but argues for a reading of the history of history which is itself nonprogressivist. In this way, White resists historiographic narratives that suggest historical writing culminates in familiar styles of contemporary forms. But beyond the formal similarities between White's medieval texts and the Adamses' software, there are also significant thematic resonances as they catalog related types of events. White notes how the annal "immediately locates us in a culture hovering on the brink of dissolution, a society of radical scarcity, a world of human groups threatened by death, devastation, flood, and famine" (7). Similarly, the inhabitants of *Dwarf Fortress* are at constant risk of being overrun by the indifferent computational wilderness in which they are placed. Although both *Dwarf Fortress* and *The Annal of Saint Gall* depict a society in a state of perpetual crisis, there are few reasons explicitly given in either that explain why events occurred. White writes,

> Why "Charles fought against the Saxons" remains as unexplained as why one year yielded "great crops" and another produced "flood everywhere." Social events are apparently as incomprehensible as natural events. They seem to have the same order of importance or unimportance. They seem merely to have occurred, and their importance seems to be

indistinguishable from the fact that they were recorded. In fact, it seems *their importance consists in nothing other than their having been recorded.* (8; emphasis added)

In *Dwarf Fortress,* the geological, biological, and social elements of the game exist as similarly incomprehensible forces and function on a flattened ontological plane. Events in *Dwarf Fortress* are recorded simply because they *happened.* Echoing White's remarks on the annal, their importance consists in "nothing other than their having been recorded." White emphasizes that annalistic forms of historical inscription make no reference to a "system of merely human morality or law" (14) that is comparable to the computational logic that drives *Dwarf Fortress,* a game in which the histories of merchants, mountains, kings, and cats are documented with equal orders of magnitude and the experience of the reader or player appears only as an afterthought. White attributes the seeming neutrality of the annal to being a product of a theistic cosmology: "since everything that happened did so apparently in accordance with the divine will, it is sufficient simply to note its happening, to register it under the appropriate 'year of the Lord'" (13).

Supporting the comparison between medieval cosmology and flattened ontology—as depicted in the Legend mode's sprawling databases, which log computational processes in the form of historical inscriptions—players resort to assigning metaphysical and supernatural explanations to unexpected in-game phenomena. On the occasion of a particularly surprising or illogical game mechanic (some of which the human player or programmer might characterize as bugs or glitches yet that are in no way ontologically distinct from other game mechanics), it is not uncommon for players to narrate their dwarves experiencing a divine act of God or some form of supernatural magic, neither of which is currently implemented in Tarn and Zach's system. Instead, the machinic processes of *Dwarf Fortress* are cast in a role similar to that of an indifferent, absent God—a kind of deus ex machina that is strikingly distinct from the version Aristotle critiqued in his *Poetics.* Rather than the unmotivated yet just-in-time divine intervention of a user-friendly deity that responds to prayers and

solves queries, the god-in-the-machine of *Dwarf Fortress* is a black box, a force that infinitely recedes from view and from whom the human remains forever and inexorably estranged.

DWARVEN EPITAPHS

Although operating from different ends of the philosophical spectrum, both White's narratology and De Landa's realism argue for a nonteleological model of history that rejects narrative coherence and the logic of progress in favor of a model of discontinuous and emergent complexity. The rise of electronic forms of inscription applies further pressure to the traditional concept of history. As theories of history have been deeply wedded to forms of chirographic and print writing, it is no coincidence that hyperbolic claims about the "end of history" have been made in an era in which print has come to the end of its dominance.[7] Digital technologies are not only reconfiguring historical models, but perhaps the perception of digital media as endlessly new and its implied lack of historicity are the result of lingering print-centric assumptions. In any case, new forms of historical inscription are now being automated on an unprecedented scale. Networked videogames log every keystroke while a Google Document records where, when, and by whom each revision was made. Smart phones report GPS coordinates and generate maps of each carrier's geographical movements, while databases, digital archives, and cloud computing support the storage of thousands of petabytes of data. Digital technologies are writing a microtemporal history of dynamic processes that include, but are not limited to, the movements of humanity. Despite this extrafunctional, machinic history appending each and every technological inscription, we continue to simultaneously ignore *and* overestimate our position as the subject of history. The history of the dwarf, however, throws human history into radical relief.

By rendering historical forms of narrative on a microtemporal scale, *Dwarf Fortress* simulates contemporary models of historical inscription. The game operates according to the same automatic and serialized logic as telephone records, bank statements, GPS systems, and e-mail exchanges. By attempting to narrativize records of processor cycles and refresh rates, players produce Dwarven

Epitaphs. Dwarven Epitaphs are memorials, monuments of critical play—a productive, practical play that generates metagames. These player-designed games created in, on, around, and about other games resist and operate outside the ontology of the Adamses' procedural world. They break the rules and make losing fun. Metagames relocate abstract, autonomous software into human spheres of play and teach us to recognize the actions of the nonhuman agents with which we constantly collaborate in all aspects of contemporary life. In this sense, dwarves live within us, around us, and without us—in vaccines and antibiotics, in mechanical and computational systems, and in the geological and cosmological happenings of the universe. The role of the human, then, is not to play videogames but to produce metagames, Dwarven Epitaphs historicizing the strange interactions amid incomprehensible ontological territories. And though we can speculate on the existence of dwarves and how deeply they affect our lives, we can never experience the radically distinct ontological spaces of the digital, the temporal, and the cosmological. The lives of dwarves are a mystery, but players continue to memorialize their history on blogs, forums, and wikis. Dwarves must die for this game to be fun.

NOTES

1 In *Dwarf Fortress,* the role of the player is not to control each individual dwarf, as with most real-time strategy (RTS) games starting with *Dune II* (1992) and the original *Warcraft* series (1994–2003). Though the RTS genre shares the same bird's- or god's-eye perspective with *Dwarf Fortress,* its gameplay relies almost entirely on harvesting, building, defending, and attacking with units that respond to the player's mouse clicks in real time. Dwarves, conversely, have a mind of their own. They are more similar to the autonomous agents populating city-building games like *SimCity* (1994) than the space marines of military-strategy games such as *StarCraft* (1998). However, in contrast to *SimCity* and most simulation games' depiction of humans as rational agents whose population size correlates directly to player progress, dwarven behavior is idiosyncratic at best and seemingly random at worst. The player's task, then, is to attempt to

curb the disruptive capacities of the dwarves by designating tasks that will keep them busy, comfortable, and full of enough food and drink to remain stable.

2 Interactive fiction like Will Crowther and Don Woods's *Colossal Cave Adventure* and Infocom's *Zork Trilogy* (1980–82) allowed players to interact with environmental descriptions and spatial riddles through a command-line interface able to register simple expressions such as "look up," "walk north," and the iconic "get lamp." In the text-based dungeon crawlers following *Rogue,* players guide a typographic glyph (often an anthropomorphic "@" sign) through randomly generated mazes of periods, pipes, and other forms of punctuation. Both textual descriptions and text-based representations are implemented in the Adamses' game.

3 E.g., if two or more characters occupy the same tile in *Dwarf Fortress,* their cohabitation is visualized through a simple animation that cycles through each entity's symbol in a slow blink. Somewhat misleadingly, this same method is used to show status updates. A dwarf, represented by a "☺" icon, blinking with a blue downward-pointing arrow signifies thirst, a gray capital "Z" means the dwarf is sleeping, and a variety of exclamation points suggest various levels of unrest: blue for melancholy, purple for possession, teal for insanity, and yellow for the dreaded tantrum. On top of all these codes, confusion arises when a single dwarf inhabits a space with other objects, extending a simple blink mechanic beyond two frames. In *Dwarf Fortress,* space itself behaves oddly owing to these text-based logics. As the saying goes, one tile is big enough to contain one thousand dragons lying down but too small to hold two dwarves standing up. Furthermore, one thousand dwarves lying in the same bed might render an illegible panoply of blinking status updates, and only one dwarf could stand up to leave at any one given time. Modifications that attempt to render *Dwarf Fortress* in three dimensions encounter similar visualization challenges given the spatial eccentricities of Tarn's tile-based world.

4 *Dwarf Fortress* is by no means the only game in which players have attempted to create a functional computer. From *LittleBigPlanet* (2008) to *Minecraft* (2010–), students and hobbyists interested in computer engineering have transformed various game platforms into constrained development environments. Essentially, any game that has the capacity to produce a logic gate also has the potential to be transformed into a computer. W. Daniel Hillis's (1998) tinker-toy computer is proof of this basic concept, which he elaborates in his

aptly named book *The Pattern on the Stone.* Hillis writes, "Present-day computers are built of transistors and wires, but they could just as well be built, according to the same principles, from valves and water pipes, or from sticks and strings" (viii). In addition to the Dwarven Computer, there have been experiments such as the fully functional, 16-bit ALU in *Minecraft* and the "Little Big Calculator" in *LittleBigPlanet.* These games continue to function as platforms, strange IDEs for playing with programming and programming play.

5 It is telling that Tarn Adams (2009) explicitly invokes J. R. R. Tolkien's *The Silmarillion,* the encyclopedia of mythic short stories, genealogies, maps, etymologies, and songs that form the "back end" to the more narratively cohesive *Lord of the Rings* (the far more commonly cited inspiration for fantasy fiction). *The Silmarillion* was not a stable mythology but "a continuing and evolving creation extending over more than half a century" (Tolkien 1977, 7). It was the database Tolkien used to build his world and on which he subsequently relied to write his more popular novels. Tarn Adams (2009) has also noted the influence of *Romance of the Three Kingdoms* and *Water Margin* on his work. In *Water Margin,* for example, there are one hundred and eight heroes, and *Romance of the Three Kingdoms* chronicles the lives of hundreds of characters. These texts resonate with the scope, scale, and dynamics of *Dwarf Fortress.*

6 Wardrip-Fruin (2009, 15) contrasts the *Tale-Spin* effect with what he calls the "*Eliza* effect." *Eliza* (1966), also known as *Doctor,* was one of the first chat bots. The program simulated conversation with a Rogerian psychotherapist in the form of natural language and even responded to the user's input. Although the mechanics of *Eliza–Doctor* are deceptively simple in the way they convert a user's answers into questions, the expectations of the audience made the AI appear more complex than it actually was. *Dwarf Fortress* suffers from the opposite affliction to the extent that players of the game resorted to building their own *Dwarven Therapist* (2009–). This software helps players to "interpret" the dwarves' complex moods, personalities, and emotional capacities, dispelling the *Tale-Spin* effect by transforming obscure, textual data into straightforward spreadsheets in line with the more traditional functions of a score sheet or status menu.

7 The associations of the terms *prehistoric* and *posthistoric* reinforce this point. The term *prehistoric* generally refers to the time before the emergence of writing as an inscription technology. As Kittler (1999, 4) notes, "history was the homogenized field that, as an academic subject, only took account of literate cultures. Mouths and graphisms

were relegated to prehistory." What is sometimes referred to as the posthistorical condition of new media also reflects the displacement of print as the privileged form of historical inscription. There are both technological and economic reasons for why new media have been accused of reflecting a dehistoricized impulse. Wendy Chun (2008) describes digital storage as a condition of "enduring ephemeral," and Terry Harpold (2009) has argued that the history of networked and programmable media has been subject to a dehistoricized "upgrade path"—the endlessly rewritable "new" in a new media economically constructed around planned obsolescence.

REFERENCES

Adams, Tarn, with Kyle [Capntastic] Brodzky and Nathan [Rainseeker]. 2009. "Dwarf Fortress Talk #1." Bay 12 Games. August 6. http://www.bay12games.com/dwarves/df_talk.html.

Adams, Tarn, and Zach Adams. 2006. "Battlefield Lunch." Bay 12 Games. May 31. http://www.bay12games.com/dwarves/story/tt_battlefield_lunch.html.

———. 2006–11. "Threetoe's Stories, and Analysis." Bay 12 Games. http://www.bay12games.com/dwarves/dev_story.html.

Apple. 2012. "Mac 101: Time Machine." June 18. http://support.apple.com/kb/HT1427.

Boluk, Stephanie, and Patrick LeMieux. 2012. "Play: Strange IDEs and the Design for a Dwarven Computer." Critical Codes Studies Working Group 2012. February 16. http://wg12.criticalcodestudies.com/discussion/54/play-strange-ides-and-the-design-for-a-dwarven-computer#Item_10.

Chun, Wendy Hui Kyong. 2008. "The Enduring Ephemeral, or the Future Is a Memory." *Critical Inquiry* 35, no. 1: 148–71.

Costikyan, Greg. 2011. "*Dwarf Fortress*: A Game from a Parallel (and Better?) Universe." http://playthisthing.com/dwarf-fortress.

Deacon, Terrence William. 2012. *Incomplete Nature: How Mind Emerged from Matter*. New York: W. W. Norton.

De Landa, Manuel. 1995. *The Geology of Morals: A Neo-materialist Interpretation*. http://www.t0.or.at/delanda/geology.htm.

———. 1997. *A Thousand Years of Nonlinear History*. New York: Zone Books.

Ganapati, Priya. 2010. "Geeky Gamers Build Working Computers Out of Virtual Blocks." October 12. http://www.wired.com/gadgetlab/2010/10/virtual-computers/.

Harpold, Terry. 2009. *Ex-foliations: Reading Machines and the Upgrade Path*. Minneapolis: University of Minnesota Press.

Hillis, W. Daniel. 1998. *The Pattern on the Stone: The Simple Ideas That Make Computers Work*. New York: Basic Books.

Jameson, Fredric. 2005. *Archaeologies of the Future: The Desire Called Utopia and Other Science Fictions*. New York: Verso.

Johnson, Neil, Guannan Zhao, Eric Hunsader, Jing Meng, Amith Ravindar, Spencer Carran, and Brian Tivnan. 2012. "Financial Black Swans Driven by Ultrafast Machine Ecology." February 7. http://arxiv.org/abs/1202.1448.

Kittler, Friedrich A. 1999. *Gramophone, Film, Typewriter*. Translated by Geoffrey Winthrop-Young and Michael Wutz. Stanford, Calif.: Stanford University Press.

Montfort, Nick. 2010. "Computing with Your Torch." *Post Position*. September 30. http://nickm.com/post/2010/09/computing-with-your-torch/.

Suits, Bernard. (1978) 2005. *The Grasshopper: Games, Life, and Utopia*. Peterborough, Ont.: Broadview Press.

Tolkein, Christopher. 1977. Foreword to *The Silmarillion*. Boston: Houghton Mifflin.

Tyson, Peter. 2012. *Getting Started with Dwarf Fortress: Learn to Play the Most Complex Video Game Ever Made*. Sebastopol, Calif.: Oreilly.

Various. 2006–7. "Dwarf Fortress—Boatmurdered: Part 18 by StarkRaving Mad." Let's Play Archive. April 14. http://lparchive.org/Dwarf-Fortress-Boatmurdered/Update%201-17/.

Wardrip-Fruin, Noah. 2009. *Expressive Processing: Digital Fictions, Computer Games, and Software Studies*. Cambridge, Mass.: MIT Press.

Weiner, Jonah. 2011. "The Brilliance of *Dwarf Fortress*." *New York Times,* July 21. http://www.nytimes.com/2011/07/24/magazine/the-brilliance-of-dwarf-fortress.html.

White, Hayden V. 1987. *The Content of the Form: Narrative Discourse and Historical Representation*. Baltimore: Johns Hopkins University Press.

7

Reading Childishly? A Codicology of the Modern Self

Patricia Crain

"MY BOOK AND HEART / SHALL NEVER PART" goes the alphabet rhyme for the letter *H* in *The New England Primer,* a crucial late-seventeenth-century literacy manual, in print in the United States through much of the nineteenth century and an object of conservative nostalgia to this day (Figure 7.1).[1] By "book," the primer rhyme means the Bible, of course, as it exhorts the reader to bind it to her heart. This "book" is a synecdoche for the Bible's important words, but the book (the Book) as an object has an equal presence in the rhyme and its accompanying image.[2] In another sense, though, by conjoining "book" and "heart," the rhyme situates the reader's heart out there, stored in the book, where she must go to find it. These two notions of bookness, as they relate to the codex form, are long-lived: the book as a sacred or quasi-sacred object and the book as a container for something that one must go to the book to acquire in order to fill the heart—or, in a sense, to have a heart at all, to become, that is, a self. These aspects of bookness, suggesting a codicology of the modern self, are rooted in an important movement in the history of print: the emergence of books for children. In the long life of the printed and bound codex form of the book, a kind of revolution occurred in the West, a little before 1800, that brought books, not only like the dour-seeming *Primer* but also like the ones that purvey what we now call "children's literature," into the hands of children.[3] While this, of course, had consequences for children, in this chapter, I will be interested in the consequences for the book. The little revolution (for it was also a revolution that found an expanding market in littleness) in publishing had a lasting effect on the cultural

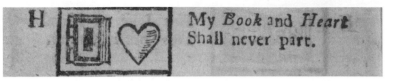

FIGURE 7.1. *The New England Primer* image alphabet for the letter *H* asserts a long-lived book-to-heart connection. From the earliest extant edition of 1727. Courtesy of American Antiquarian Society.

meaning of the codex form itself. This chapter explores how a format became a value.[4]

By 1800, when positioned in the neighborhood of children, *book* was a byword for virtue: "A good child will do as he is bid; he will soon try to read good books: he need not be afraid when it is dark, for God will take care of him by night as well as by day" (*Road to Learning* 1803). This commonplace assertion, joining divine supervision with good books, is everywhere in the nineteenth century, often posed negatively, as in Noah Webster's long-lived "blue-back speller" description of a "BAD BOY" as one who not only "is undutiful to his father and mother, disobedient and stubborn to his master, and illnatured to all his play fellows" but who also "hates his book, and takes no pleasure in improving himself in any thing" (Webster 1800, 101). As this and other such texts insist, the parting of book and heart leads more or less inevitably, if hyperbolically, to the gallows.

The capital *B* "Book" to which one's heart was supposed to stick in the opening example, became, during the nineteenth century, the little *b* "book" and a plural "books." While reading, especially by women and the young, was ringed round with admonitions of all kinds, books retained a splash of the sacral in the precincts of the lively print marketplace associated with children and, by extension, with the constellation of attributes that children had begun to represent: innocence and imagination, docility and domesticity among them.[5] If hating books opened onto the slippery slope, loving them turned you toward the tower of virtue.

Though such ancient allegorical geographies lingered into the nineteenth century, they shared the moral landscape with a new site. The by-now industrialized production of books became something of a tourist wonder and an occasion for the kind of natural

history of objects that, following *Émile,* proliferated in books for children.[6] In a modernized *Jack and the Bean-Stalk,* for example, published in Boston in 1837 and reprinted into the 1850s, what Jack finds at the end of his climb is not a fantastic kingdom, ruled by a giant with a golden egg–laying goose (or hen), but rather a world of books.[7] Having planted a "very large bean" of the kind "which you have read about in the old Jack story" (12) and which gratifyingly sprouts a tall vine, Jack climbs it "up and up and up" (13). He arrives first at a paper mill, where children are sorting rags; his next climb takes him to a type foundry, where children dress and rub the type ("Jacky thought he could soon learn to do this" [35]). He finds a man making marks on paper with a goose quill (with its whiff of the old tale) and is told that this is "copy" that he can take to the printing shop, where men and boys are setting type; men are working the press; and girls take the pages off the press, hang them to dry, and fold and stitch them into signatures, and then into books (44–49). This is all news to the until-now bookless Jack. He wants one of these novel items, but the bookseller tells him that he has to give money for it "because he had been forced to give money to the people who had worked so hard to make the paper, and the types, and print the book" (50). Jack barters some wood chopping for a "fine spelling and reading-book," and the bookseller takes him to a schoolroom where he can learn "what all these marks in my new book mean" (51). When Jack returns home with his book and all his news, his mother offers to move with him permanently to the little industrial village.[8]

This disenchanted fairy tale trades in its magic for the technology of books, providing, in place of the fabulous abundance of the golden eggs, lessons in capitalist exchange and the division of labor. Rather than bring the spoils of the fantastic realm back to the world of the "real," here, as in the bildungsroman tradition, Jack exchanges his original home for another, better, more urbane and modern one, the one with books in it. Jack's quest takes him to every way station of book production, ending with the schoolroom where the social life of the book enters a new stage, shedding its commodity form to become a site of pedagogic discipline and socialization.[9] As the book enters a new stage of its life, so does Jack, who "sat very still," was notably "attentive," and

so was assured by the schoolteacher that he would learn to read quickly (52). The contents of the books, whose production is so carefully detailed, is effaced. It doesn't matter, for that content is recursive: it's what you are reading in the book in your hands, a book that now vibrates with the condensed labor that constitutes it. This strand of antebellum print culture for children thematizes the materiality of book production and blandly acknowledges that some children work to produce the books that some other children go to school to read.[10] Books are commodities that you can own if you can pay for them. Of course, this is a *printer's* idea of a good book for a child; still, the new *Jack* attracted enough revenue to warrant at least five reprintings over fifteen years.[11] (The 1848 edition to which I refer here, digitized for the de Grummond collection, appears to have engaged its child readers enough for them to color the pictures for free.)

The prolific children's writer Jacob Abbott (most famous for his Rollo series) had a shrewd eye for the market and, like *Jack*'s anonymous maker, thought that a book about the making of books would be good children's fare. More substantially produced, between hard covers, and more elaborately encyclopedic than Jack's pamphlet-sized novel adventure, Abbott's (1855) *The Harper Establishment; or, How the Story Books Are Made* describes in seventeen chapters and forty-three engravings the two Manhattan buildings that housed the publishing company. This self-promoting natural history of books—nominally of those in the Story-Book series, by Abbott himself—follows their making from type founding, engraving, printing, and electrotyping to folding, gathering, and sewing to case making, gilding, embossing, and binding to, finally, storage and distribution. Here, too, Abbott blandly notes the highly skilled, "dexterous and quick" child workers (82).[12] The matter-of-fact participation of boys and girls in book manufactory in both the new *Jack* and *The Harper Establishment* speaks to a reality of the industry in the nineteenth century, but it also notably suggests one of the ways in which children's hearts became bound to books, as industrial producers as well as consumers in the print marketplace.

Abbott concludes *The Harper Establishment* by noting that the "productions of all these [works], and of many others, come

into this vast establishment each in the form of a single roll of obscure and seemingly useless manuscript, and then, a few weeks afterward, are issued in thousands and tens of thousands of copies, beautifully printed, embellished, and bound, to instruct, entertain, and cheer many millions of readers" (160). While in the real world of the nineteenth century, manuscripts of all kinds—autograph and commonplace books, school compositions and coterie poems, personal and business letters, indentures and wills, and all manner of legal, political, and legislative documents—circulated everywhere, here manuscripts are represented as an ephemeral and disposable stage of book production. Manuscripts, in their scruffy, fragile uniqueness, appear not as, for example, auratic signs of authorship but as "obscure and seemingly useless" rolls.

Jack's story and *The Harper Establishment* promote and valorize both the "thingness" (Brown 2001) of the codex, its seemingly durable materiality, and the collaborative labor (and laborers) invested in it. They represent the book as a labor-intensive, industrially innovative, economically and socially progressive, thoroughly modern artifact, affiliated with vertical movement (up the beanstalk and up and down the floors of the fancy new Harper's building), with horizontal circulation, with quantification, and with the schooling of children, attributes that, among others, are often taken to define modernity itself.

In one sense, such texts demystify and lower-case the book, arising as they do amid the general trend toward secularization and the movement from "intensive" to "extensive" reading practices with the increasing availability of books.[13] Look, such narratives seem to say, books are made as other things are made, and someone like you might be engaged in making them. Moreover, their warm embrace of the book in its commodity form, as a cheery artifact of industrial capital production, provides a new axiology for the book. As artifacts of industrial production, the books anatomized here assert their value not by transcending or escaping the marketplace but rather precisely by their worldliness, as drivers of industry and commerce, and engines of social mobility.

Jack and *The Harper Establishment* both chart the genealogy and gestation of books in their commodity form. But that's only one passage in the social life of a book. Inscriptions in copies of

Jack and *The Harper Establishment,* as in many other children's books, mark their transition from commodities to gifts or to private (or sometimes communal) property. Like the newly marketed "gift-books" of the mid-century, many children's books were printed with blanks inviting such writing (Piper 2010, 127).[14] Inscriptions on the inside covers and flyleaves of children's books often take the form that Abiah Chapin used to mark her copy of an 1809 chapbook of the old ballad of "The Children in the Wood": "The / property / of Abiah / Chapin" (Figure 7.2).[15] A traditional variation of this mark takes the form "Alice Comfort, Jr., her book / 5th May 1826" and "Joseph Bowers his Book" (Murray 1811a, 1811b). Here is English trying hard to make a genitive case, and such attempts often elide into the modern possessive: "Maria W. Bullard's Book" (Murray 1815).[16] Occasionally, an inscriber drops the possessive altogether, perhaps uncertain about how it works, asserting a property claim by metonymically sidling up to the substantive. Grammatically, "Decimus White Book," for example, defies parsing, but the sense is clear; Decimus White is rubbing shoulders with the book syntactically, as he's scratching its cover with his pen physically.[17] "Her book" and "property of" have a formal, quasi-contractual quality to them. For a child, as for many adults, the idiom declares ownership not only in the book at hand but in the constellation of experiences, and of rights and privileges, that the book represents and that are represented by the fact of reading and writing.

Some inscribers note that the book was "bought," sometimes with the price.[18] The tautology of such declarations suggests the novelty and importance of the event of that purchase. Along the way, the signature transfers the book from its commodity form in the shop into something individuated and associated with the person (Kopytoff 1986, 64). It's a reminder, too, that the book is one of the first consumer objects addressed specifically to children, marketed and advertised especially to them, specially designed, and purchased from a store or a peddler; the book represented one of children's first encounters with private property, as such—as a vocabulary word, as a thing, as a concept, as a practice.

Children often posted at the boundaries of their books the

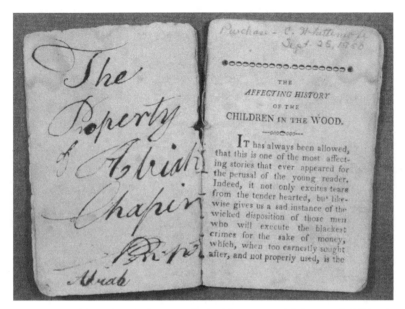

FIGURE 7.2. Many inscriptions on the inside cover and flyleaves of children's books take the form that Abiah Chapin used to mark her copy of an 1809 Windsor, Vermont, prose chapbook version of the old infanticide ballad *The Affecting History of the Children in the Wood.* Courtesy of American Antiquarian Society.

formulaic poems that bibliographers and catalogers call *ownership verses,* or, in some cases, *anathemas.*[19] Mary Lucretia Shelton of Bridgeport, Connecticut, for example, has extensively marked up her 1816 New York edition of Murray's *Introduction to the English Reader,* in 1821 (Figure 7.3). Like others of Lindley Murray's vastly popular anthologies, staples in the marketplace into the 1830s, this one gathers together short excerpts in prose and poetry from a Scottish Enlightenment and British sentimental and romantic canon for reading aloud, memorizing, and performing and for learning prosody.[20] Shelton writes on the first flyleaf,

> Steal not this Book my honest
> friend for fear the gallows will
> be your end For god will say in
> the judgment day where
> is that Book you stole away

FIGURE 7.3. Mary Lucretia Shelton of Bridgeport, Connecticut, extensively marked up her 1816 New York edition of Murray's *Introduction to the English Reader*, in 1821, with ownership verses on front and back flyleaves and often sly marginal comments throughout. Courtesy of American Antiquarian Society.

Through such owner's verses and other routine inscriptions, aspects of the codex form's affective life come into view. Britannia Anthony, wife of a prosperous Providence, Rhode Island, merchant, for example, inscribed a book to her daughter Kate, age four years and eight months, on June 3, 1857.[21] In *Little Kitty Clover and Her Friends* (1856), she wrote, "Kate J. Anthony / May this book be kept / very nice." Aside from two torn pages and a soiled (possibly chewed on?) corner of the front cover, the book has indeed been "kept very nice" by Kate, by the Anthony heirs, and by the library to which the book was given a century later. Like that of many books compiled for the bustling children's market of the mid-century, the text of this thirty-cent, eighty-five-page book was composed around a variety of engravings that the printer must have had to hand ("Illustrated with nearly one hundred wood-cuts"). Holding the image-prompted fragments together is "little Kitty Clover" herself, whose biography rhymes with Kate Anthony's (who was perhaps also, sometimes, "Kitty"?): "She lives in a pleasant home with kind parents, two brothers, and one sister, who all love her very much" (n.p.). Its narrative follows the arbitrary persons and things dropped into it; mirroring the commodity phase of its own life, it relies heavily on consumer objects, which naturally include books ("Charles brings his last new book, and wooden horse on wheels. Little Willie comes, bringing his pet cap, with the long tassel, and dissected map, that his mamma brought from Philadelphia" [10]).

Possibly Britannia Anthony wasn't thinking so much of her daughter when she wrote her inscription as of Kate's older brother Edgar, whose *Blue Pictorial Primer* (1839) has also survived— though just barely. The primer might have been purchased to be shared over time among siblings, but Edgar Anthony all but consumed this torn, crumpled, and blotted book. Passages and images that encourage sibling harmony ("George was a kind hearted boy. He loved his little sister Rosa" [25]) have been evocatively inked out by this eldest child in a growing family. That such a tattered book was preserved and formed part of the legacy to a library testifies to the value placed on even such (perhaps especially such) well-worn artifacts in nineteenth-century families. Books were a crucial adjunct to family life for the Anthony children, who

numbered them and kept them as a family library.[22] This collecting practice was common among middle-class children, likely influenced by (and in conversation with) publishers' promotion of such consumer goods as Ellen Montgomery's Library, Harper's Story Books, Mrs. Leslie's Juvenile Series, and Pleasure Books for Children (volumes from these series, by the popular writers Anna Bartlett Warner, the sister of *The Wide Wide World* author, and Jacob Abbott, among others, are in the Anthonys' little library).

Kate Anthony seems to have taken her mother's admonition to keep her books "very nice" to heart. For her eighth birthday, in 1860, she received *Mamma's Gift Book* (1854), which has been wrapped in a homemade brown packing paper cover, with the title inscribed in ink on the cover and spine, in imitation of binding. Though seemingly much read—it opens easily and is punctuated inside with small stains of use—it remains in "very nice" condition. The text of *Mamma's Gift* begins benignly, the anonymous writer vowing "to write a story book for all good children" (5). Yet many of its stories are hair-raising to a modern reader. In one, a Russian woman flees wolves in her sled, placating them by throwing one after another of her children to them; in turn, her husband and villagers axe her to death. Another tale has a community of cats tear another cat "to pieces" for his wicked ways (91); a fable tells of a hare too vain to believe that dogs can hurt him, but they break his back anyway with one bite: "Children sometimes act as foolishly as did this hare" (55). The violence of *Mamma's Gift* (an intense but characteristic example of children's literature of the period) lends to the gift, in this case a perhaps loved, and certainly cared-for, object, components of a surrogate, externalized self: looked after but wicked; punished but surviving; horrible but fascinating; full of death but infinitely accessible to revisiting. But whatever its content, as an adjunct to the self, the book is eligible for the same kind of nurture and care that attend the self in the nineteenth century.

If, in the social life of the book, it transforms from a commodity to a gift to a teacher to a transitional object, to something like a self, it sometimes demonstrates along the way one of the signal traits of a self: the capacity to keep a secret. Cached between the back cover and back flyleaf in Kate Anthony's handsomely kept

FIGURE 7.4. Kate Anthony's well-cared-for copy of *Mamma's Gift Book* (New York, 1854) did double duty as a bureau for paper doll clothes. Courtesy of American Antiquarian Society.

Mamma's Gift is a set of paper doll clothes, cut from wallpaper (Kate's father was in the hardware business and perhaps brought home samples) (Figure 7.4). Children routinely exploited the material qualities of the book that printers had long captured in titles that identify books as "caskets," "cabinets," "treasuries," and the like: its portability; its intimately miniature size; its tidy, boxlike structure.

In a heavily and dutifully marked-up 1806 copy of Murray's *Grammar,* inscribed by Nancy Smyth of Virginia in 1824, something is tucked into the leaves, where, evidenced by the stain it's made on the pages, it had rested for some time. It's a cookie-fortune-sized slip of paper with a printed message: "If you approve of my love, in your bosom put this, / Thus assenting to love, you'll perfect my bliss." A shadow between two other pages shows that the slip had once rested there as well, where there are also fragments of a flower. The acid stain dates it to long after Nancy Smyth's schooldays, at least to the 1840s, when wood pulp paper was first produced.[23] The form of the book, its aptitude for both privacy and sociability, invites such use as a postbox for a mash note, transforming the book from one kind of medium to another—from the putative fixity and long duration of print to the liveliness and temporal urgency of a post or telegraph office.[24]

Yet the form's very stasis and durability encouraged another kind of mark: "Homer S. Wire / Aged 3 years, 7 months, one day / *died 1851* / His present to M. C. Wire." These words are inscribed on the front flyleaf of an 1843 book unpromisingly called *Coverings for the Head and Feet, in All Ages and All Countries* ([1843–51]) and suggest that, in keeping with nineteenth-century deathbed rituals, the child may have asked that the book be given away. Dots of ink on the inside cover facing the inscription reveal that the inscriber closed the book before the ink could dry. An inscription in *Rollo's Philosophy: Air,* a volume in Jacob Abbott's popular series (Abbott 1853), reads, "Presented / to Howard Littlefield / from his deceased / cousin Leroy by / his parents in token / of their affection for / each other when alive / Wm H Littlefield" (Figure 7.5). The agonized syntax struggles to chart the gift's genealogy and rationale. Such inscriptions transform the artifact, marking a new phase in its social life.

FIGURE 7.5. The inscription from bereaved father to nephew in *Rollo's Philosophy: Air* (Philadelphia, 1853) lends the book the quality of memento mori. Courtesy of American Antiquarian Society.

Like these memorial inscriptions, literary narratives of the nineteenth century often invoke the codex form as a lively container for persons as well as things. In Hawthorne's (1835) gift-book sketch "Little Annie's Ramble," the narrator entices a little girl to wander with him through the bustling streets of town. When they pause at a bookstore, he muses, "What would Annie think, if, in the book which I mean to send her, on New Year's day, she should find her sweet little self, bound up in silk or morocco with gilt edges, there to remain till she become a woman grown, with children of her own to read about their mother's childhood!" (Hawthorne 1982, 230). That the tale first appeared in a New Year's and Christmas gift book, *The Youth's Keepsake* for 1835, emphasizes this fantasy's recursiveness.[25] Memorial inscriptions transform books into cenotaphs to preserve the dead child's memory. Hawthorne's trope suggests an even more full-bodied fantasy of a child stored in a book for future access by her adult self. In such figures, the book entirely contains persons, where they can be both preserved and retrieved. This trope literalizes the notion I suggested at the beginning of the chapter: that the book form is often represented as a container for aspects of the self that can only be acquired there.

In her analysis of the afterlife of the figure of Goethe's Mignon, the historian Carolyn Steedman (1995) has charted the ways in which the figure of the child became identified by the end of the nineteenth century with interiority: with the self itself. When children—and the concept of childhood—resacralized books in the nineteenth century, the discursive production of the book form engaged with its material capacity as a container to become a key site for the representation of modern interiority.[26] The book form became in the nineteenth century a container for the storage and retrieval of that spectral child.

Twenty-first-century parents, immersed in all forms and formats of the digital and its practices, nonetheless so far seem to want their children to have books. According to the *New York Times*, "as the adult book world turns digital at a faster rate than publishers expected, sales of e-books for titles aimed at children under 8 have barely budged. They represent less than 5 percent of total annual sales of children's books, several publishers estimated, compared with more than 25 percent in some categories of adult

books." As one parent captures the stakes, "there's something very personal about a book and not one of one thousand files on an iPad, something that's connected and emotional, something I grew up with and that I want them to grow up with" (Richtel and Bosman 2011). The book form seems to still hold out a promise in its very architecture: it's in that box, out there, that we come to ourselves, we become "personal," "connected and emotional." That "something I grew up with and that I want them to grow up with" may be, indeed, books. But by "books," it would seem, these parents mean a form of subjectivity and interiority that they locate there.

This echoes the sentimental account of bookishness, captured best in one of its earliest versions by Sven Birkerts ([1994] 2006), in his aptly titled *Gutenberg Elegies*. Birkerts distributes his anxiety about the digital world widely but finally locates it in the book: "the site of the struggle" (249). The essays gathered here return again and again to his children. What if, Birkerts worries, his daughter "follows the non-reading horde of her peers, where will she find the incentive, the desire to read on her own? And if she does not read on her own, where will she find the nutrients she needs in order to evolve an independent identity?" (29). In the coda to the first edition, Birkerts fears the loss of what he calls a secular soul, an "inwardness" that "we feel…when we are in sacral spaces" (212).[27] He associates this inwardness with a sense of temporal duration and, in a moving parenthetical aside in the afterword to the 2006 edition, writes of his children "(how can they never know what the slow drip-drip of time feels like?)" (234). These are not, in my view, sentiments to be scorned. But they are ones with a very particular history of cultural fantasies about children and books. Once we adults have a self, this fantasy tells us, we are inoculated; the other surfaces and depths that we now engage through a screen won't harm us. But first, so the story continues to insist, a child has to go find that something-like-a-self where it waits for her, like the mourned children of the nineteenth century, between the covers of a book.

This "book effect," if I may call it that, doesn't belong only to the melancholic lamentations of belletristic bibliophilia.[28] Thus, for example, the covers of government reports quantifying (and

largely panicking about) national literacy and "literary" reading all feature images of children seemingly immersed in reading books, whether or not the reports are about children's reading. The story these images tell when we look closely at them undermines even this already misleading claim for the reports' content. So, for example, the Department of Education's *Becoming a Nation of Readers* (Anderson et al. 1985) features on its cover a famous image based on a Matthew Brady photograph of Abraham Lincoln and his son Tad, apparently bent together over a book, sharing a parent–child reading moment (Figure 7.6). In fact, according to George Sullivan (2000), the two are not reading together but looking at a book of Brady's own photographs, used as a prop in this studio photograph (though, per Sullivan, it is often misidentified as the Bible [54]).

The image on the cover of the National Endowment for the Arts' (NEA's) 2004 *Reading at Risk* shows a boy seemingly absorbed in reading an impressively fat volume, strangely alone in an ancient-looking library (Figure 7.7). Indeed, it is a more or less ancient library—the eighteenth-century library of the University of Bologna. The boy is the son of the photographer, who was on assignment for *Travel Holiday* magazine. The book, Dennis Marsico recalls, was a thirteenth-century manuscript, which the librarians were much more sanguine about letting his son handle than he was.[29] This staged and improbable image of an American boy in the University of Bologna Library reading a medieval codex might support the NEA's message in that report, which found literary reading on the decline in America. But that report was about *adult* accounts of reading.

The most recent NEA report, from 2009, shows a reversal of the decline in reading. *Reading on the Rise: A New Chapter in American Literacy* focuses on adults, beginning with those aged eighteen to twenty-four years. Still, the close-up cover image is of a child or a very young-looking young adult in a posture evoking a dreamy immersion (or even actual sleep, as the image is cropped just below the eyes). We see the lower half of the young person's face, chin nestled on hands, hands crossed just in front of an open book (Figure 7.8). When the NEA wants to represent the loss of the experience it associates with the codex, it positions a child in

FIGURE 7.6. The cover image for *Becoming a Nation of Readers* (Anderson et al. 1985) is sometimes mistakenly assumed to be of Lincoln and son Tad catching up on Bible reading, while they were actually browsing a photo album. The image circulated as a stamp as well, proclaiming "A Nation of Readers."

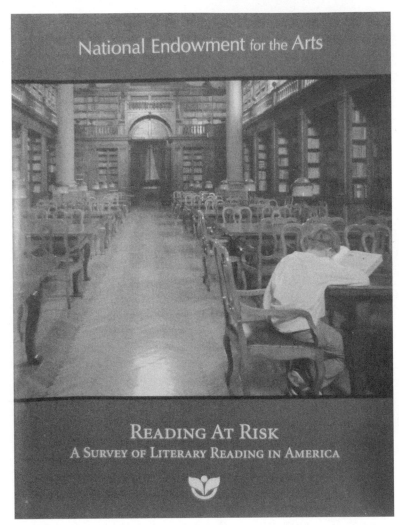

National Endowment for the Arts

READING AT RISK
A SURVEY OF LITERARY READING IN AMERICA

FIGURE 7.7. *Reading at Risk*'s cover (National Endowment for the Arts 2004) suggests a child's absorbed and self-forgetting reading in an eerily empty library (actually, at the University of Bologna), while the report concerns adult reading.

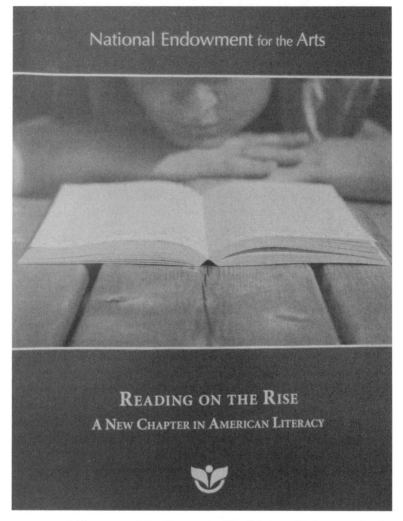

National Endowment for the Arts

READING ON THE RISE
A NEW CHAPTER IN AMERICAN LITERACY

FIGURE 7.8. The cover of *Reading on the Rise* (National Endowment for the Arts 2009) invokes an iconic image of absorbed childhood reading to express the values it associates with the codex.

front of it, as if to say that it's really an enclosed, private, booklike self that we cling to and long for and fear losing, the self that, we might say, romanticism created, that the concept of childhood has kept alive, and that we imagine has been stored and preserved for us in the codex form.

NOTES

I wish to gratefully acknowledge the American Antiquarian Society and the National Endowment for the Humanities for a fellowship that supported the research for much of this chapter. As for my subtitle, "Reading Childishly," I hope that the chapter makes clear that this is not meant in any way to disparage child or adult reading or readers. On the contrary, it's a rhyme with the title of Carol Mavor's (2007) rich meditation on children and reading (among other things), *Reading Boyishly.* With "Codicology of the Modern Self," I tip my hat and bow to Andrew Piper's *Dreaming in Books* and its powerful and influential descriptions of romanticism's "bibliographic imagination." Neither "codicology" nor "bibliography," it must be said, however, really or even nearly captures modernity's profound investment in the book form.

1 For more on *The New-England Primer*'s image alphabet, see Crain (2000, 15–52); the edition of the *Primer* referred to here is from the earliest extant, one copy of which is held by the New York Public Library (repr. in Ford 1899) and another by the American Antiquarian Society, from which the images here are drawn. Facsimile reprints of later eighteenth-century editions are available from (mostly) Christian home-schooling publishers, such as WallBuilders' 1777 version (repr. 1991).

2 The *Primer*'s rhyme for *B,* "Thy Life to Mend / This *Book* Attend," explicitly pictures a Bible.

3 The classic account of the development of children's literature is Darton ([1932] 1998). For Europe, see Hürlimann (1967). For the American scene, see Avery (1995). For a brief history of early American publishing for children, see Marcus (2008, 1–30). For a very useful chronology and some fine chapters on the development of commercial publishing for children, see Grenby and Immel (2009).

4 This regime of value is under pressure, not only because of digital

formats. In some settings, the "book" represents unpopular—or at least unpopulist—values as well as dirt and clutter: real estate agents routinely counsel house sellers to put books in storage. Furthermore, book-and-media history scholarship has recently tended to depose the codex as the idol of "print culture"; see, e.g., Lisa Gitelman (chapter 8 in this volume) and David Henkin (1999), among others.

5 The romantic discourse of childhood, undergirding the shift from thinking of children as inherently sinful to inherently innocent, is well known. See Richardson (1995) and Sánchez-Eppler (2005). For an ingenious account of the cultural complexity of childhood "innocence," see Bernstein (2011).

6 Jean-Jacques distracts Émile from an "intoxicating" scene in an "opulent home" by quizzing him on "'how many hands'" all the goods passed through (Rousseau 1979, 190).

7 The traditional "Jack" tale has a range of printed versions in the eighteenth century and early nineteenth century. See Opie and Opie (1980, 211–26). For links to versions of the Jack tale, see http://www.pitt.edu/~dash/type0328jack.html. *Jack and the Bean-Stalk, a New Version* (1848) is digitized in "The Jack and the Beanstalk and Jack the Giant-Killer Project," edited by Michael N. Salda, de Grummond Children's Literature Research Collection, University of Southern Mississippi, http://www.usm.edu/english/fairytales/jack/jackhome.html.

8 Among other things, *Jack and the Bean-stalk, a New Version* is a thoroughgoing description of paper making, type founding, and printing, in a tradition of an empirical origin-of-common-things anecdote often found in nineteenth-century children's literature. Somewhat surprisingly, but in keeping with the new version's disenchantment, Jack's mother reveals that the village can be reached simply by taking a path out of the valley.

9 For the concept of the "social life of things," see Appadurai (1986) and Kopytoff (1986).

10 Statistics for children in the book trades are hard to come by, but according to Scott Casper, "industrial production swelled the number of *women and children* in printing and publishing, from 17 percent of their workforce in 1870 to 21 percent" in 1880 (Casper 2007, 9; emphasis added).

11 The most comprehensive list I've found is in the American Antiquarian Society online catalog (which notes more editions than Worldcat does), showing printings in 1837, 1841, 1842, 1848, and 1852.

12 One of the most vivid pictures of child labor in *The Harper Establishment* describes the "setters," whose job is to arrange "the

types in rows for inspection and for the final finishing. The setters are usually small girls. The types are taken up by them from a box, where they lie in bulk, and are placed in a row upon a long stick, like a yard-stick. It is astonishing to witness the rapidity of motion and the accuracy which these girls display in taking up and placing the types, arranging them all the same way, that is, with the same side toward them, and the letter faces all turned downward" (82).

13 This is the widely cited (and frequently challenged but still useful) notion originating with Rolf Engelsing, that there was a "reading revolution" in the West circa 1750, marking a shift from a typical practice of reading a few books over and over again, "intensively," to one of reading many things, broadly and "extensively." See Darnton (1990, 133, 165–66).

14 According to the online catalog, a copy of *The Harper Establishment* in the American Antiquarian Society collection, for example, is inscribed "Brigham Dexter James, March 25th 1863" (AAS call number CL A132 H293 IV). (He was most likely age eight when the book was inscribed, as this is likely to be the only Brigham Dexter James in familysearch.org's records, born in 1855 in Boston.) An undated edition of *Jack* is inscribed "Warren E. Burger, Sterling, Mass. 1852" (AAS call number CL-Pam J12 A543 1852). (As far as I can tell, he's no relation to the Supreme Court justice.) Others are marked "Charles S. Bullock. A Christmas present from Aunt Candace. 1847; Emily" (AAS call number CL-Pam J12 A543 1847); "EJ, Waltham, 1844" (AAS call number CL-Pam J12 A543 1843); and "Stephen Child's Metcalf, Medway; George P. Metcalf. Presented by his brother S" (AAS call number CL-Pam J12 A543 1841).

15 In this and some similar cases, it is possible that an adult has inscribed the book on behalf of the child, modeling the practice of owning and the rituals surrounding property. In this case, the inscription takes up the whole inside paper cover of this small book and appears to me to be in an accomplished child's hand, especially since "Abiah" is repeated in the same hand. Abiah Chapin (1806–64) further inscribed the book to her nephew Seth Dwight Chapin (born in 1824 or 1826) in 1830 (*Affecting History* 1809). Discussions of marginalia assume that the inscriber wishes first to declare ownership: "all marginalia are extensions of the ownership inscription, which itself expresses the primary impulse of claiming the book as one's own" (Jackson 2002, 90). The child writer often asserts a property right in her book (or has it asserted by proxy), but this assertion emerges less from a

"primary impulse," some proprietary *instinct,* than from the cultural position in which the child and the book find themselves.

16 Alice Comfort's inscription appears in a multiply inscribed 1811 Philadelphia edition of Lindley Murray's *English Reader.* Joseph Bowers (and others) marked up Murray's *English Reader,* 1811 (Poughkeepsie, New York). Maria Bullard's inscription is on a hand-made bookplate in Murray's *English Exercises* (Bridgeport, 1815), a supplement to his *English Grammar,* and includes the date of inscription (1816) and the number of the book in the child's or the family's library ("No. 6"), along with a penmanship flourish. (These are all AAS call number "Dated Books.")

17 Inscribed in Clara English (1806), *The Children in the Wood* (AAS call number CL-Pam E58 C536 1806).

18 E.g., "Hannah Robinson, her book, was bought December 16th, 1818" is inscribed in Clara English, *Children in the Wood* (1818).

19 See Opie and Opie (2000) for some traditional examples; see also, for "traditional flyleaf rhymes," Hayes (1997, 89–102). Holbrook Jackson (2001) cites a number of such verses from the twelfth century onward (368–71).

20 According to Murray's biographer Charles Monaghan (1998), *The English Reader,* its introduction, and its sequel sold some six and a half million copies in America, mostly before 1850; this is not counting his very popular *English Grammar.*

21 She gave a book to Kate's six-year-old sister Sarah on the same day. Kate became the family historian; Sarah died at age fourteen. Biographical information is from Charles Lawton Anthony's (1904) *Genealogy of the Anthony Family.*

22 Sixteen books inscribed to and by the Anthony children are in the American Antiquarian Society collection, along with a few uninscribed children's books and schoolbooks and a few issues of a children's magazine donated by heirs.

23 I'm grateful to Tom Knoles for pointing this out to me.

24 Twain, always alert to the materialities of his medium, uses this capacity of the book to function as a drop box to ignite a catastrophic feud with a lover's note in chapter 18 of *The Adventures of Huckleberry Finn.*

25 Mark Twain's (1875) "The Story of the Good Little Boy Who Did Not Prosper" uses the trope to satiric ends: "Jacob had a noble ambition to be put in a Sunday-school book. He wanted to be put in, with pictures representing him gloriously declining to lie to his mother, and her weeping for joy about it; and pictures representing

him standing on the doorstep giving a penny to a poor beggar-woman with six children, and telling her to spend it freely, but not to be extravagant, because extravagance is a sin; and pictures of him magnanimously refusing to tell on the bad boy who always lay in wait for him around the corner as he came from school, and welted him over the head with a lath, and then chased him home, saying, 'Hi! hi!' as he proceeded. This was the ambition of young Jacob Blivens. He wished to be put in a Sunday-school book. It made him feel a little uncomfortable sometimes when he reflected that the good little boys always died." Those who are bound in books in the nineteenth century tend to be already bound in other ways; thus Uncle Tom is represented sardonically by St. Clare, who is about to purchase him for his daughter Eva from a slave trader, as "all the moral and Christian virtues bound in black morocco, complete!" (Stowe [1852] 1981, 234–35). Leah Price (2012, 72) notes that child heroes of nineteenth-century bildungsromane are often "*compared to* books—metaphorically imprinted, bound, sold, and scanned."

26 Others have similarly taken account of what Matthew Brown (2007, 13) has called "the phenomenology of the book," the persistent (material and discursive) resonance of the book form, and "how the book object organizes time and space for its readers and how the subjective life of readers is conditioned by this interaction with book format." Elsewhere, Brown (2001, 90) fetchingly describes the "prop semiotics" of the book. See also Piper (2010) and Brückner (2009).

27 I have long deferred reading Birkerts's ([1994] 2006) book, supposing it to be unhelpfully sentimental and backward looking. I find that it is instead a sometimes poignant memoir of passionate and often unrequited book love. I read it first on the Kindle and then bought the paperback so that I could refer to pages. For an elegy to the book form, this paperback book is a shocking example of poor production: "perfect bound" pages that seem likely to fall out, poor paper quality, blurry type. It is an unappealing vessel for what Birkerts calls the "human gravity" we risk losing when we give up the book form (249).

28 The representational power of this textual format—the printed codex—resonates with William A. Johnson's description in chapter 5 of this volume of the way in which bookrolls "signif[y] culture" in the ancient world.

29 Telephone conversation with Dennis Marsico, December 19, 2009.

REFERENCES

Abbott, Jacob. 1853. *Rollo's Philosophy. (Air.)* Philadelphia: B. F. Jackson. Inscribed to Howard Littlefield. AAS call number CL A132 R757 1853.

———. 1855. *The Harper Establishment: or, How the Story Books Are Made.* New York: Harper's.

The Affecting History of the Children in the Wood. 1809. Windsor, Vt.: O. Farnsworth. Inscribed by Abiah Chapin. AAS call number CL-Pam C5365 A257 1809.

Anderson, R. C., E. H. Hiebert, J. A. Scott, and I. A. G. Wilkinson. 1985. *Becoming a Nation of Readers: The Report of the Commission on Reading.* Washington, D.C.: National Institute of Education, U.S. Department of Education.

Anthony, Charles Lawton. 1904. *Genealogy of the Anthony family from 1495 to 1904 traced from William Anthony, Cologne, Germany, to London, England, John Anthony, a descendant, from England to America.* Sterling, Ill.: Charles L. Anthony.

Appadurai, Arjun, ed. 1986. "Introduction: Commodities and the Politics of Value." In *The Social Life of Things: Commodities in Cultural Perspective*, 3–63. Cambridge: Cambridge University Press.

Avery, Gillian. 1995. *Behold the Child: American Children and Their Books, 1621–1922.* Baltimore: Johns Hopkins University Press.

Bernstein, Robin. 2011. *Racial Innocence: Performing American Childhood from Slavery to Civil Rights.* New York: New York University Press.

Birkerts, Sven. (1994) 2006. *The Gutenberg Elegies: The Fate of Reading in an Electronic Age.* New York: Faber and Faber.

The Blue Pictorial Primer. 1839. New York: Geo. F. Cooledge and Brother. Inscribed by Edgar Anthony. AAS call number Primers B658 P611 1840.

Brown, Bill. 2001. "Thing Theory." *Critical Inquiry* 28, no. 1: 1–22.

Brown, Matthew P. 2007. *The Pilgrim and the Bee: Reading Rituals and Book Culture in Early New England.* Philadelphia: University of Pennsylvania Press.

Brückner, Martin. 2009. "Fashion Codes/Pocket Codex: Reading Little Books in Antebellum America." Paper presented at the Modern Language Association, Philadelphia, December 28.

Casper, Scott E. 2007. Introduction to *History of the Book in America: The Industrial Book, 1840–1880.* Chapel Hill: University of North Carolina Press.

Coverings for the Head and Feet, in All Ages and All Countries. [1843–51].

New York: J. S. Redfield. Inscribed to M. C. Wire. AAS call number CL-Pam C873 F692 1843.

Crain, Patricia. 2000. *The Story of A: The Alphabetization of America from* The New England Primer *to* The Scarlet Letter. Stanford, Calif.: Stanford University Press.

Darnton, Robert. 1990. *The Kiss of Lamourette: Reflections in Cultural History.* New York: W. W. Norton.

Darton, F. J. Harvey. (1932) 1998. *Children's Books in England: Five Centuries of Social Life.* Edited by Brian Alderson. London: British Library.

English, Clara. 1806. *The Children in the Wood: An Instructive Tale.* Baltimore: Warner and Hanna. Inscribed by Decimus White. AAS call number CL-Pam E58 C536 1806. Inscribed by Decimus White.

————. 1818. *The Children in the Wood: An Instructive Tale.* Philadelphia: Joseph Rakestraw. Inscribed by Hannah Robinson. AAS call number CL-Pam E58 C536 1818.

Ford, Paul Leicester, ed. 1899. *The New England Primer: A Reprint of the Earliest Known Edition.* New York: Dodd, Mead.

Grenby, M. O., and Andrea Immel. 2009. *The Cambridge Companion to Children's Literature.* Cambridge: Cambridge University Press.

Hawthorne, Nathaniel. 1835. "Little Annie's Ramble." In *Youth's Keepsake: A Christmas and New Year's Gift for Young People,* 146–59. Boston: E. R. Broaders.

————. 1982. "Little Annie's Ramble." In *Tales and Sketches,* 228–35. New York: Library of America.

Hayes, Kevin. 1997. *Folk Culture and Book Culture.* Knoxville: University of Tennessee Press.

Henkin, David. 1999. *City Reading: Written Words and Public Spaces in Antebellum New York.* New York: Columbia University Press.

Hürlimann, Bettina. 1967. *Three Centuries of Children's Books in Europe.* Translated by Brian Alderson. New York: Oxford University Press.

Jack and the Bean-Stalk: A New Version; to which is added Little Jane and her Mother. 1848. Boston: William J. Reynolds. http://www.usm.edu/english/fairytales/jack/di.htm.

Jackson, H. J. 2002. *Marginalia: Readers Writing in Books.* New Haven, Conn.: Yale University Press.

Jackson, Holbrook. 2001. *Anatomy of Bibliomania.* Champaign: University of Illinois Press.

Kopytoff, Igor. 1986. "The Cultural Biography of Things: Commoditization as Process." In *The Social Life of Things: Commodities in Cultural Perspective,* edited by Arjun Appadurai, 64–91. Cambridge: Cambridge University Press.

Little Kitty Clover and Her Friends. 1856. Philadelphia: G. Collins. Inscribed to Kate Anthony. AAS call number CL L7781 K62 1856.

Mamma's Gift Book. The Little Gift Book. Winter Holidays. Christmas Stories. 1854. New York: D. Appleton. Inscribed to Kate Anthony. AAS call number CL M263 G456 1854.

Marcus, Leonard S. 2008. *Minders of Make-Believe: Idealists, Entrepreneurs, and the Shaping of American Children's Literature.* Boston: Houghton Mifflin.

Mavor, Carol. 2007. *Reading Boyishly: Roland Barthes, J. M. Barrie, Jacques Henri Lartigue, Marcel Proust, and D. W. Winnicott.* Chapel Hill, N.C.: Duke University Press.

Monaghan, Charles. 1998. *The Murrays of Murray Hill.* Brooklyn, N.Y.: Urban History Press.

Murray, Lindley. 1806. *Murray's Introduction to English Grammar, Compiled for the Use of the Youth in Baltimore Academy, Tammany-Street. To which is added, An essay on punctuation.* Baltimore: Academy Press. Inscribed by Nancy Smyth. AAS call number Dated Books.

———. 1811a. *The English Reader: or, Pieces in Prose and Poetry, Selected from the Best Writers.* Philadelphia: Johnson and Warner. Inscribed by Alice Comfort. AAS call number Dated Books.

———. 1811b. *The English Reader: or, Pieces in Prose and Poetry, Selected from the Best Writers.* Poughkeepsie, N.Y.: Paraclete Potter. Inscribed by Joseph Bowers. AAS call number Dated Books.

———. 1815. *English exercises, Adapted to Murray's English Grammar.* Bridgeport, Conn.: L. Lockwood. Inscribed by Maria Bullard. AAS call number Dated Books.

———. 1816. *Introduction to the English reader: or, A Selection of Pieces, in Prose and Poetry.* New York: Collins. Inscribed by Mary Lucretia Shelton. AAS call number Dated Books.

National Endowment for the Arts. 2004. *Reading at Risk: A Survey of Literary Reading in America.* Research Division Report 46. Washington, D.C.: National Endowment for the Arts.

———. 2009. *Reading on the Rise: A New Chapter in American Literacy.* Washington, D.C.: National Endowment for the Arts.

The New-England Primer. (1777) 1991. Facsimile. Aledo, Tx.: Wall-Builders.

Opie, Iona, and Peter Opie. 1980. *The Classic Fairy Tales.* New York: Oxford University Press.

———. 2000. *I Saw Esau: The Schoolchild's Pocket Book.* Somerville, Mass.: Candlewick Press.

Piper, Andrew. 2010. *Dreaming in Books: The Making of the Bibliographic*

Imagination in the Romantic Age. Chicago: University of Chicago Press.

Price, Leah. 2012. *How to Do Things with Books in Victorian Britain.* Princeton, N.J.: Princeton University Press.

Richardson, Alan. 1995. *Literature, Education, and Romanticism: Reading as Social Practice, 1780–1832.* Cambridge: Cambridge University Press.

Richtel, Matt, and Julie Bosman. 2011. "For Their Children, Many E-Book Fans Insist on Paper." *New York Times,* November 20. http://www.nytimes.com/2011/11/21/business/for-their-children-many-e-book-readers-insist-on-paper.html.

The Road to Learning Made Pleasant with Lessons and Pictures. 1803. Philadelphia: Jacob Johnson.

Rousseau, Jean-Jacques. 1979. *Emile: or, On education.* Translated by Allan Bloom. New York: Basic Books.

Sánchez-Eppler, Karen. 2005. *Dependent States: The Child's Part in Nineteenth-Century American Culture.* Chicago: University of Chicago Press.

Steedman, Carolyn. 1995. *Strange Dislocations: Childhood and the Idea of Human Interiority 1780–1830.* Cambridge, Mass.: Harvard University Press.

Stowe, Harriet Beecher. (1852) 1981. *Uncle Tom's Cabin.* New York: Penguin.

Sullivan, George. 2000. *Picturing Lincoln: Famous Photographs That Popularized the President.* New York: Houghton Mifflin.

Twain, Mark. 1875. "The Story of the Good Little Boy Who Did Not Prosper." http://etext.virginia.edu/railton/tomsawye/goodboy.html.

Webster, Noah. 1800. *The American Spelling Book.* Wilmington, Del.: Bonsal and Niles. http://merrycoz.org/.

8

Print Culture (Other Than Codex): Job Printing and Its Importance

Lisa Gitelman

THE TITLE OF THIS CHAPTER deserves explanation. Like others in the volume, it is meant to refer to a form of textual media, yet it is doing a lot of other work besides. It is inclusive, appealing to the category "print culture," as well as exclusionary, excepting anything "codex." Both categories warrant scrutiny, while *codex* appears simpler to define. A codex is a text in the shape of a book: groups of pages gathered and sewn together to open along their fore edge. So the term *codex* designates a material format. One might say that a text can be a codex in the way that a sound recording can be an LP, though that isn't precisely right, because codices—unlike LPs—can come in different sizes, such as folios, quartos, and octavos, as well as in different types, such as books, magazines, and stab-bound pamphlets. That there are different contexts in which the codex, octavo, and pamphlet are each referred to as a *format* only goes to show how difficult it can be speak or write about media with any great precision. In the history of communication, the codex is typically defined in contrast to an older format, the scroll, and William A. Johnson explains in chapter 5 of this volume just how difficult it is to generalize about scrolls. (He calls them bookrolls.) By late antiquity, the widespread adoption and manifold uses of codices had helped relegate scrolls to a few highly specialized uses, notably in synagogues. When letterpress printing was developed in the West in the mid-fifteenth century, the codex had already been around for more than a millennium. So wherever "Print Culture (Other Than Codex)" may lead, another chapter remains undreamed and unwritten: "Codex Culture (Other Than Print)."[1]

Like distinguishing the codex from the scroll, the history of communication typically distinguishes print from manuscript, though there is significant poverty in these gross categories. Far from a simple precursor, *manuscript* stands as a back-formation of printing. (That is, before the spread of printing, there wasn't any need to describe *manuscript* as such.[2]) Meanwhile, *print* itself has come to encompass many, diverse technologies for the mechanical reproduction of text, despite its primary, historical association with letterpress printing à la Gutenberg. Until the nineteenth century, *every* text "printed" was printed by letterpress, using a process of composition, imposition, proofing, and presswork very like the one that Johannes Gutenberg, his associates and competitors, developed in the mid-fifteenth century, though saying so admittedly overlooks xylography (woodblock printing) and intaglio processes such as printing from copperplate engravings. Since 1800, however, multiple planographic, photochemical, and electrostatic means of printing have been developed and variously deployed, to the point that today, in the twenty-first century, virtually *nothing* "printed" is printed by letterpress. Tables turned, the term *print* has floated free of any specific technology, if indeed it was ever moored in the first place. Instead, *print* has become defined—as if in reflexive recourse to its own back-formation—by dint of "a negative relation to the [writer's] hand" (Warner 1990, 7). Any textual artifact that is not handwritten or otherwise handmade letter by letter (such as by typing) counts as "printed," while today, even the printer's hand has gone missing, because we have "become accustomed to speaking or writing of 'printers' not as people, but as machines" connected to our computers (McKitterick 2003, 1). That Gutenberg's Bible and the assortment of documents rolling out of my laser printer both count as "printed" again goes to show the difficulty we face in nailing down terms.

Print culture is a much more recent term than either *codex* or *print*. As Paula McDowell (2010) explains, it was coined by Marshall McLuhan in the 1960s and then earned its broad utility with the 1979 publication of Elizabeth L. Eisenstein's *The Printing Press as an Agent of Change: Communications and Cultural Transformations in Early-Modern Europe*. Eisenstein's version of print culture has been the subject of sustained critique for its

apparent suggestion that there is a logic *inherent* to print—the "soft" determinism, if you will, of calling the printing press itself "an agent of change"—yet even the notion's harshest critics have tended to redefine or reinstall *print culture* rather than reject that there is such a thing (231–32). Adrian Johns (1998, 35), for instance, points toward "sources of print culture" that are less technological than social, tracing the "conventions of handling and investing credit in textual materials" that emerged during the sixteenth and seventeenth centuries in Europe, mutual and coincident, as it happens, with the knowledge making of early modern science. For his part, Michael Warner (1990, 31, xiv) tries to avoid writing of "'print culture,' as though to attribute a teleology to print," while he traces the eighteenth-century development of "republican print culture" in Anglo-America, which, as it happens, came to double as the logic of the bourgeois public sphere. In both cases, print culture is something that developed according to the uses of printing, as those uses became widely shared norms. The upshot: with science and the public sphere as its mutual cousins, print culture starts to seem related in scale to modernity itself. And just as moderns people modernity, so printers, authors, readers, and publishers are among the social actors who are constituted by—as well as productive of—print culture. Or so it would seem.

Used in this way, the term *print culture* is at least as problematic as it has been handy, working as a sprawling catchall that depends on "the steadily extending social and anthropological use of [the term] *culture*" (Williams 1983, 92) to suggest a pattern of life structured to some degree by what Warner calls the shared meanings of printedness. But how widely, how unanimously, and how continuously can the meanings of printedness be shared, and what exactly are their structuring roles? A growing literature offers suggestive instances and a few theories, yet without thoroughgoing answers to difficult questions like these, the concept of print culture, and even of print cultures (plural), just doesn't make much sense. We need to jettison this term, or at least learn to specify what it means in the specific instances where we deploy it.

For the purposes of this chapter, then, and for the sake of expedience, it may be well to adopt the narrowest possible definition

of *print culture*. As a thought experiment of sorts and inspired by Johns and others, I'd like to stipulate that print culture—whatever else it may or may not be—should embrace the customs and practices that evolved within Western printing establishments, among the men and women who have, since the 1450s, specialized in the technological reproduction of textual materials. Print culture is at least the culture of printers, in other words, consolidated as such by the guild and apprenticeship systems, for instance, as well as by emergent social and economic norms that worked to structure printers as a class of actors in relation to other actors: authors and booksellers, yes, but also institutions like church and state. Print culture in this sense is a changeable beast. Developed first in the early modern period, it found expression in an elaborate and dynamic array of trade practices as well as in its own trade literature, beginning in English with Moxon's ([1683–84] 1978) *Mechanick Exercises on the Whole Art of Printing*. And it must persist in some measure today, albeit in a different and attenuated form. To give some idea, in 2008, there were just over half a million people employed in the printing industry in the United States. The Bureau of Labor Statistics (2010–11) divides the industry into twelve segments, of which the largest was commercial lithography and the smallest was "blankbook [*sic*] and looseleaf [*sic*] binder manufacturing": print culture *in extenso*.

One advantage of returning print culture to the printing house is that it helps recalibrate the relative importance of the codex or, familiarly, "the book," by focusing attention on noncodex forms. As Peter Stallybrass (2008, 109) reminds us, "printers do not print books. They print sheets of paper." Making books is a binder's business; it happens after and separately from printing.[3] And plenty of printed sheets never end up in books at all; they are noncodex for good and by design. In fact, the earliest extant example of letterpress printing in Europe that can be dated definitively is not a codex. It is a 1454 papal indulgence, a fill-in-the-blank form qua ticket to heaven, printed for the Catholic Church to sell to wealthy parishioners. Scholars think that Gutenberg took a break from printing sheets to be bound as Bibles so that he could print up a couple thousand indulgences. The full title of Martin Luther's subsequent call for reform, the *Ninety-Five Theses* posted on the

doors of Wittenberg Cathedral in 1517, was "Ninety-Five Theses on the Efficacy of Indulgences." (Luther first wrote them out by hand, but *Ninety-Five Theses* were quickly and widely printed and reprinted in a variety of formats.) Novelist Victor Hugo famously characterized the Protestant Reformation as a battle between the printed book and the Gothic cathedral, yet seen from another angle, it looks a lot more like a poster war. The Church annunciated and posted papal bulls, and reformers responded in kind, posting their own broadsides. In 1528, one group of reformers went so far as to post a fake bull urging Catholics to read and disseminate Luther (Febvre and Martin 1976, 290).

Though survival rates vary, of course, relatively few indulgences, broadsides, or other unbound printed sheets have survived to the present day. Whatever its other merits and affordances, the codex has proved a particularly effective technology for preserving print. Printers long styled their craft as "the art preservative of other arts," and Eisenstein has a section elaborating "the preservative power of print," but the relative survival rates for codex and noncodex print artifacts suggest that printing doesn't really preserve things; it's more likely folding, gathering, and sewing sheets into hardbound books that does. Where scattered instances of indulgences, posters, and similar noncodex artifacts have managed to survive, they tend to get classed according to that most unglamorous and miscellaneous of bibliographical designations, "ephemera." To the extent that "other than codex" works as a classification at all, then, it designates material experienced (in the moment) and then associated (in hindsight) with impermanence or ephemerality rather than with permanence or preservation. Noncodex print artifacts are more transitory than they are archival, one might say, more transactional than accumulative, and the meanings that they embody and convey are thus more accelerative than inertial.[4] They are used up, in short, more than they are stored away. This is probably particularly true of the most important, modern noncodex artifact that is less consistently classed as ephemera: the newspaper. In 1829, the U.S. Supreme Court decided that newspapers weren't subject to copyright because they were so "fluctuating and fugitive," changeable according to the frequency of their issue and the currency of their contents. In 1918, it elaborated that "hot" news

itself can't be copyrighted, even if the particularity of its expression can be.[5] The codex and its contents are sluggish and stable, "cold" by comparison to noncodex artifacts: books are slow to bloom, as anyone will admit who has ever tried to write and get one published.

Nowhere are the inertial qualities of things printed in books more evident, ironically, than in the printing trade literature descended from Moxon. The *Mechanick Exercises* gives a massively detailed how-to account of letterpress printing, but Moxon also renders "Ancient Customs" proper to the craft, describing the roles, rituals, and usages that had structured the "chappel," or printing house, he writes, for "time out of mind" (Moxon [1962] 1978, 323).[6] Generations of printer's manuals follow Moxon, and follow each other following Moxon. Later printer–authors borrowed liberally from one another, each of them "appear[ing] to reveal to the world some of the secrets of the trade" at the same time that they articulated an "orderliness" and regularity that was without question more wished than lived.[7] The "chappel," or chapel, could be a chaotic place, riven by strife, as well-known examples elaborated by Robert Darnton or mentioned by Benjamin Franklin readily demonstrate.[8] After 1800, this trade literature tended to express the conflict between order and actuality in terms of an unexamined contradiction between tradition and progress. Printers were caught between "time out of mind" and the many changes staring them in the face; the former earned them a solidarity that the latter helped to jeopardize. Progress was typically conceived in technological terms, and its inescapable yet largely unspoken costs were the havoc being wreaked on the orderly specialization and division of labor that every manual helped to iterate (Winship 1995). Certainly by the later nineteenth century, the printers' trade literature was largely a reactive project aimed at containment and consolidation: one result was the frequent retelling of printing history, a veritable cult of Gutenberg and Franklin.

The relative impermanence or ephemerality of noncodex print artifacts makes it all but impossible to judge the numbers in which they have circulated at different periods in the past. Survival rates are miniscule and surviving quantities meaningless, while records of production are difficult to come by.[9] The best data available come

from the U.S. Census of Manufactures (1904) and the comparable U.K. Census of Production (1907), both conducted well after the industrialization of the printing trades had penetrated all but the most remote enclaves. Printing had long been divided into three segments, not twelve: one producing newspapers and periodicals, another doing so-called book work, and the last consisting of other printing jobs. This last "other" category—what was called "job printing"—was the province of producing heterogeneous noncodex forms, and in both the United States and the United Kingdom, the capital invested—including labor—and the value of products resulting from the jobbing press were significant. In the United States, for instance, the Census Bureau found that the value of job printing comprised 30 percent of the total produced for the industry; newspapers and periodicals produced a whopping 52 percent of the whole, whereas books and pamphlets were worth just 11 percent, leaving 7 percent for other, assorted work, such as music publishing, lithography, and—that long-lived subspecialization—the manufacture of blank books (see U.S. Census 1904).[10] The industry's three segments were admittedly blurry and entangled, as material from periodicals got republished in books, for instance, and as newspapers ran jobbing houses on the side or job printers did book and newspaper publishers' work for hire. Still, taking figures like these for what they're worth, it would seem that at least a third of this sector of the economy has gone missing from media history as well as from textual studies. Gutenberg has had his cult, *print* as noun and verb has handily outlived letterpress, but who besides printers has ever heard of (or cared about) job printing?

In 1894, the *American Dictionary of Printing and Bookmaking* offered these examples in its entry on job printing, doubtlessly culling from an earlier source:

Account-book headings, ball tickets, bank notices, bonds and coupons, billheads, bills of lading, bills of fare, blank-books, business cards, certificates of deposit, certificates of stock, checks, commutation tickets, deposit tickets, drafts and notes, printed envelopes, election tickets, fare tariffs, handbills, hotel registers, indexes, inland bills of lading, insurance notices,

labels, law blanks, leaflets, letter-circulars, letter headings, manifests, memorandum billheads, money receipts, monthly statements, newspapers, note circulars, note headings, order-books, orders of dancing, pamphlets, pamphlet covers, passage tickets, programmes, price currents, policies, posters, railroad blanks, restaurant tickets, shipping cards, shipping receipts, show-cards, time-tables, transfers of stock, working lists, wedding cards and wrappers.

It is a list that recalls Gutenberg's fill-in-the-blank indulgences while yet speaking powerfully of the Anglophone world's rendezvous with bureaucracy during the nineteenth century. The arrival of finance capitalism and the modern corporation—with its managers and memos—springs to mind. Most of the items listed share a producer rather than a consumer logic. They were printed for businesses doing business, that is, not for private individuals, and as such they were intended to function as instruments of corporate speech. Even the examples that appeal to leisure (like those ball tickets and orders of dancing) do so within a managerial frame. If one subtracts banking, shipping, and insurance from the list, bureaucracy still reigns, along with vernacular documents associated still with everyday life: commuting (tickets), eating out (menus), keeping up (newspapers), shopping (labels), voting (ballots), and maybe getting sued or getting married.

Because so many of the print genres handled by the jobbing press functioned as instruments of corporate speech, they stand at odds with familiar notions of publication. Yes, a railroad company may be said to have published its schedules and published its fares, for instance, but it makes little sense to think of the same company's letterhead as a publication or to think of the headings in its account books as having been published in anything like the usual way.[11] Neither Gutenberg nor the Catholic Church, for that matter, can rightly be said to have published indulgences, even though they were certainly printed in sizeable editions. Books, newspapers, and magazines are published; posters, concert programs, and pamphlets, I guess, are published too; but much of the output of job printing seems to have been just printing, not publication. It wasn't meant to issue into the public arena, that "ongoing space

for the encounter of discourse" that is distinctively modern because it is "organized by nothing other than discourse itself" (Warner 2002, 420, 413). Instead, print artifacts like letterhead or stock certificates inform communications that are sequestered from the public sphere and only thereby beholden to it, working as part of the everyday triangulation that privately interconnects people and institutions via paper and print. The Church and its wealthy parishioner negotiated each other partly by means of the indulgence; the railroad company's representative and her correspondent likewise negotiated each other partly by dint of letterhead. In either case, parties communicate in a discursive realm organized not only by discourse but also by the ongoing and incremental relegitimation of authority, by competing structures—religious, corporate, professional, educational, clinical, financial, municipal, and so on—that work as so many loose and chaotic cross-stitches over and against the public sphere, appearing to tack it together, we must imagine, even as they potentially worry it apart.[12]

And if publishers don't seem to fit into the other-than-codex world of job printing, neither exactly do readers. Who ever really reads receipts, bills, tickets, bonds, or certificates? Yes, there is writing printed on them, but their textual qualities have become "naturalized" through the social processes that have made them useful as the instruments they are, so that the writing on them "has seemed to disappear" (Poovey 2008, 3). They wouldn't function if they didn't have writing on them, yet few people would describe their functioning in terms of reading, unless in the contexts of controversy, where a counterfeit is found out or a lawsuit seems likely; then reading *and forensics* enter in. Notably, whatever reading is entailed by genres like bills of lading and stock transfers, it is not reading that has anything to do with the sort of readerly subjectivity that came to such especial prominence in the course of late eighteenth and nineteenth centuries, the subjectivities of literature in general and the novel in particular. One might well identify with characters in Jane Austen or ponder the psychologies in George Eliot, but that's exactly what one doesn't do—what one couldn't do—with shares enumerated on a stock transfer, details spelled out in an insurance policy, or particulars identified on letterhead. Noncodex forms like these operate wholly outside

of the romantic realm that Patricia Crain describes in chapter 7 as so productive of the modern self, a realm structured in some measure by the figure of a reading child. Nor do genres like these inspire identification among communities of readers, the way that newspapers are said to have done because of the semiritualized character of their consumption (see Carey 1992, chapter 1). The other-than-codex forms I'm thinking about didn't have readers; they had *users* instead.[13]

Lacking publishers and readers or readerships, much of the output of job printing also lacked authors. Account book headings prove this point, thanks to an important copyright case decided by the U.S. Supreme Court in 1879. The case concerned a new system for keeping accounts, aimed at county functionaries in Ohio. Charles Selden had published a small manual that was illustrated with sample forms: blank ledger sheets with printed headings. Another bookkeeper, named William C. M. Baker, set out to promote a similar system, and the forces of Selden claimed copyright infringement. The case—on appeal, it was called *Baker v. Selden*—is important in American law as the origin of what lawyers call the idea–expression dichotomy. Ideas are free to all; a copyright protects the way those ideas get expressed.[14] Selden had described his method of bookkeeping; his copyright was for the description, the court said, not the method. His authorship of the manual could not extend to its sample forms, because anyone using his method of bookkeeping perforce used sheets with headings like those: they were part of his idea, not its expression, part of his method, not its description. So, too, must printed checks, receipts, and other blanks be said to constitute—not express—the very ideas of their own filling in.

Locked within *Baker v. Selden*, incidentally, was a question for the future, unaskable for another century or more. What may have looked in the nineteenth century like a question about the division of mental labor (because the managers who designed and deployed blank forms were thinking ahead to their filling in by others [see Campbell-Kelly 1996]) would look by the end of the twentieth century like a question about software. Selden's forms worked like executable little programs for bookkeeping, one might analogize, and his blanks collected data. Should software

be copyrightable? Can you author the fields of a database? Should you be able to own the menu structure of an interface? Contests over questions like these broached and then quickly exceeded the idea–expression dichotomy, while *Baker v. Selden* continues to be cited by the courts in thorny intellectual property cases. Beyond the legal context, it remains notable that so many fill-in-the-blank forms encountered online today are designed to look like nineteenth-century job printing on paper, notwithstanding the data architecture and manipulability that lie behind or beneath that interface. One renders oneself as data every time one fills in a form online, every time one completes a site registration or types something into a search box. But digital texts and their contexts must wait for a later chapter in this volume.

Generalization is admittedly difficult because "other than codex" embraces a massively heterogeneous class of printed material and the history of printing has been so long, and yet the subject of job printing proves wonderfully suggestive. Speculating on the basis of job printing statistics and genres from the late nineteenth and early twentieth centuries, it would seem that a—perhaps *the*—significant amount of bread and butter within the printing trades had been the result of printing things that weren't meant to be bound, wouldn't last for very long, weren't formally edited or published, didn't have readers or create readerships, and might not be protected by authorial rights. It would seem, that is, that by seeking so strenuously to constrain the meaning of *print culture*, I have by accident somehow managed to make it balloon enormously in size, because now it sprawls so far beyond the ambit of its constituent publishers, readers, and authors and so far beyond the interests of cultural memory and the preservation of knowledge. Either *print culture* doesn't include the culture of printers or the concept itself doesn't make much sense. Taking account of "other than codex" leads someplace other than print culture. It leads, that is, to the poverty of this well-worn analytic.

If we are to think critically about print media, it would be well to reject or refine the contrastive generalities with which the history of communication and the recent promotions of digital forms have saddled us. Consider the very specific histories that might be told of printing over the last five and a half centuries and around the

world. "Print" is not one thing; it is, has been, and will be many. The relevant multiplicities are best glimpsed not by comparing media forms but rather by attending the specific structures and practices within which those forms have come to make sense at different times and among different social groups. Historical and cultural specificity is key, while *de*-centering the media concept should earn us richer, more critical media studies.

NOTES

The author wishes to thank two groups of colleagues for their generous discussion of an earlier draft of this chapter and their many helpful suggestions. The first discussion was hosted by the Department of Art History and Communication at McGill University, and the second was hosted by the Center for the Arts in Society at Carnegie Mellon University.

1 For codex and noncodex other than print, e.g., see Clanchy ([1973] 1993, 84). Clanchy distinguishes between primary and secondary records. The latter are compiled from primary records and were often codices; "the great majority of primary documents have been lost, because they consisted of single sheets of parchment." For a recent account that wonderfully unsettles received distinctions, see Mak (2011).

2 Indeed, *manuscript* is a back-formation that likely took some time (see Stallybrass 2008, 115). For at least two centuries *after* Gutenberg, libraries in Europe made no distinction between their manuscript codices and their printed ones (McKitterick 2003, 13).

3 An exception would be paperback books.

4 I'm taking this language of acceleration and inertia from the work of Will Straw (2007), who draws on anthropologist Greg Urban.

5 The first case is *Clayton v. Stone* (2 Paine, 392), and the second is *International News Service v. Associated Press* (248 U.S. 215).

6 See the editors' note on authorities besides Moxon ([1962] 1978, 384–85).

7 McKitterick (2003, 147) makes this case on the basis of the books actually printed. R. G. Rummonds (2004) traces a genealogy of printer's manuals.

8 Recall that a London "chappel" [*sic*] extorts a "bien venu or sum for drink" from the teetotal Benjamin Franklin in his *Autobiography*, http://etext.virginia.edu/toc/modeng/public/Fra2Aut.html, 46. See Darnton's (1984, 75–105) classic essay on the "Great Cat Massacre."

9 On the early modern period, see Stallybrass (2007, 316–19).

10 Similar figures attended in Britain. Stallybrass (2008, 111) notes that the 1907 Census of Production found that books accounted for only 14 percent of the value produced by the printing trades. Making blank books was counted separately because it was often the work of bookbinders, not of job printers, a reminder that the printing trades were an agglomeration of allied specializations that overlapped in some settings and not in others. See also Weedon (2003, chapter 1).

11 Though I'm writing of publishing as having a history that reaches back to the early modern period, the role of publisher (rather than bookseller) is a relatively modern one. See Johns (2007, 411).

12 The theory of the public sphere is complicated in this last sentence by the question of social differentiation; see Niklas Luhmann (1982). Markus Krajewski and Christina Lupton were helpful in leading me to Luhmann.

13 Of course, it is impossible to generalize about the diverse agencies and subjectivities of "users" in this sense; I mean only to underscore the instrumental functions of job printed forms.

14 *Baker v. Selden* is 101 U.S. 99. McGill (2007, 176) calls this "a pivot between nineteenth- and twentieth-century thinking about copyright"; "the court contrasted the opacity of aesthetic language with the ideal transparency of commercial speech, the intransitivity of aesthetic appreciation with the iterability of scientific truth, theory with practice, and the uniqueness and physicality of the embodiment of ideas in writing with the elusive nature of disseminated habits and routines—a catalog of opposing terms that have come to underwrite the legal dichotomy between expression and idea" (177).

REFERENCES

Campbell-Kelly, Martin. 1996. "Information Technology and Organizational Change in the British Census, 1801–1911." *Information Systems Research* 7, no. 1: 22–36.

Carey, James W. 1992. *Communication as Culture: Essays on Media and Society*. New York: Routledge.

Clanchy, M. T. (1973) 1993. *From Memory to Written Record: England 1066–1307*. 2nd ed. Malden, Mass.: Blackwell.

Darnton, Robert. 1984. *The Great Cat Massacre and Other Episodes in French Cultural History.* New York: Basic Books.

Febvre, Lucien, and Henri-Jean Martin. 1976. *The Coming of the Book: The Impact of Printing, 1450–1800.* London: Verso.

Johns, Adrian. 1998. *The Nature of the Book: Print and Knowledge in the Making.* Chicago: University of Chicago Press.

———. 2007. "The Identity Engine: Printing and Publishing at the Beginning of the Knowledge Economy." In *The Mindful Hand: Inquiry and Invention from the Late Renaissance to Early Industrialisation,* edited by Lissa Roberts, Simon Schaffer, and Peter Dear, 403–30. Amsterdam: Koninklijke Nederlandse Akademie van Wetenschappen.

Luhmann, Niklas. 1982. *The Differentiation of Society.* Translated by Stephen Holmes and Charles Larmore. New York: Columbia University Press.

Mak, Bonnie. 2011. *How the Page Matters.* Toronto, Ont.: Toronto University Press.

McDowell, Paula. 2010. "Mediating Media Past and Present: Toward a Genealogy of 'Print Culture' and 'Oral Tradition.'" In *This Is Enlightenment,* edited by Clifford Siskin and William Warner, 229–46. Chicago: University of Chicago Press.

McGill, Meredith L. 2007. "Copyright." In *A History of the Book in America.* Vol. 3, The Industrial Book, 1840–1880, edited by Scott E. Casper, Jeffrey D. Groves, Stephen W. Nissenbaum, and Michael Winship, 158–78. Chapel Hill: University of North Carolina Press.

McKitterick, David. 2003. *Print, Manuscript, and the Search for Order, 1450–1830.* Cambridge: Cambridge University Press.

Moxon, John. (1683–84) 1978. *Mechanick Exercises on the Whole Art of Printing.* 2nd ed. Edited by Herbert Davis and Harry Carter. New York: Dover.

Poovey, Mary. 2008. *Genres of the Credit Economy: Mediating Value in Eighteenth- and Nineteenth-Century Britain.* Chicago: University of Chicago Press.

Rummonds, R. G. 2004. *Nineteenth-Century Printing Practices and the Iron Handpress.* 2 vols. New Castle, Del.: Oak Knoll Press.

Stallybrass, Peter. 2007. "'Little Jobs': Broadsides and the Printing Revolution." In *Agent of Change: Print Culture Studies after Elizabeth L. Eistenstein,* edited by Sabrina Alcorn Baron, Eric N. Lindquist, and Eleanor F. Shevlin, 315–41. Amherst: University of Massachusetts Press.

———. 2008. "Printing and the Manuscript Revolution." In *Explorations in Communication and History,* edited by Barbie Zelizer, 111–18. New York: Routledge.

Straw, Will. 2007. "Embedded Memories." In *Residual Media,* edited by Charles R. Acland, 3–31. Minneapolis: University of Minnesota Press.

U.S. Bureau of Labor Statistics. 2010–11. "Printing." In *Career Guide to Industries.* http://www.bls.gov/oco/cg/cgs050.htm.

U.S. Census. 1904. *U.S. Census of Manufactures.* Washington, D.C.: U.S. Government Printing Office.

Warner, Michael. 1990. *The Letters of the Republic: Publication and the Public Sphere in Eighteenth-Century America.* Cambridge, Mass.: Harvard University Press.

———. 2002. "Publics and Counterpublics (Abbreviated Version)." *Quarterly Journal of Speech* 88, no. 4: 413–25.

Weedon, Alexis. 2003. *Victorian Publishing: The Economics of Book Production for a Mass Market, 1836–1916.* Aldershot, U.K.: Ashgate.

Williams, Raymond. 1983. *Keywords: A Vocabulary of Culture and Society.* Revised ed. New York: Oxford University Press.

Winship, Michael. 1995. "The Art Preservative: From the History of the Book Back to Printing History." *Printing History* 17, no. 1: 14–23.

Part III
RECURSIONS

WHY WOULD a media framework tend to encourage recursive strategies? But we are getting ahead of ourselves; first it would be useful to define recursive strategies. *Recursion* can be understood as folding a work's logic back on itself. The mousetrap play in *Hamlet* is recursive on several different levels, from the play-within-a-play form to the repetition of actions from the main plot interpolated into the mousetrap play. Wherever they occur, recursive strategies have similar effects. They are associated with a quantum leap in complexity, and they open a work to paradoxes of the kind represented in M. C. Escher's *Drawing Hands,* where each hand is shown drawing the other. As Douglas Hofstadter (1999) masterfully explains in his definitive book *Gödel Escher Bach: An Eternal Golden Braid,* recursions hint at a lack of absolute foundations, and they gesture toward the infinity created when two facing mirrors reflect each other endlessly. In computer science and mathematics, recursion is used to create infinite sequences out of simple beginnings. For example, both the Fibonacci sequence and the set of natural numbers in set theory are generated by positing a simple base case and then using a set of rules that reduce all other cases to the base case. Because in recursion the function being defined is applied within its own definition, recursion offers a way to move from a finite statement to an infinite progression.

What does this have to do with a media framework? A media framework facilitates recognizing recursive moves and understanding their subversive effects within a given mediascape. If one does not acknowledge the medium in which a work is instantiated, one can deal with content alone (which, by the way, may also employ recursive strategies, although not necessarily). When the media framework is included inside the interpretive arena, however, the possibilities are enhanced for recursive strategies that refer at once to the medium's material properties and to the content

that metaphorically likens elements of the work to the medium. Thus a recursive loop is created in which the medium references the content and the content references the medium, an oscillation similar to two facing mirrors reflecting one another. Such devices are very well known in literary texts, from Prospero's reference in *The Tempest* to "the great globe itself" to its playful instantiation in the film *Being John Malkovich,* where John Malkovich enters his own head and then sees a scene in which all the characters have John Malkovich's head, a cinematic analogue to two facing mirrors.

In a media framework, recursion emphasizes the material properties of a medium, the means by which the work produces itself as a work. As we will see in the essays in this section, the gilt paper on which Donne wrote his letter, the code generating the text of *exquisite_code,* the "Link Trainer" in *My Name Is Captain, Captain.,* and the Paternoster diagram in the Vernon manuscript all function as the material substrates evoked by recursion strategies, which can be understood as the work commenting on its own conditions of possibility. Recursive strategies in this sense can be seen as gestures aimed to break the transparency of a medium's presuppositions, not by comparing it to an "other" medium but by burrowing inside its own assumptions until they become visible to the reader-user.

REFERENCE

Hofstadter, Douglas. 1999. *Gödel Escher Bach: An Eternal Golden Braid.* New York: Basic Books.

9

Medieval Remediations

Jessica Brantley

A DEEP ASSUMPTION underlying the field of media studies is that media consciousness is necessarily modern, or even postmodern. The institutionalization of the field along these lines perpetuates the view, leading to the belief in many quarters that media studies is necessarily the study of "new media" and that its most comfortable institutional home is schools of film and TV.[1] But, as John Guillory has recently shown, the media concept was alive long before the emergence of nineteenth-century technologies (such as the telegraph and the phonograph) would demand the creation of a term. Tracing a growing awareness of the "different things" in which imitations are made (to use Aristotelian language), he identifies a particular consciousness of *medium* arising in the early modern period. (Guillory 2010, 323).[2] Guillory's exemplary work attests to the ways in which the study of historical media can inspire the reimagining of traditional disciplinary boundaries. For, as I will argue here, historical disciplines are particularly well situated to propose alternative models for how media forms engage each other over time, models from the past that suggest how capacious media studies in the present can be.

This essay uses the example of medieval media to consider further the relation of media studies to history and to historical fields of inquiry. Medieval studies is not often included in the array of disparate fields one might consider relevant to the study of evolving media forms. In fact, the Middle Ages are left out of the story again and again, even where an effort is made expressly to historicize. In the introduction to *Critical Terms for Media Studies,* for example, Mitchell and Hansen (2010, xviii) write,

We especially want to avoid the presentism that plagues so much of "new media" studies today. Our aim is to take the field back beyond the "digital revolution" of the last twenty years to its deeper origins in antiquity and early modernity.

Even an explicit appeal to history such as this remarkably omits to consider the Middle Ages, leaping uncritically from "antiquity" to "early modernity," just as the Renaissance itself has taught us to do (see, e.g., Burckhardt [1860] 1995; Mommsen 1942). The historical leap is aided by a kind of technological determinism to which it is easy to succumb. As Mitchell and Hansen (2010, xvi) describe it,

> insofar as media studies is a historical discipline, it is driven by an obsession with invention and innovation: How did the invention of metal casting transform Roman sculpture and Chinese bell temples? How did the invention of mechanically printed coins affect ancient economies?

From the point of view of the English department, this emphasis on novelty means that historical media studies must always come down to the printing press. As John Guillory (2010, 324) boldly writes, "The early modern period saw the first truly major practice of remediation with the invention of printing, which reproduced the content of manuscript writing at the same time that it opened up new possibilities for writing in the print medium." The major remediation of script to print is what allows Guillory to identify the early modern period as the moment in which consciousness of media resurfaces for the first time since antiquity. As he memorably puts it, "remediation makes the medium as such *visible*" (324).[3]

But is print really the first practice of remediation, or even the first "truly major" one? To take just one complicating example, the remediation of the scroll into the codex—arguably, a more fundamental shift than from manuscript codex to printed one—must have occasioned reflection about the importance of the physical medium of the written text, and yet it remains much more mysterious.[4] Instead of remarking the revolution caused by printing, one might rather describe a long period of continuity dominated

by the codex, circa 400 to circa 2000, finding the most significant remediations at either end. And even if one imagines the thousand years between classical antiquity and the Renaissance as bracketed by two major medial shifts—the first from scroll to codex and the second from manuscript to print—it is not as if media were entirely static during that time. If the medieval centuries do not present seismic shifts, they do offer many significant medial transitions, as, for example, the change from parchment to paper as the most widespread material support for writing or from Carolingian minuscule to a proto-gothic script.[5]

The example of the printing press as an agent of change, familiar since McLuhan ([1964] 2003) and articulated powerfully by Eisenstein (1979), raises a still more important question: must historical accounts of medial change value only the point of origin, the new and the novel? The emergent field of media archaeology has advocated a more complex and layered kind of historical understanding that could challenge the simplicity of such a narrative.[6] In a more nuanced version of the innovation thesis, Lisa Gitelman (2006, 1) acknowledges her "assumption, widely shared by others, that looking into the novelty years, transitional states, and identity crises of different media stands to tell us much, both about the course of media history, and about the broad conditions by which media and communication are and have been shaped." Gitelman's awareness that "all media were once new" grounds her exploration of the early years of the phonograph in connection with the early years of the web. Taking a still longer view, I will argue here that the pre-print media ecology of the Middle Ages offers special complexities that challenge the explanatory power of novelty per se. Though it is no doubt true that periods of dramatic media shift are particularly revealing, ongoing smaller variations more fundamentally shape historical landscapes of communication. The multiplicity of medieval media and their complex intermedial interactions offer a reminder that media forms are always shifting fundamentally in horizontal ways, based on spatial and social landscapes, as well as in vertical ways, based on the idea of historical supersession.

For as Mitchell and Hansen's historical leap from antiquity to the Renaissance in fact reveals, the Middle Ages is constituted by its own important kind of "middleness," lying as it does between

the fall of Rome and the Reformation.[7] Although the middleness of those centuries differs from the middleness of the "physical material (as tape, disk, paper, etc.) used for recording or reproducing data, images, or sound," the etymological root of *media* forms a part of the Latin name by which we call the age: *medium aevum*.[8] In shuttling from one thing to another, both perform a useful kind of intermediation, for in the study of media and the study of the Middle Ages, scholars are trying to look squarely at phenomena that have sometimes seemed only ancillary to the real subject of inquiry. By overlooking the importance of the middle, media studies risks missing out on what medieval studies can offer to thinking about the ways in which media both represent and transform knowledge. In connecting the *medium* to the *medium aevum,* we can better understand the necessary *middleness* of new media rather than seeing only their novelty.

Among the wide variety of medieval remediations, I would like to consider three that are particularly important to understanding the role of media consciousness and intermedial practice in the Middle Ages. Most fundamental are the complex interactions between orality and literacy, ongoing for centuries before the *medium aevum* and still important to theorizations of new media today.[9] More and more, medievalists approach this transition looking not for a watershed moment—such as Augustine's description of Ambrose reading silently—but for a continual renegotiation between oral–aural and literate–visual ways of knowing continuing over centuries. And of course, this kind of dynamic is far from dead: Gitelman's (2006) work on the history of the phonograph reveals a more recent perspective on the complexities generated by the inscription of sound. As she puts it, "new media are less points of epistemic rupture than they are socially embedded sites for the ongoing negotiation of meaning as such" (6).

Related to negotiations between orality and literacy, a second kind of media shift of great importance to the late Middle Ages is the emergence of vernacular languages from Latin, which had been the lingua franca of Western Europe since the fall of Rome. Although the translation of ideas from one verbal language to another is not often imagined as a form of medial shift, it is useful to consider words themselves (written or spoken) as a material

support for thought; medieval writers imagined them this way and thought constantly about ways in which the linguistic media of Latin, or French, or English were themselves meaningful. The medieval centuries saw the rise of the western vernaculars and their increasing use for purposes that we would call literary. By the end of the period, Chaucer could write exclusively in his own nation's vernacular, founding a new literary canon and becoming the "Father of English Poetry." But again, this is not an evolutionary story dependent on supersession, a narrative of the smooth and easy dominance of English over Latin and French: England was thoroughly and complexly trilingual in the fourteenth and fifteenth centuries, and Chaucer's contemporary Gower wrote major works in all three languages.[10] The eventual triumph of English looks inevitable in hindsight, but in the medieval media ecology, complexity and circuitous change were the norm.

Finally, an important variety of medieval remediation that continues to occasion scholarly attention and debate is the translation from texts to images, and back again. The fact that this is evidently not a unidirectional shift but a continual interplay of verbal and visual forms demonstrates the dangers of imposing too evolutionary a narrative on the development of historical media. The nature of the translations between text and art was most famously addressed by the sixth-century pope Gregory the Great in his letter to Bishop Serenus of Marseilles; there Gregory defended religious images by suggesting that pictures had a utility in communicating to those who could not otherwise understand: that pictures were the books of the illiterate.[11] This idea took hold of medieval commentators (if not always of medieval artists) so powerfully that it is known to modern scholarship as the "Gregorian dictum." Gregory's influential characterization of pictures as *littera laicorum* suggests that the same information, the same content, was conveyed by both media forms. The extent to which this can be true has been the subject of much discussion (Camille 1996; Chazelle 1990; Duggan 1989, 2005; Kessler 1985), but it is a metaphor that had wide currency in the Middle Ages: medieval thinkers, following Gregory, imagined stained glass windows or manuscript illumination as a kind of remediation of biblical narrative.

Of course, John Guillory is concerned with ways that people

talked about what he calls the "media concept"—not experiments
in remediation, which were rife in the Middle Ages, but explicit
philosophical remarks about the communicative rather than mi-
metic function of material forms. The isolation of the matter from
the manner is the beginning of talking about manner—one has to
separate them to see the importance, or even to acknowledge the
existence, of media forms. In medieval thought, debates about the
role of images in relation to texts frequently provided occasions
for writers to articulate the difference a medium makes: the image
controversies in eighth- and ninth-century Byzantium, as well as
the iconoclastic writings of fourteenth-century English Lollards,
come to mind as two geographically and temporally distant ex-
amples.[12] But the critical insight of media studies is that we should
not separate medium from meaning, that it is in fact impossible
to talk about meaning without taking medium into account. Ac-
cordingly, it is experiments in remediation—whether through the
printing press or myriad other technologies—that both reflect and
bring forth a consciousness of medium as such.

 In recognition of that fact, I would like use the balance of
this essay to explore in detail the remediations that are visible
in one medieval experiment in multimedia expression: what is
usually called the Paternoster diagram in the celebrated Vernon
manuscript from late-fourteenth-century England (Plate 9.1).
This medieval object makes the interactions of its multiple media
central to its devotional project: the diagram includes a vari-
ety of visual and verbal forms that themselves, and in combina-
tion, ask its viewer and its reader (for it is unclear which one
we are) to consider consciously the difference a medium makes.

THE VERNON PATERNOSTER

The Vernon manuscript is a very large codex that must originally
have contained more than 420 leaves of vellum (or parchment),
each one approximately twenty-one and a half by fifteen and
a half inches (544 × 393 millimeters).[13] In the absence of other
clear indications of provenance, the manuscript's size provides
valuable information about its likely uses. It cannot have been car-
ried around and was therefore unlikely to have been individually

PLATE 9.1. The Vernon Paternoster Diagram. MS. Eng. poet. a. 1, fol. 231r. The Bodleian Libraries, University of Oxford.

owned; more probably, it was a coucher or ledger book, housed
on a lectern for the use of a religious community or perhaps a lay
household.[14] The book is miscellaneous, but it is not haphazard:
unusually for a medieval miscellany, the volume begins with a
table of contents and a title, *Salus Anime* or *Sowlehele*. As that
double Latin and Middle English heading suggests, the contents
of the book are concerned with the "health of the soul"; it is a
collection of devotional works, both in verse and prose, includ-
ing saints' legends, narratives of Christ's life, Marian miracles,
homilies, didactic romances, Langland's *Piers Plowman* (A-Text),
works by Richard Rolle and Walter Hilton, and a collection of
refrain lyrics. Although some scattered Latin and French appear
in the manuscript, all of its texts are primarily in Middle English,
leading scholars to speculate that it "provides a complete Christian
book for someone not in holy orders" or perhaps for a religious
community of women (Blake 1990, 57).

Even beyond its grand size, the manuscript is handsomely
produced and occasionally decorated. There are accomplished
borders and initials throughout, and two of the texts have cycles
of illustrations: *La Estoire del Evangelie* (a narrative life of Christ
translated from Latin into English, though titled in French) and
Miracles of the Blessed Virgin Mary.[15] The images that accompany
the *Estoire* are familiar from a psalter or a book of hours: like
the cycles of illustration in those prayer books, they include the
major scenes from Christ's life, such as Annunciation, Nativity,
and Passion. Some leaves are missing from the text, most likely
cut out because of the value of the images, and two other texts
that contained illustrations have also been lost: "Diuerse orisons
to the fadur and to the sone and to the holy gost," in the words
of the table of contents, and "Salutaciones to vre lady wyt peyn-
ture annex." The collection of Marian miracles is accompanied
by rather complex narrative images, including an illustration of
events from the story of "The Boy Murdered in Paris," an analogue
to Chaucer's *Prioress's Tale* (f. 124v).

The image that interests me here, named by the table of con-
tents "Pater noster in a table ypeynted," does not illustrate any
text (Plate 9.1). Instead, it is a stand-alone verbal and visual
composition, what W. J. T. Mitchell in another context has called

an *imagetext,* a representational object designed for both reading and seeing (Mitchell 1994).[16] This complicated array occupies almost all of a page, but not quite—it falls between the conclusion of *The Pope's Trental* and the beginning of *Speculum Vitae.*[17] Tellingly, the "Pater noster in a table ypeynted" is not a full-page image, designed to stand alone in the visual field, but only one item among many, perhaps following a more textual than visual model of the miscellaneous kinds of information a page might hold.[18] This intricate imagetext presents the seven petitions of the Lord's Prayer (the Paternoster) and associates them with the seven gifts of the Holy Spirit, seven vices, and seven virtues, all in a complex of text and decoration that presents crucial doctrinal information in a visual mode.

Although it is most commonly known as the Vernon Paternoster *diagram,* the visual exposition of this fundamental Christian prayer "in a table" might also adopt the vocabulary of new media, to be imagined as a matrix, or a network, or even a hypertext, for it provides multiple reading paths that link dispersed nodes or chunks of meaning to others in a variety of ways. As Avril Henry (1990, 113), its earliest interpreter, has declared, "its manner is partly its message." In this observation, although she inexplicably chooses to vary the crucial word, she neatly echoes Marshall McLuhan's ([1964] 2003) insight so fundamental to media studies: "the medium is the message." But manner is another way of talking about medium, and there is no reason to back away from that term as necessarily anachronistic here. I hope that, in what follows, it becomes clear that the "manner" of the Vernon Paternoster diagram *is* its medium and that embracing the intermedial identity of the manuscript page allows for increased insight into its ways of working. More than that, the imbricated workings of multiple media in this premodern object can enrich our engagement with more recent textual forms.

At the top of the Paternoster diagram, its four columns are titled with Latin rubrics: "vii petitiones," "vii dona spiritus sancti," "vii virtutes contra vii vicis" (see Plate 9.1). The alignment of seven with seven provides the intellectual rationale for the design, although the configuration is as likely to be opposing (virtues and vices) as mutually reinforcing (virtues and gifts of the holy spirit). The

words of the Lord's Prayer begin with a large golden initial on the second level of text: *Pater noster qui es in celis sanctificatur nomen tuum*. This first petition is followed in turn by red letters marking the first of each set of seven: *Timor dei* (Fear of God), *Humilitas* (Humility), and *Superbia* (Pride). Each of these concepts is translated into a roundel below: first petition, "Father that art in heuene thi nom be halew"; first gift of the Holy Spirit, "Drede of God"; first virtue, "mekenes & and lounesse"; and first vice, "prinde and stownesse." Reading the Latin from right to left, one has little idea of how these concepts are to be connected. On the next level, however, where the black-ink translations in roundels explicate each of these ideas, English words in red specify the relation, providing essential connective tissue that will be repeated seven times: "This preier {*a petition*}, ledith a man to {*a gift of the Holy Spirit*}, ledith a man to {*a virtue*}, is ayenst {*a vice*}."

If one reads in a normal Western mode, laterally from left to right, one encounters this alignment of each petition with a gift, a virtue, and a vice. The text leads the reader across the page, enacting the relation between prayer and its beneficent consequences, until the final opposition of the contrary vice brings it all to a stop. But the diagram is not simply laid out as a text to be read from left to right; it operates in a columnar scheme, as well, and perhaps even more forcefully. The first column provides the full text of the Lord's Prayer given in Latin, with the English translation of each phrase written in a roundel underneath. If one reads down the first column, then, one reads the prayer in an alternation of languages. Every column that follows presents its own group of seven in alternating Latin rubrics and Middle English roundels. These groupings do not read as sentences—they are not syntactic— but they communicate information through visual structures of identification and linkage, alternating formal Latin concepts, dignified through their enlarged initial letters, with their Middle English translations, set off and bounded by roundels. The diagram presents a variety of vectors of understanding, more or less continuous but meaningful in a crisscross pattern of meaning in which many linkages are possible and in which the rich possibilities for variation are a part of the point.

Visually, the diagram operates as a dense *textus* of words and

penwork decoration. Every space is filled, so when a verbal phrase is not long enough to fill the space allotted, line fillers stop the gap. Verbal and visual alternation, as well as a *horror vacui,* is an aesthetic principle of this composition; the penwork varies between red and black, with larger gold initials at the left, filled with red and blue paint. Squares and circles alternate, as the English words are in roundels and the Latin ones (as well as English rubrics) are more often in rectangular spaces. Some lettering is in black, some in red, and the decoration includes knotwork, foliate borders, and other kinds of nonrepresentational patterning. The decorative infill here recalls other kinds of medieval manuscript painting: the line fillers that dominate the pages of a psalter, for example, regularizing the text block when the verses of the psalms stop before the end of a line. The knotwork, moreover, evokes a particular place and time in medieval art: the carpet pages often found in early Anglo-Saxon manuscripts. In both cases, the decoration works in concert with the text, reminding readers that texts are visual objects, too—for the psalter's text block works on aesthetic principles as well as literary ones, and the Greek letters chi-rho that form the center of the carpet page are barely legible amid the welter of representational and nonrepresentational interlace that surrounds them.

The remediations of the Vernon Paternoster diagram meaningfully transform Latin into English, and words into shapes. The diagram alternates the colors and dispositions of words, making spoken language into a variety of visible forms. As Guillory observes, this process makes perceptible the medium as such, and in the case of the Vernon Paternoster, the remediation of the prayer into a diagram reminds its readers and viewers that they must think about which they are. The effect of this is not to erase or elide the difference between media forms. Although reading is doubtless always a kind of viewing, by oscillating so ostentatiously between the two activities, the diagram makes the difference between them observable. This diagram's self-conscious and exuberant modes of translation explore the implications of the changes among media. As it turns spoken words into written ones, Latin words into English ones, and text into a kind of image, the diagram forces its viewer to wonder what its media forms are and how they function together. In the workings of this imagetextual object,

one can discern the self-consciousness about form that heralds a consciousness of medium.

This late-fourteenth-century conglomeration of media thematizes the ongoing negotiations involved in medieval remediations, not as experiments with the new but as explorations of multiple forms of the known. The commerce between Latin and vernacular, for example, is part of a long-standing environment of multilingualism in medieval England, though it had particular parameters at the turn of the fourteenth century. English had existed for centuries, first as Old English (circa 800–1100) and then as Middle English (circa 1100–1500), but it was newly a literary language in the late Middle Ages, which saw the rise of the vernacular as a medium of expression put to new uses by new publics. The use of English for prayer in the Vernon Paternoster diagram is especially notable, for the status of vernacular expression in the devotional sphere was much debated in England in the decades around 1400.[19] On one hand, the Paternoster—the prayer most fundamental to a medieval Christian—hardly needs translating; these Latin words are so familiar, so habitual, that they have a status apart from and mediating between Latin and vernacular.[20] But the connection between them in the Vernon manuscript is not seamless; rather, the diagram ultimately marks out their differences, even as it suggests their interchangeability. The Vernon Paternoster presents translation as a kind of medium shift, marked by differences in color, layout, and shape, as the rectangular text blocks of the Latin words are punctuated with the roundels that contain Middle English.

The diagram also witnesses to distinctions between the oral and the written and to the complications that prevent the drawing of clear lines between them. The multimedia of the page stage negotiations between prayer-as-performed and prayer-as-read—between prayer in the voiced activity of performance and prayer as viewed within the manuscript book. The full complexity of the diagram is unvoiceable and therefore far from the protocols of prayer that would have mandated an "Our Father" to be audibly and reverently pronounced. At the same time, the diagrammatic structure of the prayer calls attention to the act of reading as one that requires reiterated and unstable enactments, that is, to the act of reading itself as a brand of performance (Aarseth 1999, Brantley 2007).

The left-to-right protocols of modern silent reading, facilitated by regularized word separation, have become so normalized that they are imperceptible—and this would even, I think, have been true for a late medieval reader of the Vernon manuscript. The diagram, conversely, makes the stringing together of words into its most conspicuous project: which way should a reader go? How might one group these words and concepts? Because reading is a kind of looking in this example, rather than a kind of hearing, the diagramming of the Lord's Prayer as a visual object is an emblem of the literacy usually understood to be on the rise at this historical moment. But this reading is far from a static looking—it is as various, as contingent, as active, as any oral performance could be.

Finally, the interplay of oral and literate media in the Vernon Paternoster diagram marks the conscious transformation of a linguistic object into a visual one. Letters are visible shapes, and the shift from spoken language to written language is a shift from an aural to a visual experience of words. The visual aspect of this text is heightened by several features of the diagram, including varied size and shape of lettering, and by the use of abbreviations rather than fully spelled-out words. These are all visual dispositions of the literate text—text as a visible form rather than as audible sound. The different colors of the texts show an especially deep interest in words as pictures, for color is a nonrepresentational, utterly nonlinguistic sign. And of course, the decorative knotwork alternating with the words reveals text itself to be a *textus,* a woven web of meaningful shapes. Textual information here combines with and even becomes visual information, creating meaning in a crafted ensemble of color, shape, and knotwork.

Although the Vernon Paternoster is a remarkable example of the complexity of medieval remediations, it is not entirely unique. Owing to its "extreme adaptability," the Paternoster prayer is a frequent site for such explorations, whether in varied vernacular verse and prose forms, in dramatic enactments, or in complex verbal–visual diagrams (Hussey 1958, 8).[21] Among many innovative instantiations of this familiar text, the Vernon Paternoster reaches beyond vernacularization alone, or diagramming alone, to model a complex way of thinking about the presentation and use of a simple prayer that parallels other kinds of medieval reading

and other kinds of medieval media. After exploring the multiple media of the Paternoster diagram, one returns to a carpet page or a psalter with new eyes, to see it as a page that similarly relies on a dense network of visible forms to transform a linguistic symbol, a letter, into an experience of visible art. The proliferation of diagrams of various kinds in medieval art and theology also begins to look like experiments in remediation.[22] The Psalter of Robert de Lisle, for example, comprises a famous collection of diagrams meant to teach doctrinal points, often treating similar material, such as vices and virtues and the gifts of the holy spirit (Sandler 1999, 23–27, 54). Moreover, the gridlike poems of Hrabanus Marurus offer many interesting and well-known experiments in verbal and visual media: his poem on the adoration of the cross, in which matrices of letters forms both the verses of a poem and the shape of a cross, is an example of early concrete verse (Perrin 1997). Although these texts represent gradual rather than transformative shifts in the medial ecology, none of those shifts are naturalized or invisible to the objects themselves. Their insistence on multiple kinds of translation highlights the effects of different media. Whether they seem to be poems or pictures depends on which medium their readers-viewers imagine to predominate, but the fact that both are insistently, and not transparently, present suggests that media consciousness is a structuring principle of intermedial composition.

The Vernon Paternoster also illuminates medieval media that are less explicitly experimental. For example, Chaucer's virtuoso exploration in the *Canterbury Tales* of what it means to present a deeply imagined fiction of oral tale telling in the resolutely literate medium of the manuscript codex can be read as an essay in remediation. Chaucer's poem is both spoken and bookish—a paradox that he enjoys in the two tales he assigns to himself: the bumptious oral-formulaic *Tale of Sir Thopas* and the prosy, allusive, didactic *Tale of Melibee*. And nowhere does he make the question of remediation more obvious than in the famous lines warning us away from the scurrilous *Miller's Tale*: "And therfore, whoso list it nat *y-here*, / Turne over the *leef*, and chese another tale" (emphasis mine). Chaucer even comes very close to describing media consciousness before the printing press, when he declares in

the *Treatise on the Astrolabe,* "By mediacioun of this litel tretys, I purpose to teche a certain nombre of conclusions."[23] It is no accident that Chaucer approaches the media concept most directly in the course of translating the operations of a technical scientific instrument into didactic Middle English prose: a treatise is not an astrolabe, and when the two are brought together as different kinds of communicative engines, both author and reader must acknowledge that the medium of instruction conditions the message.

As the example of Chaucer suggests, the intersecting media shifts embodied in the Vernon Paternoster help to characterize the long Middle Ages; its varieties of medieval remediation are finally exemplary as well as extraordinary. The Vernon Paternoster diagram also illuminates what historical media studies can offer to the conversation about the capacities of media in the present. Thinking about past media raises fundamental definitional questions, for example. Writing as a scholar of Renaissance literature, Guillory (2010) takes up the distinction between arts and media as a matter of historical semantics—that is, some of the old "arts," such as literature, are indisputably also "media" (322n3). One could also recognize an awareness of medial difference in the discussions ongoing since antiquity about the relation of painting to poetry. But the question of the historical relation between media and arts opens another, still more fundamental question in the present: what counts as a medium? According to Lisa Gitelman (2006, 7), media are defined by their communicative functions as well as their material platforms: media are "socially realized structures of communication, where structures include both technological forms and their associated protocols, and where communication is a cultural practice, a ritualized collocation of different people on the same mental map, sharing or engaged with popular ontologies of representation." But even if one adopts a broad definition such as this, older media forms still provoke questions, such as the ones posed by translations from one verbal structure (Latin) to another (English) or by the differences between spoken and written language as forms of communication.

Placing questions of definition along a historical spectrum can return significant insights, for media can never be fundamentally detached from history. As Rosalind Krauss (2011) has demonstrated

in her critique of what she called the "post-medium condition" of conceptual and installation art, a medium can be most of all a form of remembering. Whether it is a painterly support, such as a canvas, or a technical support, such as a video projector, whether it is structures of guild training or the horizon of expectations established by a literary genre, the medium of an artwork sets up the historical field against which its makers and interpreters understand it. Methods of communication and practices of performance—the kinds of concepts associated with "media" over the more mimetic and representational "arts"—form as stimulating a part of medieval culture as of the twenty-first century mediascape (see, e.g., Belting 2005). And just as the media concept can help to explain medieval texts and images, medieval remediations enforce an understanding of media today as not always "new" but sometimes "old."

NOTES

1 Brown University's program in modern culture and media is an instructive case: as the website explains, "Modern Culture and Media is committed to the study of media in the context of the broader examination of modern cultural and social formations." http://www.brown.edu/academics/modern-culture-and-media/.

2 Aristotle's term, as cited by Guillory (2010), is *hois* (*Poetics* 1447a).

3 For remediation in general, see Bolter and Grusin (2000).

4 But see the important work of William A. Johnson, in this volume and elsewhere, on the cultural significance of the forms of the book-roll in ancient Greece and Rome (esp. Johnson 2003, 2004). For a thoughtful exploration of the relation of books to scrolls in early modern England, see Stallybrass (2002).

5 On the history and philosophy of letter-forms, see Johanna Drucker, "From A to Screen," chapter 4 in this volume.

6 See, e.g., Chun and Keenan (2006), esp. Chun's introduction, and Huhtamo and Parikka (2011), esp. their introduction.

7 The in-betweenness of the Middle Ages serves as the inspiration for the medieval studies group blog *In the Middle* (http://www.inthemedievalmiddle.com/).

8 Latin *medium*: middle, center, midst, intermediate course, intermediary. OED, s.v. *medium*, n.4e. Cf. 4a, c, and d; and see also s.v. *media*,

n.2. On the designation of the historical period, see Robinson (1984, 749), who points out that speakers of languages (such as English) in which the designation is plural (the Middle *Ages*) "will be more likely to think of the medieval period as a succession of subperiods rather than as an unbroken continuum of years."

9 For representative studies in a crowded field, see, e.g., Ong (1982), Stock (1983), Clanchy (1979), and Green (1994). Guillory (2010), too, is interested in tracing the shift from speaking to writing as the assumed medium of language and from persuasion to communication as its assumed function. For a discussion of the ephemerality of contemporary "interactive text events," see also Rita Raley, "TXTual Practice," chapter 1 in this volume.

10 For the complexities of multilingualism in the period, see, e.g., Butterfield (2010) and Jefferson and Puter (2013).

11 For the text of Gregory's letter, see Davis-Weyer (1986, 47–49).

12 Many thanks to Roland Betancourt for useful conversations about the medium in Byzantine art and thought. For medieval English theories of text and image in the context of Lollardy, see, e.g., Gayk (2010).

13 A digital facsimile of the manuscript has recently appeared: *A Facsimile Edition of the Vernon Manuscript: A Literary Hoard from Medieval England* (2011). See also the accompanying volume of essays, *The Making of the Vernon Manuscript,* edited by Scase (2013). The standard printed facsimile of the manuscript remains *The Vernon Manuscript: A Facsimile of Bodleian Library, Oxford MS Eng. Poet.a.1* (1987).

14 Robinson (1990). For the most recent, though still inconclusive, discussion of the manuscript's probable provenance and use, see Scase (2013).

15 The *Prick of Conscience* has a single historiated initial, f. 265r.

16 For the alternative term *iconotext,* see Wagner (1996, esp. 15–17).

17 Some have thought it connected to the *Speculum Vitae,* which also contains an exposition of the Pater Noster (see, e.g., Blake 1990, 46). But for all the reasons delineated by Henry (1990, 90–92) and Farnham (2103, 143), the diagram does not obviously "illustrate" the text of the *Speculum,* and it seems to have a separate existence.

18 For a study of the page as "a careful integration of physical and cognitive architectures," see Mak (2011, 19).

19 I am grateful to Sara Gorman (2010) for sharing the text of her unpublished talk.

20 For the influence of the prayer in English vernacular writing, see Gillespie (1994).

21 Hussey (1958) mentions a comparable diagram in Cambridge UL

MS Gg.iv.32, f. 8. See also Gottschall (2004) and Johnston (1975). In the Paternoster play, the petitions of the Lord's Prayer are matched schematically with the seven deadly sins as well as with biblical narratives.

22 For examples of similar diagrams, see Evans (1980) and Carruthers (1992, 7–12).

23 Chaucer (1987, 663). Cited in passing by Guillory (2010, 342).

REFERENCES

Aarseth, Espen J. 1997. *Cybertext: Perspectives on Ergodic Literature.* Baltimore: Johns Hopkins University Press.

Belting, Hans. 2005. "Image, Medium, Body: A New Approach to Iconology." *Critical Inquiry* 31, no. 2: 302–19.

Blake, N. F. 1990. "Vernon Manuscript: Contents and Organisation." In *Studies in the Vernon Manuscript,* edited by Derek Pearsall, 45–59. Cambridge: Brewer.

Bolter, Jay David, and Richard Grusin. 2000. *Remediation: Understanding New Media.* Cambridge, Mass.: MIT Press.

Brantley, Jessica. 2007. *Reading in the Wilderness: Privated Devotion and Public Performance in Late-Medieval England.* Chicago: University of Chicago Press.

Burckhardt, Jacob. (1860) 1995. *The Civilization of the Renaissance in Italy.* With an introduction by Hajo Holborn. New York: Modern Library.

Butterfield, Ardis. 2010. *The Familiar Enemy: Chaucer, Language, and Nation in the Hundred Years' War.* Oxford: Oxford University Press.

Camille, Michael. 1996. "The Gregorian Definition Revisited: Writing and the Medieval Image." In *L'image: Fonctions et usages des images dans l'Occident medieval,* edited by Jérôme Baschet and Jean-Claude Schmitt, 89–107. Paris: Le Léopard d'or.

Carruthers, Mary J. 1992. *The Book of Memory: A Study of Memory in Medieval Culture.* Cambridge Studies in Medieval Literature 10. Cambridge: Cambridge University Press.

Chaucer, Geoffrey. 1987. *The Riverside Chaucer.* Edited by L. D. Benson. Boston: Houghton Mifflin.

Chazelle, Celia M. 1990. "Pictures, Books, and the Illiterate: Pope Gregory I's Letters to Serenus of Marseilles." *Word and Image* 6:138–53.

Chun, Wendy Hui Kyong, and Thomas Keenan, eds. 2006. *New Media, Old Media: A History and Theory Reader.* New York: Routledge.

Clanchy, M. T. 1979. *From Memory to Written Record: England 1066–1307.* Cambridge, Mass.: Harvard University Press.

Davis-Weyer, Caecilia, ed. 1986. *Early Medieval Art, 300–1150*. Toronto: Medieval Academy of America.

Duggan, Lawrence G. 1989. "Was Art Really the Book of the Illiterate?" *Word and Image* 5:227–51.

———. 2005. "Reflections on 'Was Art Really the Book of the Illiterate?'" In *Reading Images and Texts*, 109–17. Turnhout, Belgium: Brepols.

Eisenstein, Elizabeth L. 1979. *The Printing Press as an Agent of Change: Communications and Cultural Transformations in Early Modern Europe*. 2 vols. Cambridge: Cambridge University Press.

Evans, Michael. 1980. "The Geometry of the Mind." *Architectural Association Quarterly* 12, no. 4: 32–55.

A Facsimile Edition of the Vernon Manuscript: A Literary Hoard from Medieval England. 2011. Bodleian Digital Texts, The Bodleian Library.

Farnham, Rebecca. 2013. "Border Artists of the Vernon Manuscript." In *The Making of the Vernon Manuscript*, edited by Wendy Scase, 127–47. Turnhout, Belgium: Brepols.

Gayk, Shannon. 2010. *Image, Text, and Religious Reform in Fifteenth-Century England*. Cambridge: Cambridge University Press.

Gillespie, Vincent. 1994. "Thy Will Be Done: *Piers Plowman* and the Pater Noster." In *Middle English Religious Texts and Their Transmission: Essays in Honour of Ian Doyle*, edited by A. J. Minnis, 95–119. Cambridge: Brewer.

Gitelman, Lisa. 2006. *Always Already New: Media, History, and the Data of Culture*. Cambridge, Mass.: MIT Press.

Gorman, Sara. 2010. "'I kan noght parfitly my Paternoster as the preest it syngeth': Visualizing Multilingualism in the Vernon Manuscript Pater Noster Diagram." Unpublished talk.

Gottschall, Anna. 2004. "The Lord's Prayer in Circles and Squares: An Identification of Some Analogues of the Vernon Manuscript's Pater Noster Table." http://www.marginalia.co.uk/journal/08confession/circles.php.

Green, D. H. 1994. *Medieval Listening and Reading: The Primary Reception of German Literature 800–1300*. Cambridge: Cambridge University Press.

Guillory, John. 2010. "The Genesis of the Media Concept." *Critical Inquiry* 36:321–62.

Henry, Avril. 1990. "The 'Pater Noster in a table ypenyted' and Some Other Presentations of Doctrine in the Vernon Manuscript." In *Studies in the Vernon Manuscript*, edited by Derek Pearsall, 89–113. Cambridge: Brewer.

Huhtamo, Erkki, and Jussi Parikka, eds. 2011. *Media Archaeology:*

Approaches, Applications, and Implications. Berkeley: University of California Press.

Hussey, Maurice. 1958. "The Petitions of the Paternoster in Mediaeval English Literature." *Medium Ævum* 27:8–16.

Johnson, William A. 2003. "Toward a Sociology of Reading in Classical Antiquity." *American Journal of Philology* 121:593–627.

———. 2004. *Bookrolls and Scribes in Oxyrhynchus.* Toronto: University of Toronto Press.

Johnston, Alexandra P. 1975. "The Plays of the Religious Guilds of York: The Creed Play and the Pater Noster Play." *Speculum* 50, no. 1: 55–90.

Kessler, Herbert L. 1985. "Pictorial Narrative and Church Mission in Sixth Century Gaul." In *Pictorial Narrative in Antiquity and the Middle Ages,* edited by Herbert L. Kessler and Marianna Shreve Simpson, 75–91. Studies in the History of Art 16. Washington, D.C.: National Gallery of Art.

Krauss, Rosalind E. 2011. *Under Blue Cup.* Cambridge, Mass.: MIT Press.

Mak, Bonnie. 2011. *How the Page Matters.* Toronto: University of Toronto Press.

McLuhan, Marshall. (1964) 2003. *Understanding Media: The Extensions of Man.* New York: Gingko Press.

Mitchell, W. J. T. 1994. "Beyond Comparison." In *Picture Theory,* 83–107. Chicago: University of Chicago Press.

Mitchell, W. J. T., and Mark H. N. Hansen, eds. 2010. *Critical Terms for Media Studies.* Chicago: University of Chicago Press.

Mommsen, Theodor E. 1942. "Petrarch's Conception of the Dark Ages." *Speculum* 17, no. 2: 226–42.

Ong, Walter. 1982. *Orality and Literacy: The Technologizing of the Word.* London: Methuen.

Perrin, M., ed. 1997. *In honorem sanctae cruces.* 2 vols. Turnhout, Belgium: Brepols.

Robinson, Fred C. 1984. "Medieval, The Middle Ages." *Speculum* 59, no. 4: 745–56.

Robinson, P. R. 1990. "The Vernon Manuscript as a 'Coucher Book.'" In *Studies in the Vernon Manuscript,* edited by Derek Pearsall, 15–18. Cambridge: Brewer.

Sandler, Lucy Freeman. 1999. *The Psalter of Robert de Lisle.* London: Harvey Miller.

Scase, Wendy, ed. 2013. *The Making of the Vernon Manuscript: The Production and Contexts of Oxford, Bodleian Library, MS Eng. poet. a. 1.* Turnhout, Belgium: Brepols.

Stallybrass, Peter. 2002. "Books and Scrolls: Navigating the Bible." In

Books and Readers in Early Modern England, edited by Jennifer Andersen and Elizabeth Sauer, 42–79. Philadelphia: University of Pennsylvania Press.

Stock, Brian. 1983. *The Implications of Literacy: Written Language and Models of Interpretation in the Eleventh and Twelfth Centuries.* Princeton, N.J.: Princeton University Press.

The Vernon Manuscript: A Facsimile of Bodleian Library, Oxford MS Eng. Poet.a.1. 1987. With an introduction by A. I. Doyle. Cambridge.

Wagner, Peter. 1996. "Introduction: Ekphrasis, Iconotexts, and Intermediality—the State(s) of the Art(s)." In *Icons—Text—Iconotexts: Essays on Ekphrasis and Intermediality,* edited by Peter Wagner, 1–40. Berlin: de Gruyter.

10

Gilded Monuments: Shakespeare's Sonnets, Donne's Letters, and the Mediated Text

Thomas Fulton

TOM STOPPARD AND MARC NORMAN's screenplay *Shakespeare in Love* offers a splendid, though necessarily imaginary, contextualization of Shakespearean sonnetteering. On the stage of Philip Henslowe's Rose Theatre, in the year 1593, Shakespeare directs a rehearsal of an unfinished play that would become *Romeo and Juliet*. The part of Romeo is played by Thomas Kent, who, unbeknownst to Will Shakespeare, is actually the gentlewoman he had fallen for in disguise. Women were, of course, barred from acting on the Elizabethan stage, but Viola de Lesseps has found herself irresistibly smitten with the poetry of the theater, and soon with its greatest practitioner. Viola as Thomas stammers out Romeo's Petrarchan lines about Rosiline in a manner too impassioned for the author and director. Shakespeare interrupts: "No, no, no . . . Don't spend it all at once! *The rehearsal stops.* VIOLA AS THOMAS: Yes, sir. WILL: Do you understand me? VIOLA AS THOMAS: No, sir. WILL: He is speaking about a baggage we never even meet! What will be left in your purse when he meets his Juliet? . . . What will you do in Act Two when he meets the love of his life?" Ironically, Will has met the love of *his* life: she (as Kent as Romeo) is standing right in front of him. Although he remains unconscious of its source or proximity, Will's sudden recognition of this love stirs in him the untimely desire to write a sonnet. He turns to the actor Edward Alleyn, leaving the rehearsal to him: "Ned, I have a sonnet to write." Henslowe, anxious that the playwright finish his contracted work, calls after him, "A sonnet? You mean a play." But Shakespeare runs off to his writer's loft and, with ink-stained

hands, dips a quill into the well and starts writing: "For Lady Viola De Lesseps, by the hand of Thomas Kent." The text, as we learn by Viola-as-Kent's private reading of the unfolded epistle, is the poem now known as Sonnet 18, "Shall I compare thee to a summer's day" (Stoppard and Norman 1998, 56–58).[1]

The scene succinctly captures both the complexities of cross-dressing on the Shakespearean stage and the uncertainty in the reception history of this and other sonnets regarding the gender of the addressee (Schoenfeldt 2007, 137; Atkins 2007, 69). As the play within the play wryly suggests, perhaps the poet himself was unsure whether he had been moved by a woman or a man. But the scene also captures a simple fact about literary production in Shakespearean England, which is my immediate interest here: where poetry was not performed orally on the stage, it appeared first and foremost as a handwritten object. Lyric poems often originated as private letters to a specific person, and the name of the addressee would in many cases disappear in subsequent circulation, either by manuscript or print. Sadly, not a single sonnet in Shakespeare's own hand has survived, and if it were not for Francis Meres's gossipy account of contemporary literary culture in 1598, there would be little evidentiary indication that Shakespeare circulated "his sugred Sonnets among his private friends, &c" (Meres 1598, fols. 281v–282r). While most of the sonnets—1–126, as it is generally agreed—appear to be addressed to a young man, we can hardly be certain how each of them originated or when and how the sequence was constructed. Sonnets inspired by one addressee may well be reused for another, as was the case in Spenser's sonnet sequence to his wife, Elizabeth, in the *Amoretti* (1595) (Spenser 1999, 666). Although some parts of Shakespeare's sequence may have been sent in clusters, others bear the marks of originating as singular epistolary sonnets, such as the poem that became Sonnet 26: "To thee I send this written ambassage."[2]

The integrity of the group is further complicated by the fact that efforts at constructing a coherent sequence fail after 126, after which new addressees, evidently female, emerge. Some of the poems seem to have circulated, though Meres's "private friends" suggest that the verses circulated in tight coterie circuits. This privacy is also supported by the extraordinary paucity of manuscripts: there

are no extant copies of Shakespeare's nondramatic poetry in manu-
script that predate the pirated publication of two of his sonnets in
1599 or the edition of 154 sonnets in 1609, which may also have
been pirated.[3] The small collection of sonnets that appear in later
manuscripts—eleven sonnets in twenty separate manuscripts and
commonplace books (Marotti 2007, 185–203)—may in some cases
have originated from lost Shakespearean copies, or the copies of
those copies customarily made by the recipients of Renaissance
verse, rather than from the printed text. By comparison, there are
thousands of manuscript copies of poetry by Shakespeare's near-
contemporary John Donne and over five hundred by Ben Jonson,
though few of these in autograph.[4]

Weighing the incomplete evidence of manuscript and print
circulation in this period, we are confronted with an unsettling
sense of indeterminacy in the qualities of media for early modern
writers. If authors wrote for both manuscript and print, what
significance did this duality have on the meaning of the texts
themselves? As John Guillory has acutely observed, those partici-
pating in the shift into print began to understand that "writers
who compose for the medium of print will be compelled to ar-
gue—or write—*differently*" (Guillory 2010, 326). For those texts
that originated as manuscripts, and may or may not have been
destined for print, was there some understood change, either in
loss or gain, in their eventual remediation? Fundamentally, what
was their sense of each medium's capacity to preserve and convey
meaning?

Focusing on examples from Shakespeare, Donne, Jonson, and
Milton, among others, this chapter investigates ways in which
early modern writers represented the efficacy of media in their
texts, especially in permanently preserving memory. Texts that
openly aspire to literary permanence are particularly interest-
ing in relation to media consciousness because they are often
self-conscious about the textual materiality. It is now an axiom
often observed in media studies and book history that medium
and meaning are inseparable and that the "literary text must be
read as a physical object" (Kastan 2001, 4).[5] What deserves more
attention is how much authors relied on this inseparability in
their construction of meaning. Literary passages that involve the

material of expression with its contents—what I am terming *mediated texts*—commonly occur when the text's meaning is paradoxically most vulnerable to loss, when the text concerns the preservation of the written word. Such texts also resist remediation, because the meaning attached to the material text cannot be transferred to a new medium without some loss.

Writers worked with a large number of material platforms in the Renaissance, both real and imagined: stone (in epitaphs and monumental inscriptions), glass (in Elizabeth's famous verses written with a diamond), the bark of trees (as in Orlando's carved poems), in the sand (in Spenser's sonnet 75 that claims his verse "shall eternize"), "Upon a pair of gloves" (in lines dubiously attributed to Shakespeare), on erasable writing "tables," such as those in *Hamlet,* and, of course, on the stage and on the page, in both manuscript and print.[6] Only some of these forms qualify as "media" in the sense proposed by Lisa Gitelman, in which the material of communication conforms to an established system of "cultural practice" (Gitelman 2008, 7),[7] though the other modes of writing—on bark, for example—could be thought of as sub-medial or even meta-medial because they seem at least partially constructed to reflect the ontological shiftiness of established forms. The near-preoccupation in early modernity with material forms and medial shiftiness seems to derive from the destabilizing shift from an established scribal medium to the mechanized reproduction of print.

In understanding this shift, it is vital to recognize, as many critics of Elizabeth Eisenstein's (1993) influential work have done, that the print revolution did not happen overnight. Even some 125 years after William Caxton introduced print in England in 1476, the scribal production and circulation of texts remained strong, and in certain textual genres, such as lyric poetry, it dominated. This was certainly true of what is arguably (next to the sermon) the "single most important genre of the Renaissance" (Stewart and Wolfe 2004, 10), the letter, because letters would be primarily in handwritten form until the advent of e-mail. In many additional cases, print was the primary medium in neither the text's conception nor its reception. Indeed, poetry frequently did not go into print—if at all—until after the death of the author, as was the

case for the vast majority of the poems by John Donne, Fulke Greville, Andrew Marvell, Katherine Philips, Sir Walter Raleigh, Sir Philip Sidney, John Suckling, and Thomas Traherne—to name a handful of poets of different genders and social backgrounds. Thus the printing of verse was frequently understood as the sort of thing that *might* be done by one's executors, as a record or memorial thrown together after the fact by someone other than the author—a practice that surely influenced the trope of the printed codex as a tomb. This trope seems to have originated in manuscript lyric verse—frequently playing, as Shakespeare does, on the once homonymic quality of *tome* and *tomb,* words that were sometimes spelled interchangeably (*OED,* s.v. "tome"; Herbert 1949, 235–41).[8]

The concept of being rendered immortal by words goes back to scrolls and perhaps beyond written media. Shakespeare's assertion that he will make his addressee immortal through verse—"Not marble nor the gilded monuments, / Of princes shall outlive this pow'rful rhyme"—echoes a classical and Petrarchan boast that the poem will immortalize its author. The concept in Sonnet 55 occurs in many other sonnets, such as 101, when the poet claims his addressee will "outlive a gilded tomb." Horace had claimed in the *Odes,* "I have finished a monument more lasting than bronze and loftier than the Pyramids' royal pile."[9] Petrarch spoke in an oration in 1341 upon his coronation as poet laureate of a poet's achieving immortality as "twofold, for it includes both the immortality of the poet's own name, and the immortality of those whom he celebrates" (Petrarch 1955, 307). Although Shakespeare would probably not have known this text, he would have known Petrarch's practice, copied by English sonneteers, of immortalizing his addressee.[10]

One of the great puzzles in literary history, especially given Shakespeare's claims to immortality in his sonnets, is that almost half of his plays, with masterpieces like *The Tempest, Antony and Cleopatra,* and *Macbeth* among them, might never have been preserved in print had it not been for the work of the publisher Thomas Pavier and the printer William Jaggard in 1623, seven years after the author's death (Kastan and James 2012, 19, 26–29).[11] Yet when the First Folio came out, its monumentality was heralded in

the very terms that Shakespeare had used in lyric verse. The use of immortalizing tropes in commemorating Shakespeare's posthumous achievement has had the falsifying effect of suggesting a kind of eternizing intentionality in the authorship tied to the medium of print. This is necessarily a back-formation, and one that might have been less influential had it not been perpetrated by such figures as Ben Jonson and John Milton. In a prefatory poem to Shakespeare's folio, Jonson praises the work of his deceased predecessor: "Thou art a Moniment, without a tombe / And art alive still, while thy Booke doth live" (Shakespeare [1623] 1968, 9). Jonson's lines play not only on the terms in Shakespeare's eternizing sonnets but also on the idea that the addressee—here the author of the work—will "live" in the contents of the words: "You live in this" (Sonnet 55).

Milton's commendatory poem to Shakespeare, the poet's first appearance in print, appeared in the Second Folio of Shakespeare's dramatic works in 1632. Although it was an auspicious beginning, Milton's was paradoxically an anonymous entry into the world of print, which still bore something of the social "stigma" once more keenly associated with it (Saunders 1951; Coiro 1992). Playing on Jonson's and Shakespeare's metaphor of the tomb, Milton titled his poem "An Epitaph on the admirable Dramaticke Poet, W. SHAKESPEARE," a conceit that draws on the meaning of epitaph as "words written over a tomb." Like other early poems of Milton that pretend to a material function or intervention—the Nativity Ode is to be sent to Jesus, for example, before the Magi get to him; "On Time" is to be set "Upon a Clocke Case, or Dyall"—this poem aspires to replace Shakespeare's actual epitaph, carved in stone over Shakespeare's grave in a church in Stratford-upon-Avon.[12] In seemingly conventional terms, given the frequent reuse of grave sites such as that depicted in *Hamlet,* Shakespeare's epitaph implores visitors in grave humor not to disturb his remains:[13]

> GOOD FREND FOR IESUS SAKE FORBEARE,
> TO DIGG THE DVST ENCLOASED HEARE.
> BLESTE BE Yᴱ MAN Yᵀ SPARES THES STONES,
> AND CVRST BE HE Yᵀ MOVES MY BONES.

Responding to this epitaph and, seemingly, to another epitaph thought to have been written by Shakespeare to Lord Stanley

(Campbell 1999, 96), Milton's epitaph picks up on Shakespeare's "stones" and "bones" in its first lines, which dismiss the value of such material remains and even the stone monuments used to present them:

> What neede my Shakespeare for his honour'd bones,
> The labour of an Age, in piled stones

Rather than bones or stones, Shakespeare's *book* is a far more lasting tribute: "Thou in our wonder and astonishment / Hast built thy selfe a lasting Monument," one that "make[s] us Marble with too much conceiving, / And so Sepulchur'd in such pompe dost lie / That Kings for such a Tombe would wish to die" (Shakespeare 1632, A5r). Milton plays on the homonymic pun in "tomb" and "tome": kings would die to be so memorialized, as they would, perhaps, to have written such a tome. Shakespeare's achievement is so great as to turn an aspiring young poet to stone: it "makes us Marble." The "marble," "monument," and "kings" probably allude to Shakespeare's Sonnet 55: "Not marble nor the gilded monuments / Of princes shall outlive this."

Even when the sonnets appeared in 1609, the eternizing in the verse seemed retroactively reassured by the advent of their print publication. But it was not the author but the publisher who fittingly drew the association between the immortality tropes in the verse and their print remediation, in a famously enigmatic paratext. The dedicatory inscription appears in words that look cut in stone, with dots between the words in Roman lapidary style.[14] It is thus presented as a monument in a different medium, and one, of course, that the book is not: stone. The inscription itself is expressed in a way that makes it seem both from the author and (really) from the publisher, Thomas Thorpe:

TO.THE.ONLIE.BEGETTER.OF.
THESE.INSVING.SONNETS.
M^r. W.H. ALL.HAPPINESS.
AND.THAT.ETERNITIE.
PROMISED.
BY.
OVR.EVER-LIVING.POET.

WISHETH.

THE.WELL-WISHING.

ADVENTVRER.IN.

SETTING.

FORTH.

T.T.

The lines have been the subject of much debate and speculation, mostly over the identity of "the only begetter," Mr. W. H. The first three lines of this excerpt may, as Honigmann has suggested, have been part of Shakespeare's original manuscript dedication to W. H.—possibly William Herbert, the Earl of Pembroke (Honigmann 2010, 93). The next section, beginning "And that eternity promised by our ever-living poet," would then have been added by T. T. If this is the case, then it seems possible that the abbreviated "Mr." is part of Shakespeare's private irreverence, or possibly misread or added by Thorpe. The improbability that the printer would address an Earl as "Mr." gives some traction to Colin Burrow's suggestion, "Who He" (Shakespeare 2002, 103). Yet if this gesture of exclusivity were at play, the volume would pay the dubious tribute of immortalizing Anonymous and take the tone of this odd inscription to a level of comic irreverence that seems too far out of line with the production as a whole. It is equally possible that Thorpe had no idea himself who W. H. was; that he merely appropriated the poet's manuscript dedication and then added a few apologetic "well-wishing" lines as the adventurer riskily setting forth the volume. The strange lines about "our ever-living poet" reinforce the sense that Shakespeare is at some remove from the forces behind the sonnets' publication. There is no dedicatory epistle by the author, in contrast to the only known authorized printings of Shakespeare's work, *Venus and Adonis* (1593) and *The Rape of Lucrece* (1594), which contain an authorial dedication to the Earl of Southampton, Henrie Wriothesley. The texts of the sonnets are far more problematic than those of these long poems, suggesting the absence of authorial oversight. W. H. may not have wanted the sonnets printed either, because they were not printed again until 1640, when several pronouns are changed to alter the gender of the addressee, which also happened

in manuscript copies (Honigmann 2010, 943; Marotti 1995, 190; see also Orgel 2007, 140).[15]

It is easy to understand Shakespeare's sonnet "Not marble" in hindsight, especially with the aid of Milton's retrospective reframing, as a celebration of the printing press, a nod to mechanized print for making possible an author's wish for his subject's immortality. Until the recent advent of digital media, publication in the modern world has been synonymous with print. Few writers in the twentieth or twenty-first centuries would consider their written work to have meaningful circulation on a handwritten sheet of paper, and it has accordingly proven extremely hard to reconstruct the views of early modern writers and readers. In his superb edition of Shakespeare's poems, Burrow reads Shakespeare's claim to overcome mortality through literature as dependent on the media in which the poems are read: print for the author is "something approaching a monument," and manuscript is "an ephemeral epistle" (Shakespeare 2002, 122). In a still more definitive assertion, Lucas Erne (2007, 62) argues that "the hope for the immortality of his verse [is expressed] in ways which by Shakespeare's time had become closely associated with print," but gives no example. This assumption is seriously eroded by the fact that all of these ways of representing immortality derive from classical and Petrarchan antecedents. The assumption is further challenged by the simple fact that many of Shakespeare's contemporaries did not set their poetry into print. In addition, Elizabethan poets expressed the enduring monumentality of their verse on pages that circulated in manuscript.

Our assumptions about print's stability, shaped by five centuries of history, bear little relation to what Shakespeare would have seen or known about the medium. Many of his plays, such as the pirated "Bad Quartos" of Romeo and Juliet and Hamlet, were crudely reproduced; some plays, such as Pericles, might be considered among the bad quartos if only a good quarto (or folio) had ever been produced. Except for a few debatable cases, such as the second quarto of Hamlet (1604), Shakespeare seems to have made little effort to shepherd his plays into print (see Kastan 1999, 33).[16] Nor did he own what was printed in the modern sense that developed after copyright; the plays were not therefore "his" to

put out or to profit from or his to protect from textual corruption (Dutton 1997). The company's profit came from ticket sales, which must partially explain why plays were not printed. When they were printed in his lifetime, they appeared as pamphlets, stab-stitched along the side, without even the structure of the cheapest modern paperback. They were designed to be no less ephemeral than a manuscript, or no more permanent, and a great many have not survived. There exist only two copies of what we know as the first *Hamlet* (1603), on which so many scholarly positions have been staked. Many printed titles have been completely lost to posterity—a few may well be Shakespearean, such as a book called *Love's Labour's Won,* listed in a Stationer's book list from 1603.[17] Bibliographers estimate the survival rate of books printed in the early modern period to be around 60 to 70 percent (McKenzie 2002, 129; Raymond 2003, 165; Willard 1942, 171–90).[18] For printed playbooks, the situation might have been particularly unstable: in addition to their frail materiality, their contents were disparaged by such librarians as Thomas Bodley, founder of the Bodleian, who decreed playbooks to be "riff-raff" and "Baggage books," not worthy of library preservation, for even if "some little profit might be reaped (which God knows is very little) out of some of our playbooks, the benefit thereof will nothing near countervail the harm that the scandal will bring into the library" (Bodley 1926, 221).

The publication history of Shakespeare's sonnets drives home the degree to which an author had little control over the printing of his work. Two of Shakespeare's sonnets happened to appear in print in a pamphlet purportedly authored by him and titled *The Passionate Pilgrime* (1599), a title that capitalizes on the scene in *Romeo and Juliet* when the two lovers recite a sonnet together, in which Romeo likens himself to a pilgrim visiting a saint's shrine.[19] The printer, William Jaggard, got possession of two of Shakespeare's circulated sonnets, later numbered 138 and 144. Jaggard, who would later help produce the 1623 folio, did not scruple to let merchandizing interests supersede authorial integrity, and Shakespeare's sonnets were highly vendible. He patched the two unprinted sonnets and a few sonnets recited in *Love's Labour's Lost* together with a motley assemblage of non-Shakespearean

poems and peddled them with great success: the first printing sold out, prompting a second in the same year (Shapiro 2005, 214). The two sonnets filched from scribal circulation demonstrate a striking number of textual variations from those published in 1609, especially in what becomes Sonnet 138, "When my love swears that she is made of truth," where some nineteen words in fourteen lines are different. These are essentially two different poems, provoking the question whether Shakespeare revised the text or whether revisions were introduced in the process of copying, a phenomenon of scribal culture that Walter Ong dubbed "participatory poetics" (Ong 1977, 274–79). Often anonymous in circulation, poems changed slightly with each new copyist, who might make aesthetic alterations or repurpose a poem to serve the particular function of its new context. This may also be true of the several versions of Sonnets 2 and 106 that exist in poetic commonplace books as well as a handful of other sonnets whose different wordings from those of the printed version may represent a Shakespearean revision process or the alteration of the author's text through scribal reproduction (see Marotti 2007; Burrow 2007, 147–48; Beal 1980, 452–55; Taylor 1985, 210–46).

Authorship was a loose category, liable not only to the whims of aspiring scribes but also to the vicissitudes of the print market. In addition to its providing shadowy evidence of Shakespeare's lost scribal circulation, the case of *The Passionate Pilgrime* provides an unusual record of authorial indignation against publishers. Thomas Heywood complained in *Apology for Actors* (1612) that his poetry was stolen as padding for the third printing of the volume and that he and Shakespeare were offended by the printer. As Heywood reports of Shakespeare: "the Author I know much offended with M. *Iaggard* (that altogether unknowne to him) presumed to make so bold with his name" (Heywood 1612, sig. G4v). As Marcy North suggests, the author may well have taken his complaint successfully to the printer, as there are two existing title pages for the third printing of the *Passionate Pilgrim,* one without Shakespeare's name (North 2003, 82–83). The success of this crude, scant, and inauthentic volume lends further credence to the idea that the 1609 edition of Shakespeare's sonnets was un-authorized in the first place and that it was assiduously prevented

from being reprinted (Honigmann 2010, 941–42).[20] The volume's success also challenges the common belief, based on the absence of known reprints, that Shakespeare's sonnets were not in demand. Only a handful of his actual sonnets, collected under a title that refers to sonnet making in *Romeo and Juliet*, were enough to sell three print editions.

In the sixteenth and early seventeenth centuries, therefore, print remained stigmatic, largely ephemeral, and beyond the control of the author. When Shakespeare writes in Sonnet 55 of how his addressee will "pace forth" in the "living record of [his] memory," and that his "praise shall still finde room," he is not, as has been asserted, talking or thinking "of printed matter" (Forrest 1923, 44), nor can it be an expression of confidence about the medium that would eventually carry his words. The language within the sonnets about their materiality refers to them as "written ambassages" in pen on paper. Sonnet 55 is not dreaming about an eventual remediation; its point is that the words will *somehow* survive in cultural memory, despite the ephemerality of the physical medium, whatever medium that might be. The strength of this claim lies not in the technology of production but in the vitality of the expression; the more feeble the technology, the stronger the claim.

Like other expressions of extreme confidence in the sonnets, these lines also testify to the paradoxical coexistence of confidence's inverse. Stephen Booth comments that the lines "Nor Mars his sword nor war's quick fire shall burn / The living record of your memory" evoke just this lack of confidence: "Even as they assert the immortality of the poem these lines remind a reader of the flimsiness and vulnerability of anything written on paper" (Shakespeare 1977, 229; see also Engle 1989, 838). The poem's repeated key word "live," as Helen Vendler has pointed out, in "outLIVE," "LIVing," LIVE," is ingeniously ensconced in "obLIVious" (Shakespeare 1997b, 268). The poem is oddly invested in medium—"marble," "gilded monument," "unswept stone," "masonry" are materials by which words and cultural memory are stored and conveyed. But the sonnet does not specify a medium for its own words—that is, there is no explicit comparison of stone with paper and ink, either from a quill or a press. Instead, it is "these contents"—the immaterial text—in which the addressee will "shine

more bright ... Than unswept stone, besmeared with sluttish time."

A similar recognition of the instability of the medium, rather than its strength, occurs in Jonson's inscription on a printed book. Jonson inscribed a copy of *Sejanus* (1605) to a friend, "to my noble Friend Sr Robert Townsehend / Wch I desire may remayne wth him, & / last beyond Marble" (Jonson 1947, 8:665). This is no doubt an exaggerated example but one that helps to show how the trope of monumentality is not to be taken too literally. Jonson's claim has little to do with the mechanized reproduction of his text—it might as well have been a unique manuscript text because he refers to a single object with his singular manuscript inscription. Rather sentimentally, monumentality here is used in defiance of the inevitable, to suggest that human memory—even the most fragile—triumphs over matter.

Guillory's (2010) essay on the genesis of the media concept points to a moment in the Renaissance when media awareness was heightened simply because the period was in the midst of a long shift from manuscript to print. "Remediation," he writes, "makes the medium as such *visible*" (324). At the same time, texts nervously took many forms, such as the trees and bark that supply a sort of medium for Orlando:

> Hang there, my verse, in witness of my love:
> And thou, thrice-crowned queen of night, survey
> With thy chaste eye, from thy pale sphere above,
> Thy huntress' name that my full life doth sway.
> O Rosalind, these trees shall be my books,
> And in their barks my thoughts I'll character,
> That every eye which in this forest looks,
> Shall see thy virtue witness'd every where.
> Run, run, Orlando; carve on every tree
> The fair, the chaste, and unexpressive she.
> (*As You Like It*, 3.2.1–10)[21]

"Bark" recalls the Latin word for bark, *caudex,* or later, *codex,* which meant "bark," "writing tablet," and "book." Sonnets hung like leaves in trees or carved in bark possess a meaning that will last as long as such material does in the natural world: leaves,

like the "yellow leaves" of Sonnet 73, "or none, or few" which "hang / Upon those boughs" (3–4), poems hung in trees are prone to fall off and crumble; words carved in bark will die with the tree. This image occurs famously in Sidney's *Arcadia* and in Mary Wroth's *Urania,* which represents the material poetic text in a variety of states and locations, including verses held by a disembodied white hand within a fountain (Rodgers, forthcoming). The various material representations of lyric reinforce the degree to which a poem's expression may be as fragile, and as susceptible to corruption, as the stuff of which it is made.

Shakespeare's contemporary John Donne provides a useful comparison. Like most other early modern poetry, the vast majority of Donne's literary corpus circulated exclusively in manuscript: three of his poems were printed while he lived, while more than five thousand manuscript poems survive (Wolfe 2006, 121). Yet only one of his English poems survives in original holograph—providing one truly authentic text (Stringer 2011, 12–25). This astonishing statistic is even more astonishing in that the one autograph manuscript was among the most recent to surface: discovered in 1970, the poem now sits in the Bodleian Library (MS.eng.poet.d.197) (Barker 2003, 7–14).[22] This unique poetic manuscript, the "Letter to the Lady Carey" (or Carew, as he writes it), reveals a great deal about the differences between the communicative function performed by the printed version and by the original, handwritten text. Like so many lyric poems in the Renaissance, it originates as a letter, probably bundled within a packet of other letters. It is written from Amiens, France, where Donne met his friend Sir Robert Rich, brother to Lady Carey and Mistress Essex Rich, the sisters addressed in the poem, and daughters of Robert Lord Rich and Penelope Devereaux (the "Stella" of Sir Philip Sidney). These are indeed rich people, and Donne's patronage poem, possibly solicited by Robert as a favor to his sisters back in England, is in the humanist vein of instruction through flattery mixed with Donne's edgy satiric trademark. As Herbert Grierson wrote of Donne's poems to noble ladies, "scholastic theology is made the instrument of courtly compliment and pious flirtation" (Donne 1912, I, xx). In this case, the tensions between Protestant and Catholic theology structure the poem's efforts at flattery and instruction.

Many of the crucial details of the poem's original performance are entirely lost when it is set in print—the lines separating stanzas; the unusual nature of the author's punctuation, far more extensive and more nuanced than the scribal or printed versions; and even the folding of the paper into a pinned and addressed enclosure that must be unwrapped before read. Indeed, Donne carefully designed the poem to fit on the page—presumably by drafting it on a folded sheet with the same dimensions—in such a way as to create the sense that he had to end the poem where he did, though he wanted to say more about Lady Carey's sister. Because of the way it is folded and addressed, the poem needed to end on the center fold, which it does precisely. As Peter Stallybrass observes,

> this was presumably to give the complimentary impression that he wanted to go on forever—and indeed, when he turns to the second sister, Essex Rich, at line 48, the end of the poem is visibly present. But Donne imagines the effect of putting mirrors at the end of a long gallery so as to double its length: "So I should giue thys letter length, and say / That w[hi]ch I sayd of yow." But this has to be "inough to testify / My true Deuotion" for the simple material reason that he has filled up all the available space, given that he needs the "fourth page," made by his first fold, for the address and the outside of the package. (Stallybrass n.d.)

These paratextual details are lost even when the poem is copied and circulated because the punctuation and even the phrasing often changed. In this case, evidence suggests that Donne, rather than Lady Carey, circulated additional copies (Donne 2008, 713; Gardner 1972, 3).

Writers took great care in selecting the paper on which to compose a letter or a poem to another person. An expensive patron deserved expensive paper—perhaps even more expensive than the recommended "whitest, finest, and smoothest paper" ([Clement] 1587, D.ij.v; cited from Stewart 2008, 43) that was largely imported from France. The most startling of the unique features of this autograph poem are the gilded edges of the manuscript page, which prove important to the imagery of the text itself.

Donne has been praising the virtue and faith in his addressee in terms inflected by the religious differences between England and France. Although he writes from a place where many saints are invoked, Donne begins by directing his humble devotion only to her. Referring to the Catholic practice of selling indulgences, Donne writes that "Pardons are in thys Market cheaply sold" and that, unlike the Protestant stress on faith over works, "faith" is held "in too low degree" (9–10). He then turns to praise her "by faith alone" (12) in a long set of metaphors that contrast inward and outward value in more classical terms: she is "a firmament / Of virtues. . . . They're your materials, not your ornament" (13–15). This comparison of inward worth and outward value returns to the historic religious register, first criticizing the Roman Catholic monastic efforts at finding "virtue in melancholy," and then turns to extremists who find virtue in a form of zealous anger:

> spirituall Cholerique Chriqs [critics], w^ch in all
> Religions, find faults, and forgiue no fall,
> Haue, though thys Zeale, vertu, but in theyr Gall.

These choleric religious critics finding fault in "all religions" perhaps refers to the zealous Puritans, who have virtue but in "gall"—a term connoting both the source of choler and ink.

Donne finds the right balance of virtue between these polarities of hermetic melancholy and austere zeal in the stanza that continues,

> we'are thus but parcel-gilt; To Gold we'are growen
> when vertu ys our Soules Complexione;
> who knows hys virtues Name, or Place, hath none.

The "we" of "we'are" connotes the "virtue" associated by contrast with the English Church and the poet and his addressee. The nature of their virtue is one metaphorically likened to a gold-edged object that can grow into solid "Gold." Several puns seem to be operating at once in the description of the speaker and his audience as "parcel-gilt": "guilt," which follows from "forgive no fall," or simply "partly gilded, esp. on the inner surface only" *(OED)*. But

then there is the sense, deriving from the gilt edges of the paper on which it is written, that this meditation on virtue, which uses the metaphor of "gilt," is itself a "parcel-gilt" or a gilt parcel. Donne employs a complex intermedial pun in the original that would be obscured by the printed version and, indeed, by subsequent copies. Donne's "parcel-gilt" reinforces at once the ephemerality of the medium and the special, intimate singularity of his communication with Lady Carey—only she would understand the meaning of a poem written on this paper, because this poem *is* the gilt parcel, and the "we," therefore, connotes the singular relationship of a poet and his addressee. Preserved on a single, fragile quarto sheet of paper, there was little chance that this particular message in this form would reach posterity, to be found, as it was in 1970, among a pile of unrelated papers, the only poem actually written by Donne to have survived. Donne uses gilt paper in at least two other known cases: one, a letter written at about the same time as the verse poem to Carey that has the same watermark, and another, shown in Plate 10.1, that was written in August 1614.[23]

TURNING BACK to the fictitious reconstruction that began this essay, let us indulge the possibility that manuscripts of one or two of Shakespeare's sonnets might someday be found, and furthermore, that these would be the eternizing sonnets now numbered 55 and 101. These sonnets use imagery similar to Donne's—"Gilded monuments" and "gilded tombs"—and like Donne's rediscovered gilt parcel, they, too, have gilded edges. Admittedly, this is on one level a preposterous indulgence of the imagination because we stand little chance of finding such a thing. Yet it is useful as a way of thinking through the realities of what we do and do not know about the meaning of a Renaissance text as it appeared in its original medium and how that medium controls its meaning. Whether Shakespeare was punning on the material qualities of the paper that held his "gilded monuments" (or "monument," as it first, presumably mistakenly, appears in print, since the rhyme is with "these contents") is for these purposes less important than what is easily alterable about a poem by a simple material, extratextual change. If Shakespeare, like Donne, is punning on the paper he uses to carry his message, this would reinforce a

UNIVERSITY OF WINCHESTER
LIBRARY

sense, perhaps already in the printed version, of the fragility of its extraordinary claim. It also ironically reinforces the sense effected in Donne's use of the pun in his poem to Lady Carey that there is something singularly personal in their communication, which only they share, that cannot hope to transcend time even if the poem itself does in some form. Thus it is a performance, like that recounted metatheatrically in Prospero's speech in *The Tempest,* "our revels now are ended," in which the "great globe itself"—punning on the theater that holds the performance—will eventually, with all the other stage props recounted, vanish "into thin air" (4.1.148–153). This, too, is a self-referential moment, in which the artist calls attention to the temporality of the medium carrying the message it holds. As Samuel Johnson wrote of Shakespeare's propensity to pun, which he called "quibble," "he follows it at all adventures, it is sure to lead him out of his way, and sure to engulf him in the mire.... A quibble was to him the fatal *Cleopatra* for which he lost the world, and was content to lose it" (Johnson 1765, xxiii–xxiv).

The first step in indulging this question is to explode the well-established idea that Shakespeare necessarily was thinking of the permanence of print rather than the ephemerality of manuscript when he likened his poems to monuments and tombs. This is an understandable simplification, but one that does more damage than good in illuminating the complexly different qualities, both at times ephemeral, of these medial forms in the sixteenth century. It seems more correct to say that there is an ironic, even defiant interplay between "contents" and the "monuments" carrying them than an expression of confidence in any particular medial form. If anything, it was the print publication of Shakespeare's works in 1609, 1623, and 1632 that began to solidify, retroactively, this distinction, and it seems to have happened as much or more by way of printers (the most obvious proponents of print) than of writers. It is worth recalling that the classical writers who were Shakespeare's ultimate source for the eternizing use of "monument" wrote on scrolls, and Petrarch, the progenitor of this humanist art form, on manuscript leaves assembled into a codex. While the tropes on "tomb" and "monument" often appear in printed verse, they also appear in manuscript. Spenser uses the trope in a

PLATE 10.1. Autograph letter signed from John Donne, London, to Sir Robert More, Loseley, 1614 August 10, showing Donne's signature and the gilt paper. Reproduced by permission of the Folger Shakespeare Library.

patronage sonnet to Lord Charles Howard, member of the Privy Council, which is attached with many others to *The Faerie Queene*:

> Thy praises euerlasting monument
> Is in this verse engrauen semblably,
> That it may liue to all posterity. (Spenser 1977, 742)

"Engraven semblably," or "similarly, in like manner" *(OED)*, suggests that the verse strives metaphorically to work in monumental materials such as stone or metal that are written on by engraving. A similar effect is achieved in Thomas Bancroft's printed "Epitaph on Mistresse *Anne Roberts* of *Naylston*," which included the marginal gloss "White Characters in black Marble" to help readers imagine "*these Letters, which her worth containe*" as written on black marble: her life as "white, without black vices staine" (Bancroft 1639, B4v).

The material of the text is also alive in a poem attributed to Sir John Salusbury, poet and patron of poets (*Loves Martyr*, printed in 1601 and containing Shakespeare's "The Phoenix and the Turtle," is dedicated to him) (Erne 2007, 60). The poem records an argument in love that becomes memorialized in verse:

> Then write thy Censure with thy prettie hand,
> I will obay the sentence of thy minde,
> And grave the same in table faire to stand;
> So that, ensuing age the same may finde:
>> For monument in goulden letters wrought,
>> To whet with sight the accents of my thought.[24]

Salusbury plays with a multiplicity of writing materials: the special erasable table or tablet such as that in *Hamlet*, perhaps the last of the materials that can be engraved. He refers also to "goulden letters," which would have been familiar from many monumental and manuscript contexts, though the image of a "monument in golden letters wrought" is tantalizingly close to that of Shakespeare's "gilded monument."[25]

Donne uses eternizing tropes in his manuscript poem "A Valediction: Of the Book," in ways that reinforce the sense that these

tropes were not tied to mechanized print. The poem raises the question of how history of their love will live on through the written word. Donne asks how his beloved might "anger Destiny," and "out-endure / Sibyl's glory" (2, 5–6). His answer is to "Study our manuscripts" (10), and from these will come a book "as long-lived as the elements," "an all-gravèd tome" (19–20). "Tome" is spelled "tomb" in at least four different manuscript witnesses and one print (Donne 2008, 270).

Donne's most famous statement concerning the value of manuscript over print occurs in a Latin poem written to a friend whose children had torn apart a printed book he lent them, and the friend had the book copied by a scribe and returned to Donne. Donne reflects at considerable length at the superiority of the manuscript: "Those the presses give birth to in damp labour are accepted, / But those handwritten are more to be revered":

> The book which goes on shelves abandoned to book-worms
> and ashes
> If coloured only with the blood of the press,
> Let it come written with a pen, is reverently received,
> And flies to the principal bookcase of ancient fathers. (Donne
> 2008, 118–19; ll. 1–8)

But if images of "monuments" and "tombs" were used to speak of scribal as well as printed objects, how often were these objects gilded? Would this pun, in other words, have been readily available to Shakespeare? And would he have been prone to use such a pun? Certainly tropes that derive from the material of composition were common: to "write with gall" (Sharpe 1610, line 4), for example, from the oak gall used in making ink, seems to have been a particular favorite. Donne is surely punning on the "gall" of the ink of "choleric critics" (ll. 28–30). Shakespeare uses this pun on ink frequently, as when Sir Toby Belch urges Sir Andrew Aguecheek to have "gall enough in thy ink" (*Twelfth Night*, 3.2.47). Shakespeare also refers to and puns on the materiality of writing in other texts and sonnets (Stewart 2008, 48). In Sonnet 73, he writes of a withering expressive vitality:

That time of year thou mayst in me behold,
When yellow leaves, or none, or few, do hang
Upon those boughs which shake against the cold,
Bare ruined choirs, where late the sweet birds sang. (ll. 1–4.)

The imagery operates on several levels: a speaker in an autumnal mood, in which the bare ruined choirs, evocative in part of the monastic ruins that littered the English countryside after the Reformation, once possessed a voice that is now lost. Yet, especially with the original spelling, "quiers" (or "quires") also connotes the gathering of manuscript leaves that would comprise a writer's verses. The mixed metaphoric images of the ruined "quires" and the "yellow leaves" on boughs of trees where "sweet birds sang" work together to suggest that the poet is also talking about yellow "papers," as he had written in Sonnet 17, "yellowed with their age" (17.9).[26] (The ultimate source here is probably Petrarch's punning image of "scattered leaves" in Sonnet 333.) In Sonnet 78, Shakespeare puns on the materials of writing in "Feathers" (7), which builds on his comment on "every alien pen"—*pen* derives from the Latin *penna,* "feather."

How much might the edging of single manuscript leaves similarly inflect the meaning of the verse? Gilt paper seems to have been used with some frequency. It is figured in the opening scene of *Henry VIII,* in which Norfolk describes among the lavish accouterments of the ceremonial meeting of the French and English courts at the Field of Cloth and Gold, "their dwarfish pages were / As cherubims, all gilt" (1.1.22–23).[27] Henry Woudhuysen's study of scribal culture finds gilt paper among the records of raw materials. One bookseller's record book registers a "substantial trade in writing-materials" that includes "ink, three lots of ordinary paper and royal paper, [and] one lot of 'gilt paper.'" Another preserved record shows the purchase from a stationer of "a paire of vellum leaves ... & gilding them" (Munby 1954, 302–6; Larmine 1990, 194, 231, 233, 252; quoted in Woudhuysen 1996, 47). Sir John Harrington created a presentation copy of *Orlando Furioso* with a gilt binding and gilded leaves (Woudhuysen 1996, 108). Donne also uses blue-edged paper, in a letter to his brother-in-law Sir Robert More of July 28, 1614, about the arrival of Christian

IV of Denmark. The letter recounts Donne's frustration with the court, and he seems to pun on the blue-edged paper in an offhand comment about the starched colors that were popular then in English ruffs: "Others think he [the Danish king] came to correct our enormity of yellow bands, by presentinge as many, as blew."[28] It is not clear—beyond perhaps Donne's pun on his own blue band—how blue functions, but "yellow bands" here signifies a sudden fashion of yellow-dyed ruffs, which soon became controversial when Anne Turner, the inventor of this fashion, was tried for involvement in the plot to murder Thomas Overbury. Letters also circulated on paper edged in green.[29] In addition to these papers edged in blue, green, and gold, black-edged paper was used in letters of mourning, and here the connection between the edging and the contents is most clear.

It seems possible that Shakespeare also wrote on gilt "dwarfish pages" (or quarto sheets) when he speaks of "gilded monuments" and "gilded tombs." These are both peculiar phrases because neither monuments nor tombs themselves would be entirely gilded. Part of the negative resonance of "gilt" is that it is merely a veneer, not gold through and through. Indeed, the history of the use of these phrases suggests that they are virtually always metaphorical and—in the case of "gilded monuments," at least—Shakespearean in origin. Keyword searches in two major databases, Literature Online (LION) and Early English Books Online (EEBO), suggest that the phrases are fairly rare. "Gilded tomb" or "tombs" first appears in print in a pirated work of Michael Drayton in 1594, which reappeared two years later as *The Tragicall Legend of Robert, Duke of Normandy,* where it is used, as in Shakespeare, in a figurative sense describing not that which is real but that which the addressee and the poem are not: a grand something encasing a grim nothing.[30] Drayton, a fellow sonneteer, might have seen Shakespeare's sonnet before this date, and at around this date, the phrase occurs in *The Merchant of Venice,* where it is used in the short poem that accompanies the gold casket, in terms that recall the folding of paper: "gilted tombs do worms enfold." The handful of uses that follow—six in poetry, six in drama, and five in prose (including Heywood's [1612] *Apology for Actors*)—all come after Shakespeare and either plainly or likely bear his influence. The rarer combination "gilded"—or "guilded"—"monument" seems

entirely Shakespearean; it was borrowed once by John Webster for the "Funeral Elegy," written in 1613 for Henry, Prince of Wales, and then not used again until it reappeared in modern references to Shakespeare.[31] The image of the monument itself being gilded, rather than the letters on the monument, seems to be original to Shakespeare.

Though we can only guess at the particular levels of punning in Shakespeare's gilt monuments and tombs, a pattern emerges in other similar poems where we do have the materials, or sufficient record of them, in which writers employ the matter of the medium to effect their meaning. This happens repeatedly in texts expressing literary immortality, in which they simultaneously pun on the text's own materiality or imagined materiality: engraved in stone, written on a table, written in gold letters, or written in the lapidary style used in stone. Always figurative, this medial self-referentiality tropes on the materiality of writing in ways that ironically reflect the immateriality of the message.

In the historical span covered by the lives of England's most prominent early modern writers, Shakespeare (1564–1616) and Milton (1608–74), the form of the material text underwent a shift from the manuscript toward the printed object as a viable, stable, and reputable medium for words. Yet the continued presence of two dominant media forms mandates a comparative, multimedia approach to the literature of this period. In Tudor England, print remained an untrusted medium, beyond the control of the author with regard to the text (books belonged to the printer and publisher and not to the author) and with regard to readership (there was still a discernible "stigma of print" in the seventeenth century). For much of the poetic and dramatic literature of the period, rather than being the principal medium of communication, print often represented an insufficient record of a once authentic communication. In addition to the social stigma of print, there was still a sense suggested by frequent practice that print was what dead people did rather than the living. Such was the case with the aristocratic poet John Suckling, whose poetry was published by Humphrey Moseley after his death in a memorial publication published "by a friend to perpetuate his memory" (Suckling 1945, title page). The volume includes a portrait of Suckling, which presents him as a bust on a plinth in a manner suggestive of his passing.

When Milton put his poems into print in the same year, he seems to have been motivated by a desire to counteract and even erase the stigma that pamphlet printing had already produced (Corns 1982; Coiro 1992). He also chose Humphrey Moseley, a reputable publisher, who used the same engraver to create a living bust (a rarer thing) of Milton (Milton 1645, a3r–a3v). Here Milton finally acknowledged "On Shakespeare" (as it would now be called), printed anonymously thirteen years before. In addition to the desire to reshape his public persona from a "divorcer" to a respected poet, Milton's motivation to publish his manuscript poems may have derived from the extraordinary claims for the possibilities of print in *Areopagitica,* printed in late November 1644 (Coiro 1992, 261–89). Though *Areopagitica* has often been read as a tract concerned with political and religious freedom, it is first and foremost about the liberty of printing, a "SPEECH," as the title page claims it, of "*Mr. JOHN MILTON For the Liberty of UNLICENC'D PRINTING, To the PARLAMENT of ENGLAND*" (Dobranski 1995, 131–52; Hoxby 2002, 25–52; Loewenstein 2002, 152–91).[32] But it is also a defense, directed to authors, of the medium of print itself, a term that appears in different forms twenty-three times in some forty pages. In this context, Milton invokes the now wellworn trope of a text as tomb in a way that suggests that print is the medium by which the living spirit of an author might be preserved: "Books are not absolutely dead things, but doe contain a potencie of life in them.... They do preserve as in a violl the purest efficacie and extraction of that living intellect that bred them.... A good Booke is the pretious life-blood of a master spirit, imbalm'd and treasur'd up on purpose to a life beyond life" (Milton 1953, 2:492–93). Milton's description is not just of books as they are but as they ought to be seen: a repository of words composed by, and controlled by, living authors.

Fourteen years after Milton died, publisher Jacob Tonson put out a splendid folio edition of *Paradise Lost* (Milton 1688). Tonson, publisher of famous living English writers such as Addison, Pope, and Dryden, repackaged Milton's epic after it had been out of print for some ten years in a way that helped establish it permanently in the literary canon. Just as Jonson, and later Milton, had commemorated the immortal achievement of their elder contemporary in the folios of Shakespeare, here, under the portrait

FIGURE 10.1. John Milton, *Paradise Lost: A Poem in Twelve Books,* the fourth edition, adorned with sculptures (London, 1688), detail of frontispiece portrait.

frontispiece, on what is made to look like a stone engraving (see Figure 10.1), lies a powerful endorsement from England's poet laureate, John Dryden:

> Three Poets, in three distant Ages born,
> Greece, Italy, and England did adorn

The conceit of Dryden's epitaphic poem is that the reader has come across this tome (or tomb) in a distant future age, distant enough as to place England in the same historical category as the Rome of Virgil and the Greece of Homer. In suggesting that Milton equals the combined strength of Homer and Virgil, Dryden is also claiming that England has earned a place as the third great civilization of the West: Greece, Italy, and now England. And yet, even while Dryden claims a permanence of this expression, he is doing so on a medium (stone) foreign to the poem itself and in a way that ironically depends on the survival of the material on which it is made. The meaning is mediated by the imagined material form. Dryden's poem is designed to convey its complete meaning only as appears on this imagined monumental inscription. Like Donne's gilt parcel, the poem defies remediation. Even as he gestures toward immortality, the poet registers his dependence on a medium that is temporal and impermanent.

NOTES

For timely and indispensable advice, I am grateful to Richard Brantley, Julie Eckerle, Margaretta Fulton, Thomas Herron, Daniel Starza Smith, and especially Peter Stallybrass and Heather Wolfe. I also thank Rosalind Diaz for outstanding research assistance and critical intervention.

1 The scene showing the disguised de Lesseps reading was added in the film.
2 All citations to Shakespeare's sonnets are to Booth's edition (Shakespeare 1977), which has a facsimile of the 1609 edition on the facing page.
3 The argument for the unauthorized printing of the sonnets is convincingly made by Honigmann (2010, 941–42; see also Marotti 2007, 187).
4 See the entries on Donne and Jonson in Beal (1980, 245, 250–58, 262–555; also Beal 1999, 122–26). On scribal culture, see Beal (1998), Ezell (1999, 1–60), Love (1998), Marotti (1995), Woudhuysen (1996), and Wolfe (2006).
5 See also Jessica Brantley, chapter 9 in this volume.
6 On erasable tables, see Stallybrass et al. (2004); for the attribution history of the glove poem, see Duncan-Jones and Woudhuysen in Shakespeare (2007, 436–37). *Amoretti* 75.1, 11 is in Spenser (1993, 617). See also Fleming's (2001) work on graffiti.
7 See also Brantley (chapter 9) and Gitelman (chapter 8) in this volume.
8 As Herbert points out, Donne puns on *tome* as *tomb* in "Valediction: Of the Book," in "this all-graved tome," where "tome" appeared as "tomb" in the 1669 printed edition of his verse.
9 Horace, *Odes* III. xxx, ll. 1–8; quoted in Shakespeare (1977, 227). Booth also cites Ovid's *Metamorphoses* XV, 871–79. See Engle (1989, 832–43).
10 See esp. Sonnet 333 in the *Canzoniere,* which contains images of the stone tomb of Laura, the "scattered leaves" of the poet, and his claim that she lives in this: "alive, and now immortalized" (Petrarch 1985, 74).
11 For a thoughtful reconstruction of the work of Heminge and Condell, see Honigmann (2010, 937–51).
12 On Milton's poems and their manuscript circulation, see Fulton (2010, esp. 15–37). Milton's "On Time" appears with such instructions in Bodleian MS Ashmole 36/37, f. 22, and in Milton's own manuscript collection. See Milton (1945, 1:395).

13 For evidence of Shakespeare's authorship and notes on the epitaph, see Duncan-Jones and Woudhuysen in Shakespeare (2007, 462–65). The will of Dorothy Calthorpe specifies the creation of just such a gravestone: "I would have a marble stone of 10 pounds laid upon my grave with my Coat of Armes cutt upon it and buried where no body ever was either in Church or Chancell with my name on the stone and this engraven with it: I troubled no mans dust: Lett others be to me as just." Public Record Office National Archives, PROB 11/417. I am grateful to Julie Eckerle for drawing this to my attention.

14 For illustrated examples of this kind of inscription, see Keppie (1991).

15 For an argument that the 1609 printing was authorized, see Duncan-Jones (1983, 151–71).

16 For a dicussion of the authorial status of the second quarto of *Hamlet* and other plays, see Erne (2003); see also the summary in Erne (2007, 54–69).

17 The title is also in Meres (1598). See Baldwin (1957, 21).

18 For further discussion, see Fulton (2010, 15–30).

19 The title page of the first edition is lost; it probably appeared in 1598 or 99; the date and title of the second printing are used here.

20 On the popularity of the printed sonnets, see Erne (2007, 60).

21 Unless otherwise noted, this and subsequent quotations from Shakespeare's plays are from Shakespeare (1997a).

22 On other patronage poems on single leaves that survive, see Woudhuysen (1996, 92).

23 The later letter is Folger L.b.539; it has a different watermark and originated from a different source than Folger L.b.535, which uses the same paper as Bodleian MS.eng.poet.d.197. Folger MS L.b.535 has now a virtually unrecognizable gilt edge, but there is earlier documentation of it. Laetitia Yeandle (2000, 81) wrote that "the paper is gilt-edged on all four sides but not now continuously, probably because the slightly wavy edges were trimmed when the letter was repaired." Earlier reports in the Folger files indicate a gilt edge.

24 On the attribution debate, see Brown (1914, xlii–xiv, 57); a version of the sonnet is found in Parry (1597); the sonnet may be a joint composition.

25 "An Epiphalamy" for James Fortery and Mary Forterie is written in different colored inks, among them gold. Beinecke Osborne MS 17867, New Haven, Conn.

26 As Burrow points out, "Q's 'quiers' may also distantly suggest 'quires' of paper, a sense activated both by 'yellow leaves' in l. 2 (cf. 17.9) and by the disparaging remarks on Shakespeare's own works with which

the previous sonnet ends" (Shakespeare 2002, 526, note to 73.4).

27 As Gordon McMullan notes, this is "generally held to be a Shakespeare scene," rather than by Fletcher (Shakespeare 2000, 212; citation from this edition).

28 John Donne to Robert More, July 28, 1614, Folger L.b.537, in Donne (2005, 97). Alistair Bellamy (2002, 159) has shown the explosion of the fashion of the yellow ruff. I am grateful to Jan Purnis for her insights on this passage.

29 These are from Mr [George] Garrard to Conway, SP 16/329/45, SP 16/415/65 and SP 16/469/45. Here I benefit from conversation with Daniel Starza Smith and from the third chapter of his dissertation and forthcoming book (Smith 2011, forthcoming).

30 "VVhat are the rest but painted Imagrie, / Domb Idols made to fill vp idle roomes, / But gaudie Anticks, sports of foolerie, / But fleshly Coffins, goodly gilded toombs" (Drayton 1596, Stanza 81, ll. 1–4).

31 The search was conducted in April 2012, when LION claimed "350,000 literary works in the English language—343,000 works of poetry, 5000 dramatic works, and 2000 prose works." Both "gilded" and "guilded" were used, with alternate forms and spellings, with a LION count totaling six in poetry, six in drama, and one in prose, and in EEBO a few different hits added one play, one poem, and four prose works.

32 On the significance of the title page, see Blum (1988, 85).

REFERENCES

Atkins, Carl D., ed. 2007. *Shakespeare's Sonnets with Three Hundred Years of Commentary.* Danvers, Mass.: Rosemont.

Baldwin, T. W. 1957. *Shakespeare's Love's Labour's Won.* Carbondale: Southern Illinois University Press.

Bancroft, Thomas. 1639. *Two Bookes of Epigrammes, and Epitaphs.* London: Printed by J. Okes, for Matthew Walbancke.

Barker, Nicolas. 2003. "Donne's 'Letter to the Lady Carey and Mrs. Essex Riche,'" in *Form and Meaning in the History of the Book: Selected Essays,* 7–14. London: British Library.

Beal, Peter. 1980. *Index of English Literary Manuscripts. Vol. 1, 1450–1625, Part 1.* London: Mansell.

———. 1998. *In Praise of Scribes: Manuscripts and Their Makers in Seventeenth-Century England.* Oxford: Clarendon Press.

———. 1999. "John Donne and the Circulation of Manuscripts." In *The Cambridge History of the Book in Britain,* vol. 4, edited by

John Barnard and D. F. McKenzie, 122–26. Cambridge: Cambridge University Press.

Bellamy, Alistair. 2002. *The Politics of Court Scandal in Early Modern England: News Culture and the Overbury Affair, 1603–1660.* Cambridge: Cambridge University Press.

Blum, Abbe. 1988. "The Author's Authority: *Areopagitica* and the Labor of Licensing." In *Re-membering Milton: Essays on the Texts and Traditions,* edited by Mary Nyquist and Margaret W. Ferguson, 74–96. London: Methuen.

Bodley, Thomas. 1926. *Letters of Sir Thomas Bodley to Thomas James First Keeper of the Bodleian Library.* Edited by G. W. Wheeler. Oxford: Clarendon Press.

Brown, Carleton, ed. 1914. *Poems by Sir John Salusbury and Robert Chester.* London: Early English Text Society/K. Paul, Trench, Trübner.

Burrow, Colin. 2007. "Editing the Sonnets." In *A Companion to Shakespeare's Sonnets,* edited by Michael Schoenfeldt, 145–62. Malden, Mass.: Blackwell.

Campbell, Gordon. 1999. "Shakespeare and the Youth of Milton." *Milton Quarterly* 33, no. 4: 95–105.

[Clement, Francis]. 1587. *The Petie Schole with an English Orthographie.* London: Thomas Vautrollier.

Coiro, Ann Baynes. 1992. "Milton and Class Identity." *Journal of Medieval and Renaissance Studies* 22:261–89.

Corns, Thomas N. 1982. "Milton's Quest for Respectability." *Modern Language Review* 77, no. 4: 769–79.

Dobranski, Stephen. 1995. "Letter and Spirit in Milton's *Areopagitica.*" *Milton Studies* 32:131–52.

Donne, John. 1912. *The Poems of John Donne.* 2 vols. Edited by Herbert Grierson. Oxford: Clarendon Press.

———. 2005. *John Donne's Marriage Letters in the Folger Shakespeare Library.* Edited by M. Thomas Hester, Robert Parker Sorlieu, and Dennis Flynn. Washington, D.C.: Folger Shakespeare Library.

———. 2008. *Complete Poems of John Donne.* Edited by Robin Robbins. London: Longman.

Drayton, Michael. 1596. *The Tragicall Legend of Robert, Duke of Normandy.* London: Ia. Roberts for N. L[ing].

Duncan-Jones, Katherine. 1983. "Was the 1609 Shake-speares Sonnets Really Unauthorized?" *Review of English Studies* 34:151–71.

Dutton, Richard. 1997. "The Birth of the Author." In *Texts and Cultural Change in Early Modern England,* edited by C. Brown and A. Marotti, 153–78. New York: Macmillan.

Eisenstein, Elizabeth L. 1993. *The Printing Revolution in Early Modern Europe.* Cambridge: Cambridge University Press.

Engle, Lars. 1989. "Afloat in Thick Deeps: Shakespeare's Sonnets on Certainty." *PMLA* 104, no. 5: 832–43.

Erne, Lucas. 2003. *Shakespeare as Literary Dramatist.* Cambridge: Cambridge University Press.

———. 2007. "Print and Manuscript." In *The Cambridge Companion to Shakespeare's Poetry,* edited by Patrick Cheney, 54–71. Cambridge: Cambridge University Press.

Ezell, Margaret. 1999. *Social Authorship and the Advent of Print.* Baltimore: Johns Hopkins University Press.

Fleming, Juliet. 2001. *Graffiti and the Writing Arts of Early Modern England.* Philadelphia: University of Pennsylvania Press.

Forrest, H. T. S. 1923. *The Five Authors of Shakespeare's Sonnets.* London: Chapman and Dodd.

Fulton, Thomas. 2010. *Historical Milton: Manuscript, Print, and Political Culture in Revolutionary England.* Amherst: University of Massachusetts Press.

Gardner, Helen. 1972. *John Donne's Holograph of "A Letter to the Lady Carey and Mrs Essex Riche."* London: Scolar Mansell.

Gitelman, Lisa. 2008. *Always Already New.* Cambridge, Mass.: MIT Press.

Guillory, John. 2010. "Genesis of the Media Concept." *Critical Inquiry* 36:321–62.

Herbert, T. Walter. 1949. "Shakespeare's Word-Play on *Tombe.*" *Modern Language Notes* 64, no. 4: 235–41.

Heywood, Thomas. 1612. *Apology for Actors.* London: Printed by Nicholas Okes.

Honigmann, E. A. J. 2010. "How Happy Was Shakespeare with the Printed Versions of His Plays?" *Modern Language Review* 105, no. 4: 937–51.

Hoxby, Blair. 2002. *Mammon's Music: Literature and Economics in the Age of Milton.* New Haven, Conn.: Yale University Press.

Johnson, Samuel. 1765. *Mr. Johnson's Preface to His Edition of Shakespear's Plays.* London: printed for J. and R. Tonson et al.

Jonson, Ben. 1925–53. *Ben Jonson.* 11 vols. Edited by C. H. Herford Percy and Evelyn Simpson. Oxford: Oxford University Press.

Kastan, David Scott. 1999. *Shakespeare after Theory.* New York: Routledge.

———. 2001. *Shakespeare and the Book.* Cambridge: Cambridge University Press.

Kastan, David Scott, and Kathryn James. 2012. *Remembering Shakespeare.* New Haven, Conn.: Yale University Press.

Keppie, Lawrence. 1991. *Understanding Roman Inscriptions*. London: B. T. Batsford.

Larmine, V. M., ed. 1990. *The Undergraduate Account Book of John and Richard Newdigate, 1618–1621*, in Camden Society, *Camden Miscellany* 39, 149–269.

Loewenstein, Joseph. 2002. *The Author's Due: Printing and the Prehistory of Copyright*. Chicago: University of Chicago Press.

Love, Harold. 1998. *The Culture and Commerce of Texts: Scribal Publication in Seventeenth-Century England*. 2nd ed. Amherst: University of Massachusetts Press.

Marotti, Arthur F. 1995. *Manuscript, Print, and the English Renaissance Lyric*. Ithaca, N.Y.: Cornell University Press.

———. 2007. "Shakespeare's Sonnets and the Manuscript Circulation of Texts in Early Modern England." In *A Companion to Shakespeare's Sonnets*, edited by Michael Schoenfeldt, 185–203. Malden, Mass.: Blackwell.

McKenzie, D. F. 2002. *Making Meaning: Printers of the Mind and Other Essays*. Edited by Peter D. McDonald and Michael F. Suarez. Amherst: University of Massachusetts Press.

Meres, Francis. 1598. *Palladis Tamia. Wits Treasury*. London: printed by P. Short, for Cuthbert Burbie.

Milton, John. 1645. *Poems of Mr. John Milton both English and Latin, compos'd at several times*. London: Humphrey Moseley.

———. 1688. *Paradise Lost*. London: Jacob Tonson.

———. 1945. *John Milton's Complete Poetical Works Reproduced in Photographic Facsimile*. 4 vols. Edited by Harris Fletcher. Urbana: University of Illinois Press.

———. 1953–82. *The Complete Prose Works of John Milton*. 8 vols. Edited by Don M. Wolfe et al. New Haven, Conn.: Yale University Press.

Munby, A. N. L. 1954. "Fragment of a Bookseller's Day-Book of 1622." *The Book Collector* 3:302–6.

North, Marcy L. 2003. *The Anonymous Renaissance: Cultures of Discretion in Tudor–Stuart England*. Chicago: University of Chicago Press.

Ong, Walter. 1977. *Interfaces of the Word: Studies in the Evolution of Consciousness and Culture*. Ithaca, N.Y.: Cornell University Press.

Orgel, Stephen. 2007. "Mr. Who He?" In *A Companion to Shakespeare's Sonnets*, edited by Michael Schoenfeldt, 137–44. Malden, Mass.: Blackwell.

Parry, Robert. 1597. *Sinetes Passions*. London: printed by T[homas] P[urfoot] for William Holme.

Petrarch, Francesco. 1955. "*Coronation Oration*." Translated by E. H.

Wilkins. In *Studies in the Life and Works of Petrarch*, 300–13. Cambridge, Mass: Mediaeval Academy of America.

———. 1985. *Selections from the Canzoniere and Other Works*. Edited by Mark Musa. Oxford: Oxford University Press.

Raymond, Joad. 2003. *Pamphlets and Pamphleteering in Early Modern England*. Cambridge: Cambridge University Press.

Rodgers, Sarah. Forthcoming. "Embedded Poetry and Coterie Readers in Mary Wroth's *Urania*." *Studies in Philology*.

Saunders, J. W. 1951. "The Stigma of Print: A Note on the Social Bases of Tudor Poetry." *Essays in Criticism* 1:139–64.

Schoenfeldt, Michael. 2007. "The Sonnets." In *The Cambridge Companion to Shakespeare's Poetry*, edited by Patrick Cheney, 125–43. Cambridge: Cambridge University Press.

Shakespeare, William. 1632. *Mr. William Shakespeares Comedies, Histories, and Tragedies*. London: printed by Tho. Cotes for Robert Allot.

———. (1623) 1968. *The First Folio of Shakespeare*. Facsimile edition prepared by Charlton Hinman. New York: W. W. Norton.

———. 1977. *Shakespeare's Sonnets*. Edited by Stephen Booth. New Haven, Conn.: Yale University Press.

———. 1997a. *Riverside Shakespeare*. 2nd ed. Edited by G. Blakemore Evans et al. Boston: Houghton Mifflin.

———. 1997b. *The Art of Shakespeare's Sonnets*. Edited by Helen Vendler. Cambridge, Mass.: Harvard University Press.

———. 2000. *King Henry VIII (All Is True)*. Arden third series. Edited by Gordon McMullan. London: Thomson Learning.

———. 2002. *Complete Sonnets and Poems*. Edited by Colin Burrow. Oxford: Oxford University Press.

———. 2007. *Shakespeare's Poems*. Edited by Katherine Duncan-Jones and H. R. Woudhuysen. London: Arden.

Shapiro, James. 2005. *1599: A Year in the Life of William Shakespeare*. London: Faber and Faber.

Sharpe, Roger. 1610. "To the Reader." In *More Fooles Yet*. London: printed [by T. Purfoot] for Thomas Castleton.

Smith, Daniel Starza. 2011. "John Donne and the Conway Papers." PhD diss., University College London.

———. Forthcoming. *John Donne and the Conway Papers*. Oxford: Oxford University Press.

Spenser, Edmund. 1977. *The Faerie Queene*. Edited by A. C. Hamilton. London: Longman.

———. 1993. *Edmund Spenser's Poetry*. Edited by Hugh Maclean and Ann Lake Prescott. New York: W. W. Norton.

————. 1999. *The Shorter Poems*. Edited by Richard A. McCabe. London: Penguin.

Stallybrass, Peter, Roger Chartier, J. Franklin Mowery, and Heather Wolfe. 2004. "Hamlet's Tables and the Technologies of Writing in Renaissance England." *Shakespeare Quarterly* 55, no. 4: 279–419.

————. n.d. "John Donne's Holograph Letter/Poem, 'A Letter to the Lady Carey.'" Unpublished manuscript.

Stewart, Alan. 2008. *Shakespeare's Letters*. Oxford: Oxford University Press.

Stewart, Alan, and Heather Wolfe. 2004. *Letterwriting in Renaissance England*. Washington, DC: Folger Shakespeare Library.

Stoppard, Tom, and Marc Norman. 1998. *Shakespeare in Love*. New York: Hyperion.

Stringer, Gary A. 2011. "The Composition and Dissemination of Donne's Writings." In *The Oxford Handbook of John Donne*, edited by Jeanne Shami, Dennis Flynn, and M. Thomas Hester, 13–25. Oxford: Oxford University Press.

Suckling, John. 1945. *Fragmenta Aurea*. London: Humphrey Moseley.

Taylor, Gary. 1985. "Some Manuscripts of Shakespeare's Sonnets." *Bulletin of the John Rylands Library* 68:210–46.

Willard, O. M. 1942. "The Survival of English Books Printed before 1640: A Theory and Some Illustrations." *The Library* 23, 4th series, no. 4: 171–90.

Wolfe, Heather. 2006. "Manuscripts in Early Modern England." In *A Companion to English Renaissance Literature*, edited by Donna B. Hamilton, 114–35. Oxford: Blackwell.

Woudhuysen, H. 1996. *Sir Philip Sidney and the Circulation of Manuscripts, 1558–1640*. Oxford: Oxford University Press.

Yeandle, Laetitia. 2000. "Watermarks as Evidence for Dating and Authenticity in John Donne and Ben Franklin." In *Puzzles in Paper: Concepts in Historical Watermarks*, edited by Daniel W. Mosser, Michael Saffle, and Ernest W. Sullivan II, 81–92. London: Oak Knoll Press.

11
Reading Screens: Comparative Perspectives on Computational Poetics

John David Zuern

ON JULY 27, 1929, *Lindbergh's Flight,* a cantata for radio written by Bertolt Brecht (2003), with a score by Paul Hindemith and Kurt Weill, premiered as a live performance at the Festival for German Chamber Music in Baden-Baden. At once celebrating and commenting critically on Charles Lindbergh's historic solo crossing of the Atlantic two years earlier, the piece also advances Brecht's famous appeal for an application of the relatively new technology of the radio that would go beyond the function of a few-to-many broadcasting system in the grip of a capitalist media elite to become a means of many-to-many communication for a society of equals. In its first performance, the soloist who played the role of the lone pilot also represented the individual radio listener; he sat alone on the opposite side of the stage from the orchestra and chorus, who represented the apparatus of the radio transmitting its accompaniment to the distant vocalist. Comprising largely duets between Lindbergh and personifications of the various elements that aided and impeded him on his journey—the Motor, the Fog, the Snowstorm, and Sleep—the cantata seeks to embody Brecht's vision of the radio as a platform for dialogue and participation.

I open this chapter on electronic literature by looking back to *Lindbergh's Flight* because Brecht's imaginative intervention into the emerging communication technology of his time makes him a notable forerunner to present-day writers whose works, leveraging the distinctive features of digitized text, are expressly written to be read on the computer screen. Brecht's cantata also happens to provide an example of an early use of a screen to incorporate

a significant amount of text into a multimedia artwork. As an experiment *(Versuch)* and a didactic exercise *(Lehrstück), Lindbergh's Flight,* like many of Brecht's works, is more committed to demonstrating principles than to entertaining its audience. To drive home the work's lesson, throughout the Baden-Baden performance, a short paragraph encapsulating its political philosophy was projected onto a large screen of stretched fabric covering the back of the stage.[1] In 1929, this screen, which allowed Brecht and his collaborators to integrate a graphically dramatic text into a predominantly acoustic artwork, was historically poised to advance into the forefront of twentieth-century textual, visual, and musical cultural production. Within a few decades, it would assume a far more technically sophisticated form as an integral component of a vast telecommunication system of which the radio was an early avatar. Four months after the premiere of *Lindbergh's Flight,* at a meeting of the Institute of Radio Engineers in Rochester, New York, Vladimir Zworykin unveiled his kinescope, a prototype of the cathode ray receiver tube that would lay the foundation of the television industry (Abramson 1995, 84). Advances in computing technologies, accelerated during the Second World War, eventually adapted the television screen into the video terminal, through which programmers communicated with their machines. With the emergence of the Internet in the 1970s and the World Wide Web in the 1990s, the computer screen—by then widely available thanks to the mass-marketing of personal computers—took on its present role as a powerful medium for the production and reception of works of art of all kinds.[2]

Beginning with Brecht's 1929 production also signals this chapter's principal argument, which maintains that a broadly historical and robustly comparative approach to literary production in digital media will offer us deeper insights into the aesthetic, ethical, and political dimensions of individual screen-based works. As I see it, a critical orientation that emphasizes electronic texts' complex and sometimes occult relationships with counterparts in earlier media—without ignoring their very real innovations—is also likely to help electronic literature achieve wider recognition within the institutional frameworks of literary scholarship as a coherent, valid, and valuable field of study.

In what follows, I first sketch out a rationale for an explicitly comparative critical perspective on literature written for "the screen." I then attempt to provide an illustration of that approach by aligning *Lindbergh's Flight* with a text that exhibits many of the typical features of screen-based electronic literature: Judd Morrissey and Lori Talley's (2002) *My Name Is Captain, Captain.*,[3] published on CD-ROM in 2002 by Eastgate Systems. Like Brecht's cantata, *Captain, Captain* takes up the theme of pioneering aviation, turning the navigational techniques on which pilots like Lindbergh depended into an allegory of reading and a pointed, historically grounded appeal to the reader's moral imagination. I hope to show that comparing the poetics of a text bound for the computer screen with the poetics informing textual compositions bound for other modes of presentation can reveal how profoundly our perception of a text's significance is enmeshed in our experience of its specific material interface. I conclude by reflecting on the institutional implications of the historically inclusive, comparative approach for which I advocate, stressing the need for programs that embrace electronic literature to make curatorial as well as critical commitments to these culturally vital but materially precarious artifacts.

READING THE SCREEN AND READING SCREENS

In his 1997 book *Interface Culture,* Steven Johnson predicts that as human–computer interfaces become more pervasive in our everyday lives, we will begin to look beyond their mere utility and recognize them as fertile ground for artistic expression. "The most profound change," he writes, "will lie with our *generic* expectations about the interface itself. We will come to think of interface design as a kind of art form—perhaps *the* art form of the next century" (213; emphasis original). Although the graphical user interface has yet to achieve that lofty status, authors have been exploring its potential to enhance and expand literary composition since long before the turn of the millennium. From the earliest poetry generators and interactive adventure games to the hypertext novels and poems of the 1990s to the various hybrid multimedia artworks that have emerged over the past two

decades, experiments in writing on and for the computer screen have built up what might be called a computational poetics, an approach to *making* literary artworks *(poeisis)* that consciously draws on the computer's distinctive capacities for processing and displaying words.[4]

Many practitioners of this computational poetics are motivated by political and moral impulses similar to those that propelled Brecht's projects; in the very act of exploiting new technologies in their creative work, these writers ask us to reflect on our susceptibility to exploitative, manipulative, and alienating applications of these technologies. Others highlight the particular experiences of play, pleasure, and beauty that human–computer relationships can afford. A great many writers accomplish both these ends in the same text.[5] The defining role of computational processes and human–computer interfaces in these authors' productions sets all of them apart from those working in more traditional media. In chapter 6 in this volume, Stephanie Boluk and Patrick LeMieux note that computer games such as *Dwarf Fortress* "conflate the rules of a game with the mechanics governing the environment in which the game is played." Likewise, electronic literary texts that make the fullest use of their medium create intimate linkages between the imaginative use of human language and the equally imaginative deployment of the programming and interface design resources of their chosen systems. Like *Lindbergh's Flight,* which emerged out of the excitement and anxiety of the early days of radio broadcasting, these texts are emerging out of the pathos of our own historical moment, a time in which dense amalgams of cultural and computational codes increasingly govern and give meaning to our lives.

Crucial as they are as the *Lehrstücke* of our age, electronic literary texts have received too little serious attention in mainstream literary scholarship. Literary critics, whose job it is to assess and articulate the cultural value of literary innovations, have on the whole been slow to apprehend the screen as something other than an upgrade from paper.[6] Adapting Kenneth Burke's (1966, 28–44) concept of "terministic screens"—the ideological filters that necessarily condition our understanding of the world—we might say that these readers are encumbered by "reading screens," a kind of medium-myopia in the face of emerging modalities of literary

expression. Alongside the relatively small group of critics who are now studying electronic literature, the most screen-literate scholars in the literary domain are those engaged in the field of humanities computing, which seeks to use digital technologies to preserve, edit, and interpret our literary heritage.[7] Though this field is also struggling for appropriate recognition, its contribution tends to be more immediately evident to the broader academic community, though often in reductively utilitarian ways.

Print-focused reading screens are still endemic in the academy—more so, perhaps, than in society at large. For the time being, the scholarly projects that are most likely to awaken a more widespread appreciation of the literary capacities of the screen will be those that trade the simplistic contrast between the (old, presumably confining) page and (new, presumably liberating) screen—a contrast that has underpinned too many analyses of digital literature—for rigorously comparative perspectives on digital literary artifacts. Making good on Hayles's (2003, 263) observation that "the advent of electronic textuality presents us with an unparalleled opportunity to re-formulate fundamental ideas about texts and, in the process, to see print as well as electronic texts with fresh eyes," critical projects that look back from the cutting edge of digital literary production to the richly complex textual practices of the past may better serve to dispel, or at least expand, the reading screens of colleagues and students who have been hitherto reluctant to engage with electronic texts.

We already have excellent examples of this kind of scholarship. In her recent analyses of the poetry of Ezra Pound and Emily Dickinson in the light of present-day computational poetics, Lori Emerson (2008) shows how a comparative approach reveals the extent to which our naturalized reading screens limit our appreciation of the complex material histories of even well-known works. Examining Dickinson's idiosyncratic practice of assembling (and reassembling) poems by pinning small slips of paper together and compiling manuscript poems into handmade fascicles, Emerson points out that print editions of Dickinson's work can only amount to static snapshots of this writer's dynamic process. Though they appear to provide more convenient access to these documents, print editions alienate the reader from the

ıx and indeterminacy of the artifacts themselves. "After
ʀson asks, "what else is a fascicle, a pinned poem, or a
ınd poem that has been put into conventional type but
a fom of writing interface? It is not possible to have access to
a pure reading of Dickinson's poems, one that is unmediated by
either twentieth- or twenty-first-century interfaces or by our own
thinking habits similarly enmeshed in reading/writing interfaces"
(58). Emerson suggests that shape-shifting electronic texts like
Mary Flanagan's *[theHouse]* and Judd Morrissey and Lori Tal-
ley's *The Jew's Daughter* approximate the function of Dickinson's
manuscripts as reading–writing interfaces far more than print.
With her apt formulation of the "bookbound" nature of printed
texts, Emerson prompts further reflection on the terministic screens
that condition our understanding of how the poetic dimensions of
literary texts intersect with the various inscriptional technologies
through which we encounter them.

While printed texts are, as Emerson notes, literally "book-
bound," it is also appropriate to speak of digital literary texts as
"screen bound" in at least two senses. As with all inscriptions, the
survival of digital texts depends on the durability of their material
matrices, and rapid changes in digital file formats and operating
systems have left many early works of electronic literature fatally
"bound" in cloven pines of obsolete software. Equally impor-
tant to understanding the distinctive materiality of screen-bound
texts, however, is the sense of *bound* as *having an itinerary*—an
orientation toward a destination. Unlike ink on paper, the digital
text does not adhere permanently to the screen itself. It is stored
as code, and prior to its execution, it is not yet *on* the screen but
rather *bound for* the screen, just as Brecht's libretto, as a script, is
bound for the brain and larynx of a performer. Unlike the libretto,
however, the stored files of digital texts are illegible to human
readers; on their way to the screen—the interface through which
they are written and read—the computer processor interprets
these texts and reassembles them into human-readable symbols.
The actual screen, as a piece of hardware, has little direct impact
on the physical properties of these texts, which are much more
determined by the specific codes and media formats in which they
are stored. As a destination, however, the screen has an enormous
indirect influence on the construction of electronic literary texts,

the most intriguing of which are scripted to take meaningful advantage of the screen's ability to transform the appearance and behavior of texts as well as to solicit readers' interactions. In digital literary studies, much has been made of the split between inscription and display; space here does not permit me to comment on these discussions beyond noting that, by raising the question of where, and indeed what, "the text" actually is, the phenomenon of screen-bound textuality makes one of its most vital contributions to literary studies as a whole.[8]

The question is hardly new. Scholars in textual editing and the history of the book, many of whom now work as or alongside scholars in humanities computing, have long recognized that "the text," insofar as it often exists in multiple versions and formats, is far from a stable phenomenon—Dickinson's fascicles are only one of countless examples. Likewise, by attending more closely to the dynamics of translation and textual transmission, many scholars in the field of comparative literature are coming to understand that texts undergo dramatic changes when they cross into new languages and cultural contexts and that the concepts that once served as the cornerstones of their discipline cannot adequately account for those transformations. As Rebecca Walkowitz (2009, 568) observes, both traditional literary studies and comparative literature tend to "trade in national categories and assume the ontological integrity of a given text." Freeing critical inquiry from these confining presuppositions, Walkowitz proposes, requires a reconfigured field of "comparison literature" that "fits uneasily within methodologies, comparative and national, that assign unique locations or unique substance to literary artifacts. It asks us to imagine new geographies of literary production and requires methodologies that understand the history of a book to include its many editions and translations" (568). Walkowitz fleetingly refers to Kirschenbaum's (2008) use of the phrase "born-digital" in his book *Mechanisms: New Media and the Forensic Imagination,* which inspires her own coinage "born-translated" (569)—a gesture that bears witness both to the potential affinity between comparative literature and digital literary studies and to the disciplinary distance that remains to be crossed.

In *Mechanisms,* Kirschenbaum's meticulous literary-critical and material analysis of key works of electronic literature compellingly

demonstrates the inseparability of a text's cultural significance from its specific physical instantiations. Even highly screen-literate critics, Kirschenbaum notes, too often overlook the material constraints specific to computational processing and display, thus succumbing to a "medial ideology" that is the screen-centric corollary to print-centric reading screens. A medium-conscious "forensic imagination," for Kirschenbaum, provides an antidote to both exclusively book-bound conceptions of literature and to the "screen essentialism [that] becomes a logical consequence of a medial ideology that shuns the inscriptional act" (43). Kirschenbaum's emphasis on the particularity of inscription technologies points to how we might productively extend Walkowitz's "comparison literature" beyond the print tradition, replacing "book" with "text" and adding "its many material interfaces" to "its many editions and translations," thus clearing common critical ground among the disciplines of digital literary studies, humanities computing, and comparative literature.

Viewed from such a vantage point, and from the comparative perspectives we find in critics such as Emerson, Walkowitz, and Kirschenbaum, the computer screen reminds us that the ultimate "integrity" of a literary text inheres not only in its persistence and consistency as a singular artifact but also, if not more so, in its capacity to serve as a dynamic interface at which it, its readers, and a welter of other texts are provisionally yet distinctively and consequentially integrated. In the next section, I suggest how we might reinforce such a double vision of textual integrity, looking both at what texts *are* as material artifacts and at what they *do* as cultural agents, by tracing continuities among book-bound, stage-bound, screen-bound, and body-bound texts across time and media.

THE SCENE OF AN ABDUCTION: JUDD MORRISSEY AND LORI TALLEY'S *MY NAME IS CAPTAIN, CAPTAIN.* AND BERTOLT BRECHT'S *LINDBERGH'S FLIGHT*

Given its tremendous capacity to promote exchange, collaboration, and innovation, it is tempting to regard the networked computer as the fulfillment of Brecht's utopian ambitions for the radio. At

the same time, a moment's reflection will reveal that our highly evolved communication systems, for which "the screen" has become the master metonym,[9] have by no means escaped the strictures of corporate control and—especially when we look beyond the United States and Europe—governmental interference and censorship. As Matthew Wilson Smith (2007, 89–90) has observed regarding Brecht's ambitions, "truly interactive mass communications through independent transmitter/receivers will have to wait until the invention of the Internet—a mass medium that, for all its interactive potential, has hardly found itself at odds with capitalist political economy." Individual users of these technologies remain vulnerable to the consciousness-shaping influence of the technologies themselves. Golumbia (2009) cautions against the detrimental effects of the "cultural logic of computation," predicting that

> the more we imagine ourselves to be like computers, the more computer-like we will become; conversely, the more we imagine computers can take over sociopolitical functions, the more we will give up our own influence over those phenomena—and the more they will pass into the domain of exactly the powerful agents (states, transnational corporations, and capital itself) that already dominate so much of social life. (221)

In less dire tones, Hayles (2005, 204–5), borrowing a term from Mark Poster, describes our transformation into "digital subjects" who "participate every day of our lives in the distributed cognitive complex adaptive systems created by digital technologies in conjunction with global capitalism." At stake for Hayles is the elaboration of a perspective on the "intelligent machines" with which we now live that allows her to see them as "neither objects to dominate nor subjects threatening to dominate me. Rather, they are embodied entities instantiating processes that interact with the processes that I instantiate as an embodied human subject" (243). If we are to gain such a perspective on our interdependency with the increasingly ubiquitous and captivating screen, we still urgently need critical artistic experiments of the kind *Lindbergh's Flight* exemplifies. They need not all be as tendentious as Brecht's, nor need they all undertake a reflexive critique of their technical

conditions of possibility, but without works that in some way test, stretch, and estrange the capacities of the screen, we will be less able to realize the potential and assess the risks of the powerful technological and institutional apparatuses for which the screen stands.

Just as *Lindbergh's Flight* tests the poetic capacities of the new mass medium of radio, *Captain, Captain* explores the resources for literary composition offered by the powerful animation and interface-design software programs that became available to writers and artists in the 1990s. By the turn of the twenty-first century, programs such as Macromedia's Director and Flash, both of which were used to create *Captain, Captain,* had become widely established platforms for interactive content on the World Wide Web. Whereas Brecht's adaptation of Lindbergh's story is shaped by the fundamental sender–receiver functions of radio communication, Morrissey and Talley's adaptation of the same material is shaped by the fundamental navigation-interaction functions of the Flash-enhanced graphical user interface. In *Lindbergh's Flight,* even the Motor of the *Spirit of St. Louis* transmits its noise to Lindbergh via the Radio (see Brecht 2000, 15–16); *Captain, Captain* associates the plane and its Engine with the operations of the computer and the interface. Morrissey and Talley create an elaborate analogy between the experience of exploring and comprehending their elusive animated text and the experience of piloting an airplane, going so far as to build a textual flight simulator into the work, as I discuss in more detail later. Including references to the famous Lindbergh kidnapping case, they extend this metaphor of interpretive orienteering to the procedures of criminal investigation. The result is a densely layered meditation on the intersections of technological achievement, interpretive prowess, and moral culpability.

Originally composed in Director, *Captain, Captain* was remastered in Flash before its publication by Eastgate to take advantage of Flash's vector-based implementation of digital typography, which allows for very small-scale but high-resolution time-based changes to the visual appearance of individual letterforms.[10] As Morrissey and Talley report in a 2003 interview with Pressman (2003a), "the malleability of text, the ability to break it, smear it, and transform it was probably the most interesting compositional lure, in

retrospect, because it afforded the most compelling surprises." Their poem offers an especially powerful example of a computational poetics insofar as it integrates the distinctive capacities of screen-bound text with the aesthetic and ethical sensibilities infusing its treatment of its central themes.

Captain, Captain exhibits many of the characteristics that most distinguish the computer screen from other textual interfaces. Its textual elements are animated; they move and morph, sometimes beyond legibility. Insofar as it requires the reader to follow links to explore the text and make meaningful connections, the poem shares features with classic hypertext as well as the puzzle-solving frameworks of early text-based adventure games and later forms of interactive fiction. In Wardrip-Fruin's (2005) terms, it is an "instrumental text" that "package[s] together logics of graphical play and methods of response with textual and graphical material." Its emphasis on textual fragmentation and its invitation to use the Flash Player's zoom function to "fly" along the z axis in an attempt to identify very small images confirm Raley's (2006) observation that, for readers of digital literature, "the unit of poetic analysis has shrunk from line to word to letter and now we have need of another unit: the three-dimensional projecting plane." Morrissey and Talley enlist all these elements in the service of a poetics that binds the rich themes of their work's verbal and visual text to the computational processes that transport it to the screen and to the reader's eyes and hands.

In the opening sequence of *Captain, Captain*, lines of text rest-lessly disintegrate and reassemble themselves, finally settling into a dense palimpsest of words arrayed within a shape that appears to be a Venn diagram (Figure 11.1). The effect is disorienting, especially when my attempt to use the cursor to find active links in the text—spurred by my own hypertext-dominated presuppositions about on-screen reading—proves fruitless. I finally discover the graphical link in the lower right corner. It leads me to a screen titled "Under the Hood," where I find instructions for the "Link Trainer," a reference to the early flight simulator invented by Ed Link and widely used for pilot training during the historical period from which the poem draws so many of its images. The didactic impulses of *Lindbergh's Flight* carry over into *Captain, Captain*

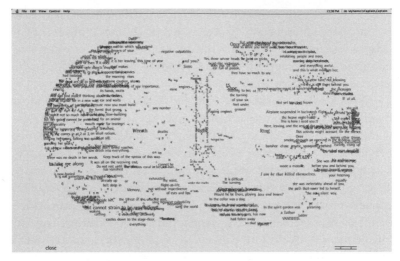

FIGURE 11.1. Judd Morrissey and Lori Talley. Screen capture from *My Name Is Captain, Captain*. Reproduced with permission.

in the guise of this Link Trainer, "an ingenious miniature airplane, inside of which are bellows and valves that move the trainer in response to control movements." The poem presents itself to me precisely as an *exercise*: as a pilot in training, I must practice navigating the poem's often turbulent airspace, accommodating myself to its interface and learning how to "link" its disparate elements to arrive at a meaning. For Brecht, the word *Apparat* designates both Lindbergh's airplane and the radio; the text of *Captain, Captain* likewise fuses its aeronautic themes with the computational apparatus that communicates them to the reader.

In *Captain, Captain,* as Morrissey and Talley reveal in their interview with Pressman (2003a), "dead reckoning, or flying blind, is the central metaphor and it relates to both the writing and reading of the work, to a sort of real-time urgency and elusiveness." With "dead"—possibly from "deduced"—reckoning, pilots determine the aircraft's position and bearing by correlating predictable variables, for example, the rate of fuel consumption, with data from the immediate surroundings, such as wind speed and the position of celestial bodies. In *Captain, Captain,* the metaphor calls our attention to the logics we employ to orient ourselves cognitively within a text: we deduce its genre and status as "literary" from a

priori categories, for example, and we apply induction as we build up our understanding of its meaning by piecing together bits of textual evidence. Our terministic reading screens are so powerful because they provide ready-to-hand frameworks for these deliberations. Works that depart radically from conventions, such as *Captain, Captain* and many other experimental texts, draw to the fore a third logical procedure, the art of conjecture C. S. Peirce named "abduction."

Abduction is reason's means of coping with surprise. As Nordby (1999, ix–x) explains, "abduction provides a method of reasoning from presented signs to their probable explanations. A cloak of interpretive uncertainty shadows both the method and its result. As in navigating by dead reckoning, correctly reading the signs forms part of the process." Eco and others have pointed out that abduction is the logic of detective work (see Eco and Sebeok 1983). When a child mysteriously disappears, for example, the investigator must imagine scenarios that explain the extraordinary occurrence. According to Eco (1990, 59), abduction is also the logic of literary interpretation: "To make a conjecture means to figure out a Law that can explain a Result. The 'secret code' of a text is such a Law." As Pressman (2003b) observes of *Captain, Captain,* "the poem provokes an understanding of reading as a collaboration between actions on the part of the reader (seeing, hearing, physically interacting and decoding) with the technology of reading machines." Simulating flight, *Captain, Captain* stimulates abduction. Indeed, this poem's kinetic, spatial, and navigational features are as much a part of its "secret code" as its verbal clues and ambiguities. If I do not include them in my abductive deliberations, I cannot hope to formulate an adequate question about what *Captain, Captain* means, to say nothing of an answer.

In chapter 12 of this volume, Mark Marino remarks on the degree of deductive reasoning the collaborative novel–program *exquisite_code* demands of its readers. This text was composed by a group of writers and programmers working simultaneously; the writers' contributions were transformed and combined in real time by the custom software the programmers were coding. As a result of this process, Marino observes, "reading the text . . . becomes a game of trying to detect the signatures of the particular collaborators

in the mash, as evidenced by repeating themes, diction, and punctuation, as well as deducing the process, how each passage grew out of the dynamics of the group and the randomly selected prompts." Discovering the patterns created by the text-processing programs is no less crucial for a grasp of *exquisite_code*'s meaning than is tracking the patterns emerging from the human authors' verbal texts. The published text of the novel includes its Python programs in an appendix, thus allowing readers to test some of their hypotheses against the actual programming. No such cross-checking is possible for readers of *Captain, Captain,* as Morrissey and Talley's Flash files do not give access to their source codes. Nevertheless, if readers fail to attend to what *Captain, Captain*'s interface is "doing" alongside what its words are "saying," they will miss much of the poem's historical, cultural, and ethical significance.

Luring me into textual detection, *Captain, Captain*'s interface simultaneously engages me in actual, historical mysteries. The poem's principal themes come from the lives of aviators Charles Lindbergh and Amelia Earhart, including the kidnapping and murder of Lindbergh's infant son in 1932, the investigation that led to the conviction of Bruno Richard Hauptmann for the crime and his execution in 1936, and the disappearance of Earhart and her navigator, Fred Noonan, in the western Pacific in 1937. The "speaker" of the poem's title is Hauptmann; in a line taken from the transcript of his trial, Hauptmann notes that his name (German for "captain") is the same as Lindbergh's rank (see Pressman 2003a). This mirroring of alleged criminal and apparent victim introduces an ambiguity that resonates throughout the poem. The text itself is strewn with tantalizing allusions to Lindbergh, Hauptmann, and Earhart. On one screen, for example, I encounter a row of three boxes bearing the initials B, R, and H, suggesting that the boxes may point to the incriminating shoebox full of ransom money found in Hauptmann's home. The lines of Morse code that sometimes stream across the screen and the "dit dah dit dah" that breaks into the text may stand for the messages the ship *Itasca* radioed to Earhart near the end of her doomed mission, not realizing that neither she nor Noonan could interpret them (Winters 2010, 206–8). Like Brecht, who lifted passages verbatim from the German translation of Lindbergh's 1927 memoir *We* for

his libretto, Morrissey and Talley incorporate material from A. Scott Berg's biography *Lindbergh*, most conspicuously a popular song lampooning Hauptmann's defense (Berg 1999, 324–25), stanzas of which appear when I roll my cursor over those boxes labeled B, R, H. My abductive reading must coordinate this array of historical allusions with the exploratory procedures the poem's interface structures provoke me to undertake.

One section of *Captain, Captain* illustrates this amalgamation of navigational and hermeneutic orienteering particularly well. Clicking the box labeled "H" takes me into a space dominated by a table on which stands another box constructed with lines of text describing the Lindbergh baby's cradle. When I attempt to "open" this box by clicking it, the words scatter upward and resolve into a rotating ring of numerical coordinates. When I click the ring, it collapses into a box again, each time composed of different words; one iteration reads "I have become / terribly implicated in / initials the use of initials / in the place of names." Exploring further, I discover that I can use my cursor to open a drawer in the table, out of which a swarm of specks rise in an undulating cloud (Figure 11.2). Using the Flash player's zoom feature to magnify these specks, I discover they are smeared, fragmented letterforms. Once the swarm emerges, I cannot shut the drawer. Like all acts of discovery, this one is irreversible, and, like many in this piece, it only leads to more questions. Sequences like this one, alongside lines such as "unseen tape / marks endless investigation" and "no longer the breadcrumb trail / that led clearly into the forest / and as the tale goes, has now / vanished," suggest that *Captain, Captain* is designed to trigger interminable chains of abductions. The conceptual integrity of the poem, then, lies precisely in its resistance to any definitive hermeneutic integration. This interpretation would be little more than a postmodern commonplace if the dynamic structures of this poem's interface were not so deeply entwined with its historical themes.

An especially striking instance of intertextuality in *Captain, Captain* is the recurring image of two intersecting circles pierced with three holes, so very like a Venn diagram (Figure 11.3), which in fact mimics the identifying mark, the "singnature"—one of the kidnapper's many misspellings—on the series of ransom notes sent

FIGURE 11.2. Screen capture from *My Name Is Captain, Captain*. Reproduced with permission.

to Lindbergh (Figure 11.4). Thus it turns out that a criminal's cipher masquerades as a logician's tool in a dominant visual feature of *Captain, Captain*'s interface. Further interpretive, comparative dead reckoning suggests how I might decipher this intermedial intersection of poetic text and historical document.

The most laudable technological achievements and the most deplorable crimes of the twentieth century come together in the figure of Charles Lindbergh. Both *Captain, Captain* and the textual history of *Lindbergh's Flight* are marked by this national hero's purported complicity in the other "crime of the century": the Nazi genocide. Reworking his libretto for a broadcast in 1950, Brecht expunged the airman's name from the text and changed its title to *The Flight over the Ocean* to register his contempt for Lindbergh's admiration of the German Luftwaffe, his efforts to discourage American involvement in the conflict in Europe, and his notorious public worries about the number of Jewish refugees entering the United States (see Brecht 1998, 7).[11] Alluding to Lindbergh's wartime positions as well as to the many doubts about the validity of Hauptmann's conviction, Morrissey and Talley note that "there is an intersubjectivity in terms of criminality, either person in the relationship could be said to be the criminal for various reasons"

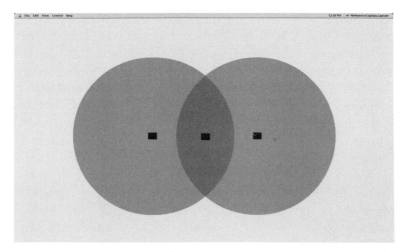

FIGURE 11.3. Screen capture from *My Name Is Captain, Captain*. On the screen, a streaming line of white Morse code is visible through the black holes. Reproduced with permission.

FIGURE 11.4. "Singnature" from the second ransom note. Photo courtesy of the New Jersey State Police Museum.

(Pressman 2003a). By binding the themes of navigation, detection, reasoning, and guilt to an interface that requires me to "steer" my way through the text, *Captain, Captain* opens a circuit into a development in mid-twentieth-century American technoculture that laid the foundation for the present-day "cultural logic of computation" that so concerns thinkers like Golumbia.

Lindbergh's and Earhart's accomplishments contributed enormously to all aspects of aviation, including the use of aircraft in warfare. During the Second World War, the revolutionary science of cybernetics greatly accelerated these advances in military aeronautics. Noting that "the steering engines of a ship are indeed one of the earliest and best developed forms of feed-back mechanisms," Norbert Wiener (1965, 19) borrowed the Greek word for "helmsman"—or "pilot"—to name the new field, which was initially devoted to automating the navigational systems of missiles. Writing in 1947, Wiener expresses grave concerns about future applications of the science he had helped found, which in his view "embraces technical elements with great possibilities for good and for evil. We can only hand it over to the world that exists about us, and this is the world of Belsen and Hiroshima" (28). Wiener's postwar soul searching has left a lasting impression; monitory reminders of the martial origins of cybernetics, often tied to citations from Weiner, are a recurring feature in theories of computer technology's world- and consciousness-shaping influence. Friedrich Kittler (1999, 260), for example, after a long quotation from Wiener's *Cybernetics,* asserts that "today [digital signal processing] ensures the sound of most reputable rock bands; in actuality, however, it was only a 'new step' in ballistics." The implication seems to be that nonmilitary adoptions of cybernetic systems, including artistic appropriations, must be wary of a potential for violence that lies coiled in these technologies. A further implication is that computer-based poems like *Captain, Captain,* human–computer collaborative novels like *exquisite_code,* and text-intensive games like *Dwarf Fortress* might offer especially effective means of encouraging reflection on those incipient dangers.[12]

Read alongside lines from *Captain, Captain* such as "the Captain / made a mistake" and "I am he that killed themselves," Wiener's scruples about the humanitarian risks of cybernetics

enter the conceptual field of the Greek idea of "missing the target," *hamartia*, a term Aristotle borrows from archery to designate the "mistake" or "miscalculation" of a protagonist—Oedipus, for example, the paradigm of the misguided detective—that precipitates the action of a tragic drama. If I view the errors of *Captain, Captain*'s protagonists—Lindbergh, Hauptmann, and Earhart—as "tragic" insofar as they result from varying degrees of hubris, I gain a more morally resonant understanding of the Link Trainer's caution that "once you have mastered your banks and turns—on instruments alone—you'll encounter simulated misfortune." Figuring the act of reading as an instance of abductive, dead-reckoning navigation, *Captain, Captain*'s visual–textual–kinetic interface also simulates the responsibilities of anyone whose hands are (presumably) in control of the powerful technologies the poem at once describes and embodies.

In the seventh movement of *Lindbergh's Flight*, the personification of Sleep tempts the aviator: "Only for a minute, just let your head / Droop towards the joystick. Let your eyes close for one brief instant / You've a wakeful hand" (Brecht 2003, 9). *Captain, Captain* presents parallel images of tested vigilance in the recurring mantra "our hands must keep pace with our instruments" and the lines "Vacuum within which you extend / the sleeping fingers of your / negative culpability." The malapropistic nod to Keats's "negative capability," which for Keats (1899, 277) makes us "capable of being in uncertainties, mysteries, doubts, without any irritable reaching after fact & reason," offers at least one key to *Captain, Captain*'s "secret code," revealing how what the poem calls "that moment of tragic insight" might apply to me, its reader. While the poem certainly creates a Brechtian *Verfremdungseffekt*, alienating me from my book-bound assumptions about reading, it is not just any reading, nor exclusively "literary" reading, to which this estrangement most urgently calls my critical attention: above all, this postmodern, post-9/11 tragedy is about acts of interpretation in which *lives are at stake*. Appealing to my moral imagination, the poem steers me through twentieth-century history toward the dawning realization that the fallibility of my own reasoning and of the machines I use to enhance my reasoning is inextricable from my liability for the potentially lethal outcomes of my decisions.

Bound to specific physical materials, texts are always also bound to historically and culturally specific worlds; this double binding consolidates a text's "integrity" and underwrites its ongoing relevance. Lance Olsen (2003) has described *Captain, Captain* as "a hyper-elegy about the anniversary of a woman's death whose real protagonist turns out to be the text's own processes (the beautifully designed interplay between elusive language and the motion of ever-morphing surfaces)." This representation is hardly inaccurate, but as I hope I have shown, some of the protagonists of this poem, though never definitively identifiable, haunt historically situated positions that imbue the questions I am prompted to ask about them with serious ethical implications. Reading *Captain, Captain* alongside *Lindbergh's Flight* against the backdrop of 9/11, the spurious investigation into Iraqi weapons of mass destruction, the outsourcing of life-or-death military decisions to unmanned drones, the designation of cyberspace as the fifth domain of war, as well as the digitally enhanced malfeasance that brought down the global economy in 2008, we might hear the continuing resonance of both texts' reflections on the role of human judgment—and the ideological screens that inevitably cloud it—in the operating procedures of all our apparatuses.

"YOU MUST BUILD A STUDIO": CRITICAL AND CURATORIAL COMMITMENTS

In coming years, screen-bound texts will dominate our reading and writing lives in ever more supple forms. Some will be born digital; many others will be digitally reproduced editions of texts from other media, optimized in various ways for the interface of the screen. This great migration of past and present writing onto the screen—and, as the contributions to this volume by Raley (chapter 1) and Hayles (introduction) suggest, beyond the screen—is drawing literary critics, humanities–computing specialists, digital archivists, and creative writers into increasingly interdependent relationships. It remains to be seen whether the present-day structures of our academic institutions will be equipped to facilitate and nurture these relationships.

In December 1927, in a set of "recommendations" published in

a Berlin newspaper, Brecht (2000, 36) issued a directive that applies as forcefully to today's university programs in the humanities as it did to its original addressee, the director of the Berliner Rundfunk: "You must build a studio. Without experiments it is simply not possible to assess fully your apparatuses or what is made for them." By "studio" Brecht meant a laboratory devoted to collaborative experimentation in the then-new medium of radio. Today, although text-oriented scholars and artists are certainly assessing the complex communication apparatus of "the screen," too few of them are truly experimenting with it in the thoroughgoing way Brecht advised. Such initiatives are now essential to the sustainability and, indeed, the integrity of our scholarly communities, for as Hayles (2005, 243) has observed, "'what we make' and 'what (we think) we are' coevolve together; emergence can operate as an ethical dynamic as well as a technological one." A studio model for literary studies, going so far as to bring creative writers, literary critics and historians, experts in archiving and preservation, and digital humanists into the same room, might well allow us to capture the energy of the ethical dynamic Hayles invokes in ways that raise the stakes and reinforce the relevance, for the academy and for society as a whole, of all these intellectual endeavors.

In addition to facilitating closer collaborations among scholars and artists invested in texts, the creation of a university-based studio for experiments with a range of textual media would entail not only departures from the restrictive reading screens of conventional scholarship but also reaffirmations of some traditional fields now under threat in the downsizing academy. Decrying the scaling back of courses in bibliography in English graduate programs, along with reduced requirements in ancient and foreign languages, Tabbi (2008, 318) asserts that "what professors of literature are jettisoning from the curriculum, it seems, are precisely those disciplinary forms that would allow us to enter both the media and world culture on terms specific to our own practice as writers." The ability of humanities programs to justify their continuation may well depend on the adroit act of recovering old skills while developing new ones. Spivak (2004, 110), a leading advocate for an overhauled comparative literature, presents this idea as an imperative:

The humanities must learn to de-trivialize themselves and to stake their suitable place at the university of this troubled century. I am utterly appalled by conservative young colleagues who insist with amazing insularity on teaching "only literary skills"—what are they?—because the students arrive untrained; as the world breaks around them.

One of the exciting possibilities of a university-based textuality studio is the opportunity it would provide to retool humanities training to better prepare students to read, write, and interpret in a world dominated by "the screen," assured of their ability to engage effectively not just with the screen's legible surface but with at least some of the computational codes and mechanisms subtending it; in their chapters in this volume, Kirschenbaum (chapter 3) and Marino (chapter 12) chart paths in this direction. Such a studio might take its motto from Morrissey and Talley's Link Trainer: "confidence is the watchword, and knowing one's instruments is the prime requisite."[13]

An important role for a literary-studies studio would be to explore more intimate links between the critical analysis of textual artifacts and their preservation. Literary texts retain their actual and potential cultural relevance only so long as they remain accessible to readers. Compared to the book-bound, stage-bound *Lindbergh's Flight,* Morrissey and Talley's screen-bound poem is at once more consistent and more precarious. As a set of Shockwave files burned onto a CD-ROM, Morrissey and Talley's poem is virtually frozen in the form its authors gave it, whereas Brecht's text morphed through several versions between 1929 and 1950. Conversely, as printed documents, Brecht's Lindbergh materials may well prove to be more durable than their digital descendant. Corporate competition, at present between Apple and Adobe, has put Flash's longevity in doubt, and other animation platforms are bound to supplant it in the future. At the time of this writing, the current CD-ROM edition of *Captain, Captain* no longer runs on the most recent versions of the Macintosh operating system. Technical hurdles like these can interfere with a text's enduring reception. In comparison to Morrissey and Talley's widely discussed *The Jew's Daughter,* published on the web in 2000, *Captain, Captain* has

received little critical attention apart from Pressman's (2003b) perceptive essay. If critics fall asleep at the controls, taking too little account of the material vicissitudes of screen-bound writing, works like *Captain, Captain,* so valuable both as signposts in the history of literature and as milestones in individual artists' careers, are bound for obscurity. To remain vigilant, we need to combine our comparative perspective with a curatorial commitment, augmenting our critical investigations into the remarkable capacities of screen-bound texts with practical efforts to keep those texts alive (see Montfort and Wardrip-Fruin 2004). Both perspectives can best be cultivated through hands-on engagement: looking under the hood of existing works to discover how they are made and prototyping new computational compositions that continue to push the limits of the screen.

If, in our roles as academics and artists, we are to realize the aesthetic, cultural, and political potential of the cybernetic technologies that pervade our world and resist their more baleful influences, we will need to intervene into these technologies productively, on our own terms, and in the spirit of creative inquiry embodied in both *Lindbergh's Flight* and *My Name Is Captain, Captain.* I present my literal text-to-text comparison in this chapter not as a paradigm but as a maquette of the kind of larger-scale investigations into textual, technical, and historical connections that a studio approach to scholarly work on textuality might foster. I have tried to point out some of the poetic and ethical dynamics that become more visible under a comparative critical gaze that regards the screen itself as a kind of studio, a vibrant space of experiment, exploration, exchange, and, perhaps most crucially, improvisation on the theme of our ever more mediated yet ever more intimate interactions with each other and our machines.

NOTES

Warm thanks to N. Katherine Hayles and Jessica Pressman for their invitation to contribute to this collection and for their editorial advice as well as to Dorothee Aders, Mark Bernstein, Mark Falzini, Diane Greco, K.-D. Krabiel, Laura E. Lyons, Judd Morrissey, Laurie McNeill, Marc Silberstein, Lori Talley, and Markus Wessendorf for their generous assistance and commentary.

1 This "lesson" read in part, "In obedience to the principles: the state shall be rich, man shall be poor, the state shall be obliged to have many skills, man shall be permitted to have few, where music is concerned the state shall provide whatever requires special apparatuses and special skills, but the individual shall provide an exercise" (Brecht 2000, 39). For descriptions of the cantata's first performance, see Brecht's own "Explanations" in Brecht (2000, 38–41) and Krabiel (1993, 43–48).

2 Wardrip-Fruin and Monfort (2003) present key texts documenting these developments since 1945.

3 Pressman (2003b) rightly points out that the final period, "the visual grammatical symbol that marks content endings and somatic pauses," is integral to the poem's full title. In my discussion, I will use *Captain, Captain* to economize without sacrificing the title's consequential doubling.

4 On the early history of literary experiments with computation, see Funkhouser (2007). For concise definitions of electronic literature, see Hayles (2008) and Wardrip-Fruin (2010). Currently the most accessible compendia of major works of electronic literature are the two volumes of the *Electronic Literature Collection*; see Hayles et al. (2006) and Borràs et al. (2011).

5 Two among many possible examples of works that deftly combine play and cultural critique are Berkenheger's (2011) *The Bubble Bath* and Jason Nelson's (2011) *Game, Game, Game, and Again Game,* both of which can be found in volume 2 of the *Electronic Literature Collection.*

6 Simanowski (2010, 231–48) reflects on possible reasons for the slow uptake of digital literature into the academy.

7 See Schreibman, Siemens, and Unsworth (2004) for an overview of this many-faceted field. Tracing the transfer of the medieval text *Controversia de nobilitate* from manuscript to codex to digital edition, Mak (2011) offers a compelling recent example of this kind

of scholarship, with a particular focus on the materiality of texts.

8 With his distinction between "textons" and "scriptons," Aarseth (1997, 62–65) provides an influential model of this split between the potentiality of stored text and the text's actualization by a reader.

9 Kirschenbaum (2008, 35) has noted how readily "the screen still seems to slip into a synecdoche for 'the computer' as a whole"; with the emergence of the World Wide Web, "the screen" has become a stand-in for all the networks of telecommunicated social relationships the computer facilitates.

10 Judd Morrissey, e-mail correspondence with the author, November 26, 2011.

11 For an account of Lindbergh's wartime activities and attitudes, see Berg (1999, 384–458). In his novel *The Plot against America,* Roth (2005) imagines a dystopian American history with Lindbergh as the country's anti-Semitic president.

12 In this context, I find it striking that the inventive programming behind both *exquisite_code* and *Dwarf Fortress* has been associated with widespread, massively powerful computational systems: the applications of Web 2.0 in the case of Brendan Howell's Python programming for the novel (Marino, chapter 12) and the design software used in the aerospace industry in the case of Tarn and Zack Adams's coding of the game (Boluk and LeMieux, chapter 6).

13 A few such studios already exist, e.g., the Literary Arts Program at Brown University, where Judd Morrissey, Noah-Wardrip Fruin, Brian Kim Stefans, and other noted writer–critic–theorists of electronic literature have studied; the Program in Writing and Humanistic Studies at MIT; and the Greater Than Games Lab at the John Hope Franklin Humanities Institute at Duke University.

REFERENCES

Aarseth, Espen. 1997. *Cybertext: Perspectives on Ergodic Literature.* Baltimore: Johns Hopkins University Press.

Abramson, Albert. 1995. *Zworykin: Pioneer of Television.* Champaign: University of Illinois Press.

Berg, A. Scott. 1999. *Lindbergh.* New York: Berkley Books.

Berkenheger, Susanne. 2011. *The Bubble Bath.* In *Electronic Literature Collection,* vol. 2, edited by Laura Borràs, Talan Memmott, Rita Raley, and Brian Stefans. Electronic Literature Organization. http://collection. eliterature.org/2/.

Borràs, Laura, Talan Memmott, Rita Raley, and Brian Stefans, eds. 2011.

Electronic Literature Collection. Vol. 2. Electronic Literature Organization. http://collection.eliterature.org/2/.

Brecht, Bertolt. 1998. "An den Süddeutschen Rundfunk." In *Werke,* vol. 30, edited by Werner Hecht, Jan Knopf, Werner Mittenzwei, and Klaus-Detlef Müller, 7. Berlin: Aufbau.

———. 2000. *Brecht on Film and Radio.* Translated by Marc Silberman. London: Methuen.

———. 2003. *Lindbergh's Flight.* In *Collected Plays: Three,* edited and translated by John Willett, 2–19. London: Methuen.

Burke, Kenneth. 1966. *Language as Symbolic Action: Essays on Life, Literature, and Method.* Berkeley: University of California Press.

Eco, Umberto. 1990. *The Limits of Interpretation.* Bloomington: University of Indiana Press.

Eco, Umberto, and Thomas A. Sebeok, eds. 1983. *The Sign of Three: Dupin, Holmes, Peirce.* Bloomington: University of Indiana Press.

Emerson, Lori. 2008. "My Digital Dickinson." *Emily Dickinson Journal* 17, no. 2: 55–76.

Funkhouser, Chris. 2007. *Prehistorical Digital Poetry: An Archaeology of Forms, 1959–1995.* Tuscaloosa: University of Alabama Press.

Golumbia, David. 2009. *The Cultural Logic of Computation.* Cambridge, Mass.: Harvard University Press.

Hayles, N. Katherine. 2003. "Translating Media: Why We Should Rethink Textuality." *Yale Journal of Criticism* 16, no. 2: 263–90.

———. 2005. *My Mother Was a Computer: Digital Subjects and Literary Texts.* Chicago: University of Chicago Press.

———. 2008. *Electronic Literature: New Horizons of the Literary.* Notre Dame, Ind.: University of Notre Dame Press.

Hayles, N. Katherine, Nick Monfort, Scott Rettburg, and Stephanie Strickland, eds. 2006. *Electronic Literature Collection.* Vol. 1. Electronic Literature Organization. http://collection.eliterature.org/1/.

Johnson, Steven. 1997. *Interface Culture: How New Technology Transforms the Way We Ceate and Communicate.* San Francisco: HarperEdge.

Keats, John. 1899. *The Complete Poetical Works and Letters of John Keats.* Cambridge ed. New York: Houghton, Mifflin.

Kirschenbaum, Matthew. 2008. *Mechanisms: New Media and the Forensic Imagination.* Cambridge, Mass.: MIT Press.

Kittler, Friedrich A. 1999. *Gramophone, Film, Typewriter.* Translated by Geoffrey Winthrop-Young and Michael Wutz. Stanford, Calif.: Stanford University Press.

Krabiel, Klaus-Dieter. 1993. *Brechts Lehrstücke: Entstehung und Entwicklung eines Spieltyps.* Stuttgart, Germany: Metzler.

Mak, Bonnie. 2011. *How the Page Matters*. Toronto, Ont.: University of Toronto Press.

Montfort, Nick, and Noah Wardrip-Fruin. 2004. "Acid-Free Bits: Recommendations for Long-Lasting Electronic Literature." Electronic Literature Organization. http://www.eliterature.org/pad/afb.html.

Morrissey, Judd, and Lori Talley. 2002. *My Name Is Captain, Captain*. Watertown, Mass.: Eastgate Systems.

Nelson, Jason. 2011. *Game, Game, Game, and Again Game*. In *Electronic Literature Collection*, vol. 2, edited by Laura Borràs, Talan Memmott, Rita Raley, and Brian Stefans. Electronic Literature Organization. http://collection.eliterature.org/2/.

Nordby, Jon J. 1999. *Dead Reckoning: The Art of Forensic Detection*. New York: CRC Press.

Olsen, Lance. 2003. "Narratological Amphibiousness, or: Invitation to the Covert History of Possibility." *Electronic Book Review*. http://www.electronicbookreview.com/thread/endconstruction/betweenness.

Pressman, Jessica. 2003a. "Flying Blind: An Interview with Judd Morrissey and Lori Talley." *Iowa Review Web*. http://iowareview.uiowa.edu/TIRW/TIRW_Archive/tirweb/feature/morrissey_talley/interview.html.

———. 2003b. "The Very Essence of Poetry: Judd Morrissey and Lori Talley's *My Name Is Captain, Captain*." *Iowa Review Web*. http://iowareview.uiowa.edu/TIRW/TIRW_Archive/tirweb/feature/morrissey_talley/essay.html.

Raley, Rita. 2006. "Editors Introduction: Writing .3D." *Iowa Review Web*. http://iowareview.uiowa.edu/TIRW/TIRW_Archive/september06/raley/editorsintro.html.

Roth, Philip. 2005. *The Plot against America*. New York: Vintage.

Schreibman, Susan, Ray Siemens, and John Unsworth. 2004. *A Companion to Digital Humanities*. Oxford: Blackwell.

Simanowski, Roberto. 2010. "Teaching Digital Literature: Didactic and Institutional Aspects." In *Reading Moving Letters: Digital Literature in Research and Teaching*, edited by Roberto Simanowski, Jörgen Schäfer, and Peter Gendolla, 231–48. Bielefeld, Germany: Transcript.

Smith, Matthew Wilson. 2007. *The Total Work of Art: From Bayreuth to Cyberspace*. New York: Routledge.

Spivak, Gayatri Chakravorty. 2004. "Terror: A Speech after 9–11." *boundary 2* 32, no. 1: 81–111. http://muse.jhu.edu/journals/b2/summary/v031/31.2spivak.html.

Tabbi, Joseph. 2008. "Locating the Literary in New Media." *Contemporary Literature* 49, no. 2: 311–31.

Walkowitz, Rebecca L. 2009. "Comparison Literature." *New Literary History* 40, no. 3: 567–82.

Wardrip-Fruin, Noah. 2005. "Playable Media and Textual Instruments." *dichtung-digital.* http://www.brown.edu/Research/dichtung-digital/2005/1/Wardrip-Fruin/.

———. 2010. "Five Elements of Digital Literature." In *Reading Moving Letters: Digital Literature in Research and Teaching,* edited by Roberto Simanowski, Jörgen Schäfer, and Peter Gendolla, 29–57. Bielefeld, Germany: Transcript.

Wardrip-Fruin, Noah, and Nick Montfort, eds. 2003. *The New Media Reader.* Cambridge, Mass.: MIT Press.

Wiener, Norbert. 1965. *Cybernetics, or Control and Communication in the Animal and the Machine.* Cambridge, Mass.: MIT Press.

Winters, Kathleen C. 2010. *Amelia Earhart: The Turbulent Life of an American Icon.* New York: Palgrave Macmillan.

12

Reading *exquisite_code*: Critical Code Studies of Literature

Mark C. Marino

FOR OVER A DECADE, since Lev Manovich's (2002) call for "software studies" and N. Katherine Hayles's call for media specific analysis (Hayles and Burdick 2002), critics have been turning to examine the computational artifacts used to create these works of art, examining the platforms, the broader networks, and, of course, the software. Critical code studies (CCS) emerged in 2006 as a set of methodologies that sought to apply humanities-style hermeneutics to the interpretation of the extrafunctional significance of computer source code (Marino 2006). Since that definition first appeared in *electronic book review,* the field of CCS has emerged through online working groups, conferences, articles, a research lab, and several collaborative book projects. The goal of the study is to examine the digitally born artifact through the entry point of the code and to engage the code in an intensive close reading following the models of media archaeology, semiotic analysis, and cultural studies.

CCS takes the analytic approaches of cultural studies and applies them to the source code; however, its readings cannot discuss the code without a full discussion of the software, processes, and platform. In other words, CCS does not fetishize the code or abstract it from its conditions but engages the code as an artifact contextualized in a material and social history. When the source code of a work is published with the output text, whether in print or online, CCS takes on an even more necessary function as the artists have situated the code as part of the artwork, inviting close readings. What follows is a case study in CCS built around a multiauthored, procedurally produced[1] text called *exquisite_code.*

Enter your text here.

So begins the collaboratively authored novella *exquisite_code* (Griffiths et al. 2010), "a radical constructivist experiment," featuring a fragmented tale of a dark future populated by zombies, exiled yuppies, and a talking horse. As the "exquisite" of the title suggests, the novel's creation grew out of an adaptation of the surrealist technique, the "exquisite corpse." During its composition, seven artists sat writing together continuously at a table while being recorded through time-lapse video and audio in a London gallery for roughly eight hours a day for five days, February 15–19, 2010. The result of the process is available in a print-on-demand novel, while text, audio, and video archives are available online.

In one type of exquisite corpse *(cadavre exquis),* developed from a parlor game called "consequences," authors continue a piece of writing only having seen the last portion of the segment the previous writer has created; *exquisite_code* preserves that basic model but then adds computational elements and a few more requirements to its process. First, the collaborators would each write a prompt from which only one was randomly selected. Then, the authors had roughly six minutes to respond with a text that presumably continued an overall story. However, once submitted, these text passages were subjected to another combination or selection process according to a set of undisclosed rules and computational processes, the code for which has been published as an appendix to the print and online editions. Those programs employed variations on Markov chains, an algorithmic adaptation of Burroughs's cutup method, and even a text message (SMS) style to process the prose. Some of these mixing processes were created by the writers themselves during the five-day period.

More than foregrounding its machine-centered processes, *exquisite_code* entices readers to read in order to deduce the processes of its composition. Just as the procedural generation behind *Dwarf Fortress* drew Boluk and LeMieux's focus in chapter 6 of this volume, *exquisite_code* draws attention to the processes that produced the final text. Reading the text, then, becomes a game of trying to detect the signatures of the particular collaborators in the mash, as evidenced by repeating themes, diction, and punctuation,

as well as deducing the process, how each passage grew out of the dynamics of the group and the randomly selected prompts. However, the finished text is not the only type of evidence available for this detective work. The appendix of the book features author bios, a list of software used, and, notably, the Python code that was used to process and produce the text. In this way, the book invites us to read this code in conjunction with the output text. Additionally, the website for the project offers even more data, with archives of the text database, video and audio recordings from the sessions, and other documentation. These attendant files offer the ability for others both to stage an exquisition of their own and to reconstruct the process behind this text. The code offers traces of one part of the process, the text another, the audio and video still more. All these traces are tools for reverse engineering the process of creating the text, which I would argue is one of the principal pleasures of reading this book. Most of these processes are not explicitly referenced in the book or its ancillary materials. The code alone marks a discrete, fossilized portion of this process; the text fossilizes the product of the execution. There is therefore no discontinuity between reading the process of the code and reading the product of the processes in the text. One leads into the other in a Mobius feedback loop.

In this chapter, using the techniques of CCS, I will use *exquisite_code* as a case study in close reading a text in conjunction with the computer source code that made it possible. In a work that emphasizes its process, the code becomes a crucial component to understanding the conceptual framework and practical methods used to produce the piece. Because the code was written by the authors of the piece, and some of it was created even during the time of the live writing, the code, too, becomes a primary component of the artwork produced. As code and text collide and intermingle in various portions of the work, the line between the processed data (text) and the processing code is not just blurred but wiped away as the two texts (code and story) are imbricated together. While the exquisite corpse uses a process that disrupts the romantic notion of the single-authored text, *exquisite_code* disrupts the conventional division between artistic process and product. Reading through the code, the work proves to be a portrait of a

set of authors anguishing over, marveling at, and wrestling with the processes that are randomizing and remixing (what the work calls "munging") their texts. Through this case study, it becomes clear that code is no longer mere scaffolding of the digitally born art object but another literary component of the work.

THE STORY AND ITS ORIGINS

The "History" page of the *exquisite_code* website describes its genesis when programmer Brendan Howell was describing to writer Sabrina Small "live coding," the practice of composing code, often projected on a large screen, in front of an audience as a type of performance. Howell made specific reference to the work of Dave Griffiths, who would become one of the collaborators in the project. In live coding, as Stephen Ramsay (2010) has argued, the programmer writing the code is in the position of the musician performing a jazz solo.[2] Coding becomes public performance. Inspired by live coding, Howell and Small asked themselves, "What if there were a panel of writers all plugged into the same program and the program dictated the rules of their writing?" The co-conspirators concocted a plan to assemble a system that would select writing automatically and assign a random set of prompts.

The program could randomly select a writer from the panel, and the chosen writer would dictate the path the story took. Each time a section of the story was completed, a random writer would be chosen, so the story would be a collaborative work based on different writers scrambling to make sense of what came before. This vision of the writer "scrambling" epitomizes the way in which the performance feeds off the tension of the seeming impossible machine-like challenge put to the artists' abilities. The entertainment, again similar perhaps to certain theatrical improv games, or even to reality TV, is in watching the writers squirm.

However, it was not enough to have the writer scramble to process what had come before; the two collaborators decided to add additional constraints in prompts drawn from a collection of writing manuals for disparate genres from science fiction to "Dan Brown fan fiction." Such reappropriation of more popular formula-driven genre instruction to the creation of experimental

literary writing would mark yet another sign of the lineage of their aesthetic from the Oulipo *(Ouvroir de littérature potentielle)* to the Situationists and, of course, the Surrealists. The goal was not to lay the groundwork for spontaneous works of literary genius but to challenge the idealized, romantic notion of authorship by subjecting authors to processes derived from industrial fiction production. The process was formalized further through a "proctor": "someone who oversaw the writers and the program and read aloud to an audience" (Howell 2010). The proctor served as a human functionary to marshal the overall process, though he would ultimately become an object of scorn among the writers.

It may seem unusual that the function of this literary game is to situate the act of creative writing as performance. Authors generally understand the practice of literary creation to be a labor-intensive process of drafting, refinement, and revision. However, consider that Howell and Small are developing this project out the model of live coding, a highly performative act, where code is created in real time. As in the case of creative writing, artful programming, as advocated by such luminaries as Donald Knuth,[3] is also predicated on drafting, refinement, and revision, with a healthy dose of debugging as well. Thus, writing code live is no less provisional and precarious, and is perhaps more so, for it has to function. To write "live," then, is to produce publishable text and (it is hoped) functional code while an audience is watching. Writing and coding then become performative when they are staged as a spectacle, a process that raises the act of composition to a kind of virtuoso real-time public improvisation rather than a lengthy process of cycles of construction, feedback, and refashioning.

Furthermore, this project adheres to the spirit of the exquisite corpse. André Breton ([1948] 2012), who is credited with developing the technique, explains that these works "bore the mark of something which could not be created by one brain alone.... With the Exquisite Corpse we had at our command an infallible way of holding the critical intellect in abeyance." Neither the exquisite corpse nor exquisite code work to promote the romantic notion of the solitary author laboring but instead open up the process of writing as collaborative play. Consider that the game of exquisite corpse takes its name from a sentence produced in its initial playing:

"Le cadavre exquis boira le vin nouveau" (The exquisite corpse will drink the young wine) (Breton [1948] 2012). These projects aim to free the process of writing from the baggage of solitary visions and tightly wrought crafts. Such an ethos pervades the process-intensive experiments of groups such as the Surrealists, the Situationists, and the Oulipo.

Although the first few iterations of exquisite code had a more intimate context,[4] the project took on a more formal, more self-consciously artistic element when Jonathan Kemp brought the project to a London gallery in February 2010. The writers in the London implementation included Leif Elggren, Dave Griffiths, Jonathan Kemp, Eleonora Oreggia, and Laura Oldfield Ford, along with Howell and Small. The structure involved the seven writers working eight hours a day for five days in a windowless room in the E:vent Gallery in London under the surveillance of occasional human monitors, a video camera, and an audio-recording device. A dot matrix printer spit out a continuous stream of the live novel. Their laptops were networked together via Ethernet hubs, running a special word processing program developed by Howell. The program would first ask the writers to type in a one-line writing prompt in one minute. From those, one prompt was randomly selected, and the writers then had six minutes to write their individual text chunk, though these six minutes ultimately varied between two and fifteen minutes (Howell 2011b). The produced text chunk, either selected or munged, was then displayed in their browsers.

Ultimately, six processes were applied to the chunks:

ℜ The Classic Random Select—One text selected from all submissions. Modified to have some kind of fair-queuing or round-robin selection.

β Burroughs Columnar Cut-Up—Texts are justified to 80 columns (typewriter width) and chopped horizontally into thirds. These chunks are randomly realigned. Orphaned letter strings are killed off.

Σ Markovian Gang Chaining—Takes all of the texts and builds a statistical index based on word order and then spits out words based on probable next words. Text length is based on average of submissions.

Δ Dave—ASCII art inspired concrete poetry rendering.

∈ Eleonora—Cheeky recursive recombination of Burroughs and Markov.

ꝑ TEXTR—Attempt to compress random select to 168 character abbreviated SMS Message.[5]

Each of these processes was implemented in the code of the project. The final three were developed during code-writing stints scheduled into the writing process on an ad hoc basis. Although neither the code nor the published novel indicates the order in which these techniques were encoded, their use in the story suggests that the order given represents the order in which they were developed. In other words, the list represented the order of appearance of these techniques, with later ones used only at the end of the five days and infrequently.

The group of writers was not told which edit method was used on the text. The proctor followed a system that involved a combination of automatic conditions (if the gallery director walked by the window) to group consensus. Howell (2011b) notes in an e-mail, "Towards the end we started to really enjoy using Markov, burroughs and xtext for the longer writing sessions as they all guaranteed a certain level of inclusion and serendipity." The absurd arbitrary nature of these rules again intensified the role of the system on the process of producing this novel over carefully selected artistic planning.

Yet the authors themselves had to guess the nature of the processes applied to their texts. The collaborators were not told which edit had been applied to the text but instead were given only the output text and had to determine for themselves what had happened to it. Consequently, the readers of the novella have an advantage in knowing the edit process, whereas the writers have the advantage of knowing the prompt. Both reader and writer share the challenge of trying to determine the machinery that is producing this text.

THE CODE

To say a novel is about its process more than its plot suggests that such an interpretive approach is evoked rather than chosen. By publishing the book with its code, however, *exquisite_code*

encourages its audience to read the work through the code (and vice versa). The code seems to lay bare the process, and yet a quick comparison between the book's code and the code available for download on the website suggests otherwise. For example, a file called prompts.py contains a set of rules or guidelines from a prior exquisition. It was only on questioning Howell about this file that I realized that the book text was created through the use of a different set of unpublished prompts written by the authors before each session and randomly chosen. So the inclusion of the code offers yet another partial trace of the processes, and yet its inclusion in the book suggests that it is also part of the work of art called *exquisite_code*, to be read, examined, and interpreted as such.

According to the project documentation, the project emerged from an interrogation of the relationship between coding and writing as discussed by a writer and a programmer. "Exquisite Code began," recounts the website, when the writer "asked the programmer what it felt like to program. The programmer began to describe the process in language suited to the writer's experience of writing and the writer began to understand that programming was like writing in many ways and that perhaps the intersection between the two was more creatively alligned [*sic*] than previously assumed." Code is therefore at the heart of this process. It takes the place of the "corpse" of the exquisite corpse, and therefore the subject of this experiment is not the constituted body but the series of instructions and the encoded text that they have produced.

Howell has situated the project in the context of live coding both in adapting a writing process that emulates live coding and in encouraging the programmers, particularly Griffiths and Oreggia, to code during the five days of the writing of the novella. Coding, then, becomes another generative activity placed under the pressure and scrutiny of the overall performance.

Part of the code for this project establishes the basic interface for the writers, which Howell says employs the structure of the collaborative environment of Web 2.0. The architecture of exquisite code thus reflects a modern-day *detournement* inasmuch as the framework of the piece has the same basic form of the platforms for social media: model, view, controller (MVC). The models included the sessions with users, chunks, and prompts, each

being its own object class. The views were presented using HTML and eventually were exported to the printed novel. The controller was "the logic that glued the model and the view together." The model was the same Howell (and countless others) had been using in his freelancing, "the design paradigm that programmers for every Website use when people make lots of money building big corporate websites and Web 2.0 applications" (B. Howell, pers. comm.). So what does it mean to use a Web 2.0 framework for this piece? It, the code, the framework, the ethos, becomes part of the exquisition.

The *exquisite_code* was written in Python, a dynamic, flexible language offering run-time debugging to catch errors, which no doubt facilitated the collaborative, on-the-fly composition. Howell has expressed his personal predilection for Python and was inspired enough by the success of the programming platform Processing to develop his own development environment, Pycessing, for teaching novice programmers to code using Python. In his introduction to that project, Howell (2011a) extols the virtues of Python, writing,

> Contrast [Java and C] to the programming language Python which has a syntax derived from ABC, a programming language designed in the Netherlands in the 1980s for pedagogical use. Python limits the use of curly braces, parentheses, semicolons and does not require the programmer to keep track of data types. In addition, the language is "whitespace based," meaning the indentation from the left side indicates the logical functional blocks. This tends to be easier to read and understand.

Howell explained that he selected Python for the programming platform for *exquisite_code* both because of his storehouse of code in that language and for ease of use and development in combination with new pieces of code.

However, the program does not run on Howell's handmade Python code alone, for he also relies on software with equally colorful names, Cheetah, CherryPy, and SQLAlchemy, all of which serve the implementation of the MVC structure, making the code more elegant. Cheetah is a template engine and code generator, CherryPy is an object-oriented web application framework for

Python, and SQLAlchemy is a Python database tool kit and object relations mapper. To frame it as an exquisite corpse of software metaphors, Howell's CherryPy (SQL)Alchemizes Python with a Cheetah, which is another way of saying that the source code printed at the end of the book does not offer the entire picture. Howell made use of template generators, web application frameworks, and database software to help separate the layers of the project and to lighten his own programming load and make the system more scalable for future exquisitions.

The primary activity of the software is to take the entered text chunks and process them into output, a process that Howell calls munging. Munging is a chief metaphor in the text as well as the code. A file called munger.py defines the major selection and recombinant methods from the round-robin to txtr. An online reference called *The Jargon File,* later published as *New Hacker's Dictionary,* offers the following definition of *munge* (Raymond 2012):

> munge: /muhnj/, vt.
> 1. [derogatory] To imperfectly transform *information.* 2. A comprehensive rewrite of a routine, data structure or the whole program. 3. To modify data in some way the speaker doesn't need to go into right now or cannot describe succinctly (compare *mumble*). 4. To add *spamblock* to an *email address.*

To this extent, munging seems to be a transformation as to revise, to obfuscate, or to impair automatic tracing. It is a process of transformation that is not fully specified enacted on data. In the case of *exquisite_code*, munging is the name applied to the operations and procedures, applied to the submitted text chunks. However, the challenge for both the readers and writers participating in the creation of this text is to discern the nature of the munging process. Beside these natural language dictionary definitions, consider the function definitions of "mungefunction" in the following code:

```
#this is very hacky but allows for dynamic creation of new munge
functions
mungefunction = eval("munger."+algorithm)
```

```
munged_output = mungefunction(chunks)
#chunk = random.choice(chunks)
#chunk.selected = True
round.text_out = munged_output
txtout = open("out.txt", "a")
txtout.write(munged_output)
txtout.close()
```

What Howell here refers to as "hacky" is his quick and dirty way of allowing for new munge functions to be easily added to the code, crucial because the code and the writing are supposed to be developed simultaneously. By framing the text processes as munging throughout the code, the programmers, specifically Howell, establish it as the central framing metaphor for the overall writing process.

The text itself also mentions munging. One passage discusses the writing process of 532, who is at once an author "known as Jim in some circles" and seemingly a machine: "[writing] kind of comes easy in a while and it feels like you're connected like the 532" (Griffiths et al. 2010, 16, ℛ4). The passage continues with broken typing: "you just had to connect to a particular way of writing and it can really flow out quite easily and for some considerable time. But then that, as 532 had found out, could prove pretty disastrous in the not so long run" (16–17). The writer seems to be describing the best approach to their particular writing conditions, strategies for dealing with the continuous six-minute cycles. At once the text changes to discussing the 532 as some sort of writing machine:

> But I guess the 532's algorithms had been slightly different then, a bit more rigid with no munging opportunities inn-built. a pity he thought. Well, maybe some of the others would be able to hack into it all at some later date. but we'll have to wait and see. (Griffiths et al. 2010, 17, ℛ1)

Interestingly, the writing process of the character called 532 is presented as "flabby," while algorithms that "munge" are situated as a relief, as a recourse from weaker prose.

Munging may be a deeply computational concept thoroughly infused with the culture practices of programming, but in the case

of *exquisite_code*, "munging" is the encoded practice of a literary activity with roots in the surrealist technique of the exquisite corpse as well as the spirit of the Situationist technique of *detournement*, by which materials are remixed and reused to speak back to their original purpose, a kind of speaking back to the utterances of powerful communicators. Writers and writing are automatically processed, and much of the novel of *exquisite_code* reveals writers coming to terms with that loss of control.

READING AS REVERSE ENGINEERING

Reading to determine the underlying process of a piece of software involves imagining that you are tracing the actual code while actually creating what Jeremy Douglass (2007, 69) has called the "implied code." Douglass describes the use of these user models of how the code functions in the playing of interactive fictions (IF). An accurate model of the implied code can allow the players to navigate the various riddles, puzzles, and passages of IF. In the case of *exquisite_code*, the reader can rely on the published code itself to understand how the novella emerged, and yet that code is just one piece of a much larger set of processes, many of which are not documented in the published novella.

It is my contention that a major pleasure of reading this novel, and other procedurally generated works of literature, involves attempting to detect the processes that lead to any particular piece of text. Each text chunk was the result of at least three discrete processes: the randomly selected prompt, the texts produced by the writers in response to that prompt, and the process used to select or combine the texts produced. Because the text presents the symbol representing each constraint beside each text passage, the reader is encouraged to read the text chunk through that process, in other words, imagining the source material from the traces in the "munged" text. Conversely, the reader does not know the prompt nor who wrote which lines and can only detect these from the text.

Part of the fun of reading this text is watching the narrative unfold or, rather, emerge. The story, as much as there is one, begins in London, where "some kids were smashing up the dole office in Shadwell" (Griffiths et al., 1, ℛ1). As the chunks continue in

the round-robin style, which incorporates the text as written, randomly chosen from the assembled authors, a fairly consistent tale emerges. London has been renamed Magna London, a Big War has replaced the Christian Empire with a Jewish one, and Christians are now slaves in Australia.

However, the place of the Jews and religious groups continues to emerge over a few text chunks. The enslavement of the Christians emerges immediately after a passage that describes the exportation of the Jesuits to Australia. The text chunk that mentions "the Big War" ends, "And at the end, maybe the Nazis were right to say that," which is continued in the subsequent text chunk with "Esther Bloomberg, she had the answers to these problems" (Griffiths et al. 2010, 2, ℛ2, ℛ3). In many ways, this passage ends a potentially anti-Semitic fantasy by displacing it with the search for Esther Bloomberg. Esther will later turn out to be called a nonexistent person and elsewhere reemerges as a cyborg.

Tracing the leitmotif, the way the mention of exiled Jews becomes the search for Bloomberg, models a reading process of tracing the emergence of themes through a collaborative text. A sussing out of sources of these plot points demonstrates a basic manner of reading the novel by which I am trying to determine a source of a particular thread in the novel by reading back over the preceding text passages with the understanding that the writers can only rely on the previous passage as presented to them through the custom writing platform Howell built; their memory of prior text chunks; or the dot matrix output of the used text, which Howell noted was infrequently consulted.

The story continues to evolve in these ways, punctuated by rather sudden shifts that seem to mark either divergent directions from the authors or, more significantly, the end of a day of writing. Within the first few rounds, the setting is established as a futuristic, dystopian London in which gangs of youths are enacting some measure of violence and a character is searching for someone named Esther. However, at one point, the storyline switches suddenly, violently even, to New York. The other writers include New York in subsequent passages for a time before pulling the action back to London. However, after approximately a quarter of the text, or one day (since the last day had comparatively

fewer writing sessions), that previous plot all but disappears. Back in a dystopic future United Kingdom, yuppies have been exiled, zombies wander the city and take classes, and a few characters frequent their favorite pubs and occasionally have old-fashioned sex. Subsequent storylines emerge involving a character named Markov who has developed a new math involving bullet points, Bianconero the talking horse, a call to a suicide hotline, a romantic relationship that is falling apart, and quite a bit of time in one or more pubs. Suffice it to say, the novella is not really about the plot but instead a particular set of processes, part of whose output and processes have been revealed. Tracing the effects of this process requires reading by way of reverse engineering.

Similarly, the narrative flows for a pace in a fairly tame style, until it turns explicitly pornographic, as a writer depicts a scene of fellatio and other acts with little narrative or poetic ornamentation. The next passage seems to withdraw the story from that genre by contextualizing that scene as pages of pornography that have become strewn over the landscape: "The pages of hedgerow porn ran together as they got rained on. The advert for microwave food bled into and mixed with some kind of copulation scene" (Griffiths et al. 2010, 20, ℜ1). It is an act of repair, like conversational repair, drawing the manuscript back from a randy precipice. Of course, it is an imposition on the text to suppose such intentionality, but I would argue such is the pleasure of reading this type of collaboratively authored text.

Howell (pers. comm.) notes that there were various times when each of the contributors went a bit blue, and such sexually explicit writing seems to fit the form of the fragmentation akin to Robert Coover's (1969) "The Babysitter" or the collaborative writing project of *Naked Came the Stranger* (Ashe 1969), two works that emerged from a period of formal and sexual liberation, although the latter is positioned as a moral corrective. Perhaps such outbursts of libido should be expected from a project written from behind a curtain, texts slipped under the door with relative anonymity. The blurring of advertising and pornography in the "repair" passage paints this picture of an Internet as sidewalk refuse, of a networked information amalgam, as a pile of free city papers strewn in a modern-day muck that leads not to moralizing but to

"Shantels bio washed out and blended and" (note here a Markov chain takes over) "Peace of Mind You Just Can't Buy" (Griffiths et al. 2010, 20, ℜ3, Σ1). Like so much art from the Situationists to other postmodern art, the book relishes the sublime miasma of porn, pop culture, and commerce.

To assign a logic, to narrate the process by which these text chunks may have come into being, is to project a fantasy on the text, and yet to read *exquisite_code* is to watch a novel emerge, and reverse engineering is the process of trying to trace that emergence. For example, at one point, the text mentions a "new form of mathematics that has been discovered involving arranging bullet points in new ways to unlock mysteries of logic" (Griffiths et al. 2010, 21, ℜ1). Subsequently, a writer includes a passage:

- I am writing
- I am writing that I am writing.
- I am writing that I am writing that I am writing...
 (Griffiths et al. 2010, 21, ℜ3)

These bullet points seem to have been called forth by a germ of an idea of one of the writers carried on by (presumably) another writer.

Another passage gives birth to one of the munging methods applied to the text chunks. Describing a cat, the author explains, "In this state he could communicate telepathically but he got aggressive and started blasting you with banal but bitchy text messages: TNAFSH PLS. BRD BRD BRD. YPPY CNT" (Griffiths et al. 2010, 32, ℜ1). The subsequent text chunk includes the line "TNA FSH TNA FSH TNS FSH TNA FISH TNA FSH TNA FSH" (Griffiths et al. 2010, 32, ℜ2). Howell would turn this plot point into a munging method, which chooses the first 150 characters from a random chunk and strips out the vowels:

```
chunk = strip_tags(random.choice(chunks).text)[0:150]
chunk = chunk.replace("a", "")
chunk = chunk.replace("e", "")
chunk = chunk.replace("i", "")
chunk = chunk.replace("o", "")
chunk = chunk.replace("u", "")
```

```
chunk = "<p>" + chunk + " L8R!</p>"
return chunk.upper()
```

The text here is an object that can be operated on. The reference to "chunks" places the text within a very particular legacy of text processing using computers. While George Landow would place text passages under the literary category of "lexias," "chunk" seems to remove all literary pretense, treating prose as undifferentiated globs of language. Merely removing the vowels does not entirely replicate the practices of texting, but it does create a playful caricature of the cultural practice while reducing literary lines to abbreviated messages. Similarly, to the end of the output text, the munge method appends L8R ("later"), a conventional and highly typified SMS convention.

THE MARKOV CHAIN GANG

One of the clearest examples of the feedback loop between the encoded process of munging the text and the content of the text arrives in the form of Markov gang chaining. According to Howell (pers. comm.), he had to work some kinks out of this code, and so the process does not appear until page 18, shortly after a character named "Markow" rides in on a black-and-white horse, subsequently and eponymously named Bianconero, who will soon take on the ability of speech. Subsequent to this passage, the Markov chain process is employed for processing the text chunks.

Favorite tools of e-lit artists as well as spammers trying to avoid spam filters, Markov chains are perhaps the most widely used text-generating method, dating back to their use in analyzing sequences in Pushkin's "Eugene Onegin." However, it was Claude Shannon who first articulated how this method, and the incumbent n-grams, could be used to generate text on a stochastic model (Wardrip-Fruin 2009). The process builds a new text out of patterns based on phrases found in the text chunks. The writers of *exquisite_code* tended to like the Markov chain, for it, like the Burroughs method, offered a high likelihood that at least some of their text would be used, as opposed to the all-or-nothing round-robin method.

In Howell's code, the Markov chain generator uses each of the

text chunks written in a session as its basis and creates an output whose length is the average length of those chunks. Of course, attributing the code to Howell imposes a model of authorship that does not entirely fit, as one can find nearly identical code predating Howell's code circulating online without copyright. Such reuse is negligible but becomes significant in the context of a creative, poetic work in which poetic authorship has been removed from its romantic status by subjecting creative writing to anonymity and remixing procedures. Yet, unlike the creative writing, the code was not subject to arbitrary processes but was worked into functional form by Howell, who takes credit and responsibility for this code. To that extent, authorship reemerges in the realm of code, though it is much more of a craftsman's signature, the mark of the chief architect, head chef, or head contractor.

As mentioned, this Markov chain generator relies on triples. Following is a segment of that code:

```
def database(self):
    for w1, w2, w3 in self.triples():
        key = (w1, w2)
        if key in self.cache:
            self.cache[key].append(w3)
        else:
            self.cache[key] = [w3]

def generate_markov_text(self):
    seed = random.randint(0, self.word_size-3)
    seed_word, next_word = self.words[seed], self.words[seed+1]
    w1, w2 = seed_word, next_word
    gen_words = []
    for i in xrange(self.out_size):
        gen_words.append(w1)
        w1, w2 = w2, random.choice(self.cache[(w1, w2)])
gen_words.append(w2)
return ' '.join(gen_words)
```

This Markov chain algorithm searches for a random pair of sequential words and then chooses randomly from the possi-bilities for the third word. Consequently, those second and third

words become the first and second, and a new third is randomly selected. For example, if one text had written "I love you" and another text included "I love cheese," the system would choose randomly between one of those two endings and then search for "love you" or "love cheese" plus the next most likely word. As you can imagine, the phrase "love cheese" is probably unique to just one of the text chunks, whereas "love you" again might lead to multiple options.

As opposed to longer strings, triples or 3-grams cause this generator to lean toward more fragmentation and a higher likelihood of switching from one section of a text chunk to another. In Markov chains, the higher the number of terms used to establish the pattern, the less likely the pattern is to appear anywhere else. For example, if the required phrase were "I love you cheese puffs" in a 4-gram, the system would look for "I love you cheese," a much less frequent phrase than "I love." Therefore this Markov chain generator, with its smaller number of required words, leads to less stability, or perhaps more clearly, less continuity, a specific kind of aesthetic more akin to a cutup method than generating the kind of text likely to pass as single authored, assuming the authors do not attempt to write in a purposefully broken style.

This choice of the Markov chain generator based on triples will have measurable effects not just on the text it munges but on the style of the individual writers. First, the character Markow–Markov enters "riding a beautiful black and white horse," and at one bar, "each day Markov would come in and talk about maths [*sic*]" (Griffiths et al. 2010, 18, ℜ2). Yet the use of this particular Markov chain generator has another effect on the prose. Consider this passage:

> People were lost, people were fucked, people were waiting for something to happen, their lives appended by solar panels and small generators, trying to remember who they were, their consciousness fragmented in dislocated hard drives, like canguros: they jump all the time, and there is nothing more dangerous than a car crash with a canguro. (Griffiths et al. 2010, 31, ℜ1)

First, the anaphora, the repetition of "people were," in any other writing circumstance, would merely create a sonorous effect or

rhetorical emphasis, yet here it creates three possibilities for a Markov generator. Second, the unique phrases "consciousness fragmented in" and "dislocated hard drive" create strings that are highly unlikely to have alternatives. In other words, the person whose word choices or strings of words are unusual can game the Markov chain generator to remain in his text chunk for as long as the language strings are unique triads. But it is the transition into *canguros*, this non sequitur, that most resembles the sudden switching of topic of the Markov chain, not to mention the fact that this Italian word for "kangaroos" would be unlikely to appear in anyone else's text. While such free associating occurred in earlier passages, the sudden switch encoded in the Markov chain generator becomes a dominant aesthetic in the work the more that method of munging is used. And yet Markov chains are tools of happy accidents. As one passage reads, "Markov became a sort of revelation, a sort of miracle.... Markov's chain of events is only useful to represent a series of discrete random independent states" (Griffiths et al. 2010, 18, Σ1). Note that this very verdict, the miracle of Markov, was itself yielded by the generator.

Ultimately, the Markov chain proves to be a strong analog to the process of writing the text in general. Just as the Markov chain relies on very shallow memory, building out on triadic sequences, the process of *exquisite_code* essentially only remembers the most recent text passage produced. This is an amnesiac writing process that generates lines such as "We have been writing for days and almost no one know but.—OK then, let's try to write a normal novel" (Griffiths et al. 2010, 25, Σ1).

WHEN THE CODE ENTERS THE TEXT

According to Howell, the person of the "Proctor," whom he played, took on a mock life among the writers as an unrelenting bureaucrat who was subjecting the writers to all sorts of unpleasantries. Because the Proctor is part of the process, deciding which munging technique was to be used according to a fairly loose system, the Proctor becomes metonymic for the code. Curiously, the Proctor character subsequently appears in the text, most notably in a code-heavy passage. This code is a kind of "munging" or mashing pseudocode play on the main.py code itself. Though it is

nonfunctional, it offers commentary and reflection on the processes of exquisite code:[6]

```
def proctor (self, nazi) :
```

[MCM: A new function is being defined with arguments "self" and "nazi." By giving proctor the argument nazi, this code art suggests that the variable extent of nazism affects the operations of proctor. In the context of the procedural writing challenge, the tyranny of the enforcer of the constraints, particularly with regard to the amount of time allowed to answer each prompt, no doubt greatly affects the mood of the writers.]

```
if nazi = 0;
proctor++;
```

[MCM: proctor is being advanced, if the variable nazi is set to null. Of course, these plusses also read as points being awarded to the proctor for not acting like a nazi, or like a tyrant.]

```
# if it is time to go, then go
```

[MCM: In this comment, "time to go" could be "time to give up" or "time to proceed."]

```
def proctor(self, prompt=0):
    template = templdir + "/proctor.tmpl"
    page = Template(file=template)
    prompt = int(prompt)
    text = "..."
```

[MCM: This code creates new code based on the proctor template, using the Template object imported from the Cheetah code generator. Compare with the following:

```
def session (self, sid):
    template = templdir + "/session.templ"
```

In this case, the system writes code ostensibly to display some aspect of the proctor, but at the same time, it situates the proctor as a kind of cultural form, a type, produced by implementing a systematized template.]

```
if prompt != 0:
    text = self.theText()
    path = os.path.join(datadir, \
        str(prompt-1) + "/*.txt"
    print "path :" + path
    files = glob.glob(path)
```

[MCM: This section largely mimics the main code. If there is a prompt, the text is assigned the text element of self, a path is specified apparently for storing the file, and that path name is printed. "Files" will be assigned the path names that match the "path."]

```
else,
    pack up and go. when things reach the\
stage of botheringnessness,
```

[MCM: Here a natural language set of instructions encourages the writer to go when she gets bothered.]

```
    then

:~/text$ sudo ifconfig eth() 192.168.0.7 netmask

    255.255.255.0
```

[MCM: This 24-bit netmask essentially establishes a subnet of computers at the 192 address, creating the local network used in the project. Thus, once the program or programmed user is bothered, he can establish a network.]

```
    else
```

```
talk to an immortal,

    life > entity > death
```

[MCM: The conditional continues with a natural language instruction to speak to an immortal the statement that life is greater than an entity that is greater than death.]

```
elif:
```

[MCM: Though one might expect "else if," this word appears to be "file," life's anagram, written backward.]

```
    Submit,

    or make a tea

# but please, do not sleep now!
```

[MCM: Followed by instructions to submit or make tea and a comment about getting some rest, fatigue no doubt sets in again with the writer programmers.]

```
    page.text = text
    page.prompt = promptList[prompt]
    page.next = prompt + 1

    return str(page)
proctor.exposed = True
```
(Griffiths et al. 2010, 33–34, ℜ1)

[MCM: The code ends with assignments of text, prompts, and an advancement to the next prompt with the proctor's property of "exposed" set to true.]

Here are the authors imagining a conflation of the role of the proctor (Howell 2011a), the character of the Proctor evaluated for the extent of his Nazi tendencies, and the code as Proctor, governing their work. Again, "Nazism" here presumably figures

as joking hyperbole along the lines of Seinfeld's infamous Soup Nazi, the character who would serve none of his much-desired soup unless interfaced with according to his exacting whims. Yet it is curious to see this allusion to Nazism within a work that begins with a scrap of paper with a Jewish name, belonging to one of the only identifiable characters, Esther Bloomberg, who changes her name (variously Bloomberg or Bloomenthal) and her essence from person to nonexistent person to cyborg, depending on the text chunk. To be Jewish, in this work, is to be the subject of persecution and at the same time to be the amorphous or morphing object of mystery. At the opposite pole, Nazism emerges as a marker of the unyielding enforcement of codes—and the political, social, and real-world effect of aesthetic code. To be processed is to be munged, to resist is to munge back.

At once this pseudo-code seems to enjoin the writer to give up when she has had enough or else submit to the process. The ending seems to imply that the process of executing these instructions (or perhaps writing them) has exposed the Proctor, which is ultimately a code imposed on the writer, like an overbearing constraint. Furthermore, by employing the Cheetah template object, even the code that is the Proctor is figured as autogenerated, as the product of a machine process. It is in this section, then, that the writer engages with the procedures to which she has submitted herself. In munging the code itself, the writer is writing back to that process, even though this text appeared merely by the luck of the round-robin draw and may in fact only be a private conversation between the writer and the software that processes the text chunks, written in a hybrid language that cannot be processed as code.

In addition to their critiques of the caricatured Proctor, the writers also push back on the process more generally. In the following passage, the character known as 532 plays a writing game that seems modeled on the one used to produce *exquisite_code*:

532's favorite game was sitting in a white box and frantically typing in 6 minute intervals. The problem was constantly trying to remember things that 532 had written in scraps of stories that had been allowed to be chipped into stone by the

loud machine chipping away at paving slabs all day. Some of his scraps were deemed lucky enough, others were not, and at some point (after the illegalisation and amputation of his copy/paste apendage) he forgot which things had been recorded and which things he could recycle, recycle, recycle on endlessly. (Griffiths et al. 2010, 17, ℜ2)

In this passage, as the process becomes the focus of the project, the text attests to the author's irritation at not having his text chunk selected for use. Howell explained that sometime during the first day, he realized that the writers were copying their text chunks on their machines, only to paste them in during the next round if theirs was not chosen. Acting as Proctor, he outlawed the practice, here envisioned as an appendage, an extension of the body of the writer, interfering with the recycling of past material.

Other passages reveal fatigue and even confusion about the process. The following passage appears with struck-through writing:

~~claude was on the coach and claudine under the coach what did they do?~~
i thought this was a prompt but it was not so i just have to start writing again and today i have something against it, it is more physical than mental, like a sort of clumsiness with my hands in relation to the materia, the machine that take my orders and organize the agreeable signs to a more or less mutually understandable code. (Griffiths et al. 2010, 44, ℜ2)

With the explicit mention of the writing prompts and machine, the wrestling match between authors and authoring system tumbles out of the ring, into the narrative, or rather the wrestling match becomes the narrative, foregrounding the "clumsiness," asking who is giving the orders: the writer or the process. The machine in this passage is at once servant and collaborator, and the final product is not fiction or poetry but "mutually understandable code," where the two entities of the mutuality are presumably the human and machine coauthors.

In reading *exquisite_code*, the search for meaning is replaced by the acknowledgment of the textual process and an attempt to

process its munged output, while speculating on the nature of the original texts. The poetic pleasures of *exquisite_code* can be found in "reading for the process" that can be traced in the text and in the code but lies explicitly in neither. In effect, *exquisite_code* identifies the way a literary work's engagement emerges not solely from its finished prose or the algorithms and procedures that produced it but with the interplay between the two as imagined by the reader always unmaking and remaking the text.

CONCLUSION

At the start of the video that recaps the project, Jonathan Kemp says,

> Forget insulation from the cold, nagging existential doubt or refuge in the stories comforting the general intellect, a dark forest of things was foregrounded in *exquisite_code*, a radical constructivist experiment that housed a collaborative writing project.

Narrative coherence is here posited as the child's blanket, while fragmentation is raw material for grown-ups. I would argue that this description is more than just an excuse masquerading as bravado. The claim is that the pleasures and promises of *exquisite_code* will be something other than well-wrought stories. The pleasure is in tracing the tensions between the authors and the process to which they submit themselves. In this chapter, I have spent less time on plot and more on a reading process of reverse engineering this constructivist experiment, enjoying the subtle pleasures involved in teasing out constraints both stated in the code and evidenced in the final text, as in the prompts. The search for Esther Bloomberg/enthal, which fades from the novel, is replaced with the search for the process that changed her from an unnamed Jew to a cyborg, as definite signs of process in code yield to unknown processes and artists. Just as the code is a remnant of what has been compiled and executed, the text is a remnant of processes both documented and undocumented surrounding the unknowable procedures of creative invention, accentuated in the context

of writing as constrained collaborative live performance. What makes the act of writing, code or prose, a compelling performance is witnessing the artist confronting constraints, be they proctors, processors, or prompts, in real time.

NOTES

1 The procedure used here is not purely procedural in the sense of a poetry-generating program but is instead a set of writing constraints intertwined with a set of encoded processes for choosing and combining them.

2 See the video "Algorithms Are Thoughts, Chainsaws Are Tools," https://vimeo.com/9790850.

3 In Knuth's (1987) Turing Award lecture, he calls for programmers to treat programming as an art, with care toward the expression and implementation of the algorithm in the code.

4 Following this sense of play, writing as social frivolity, the first two performances of Exquisite-Code were held in Howell and Small's Berlin apartment and involved three to four writers, a proctor, a case of beer, and an audience of about fifteen people. The proctor's job was to read the selected text. The third performance was held at Breakthrough, an experimental multivenue event held in Berlin over twelve hours, on June 27, 2009.

5 An unlisted one, "Two Column Robin," presents side by side two texts selected via round-robin.

6 I interject my readings of the lines in square brackets.

REFERENCES

Ashe, Penelope. 1969. *Naked Came the Stranger.* New York: L. Stuart.

Breton, André. (1948) 2012. "Le Cadavre Exquis: Son Exaltation." In catalog of La Dragonne, Galerie Nina Dausset, 5–7, 9–11.1. October 7–30. http://www.exquisitecorpse.com/definition/Bretons_Remembrances.html.

Coover, Robert. 1969. "The Babysitter." In *Pricksongs and Descants: Fictions,* 206–39. New York: Plume.

Douglass, Jeremy. 2007. "Command Lines: Aesthetics and Technique in Interactive Fiction and New Media." Ph.D. diss., University of California, Santa Barbara.

Griffiths, Dave, Leif Elggren, Brendan Howell, Jonathan Kemp, Laura Oldfield Ford, Eleanora Oreggia, and Sabrina Small. 2010. *Exquisite_code*. London: Mute.

Hayles, N. Katherine, and Anne Burdick. 2002. *Writing Machines*. Cambridge, Mass.: MIT Press.

Howell, Brendan. 2010. "Exquisite_code » History." http://exquisite-code. com/?action=page&url=history.

———. 2011a. "Introducing Pycessing—A System for Learning to Program." In *PyCon DE 2011*. Leipzig, Germany. http://2011.de.pycon. org/2011/schedule/sessions/82/.

———. 2011b. "Re: Prompts Etc. for Ex_code." Unpublished manuscript.

Knuth, Donald E. 1987. "Computer Programming as an Art." In *ACM Turing Award Lectures: The First Twenty Years: 1966–1985*, 667–73. New York: ACM Press/Addison-Wesley. http://doi.acm.org/10.1145/ 1283920.1283929.

Manovich, Lev. 2002. *The Language of New Media*. Cambridge, Mass.: MIT Press.

Marino, Mark C. 2006. "Critical Code Studies." *Electronic Book Review*. http://www.electronicbookreview.com/thread/electropoetics/codology.

Ramsay, Stephen. 2010. *Algorithms Are Thoughts, Chainsaws Are Tools*. http://vimeo.com/9790850.

Raymond, Eric S., ed. 2012. "Munge." *The Jargon File*. http://catb.org/ jargon/html/M/munge.html.

Wardrip-Fruin, Noah. 2009. *Expressive Processing: Digital Fictions, Computer Games, and Software Studies*. Cambridge, Mass.: MIT Press.

CONTRIBUTORS

Stephanie Boluk is assistant professor in the Department of Humanities and Media Studies at Pratt Institute.

Jessica Brantley is associate professor of English at Yale University. She is the author of *Reading in the Wilderness: Private Devotion and Public Performance in Late Medieval England.*

Patricia Crain is associate professor of English at New York University. She is the author of *The Story of A: The Alphabetization of America from "The New England Primer" to "The Scarlet Letter."*

Adriana de Souza e Silva is associate professor of communication, affiliated faculty at the Digital Games Research Center, and a faculty member of the Communication, Rhetoric, and Digital Media program at North Carolina State University. She is the coeditor (with Daniel M. Sutko) of *Digital Cityscapes: Merging Digital and Urban Playspaces,* coauthor (with Eric Gordon) of *Net-Locality: Why Location Matters in a Networked World,* and coauthor (with Jordan Frith) of *Mobile Interfaces in Public Spaces: Control, Privacy, and Urban Sociability.*

Johanna Drucker is the Breslauer Professor of Bibliographical Studies at the University of California, Los Angeles. Her publications include *The Alphabetic Labyrinth, The Century of Artists' Books, The Visible Word, Sweet Dreams, SpecLab,* and the coauthored *Digital_Humanities* (with Anne Burdick, Peter Lunenfeld, Todd Presner, and Jeffrey Schnapp). She is also a book artist and visual poet.

Thomas Fulton is associate professor of English at Rutgers University. He is the author of *Historical Milton: Manuscript, Print, and*

Political Culture in Revolutionary England and coeditor (with Ann Baynes Coiro) of *Rethinking Historicism from Shakespeare to Milton.*

Lisa Gitelman is professor of English and media studies at New York University. She is the author of *Always, Already New: Media, History, and the Data of Culture.*

N. Katherine Hayles is professor and director of graduate studies in the literature program at Duke University. Her books include *How We Became Posthuman: Virtual Bodies in Cybernetics, Literature, and Informatics,* which won the Rene Wellek Prize for the Best Book in Literary Theory for 1998–99, and *Writing Machines,* which won the Suzanne Langer Award for Outstanding Scholar. Her most recent book is *How We Think: Digital Media and Contemporary Technogenesis.*

William A. Johnson is professor of classical studies at Duke University. His books include *Readers and Reading Culture in the High Empire: A Study of Elite Reading Communities, Ancient Literacies,* and *Bookrolls and Scribes in Oxyrhynchus.*

Matthew G. Kirschenbaum is associate professor of English at the University of Maryland and associate director of the Maryland Institute for Technology in the Humanities. He is author of *Mechanisms: New Media and the Forensic Imagination* and coauthor (with Richard Ovenden and Gabriela Redwine) of *Digital Forensics: Born-Digital Content in Cultural Heritage Collections.*

Patrick LeMieux is a PhD student in the Department of Art, Art History, and Visual Studies at Duke University.

Mark C. Marino is a critic and author of electronic literature. He is a coauthor of *10 PRINT CHR$ (205.5 + RND (1)); : GOTO 10.* He teaches at the University of Southern California, where he directs the Humanities and Critical Code Studies Lab. He is also director of communication for the Electronic Literature Organization.

Jessica Pressman is a fellow at the American Council of Learned Societies and a visiting scholar in literature at the University of California, San Diego.

Rita Raley is associate professor of English at the University of California, Santa Barbara. She is author of *Tactical Media* (Minnesota, 2009) and coeditor of the *Electronic Literature Collection, Volume 2.*

John David Zuern is associate professor of English at the University of Hawai'i at Mānoa. He is coeditor (with Cynthia Franklin) of *Biography: An Interdisciplinary Quarterly.*

INDEX

Abbott, Jacob, 158–59, 164, 166
abduction (interpretive method),
 xxx, 267–74, 276, 289–94,
 301–7
Acid-Free Bits (ELO), 63
Acland, Charles, 13
Adams, Tarn and Zach, xxvii,
 126–54, 152n5, 279n12
Adobe, 79
Aeschylus, 106
affect, 8, 16, 25, 158–68
*Affecting History of the Children
 in the Wood, The* (chapbook),
 161
agency (of nonhuman actors), 71–
 72, 141–43, 200, 284. *See also*
 code; evolutionary algorithms
Ahrens, Marlene, 49
Allen, Christopher, 35
Alma-Tadema, Laurence, 104
alphanumeric system, 71–76, 82–
 83, 86, 92–94. *See also* fonts;
 letters (forms); optical character
 recognition (OCR)
*American Dictionary of Printing
 and Bookmaking,* 189
Amoretti (Spenser), 222
And, Mikael, 62
Annal of Saint Gall, 145–47
annals, 144–48
Anthony, Brittania, 163
Anthony, Kate J., 163–66, 165
anthropomorphization, 137–38.
 See also human (category)
anti-aliasing (term), 80
Antony and Cleopatra

(Shakespeare), 225
Apology for Actors (Heywood),
 231, 242
Apple, 78–79
Arcadia (Sidney), 234
Archeologies of the Future
 (Jameson), 132
archeology (media), 66–68
archiving, xxiv–xxv, 22–27,
 54–56, 126, 223, 234, 259–61,
 274–77
Areopagitica (Milton), 244
Aristotle, 148
arithmetic logic unit (ALU), 141
artificial intelligence, 1, 125–54,
 152n6
ASCII, 77
As You Like It (Shakespeare), 222,
 233
atomism (in semiotics), 71–75, 88,
 91, 94
audio walks, 33–35, 38–42, 45,
 51n7
augmented reality, 37
Augustine (saint), 204
Augustus Caesar, 117–18
authorship, 13–18, 33–52,
 284–88, 298–301. *See also*
 exquisite_code (Griffiths et al.);
 intellectual property issues;
 participation (in creation of art
 and literature); performativity

"Babysitter, The" (Coover), 296
Baker, William C. M., 192
Baker v. Selden, 192, 195n14

315

"Why Compare?"
(Radhakrishnan), viii
Wiener, Norbert, 272
WikiMe, 36, 38
Willerton, Chris, 62
Winfrey, Oprah, 54
World Wide Web, 37, 39–40, 256
Woudhuysen, Henry, 241
Wriothesley, Henrie, 228
writing. *See* inscriptions; literature
(and writing); practices;
technology; *specific media and
technology*

Wroth, Mary, 234

Yeandle, Laetitia, 247n23
Yellow Arrow (Allen, Counts,
House, and Shapins), 35, 42–44
Yelp, 47, 50
Youth's Keepsake, The (book), 168

*Zeitschrift für Medien-und
Kulturforschung* (journal), xx
Zork Trilogy (game), 151n2
Zuern, John David, xxx, 134,
255–79

(continued from page ii)

UNIVERSITY OF WINCHESTER
LIBRARY